Graphis Inc. is committed to celebrating exceptional work in Design, Advertising, Photography & Art/Illustration internationally.

Published by **Graphis** I Publisher & Creative Director: **B. Martin Pedersen** I Design Director: **Hee Ra Kim**

Designer: **Hie Won Sohn** I Editor: **Riyad Mammadyarov** I Associate Editor: **Brittney Feit** I Account/Production: **Leslie Taylor**

Graphis New Talent Annual 2019

Published by:
Graphis Inc.
389 Fifth Avenue
New York, NY 10016
Phone: 212-532-9387
www.graphis.com
help@graphis.com

Distributed by:
National Book Networks, Inc.
15200 NBN Way
Blue Ridge Summit, PA 17214
Toll Free (U.S.): 800-462-6420
Toll Free Fax (U.S.): 800-338-4550
Email orders or Inquires:
customercare@nbnbooks.com

Legal Counsel: John M. Roth
4349 Aldrich Avenue, South
Minneapolis, MN 55409
Phone: 612-360-4054
johnrothattorney@gmail.com

ISBN 13: 978-1-931241-77-9
ISBN 10: 1-931241-77-5

This book contains some logos
that were designed by students for
mock clients for the purpose of
completing classroom assignments.
All trademarks and logos depicted
in this book belong solely to the
owners of the trademarks and logos.
By using the trademarks and logos
in these student projects, neither the
schools nor the faculty and students
intend to imply any sponsorship,
affiliation, endorsement or other
association with the trademark and
logo owners. The student projects
were executed strictly for non-
commercial, educational purposes.

The students whose work includes
the logo or trademark of a company
or corporation in this book clearly
have passion for that company.
Graphis would therefore encourage
the ad agencies that have these
accounts to perhaps connect directly
with these students and to seriously
consider employing them.

We extend our heartfelt thanks to
the international contributors
who have made it possible to publish
a wide spectrum of the best work
in Design, Advertising, Photography,
and Art / Illustration.
Anyone is welcome to submit
work at www.graphis.com.

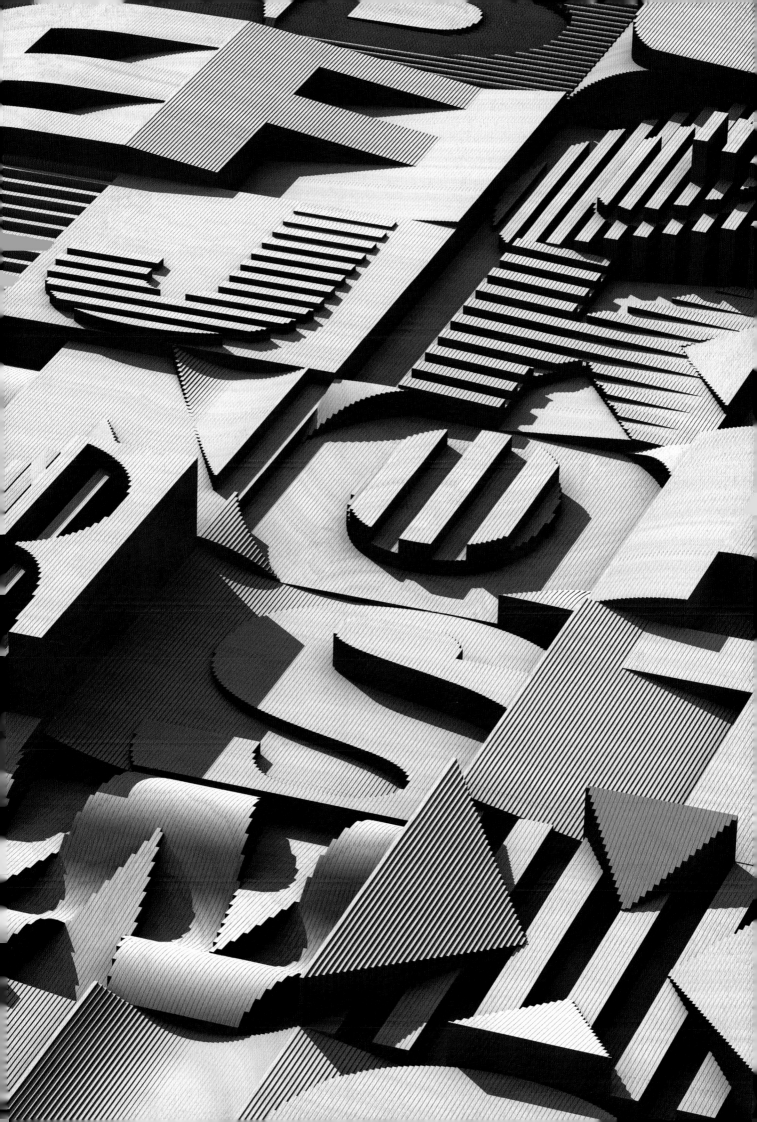

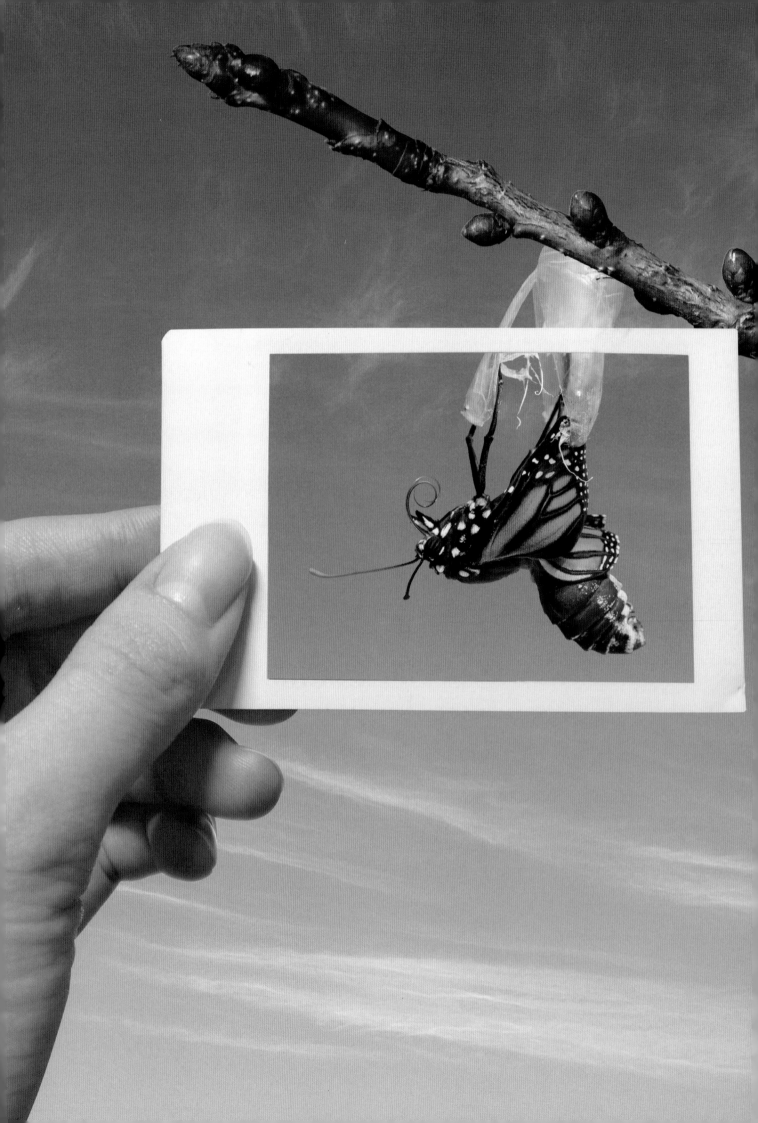

Contents

Miami Ad School: Ron & Pippa Seichrist Continue to Cultivate Student Creativity in Their 15 International Schools

I'm delighted to introduce you to Ron and Pippa Seichrist, the inspiring educators and co-founders of the Miami Ad School. Working together over the last 25 years, they have grown a global network of 15 schools with more than 8,000 graduates. They have each been continuously committed to challenging creative innovation in education. Ron and Pippa, both artists and visionaries, share a passion for helping others achieve their full potential. ■ They have cultivated countless opportunities for their students, pushing them to top advertising agencies, design firms, consultancies, and corporations. Day after day, the love and respect they have for each other can clearly be seen through their work. The place where Ron proposed to Pippa–marked by a heart at the front door of Miami Ad School at Portfolio Center–is still the heartbeat of their school. Each and every day, where Pippa's imagination meets Ron's ever-evolving vision, they make magic happen.

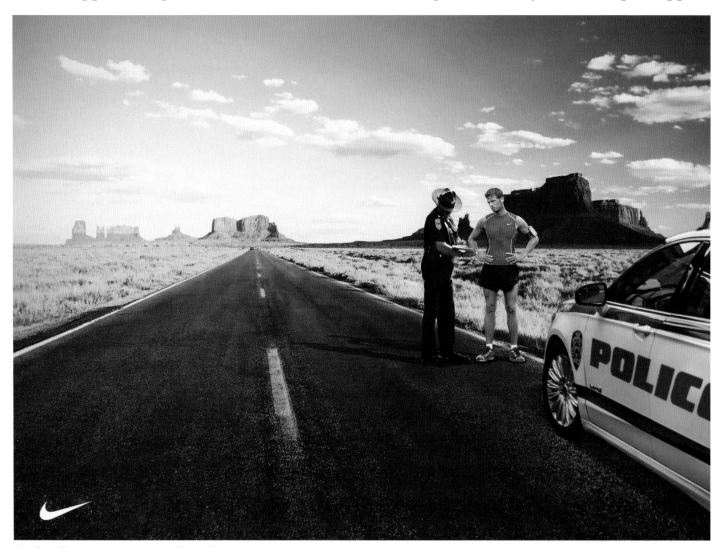

"Nike Speed Ticket"; Professor: Mark Smith; Student: Soham Chatterjee

Hank Richardson is the Director of Opportunities and Outreach and Design Coach at Miami Ad School @ Portfolio Center. He is an AIGA FELLOW and recipient of the NY Art Director's Club 2010 Grandmaster Teacher's Award. He is the 2018 recipient of the Educator of the Year, Golden Apple Award from the Dallas Society of Visual Communicators, National Student Conference. He is a Director of the Museum of Design Atlanta and has served on the AIGA National Board and board of The Society of Typographic Aficionados. As an educator at Miami Ad School @ Portfolio Center, Hank brings strategic design-thinking into his teaching, integrating design, business, and technology. Hank advises student leadership teams that translate design-led business development for start-up companies and products within a real-world context. He has contributed to such books as Design Wisdom, The Education of a Graphic Designer, Becoming a Graphic Designer, Design for Communications, The Education of a Typographer, Graphis, and Teaching Graphic Design.

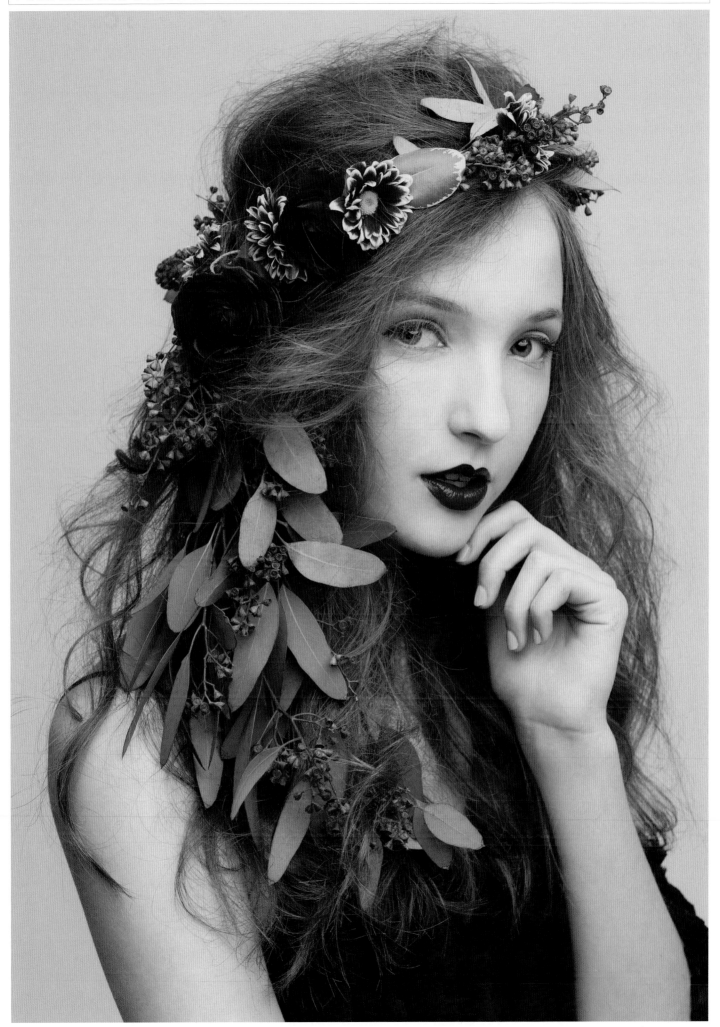

"Wonderment"; Professor: Hank Richardson; Student: Allie Hine

Ron and Pippa are visionaries who keep creativity at the heart of things and have revolutionized the creative education industry. Soham Chatterjee, *Senior copywriter, Leo Burnett*

What inspired or motivated you into your career in advertising, design—the creative world?
I grew up in an immigrant family during WWII. The only way I could get money was to steal and return coke bottles for the two cent deposit or sell poorly drawn pornography to the other kids. I drew cartoons of Dagwood "doing" Blondie, for example. Better money than coke bottle deposits. And more fun. My first real commission was as a freshman in high school. A local businessman came to the principal and asked for someone to draw a label for his product. I got the job. I drew a terrible cartoon of a fisherman holding a big fish and a balloon over his head saying, "WOW! THEM BLOOD WORMS! Many years later a bunch of my NYC creative director friends and I went down to the Chesapeake Bay, rented a boat and captain and fished for four hours or more. And for bait we had cups with my label for bloodworms and my signature, of course, larger than the headline. Embarrassing. A lesson: never make your signature very large or legible.

What is your work philosophy?
Life is short. At 83 years—very short. If life is just a bowl of cherries, work is eating them.

Where do you seek inspiration?
When I was a boy, I had to work with my father in his woodworking shop until midnight. I helped him make stuff. At night we listened to a shortwave radio in both English and German and posted national flags on the progress of all the various armies in the war on a giant world map he had on the wall. He installed a morse code unit next to my bed to call me into his shop whenever. In grade school I wrote stories and drew cartoons. In high school I wrote articles for the school newspaper. I won a contest for designing the uniforms for the high school football team. I learned taxidermy and made sculptures of dancing frogs and tried to sell them. ▪ Later I collected tombstones with typos. Did neon sculptures using old neon signs. I collected old telephone poles and made sculptures in the woods behind my house. I took photographs of flotsam and jetsam around storm sewers using a Rolleiflex camera a cousin brought back from the war. I customized my mother's 50 Mercury using tons of Bondo (plastic compound for dents and re-shaping). Then I worked weekends for a welder to do more radical things on the Mercury. ▪ After I got my first job as a graphic designer in a pharmaceutical company, my inspiration skyrocketed. I designed everything from ads, direct mail, posters, packaging to gigantic exhibits. I could do anything I wanted. My life continued that way, with great times and rough times. It's the way life goes for all of us.

How do you define success?
Living with my rescue dogs; a hound, a sorta pit bull, a doberman. Loving my wife.

Who is or was your greatest mentor?
Perhaps my father. I thought he could make anything. He made me a toy that was an aircraft carrier and an airplane that had a lever to drop a lead bomb onto one or two spots on the carrier. If you hit the spot, the carrier would fly apart in many pieces. Then I had to spend an hour or more putting it back together. In the meantime he could do his work. On the other hand—he was German. So when the other kids were playing basketball after school I was breaking rocks into gravel. He did not believe you should pay for gravel.

Who were some of your greatest past influences?
As a young designer I liked the work of Celestino Patti, a Swiss poster artist. I was doing a lot of woodcuts and so I was influenced by the work of Rockwell Kent. Later on I was greatly impressed with Willy Fleckhaus and TWEN magazine. Takenobu Igarashi is a genius. And of course, Graphis Magazine.

Who among your contemporaries today do you most admire?
For a number of years now, I have followed the Outsider Artists. My wife and I collect folk art from South America and the USA. We have a collection of Howard Finster. Photography has always been important to me. At the moment I am very taken with the work of Nick Knight on his iPhone. And creative directors like Lee Clow, Helmut Krone (art director on the ground-breaking original DDB Volkswagen campaign of the sixties), and even the iconoclastic Alex Bogusky. The late Mike Hughes, of the Martin Agency, was certainly a rare human being.

Who have been some of your favorite people or clients you have worked with?
Pippa Seichrist. An incredibly talented, driven, supportive—difficult woman. Who pushed me and pulled me at the same time.

What are the most important ingredients you require from a client to do successful work?
Freedom to try.

What is your greatest professional achievement?
When I was a senior in high school I thought somehow I would be able to go to college. My parents, who were poor said no way, I was crazy. I was dejected, morose. One of my teachers noticed and

Ron Seichrist started his career as a graphic designer. First with a pharmaceutical company and later with Xerox. In his mid-20s he was featured in Communication Art magazine. He shifted to art direction working in agencies in Richmond, VA and NYC. He left New York in the early 70's to work in Frankfurt, Munich, and London. Coming back to the USA he spent a year as a photo journalist focusing on annual reports and his own personal work. He had a design company in Minneapolis and began teaching at the Minneapolis College of Art and Design where he became the youngest full professor and then Dean of the Design Division. After 10 winters Ron moved to a warmer climate, Atlanta, to start the first portfolio school in the world, Portfolio Center. Ron was featured in ADWEEK magazine as "one who changed advertising in the South." After ten years he left the school he founded and with his wife, Pippa, started an agency specializing in German and Dutch companies doing business in the USA. In 1993 the duo moved farther south to start Miami Ad School. Ron was honored by the New York Art Director's Club Hall of Fame for his commitment to education and also received the Mosiac Award for Diversity.

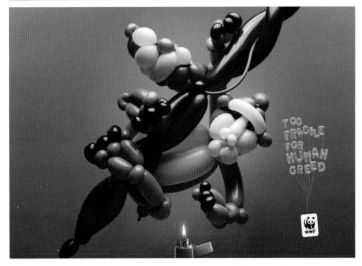
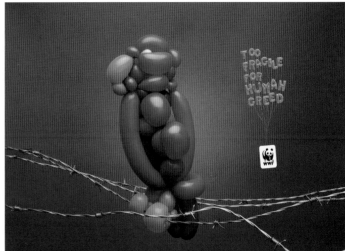
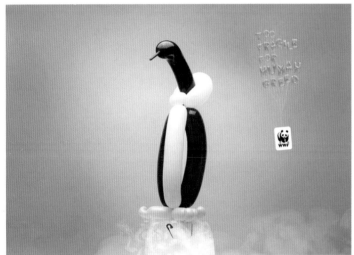
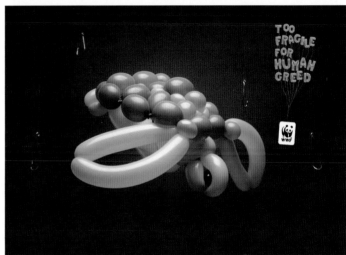

WWF - Balloon Animals; Professor: Alé Torres; Students: Thomaz Jefferson, Eduardo Chaves, Bruno Giuseppe, Lorran Schoechet Gurman, Adriano Tozin, Gabriel Gakas

asked what was wrong. I told her. She said to meet her Saturday morning in front of Overton's Market at 6am. We went into the market to meet Mr. Overton, the owner of the supermarket. He was a little man in a bowtie with a gruffy, unfriendly voice. "Ronnie Seichrist. Your teachers told me about you. I will send you to college and pay all your expenses. But you can never get less than a B, although I expect more than that. And you must make one promise. That someday you will send somebody else's child to college. Yes or no!" That was the entire conversation. I have lived up to my promise to him many times over. Years later, I discovered that he had anonymously sent 27 other poor kids to college.

What is the greatest satisfaction you get from your work?
Teaching. When I see the light come on in a student's eyes.

What part of your work do you find most demanding?
45 years ago I was profoundly deaf. Amplified phones hadn't yet been invented. Even so, during that time I was a creative director and started my first school. Four hearing operations improved my hearing somewhat for many years. But now I am almost deaf again. However, I discovered how to use Google docs in my classes. It's amazing how technology can change your life.

What would be your dream assignment?
To write a Netflix 13 episode story. The story would be about my childhood growing up during WWII, living in a military area in Norfolk, VA. Going with my dad, a German immigrant, to the POW camp where he translated for the American marine guards to the German prisoners. Living with an alcoholic mother who, when on a drunken binge, would forget my name or disappear for months at a time. My struggle to get into my father's secret room. Wondering if my father was a Nazi. It wasn't a far fetched idea: he worked in the Norfolk navy yard and according to a recent TV documentary, the shipyards were filled with spies who reported the ships' coming and leaving the shipyards. German U-Boats waited in the harbor entrance to the ocean. A great sport for my friends and I was to spend weekends at the beach finding wreckage from the torpedoed boats. When my father died my mother sent me his wallet. Pinned inside was a medal. A swastika and an eagle.

What professional goals do you still have for yourself?
Invent the next kind of creative school with Pippa.

What advice would you have for students starting out today?
To become a storyteller.

What interests do you have outside of your work?
I make slab, live edge furniture. I write stories. I take photographs. I carve. I'm restoring a vintage VW pickup, helping my wife restore a '49 Chevy rat truck. I collect and restore Airstream trailers.

What do you value most?
The success of a student. I wish I heard from them more often.

What would you change if you had to do it all over again?
Nothing. Fucking-Up-Big-Time is the best incentive to success.

Unpredictable; Professor: Mark Smith; Students: Felipe Molina, Carlos García

What inspired or motivated you into your career in advertising, design—the creative world?
If it hadn't been for a chance meeting my mom had at the post office one afternoon when I was 21, I never would have become an art director. It's odd that such a seemingly insignificant thing can change your life. Everyone in my hometown was a rocket scientist—literally. I grew up near Cape Canaveral, NASA's launch center. I think the whole town had a PhD in engineering. The people in my life knew that 4,187 is the square root of the distance to the sun divided by four. Fortunately, my parents encouraged my creativity. They even thought it was wonderful when my friends and I painted our feet bright colors and danced through the living room. After graduating with a degree in art I was lost. My family and I knew nothing about creative careers. Then my mom went to the post office and ran into a friend. Their daughter had graduated from an amazing school in Atlanta and got paid to do all sorts of creative things. "Pippa should go to Portfolio Center." I did and my life changed forever.

What is your work philosophy?
There is no division between work and play. Each expands the other.

Where do you seek inspiration?
My first stop is always a stack of books. I just like to wander and fill my head with ideas, words, images, strategies, techniques, and colors. Mix all that intentional randomness with the problem and usually something interesting happens. My husband and I are book addicts. Hundreds of our books are at the school to share with the students. But in-person inspiration is best. When we see someone inspiring or someone we admire we invite them to speak and give a workshop at the school. Then students and staff get to spend time with them. We brainstorm ways a brand can target their core belief. Create something that makes the world better. Invent. Collaborate. Disagree. But above all—explore.

How do you define success?
I feel successful when a graduate is successful. When they start their own design firm with a classmate. Or come from a disadvantaged background and go on to win lots of awards and make more money than they ever imagined. The best successes are those that make the world better like when a graduate created a website to combat child sex slavery in India. Her idea raised enough funding to allow thousands of girls to stay in school instead of being sold into slavery.

Another graduate came to school to learn how to market the stem cell research foundation she wanted to start. At the time, I never dreamed that helping her accomplish her career goals would, years later, wind up saving Ron's life and the lives of many other people.

Who is or was your greatest mentor?
Remember the story of how I got to Portfolio Center? Ron Seichrist started that school. He was one of my instructors. That school changed my life. For the first time I was in a place where everyone thought like me. The other students and I learned how to turn our crazy ideas and our love for making things into a career. ■ The day after my graduation the school had a Portfolio Review. Design companies and ad agencies came to interview the graduating students. I was sitting on the sofa waiting my turn when Ron walked by and tossed a piece of folded paper into my lap. When I opened it there was written, "Since I can't flunk you, will you marry me?" The note didn't really surprise me. I knew I was one of his favorite students. I thought it was his clever way of saying, "I'll miss you." As I was leaving the school I saw him standing by the front door. He looked nervous. Before I could say anything he said, "I just wanted to let you know I really meant what I said." My stomach plummeted to my feet. Zoomed up. And flew out my mouth. I said, "Can we have lunch first?" We had lunch a couple of days later. He explained that when I was around he felt happier. He wanted me in his life forever. A mentor makes you realize your own creativity. I've been married to mine for 30 years.

Who were some of your greatest past influences?
For their strength: Frieda Khalo, Catherine the Great, and Oprah Winfrey. For their creativity, these women make me drool: Nicole Jacek and Noreen Morioka, creative design team at Weiden & Kennedy; Chloe Gottlieb, Director of UX at Google; Helayne Spivak, amazing writer and first woman to be the CCO of two global agencies, JWT & Y&R; Katherine Gordon, Founder of The 3% Movement; our graduates Margaret Johnson, Chief Creative Officer of Goodby Silverstein & Partners and Tara LaWall, Creative Director at 72andSunny. Many of these women are also amazing mothers. It's a great time to be a woman. ■ There are some very inspiring men too: artists Saul Steinberg and Alexander Calder; authors Malcom Gladwell and Steven Johnson; creative/strategic leaders and geniuses Lee Clow, TBWA; Alex Bogusky, CP+B; Barry Wacksman, R/GA. Many of these men are also great fathers.

Pippa Seichrist is an art director, creative director, ad agency owner, and co-founder of Miami Ad School, a global network in fifteen cities. Pippa developed, with her husband Ron, an experiential educational model for creative education. Miami Ad School is the only school in the industry that encourages the cross-pollenization of ideas by allowing students to study and intern around the globe. The result is the most award-winning school in the world and a nearly perfect placement rate. Pippa's students have been recognized by the One Club, Clios, Future Lions, D&AD, and in Graphis New

Talent Annuals. Pippa is now a featured speaker at numerous conferences from 3% Conference, 4A's Strategy, Facebook Summit, New York Festivals, AHAA, Google Agency Offsite, One Club—Here Are All The Black People, AdAge Small Agency Conference, and others. Her focus is now on increasing diversity in the creative fields. Miami Ad School reflects this with a student diversity rate that far exceeds that of the advertising industry today. Pippa is now based at the school in Atlanta. When she isn't traveling to the other locations, she carves rustic furniture and does pottery at her farm in North Georgia. Her dog face jugs are in high demand.

Who have been some of your favorite clients you have worked with?
Tough question! The school's Innovation Lab has worked with a lot of great clients: Starbucks, Ford, UNICEF, Wendy's, and The New York Times, to name a few. Our favorite client to work with is probably Burger King. The Global Chief Marketing Officer, Fernado Marchado, and creative staff from Burger King's ad agency, work with the students every term. The most recent work the students brainstormed and produced, won a Lion at Cannes, the most prestigious advertising competition in the world. Burger King sent the students to Cannes, France so they could be there to receive the award in person.

What is your most difficult challenge that you've had to overcome?
In the early days of Miami Ad School I had a fierce onset of Multiple Sclerosis. MS is a progressive illness that affects the nervous system. Overnight I had virtually no feeling on my left side, which made it almost impossible to walk. Several very prominent people in advertising came out of the MS closet and called me. Their advice and moral support gave me a lot of hope. Focusing on the students and going to a job I love distracted me from the pain. Determined to keep whatever functionality I could, I joined a gym. In two and half years I had gained back the use of my leg and had no pain! That was years ago. A doctor recently told me, "You healed yourself." New research shows that a positive attitude and exercise helps the body rebuild the nerve endings that the disease destroys.

What is your greatest professional achievement?
The experiential concept behind Miami Ad School. From the beginning, we brought in great, creative thinkers and all industry professionals to work with the students. They were from all over the world. This cross-pollenization of ideas worked so well we decided to flip the idea—send students to go to the great thinkers. For the first time students could customize their education based on their interests and Study and intern in multiple cities and countries. They could develop unique portfolios based on their own individual experiences and mentors they worked with. ■ Our idea has grown to be a global network with 15 schools around the world. Through the school's partnerships with design firms, ad agencies, brands, and platforms, students have hundreds of opportunities each year to get hands-on experience at R/GA, Ogilvy, Facebook, 360i, Vice, Disney, and Sapient, to name just a few. Students graduate with a portfolio of great work and life experiences.

What is the greatest satisfaction you get from your work?
Seeing happy students and graduates doing what they love, keeping the economy chugging along, and coming up with meaningful ideas.

What professional goals do you still have for yourself?
Create a wide variety of training programs that allow people to level-up their skill sets from short courses and workshops to Masters degrees and online training. We want to provide people with the skills and network they need to take their career to the next level. People come in all shapes, sizes, and goals. Education needs to parallel that.

What advice would you have for students starting out today?
Recognize opportunity.

What interests do you have outside of your work?
Currently, I'm getting the most attention for my custom dog face jugs. Several galleries carry my work (dogfacepottery.com). With Ron, I'm restoring a 1949 Chevy rat truck. I also hang out with our two adopted children from Ukraine, Olya and Andry. We adopted our daughter when she was six, searched for her biological brother for five years, and adopted him when he was 13. He and I are about to finish a memoir we are writing together, "My Life Before."

What do you value most?
Time to do the things I love and believe in. One of those things is fairness and diversity. Ever since the Mad Men days, the advertising and design fields have been dominated by white men. The industry has been slow to accept women and minorities. Agencies now realize that it is imperative to have a diverse creative staff. We decided to do our part to make it easier for agencies to diversify their creative departments. In the last two years the school has awarded half a million dollars in minority scholarships and established a mentoring program. ■ Miami Ad School's minority enrollment has grown to 48%, compared to the minority population of the U.S., which stands at 38%. We have the talent the industry needs to diversify their creative departments. Now companies including IPG, VaynerMedia, and Facebook are contributing to the scholarship fund and helping mentor students. It's great for the companies because they get to develop relationships with all of our minority students and hire their favorites.

What would you change if you had to do it all over again?
I wish, when I first started, I had the confidence I have now.

Thank you Ron and Pippa for creating life-changing educational experiences for strategic and creative misfits who blossom at global ad agencies.

Jerrod New, *Account Planning Bootcamp Alum, Art Director Alum, Miami Ad School's Ringmaster*

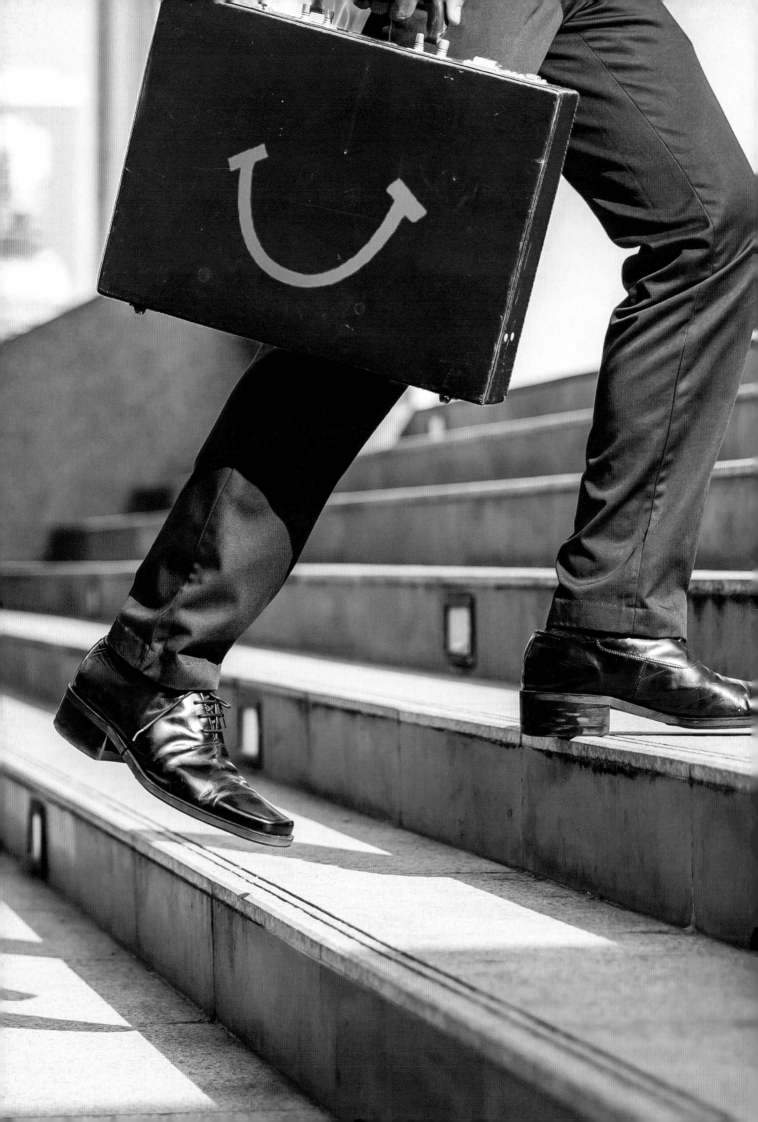

Hank Richardson | Miami Ad School @ Portfolio Center | Dean: Hank Richardson | Page: **16**
Biography: See page 6 for his biography.

Patrik Hartmann | Miami Ad School Hamburg | Dean: Niklas Frings-Rupp | Page: **17**
Biography: After finishing his studies at the University of East London, Patrik returned to Germany in 2005 where he joined Jung von Matt/Elbe for five years. He worked his way up to Art Director, working on clients like BMW Motorsport F1, BOSCH, Konzerthaus Dortmund, Sixt, Lemonaid and Arte. In 2010, he moved on to LeagasDelaney working on SKODA Motorsport, Skoda international and national, Deutsche Schauspielhaus. In 2012 he joined FCB Hamburg as a Creative Director. His portfolio covers clients like NIVEA MEN, Philharmonisches Staatsorchester Hamburg, WWF, and more. With more than 100 national and international awards, he joined the Art Directors Club Germany in 2014 and has been lecturer at the Miami Ad School in Hamburg since 2015.
Advice: Know your skills and enhance them. Work with people who are better and smarter then you, that's where you learn the most.

Eileen Hedy Schultz | School of Visual Arts | Dean: Richard Wilde | Page: **17**
Biography: President and Creative Director, Design International; Creative Director, The Depository Trust Company. Formerly, Creative Director, Hearst Promotions; Creative Director, Advertising and Sales Promotion, Good Housekeeping. B.F.A., School of Visual Arts; Art Students League; Columbia University. President, Society of Illustrators. Past Chairman, The Joint Ethics Committee. Past President: Art Directors Club (only woman President in 96 years). The School of Visual Arts Alumni Society. Board of Trustees, School Art League. Board of Directors, School of Visual Arts; Advisory Board, F.I.T.; Art Director, Designer, Editor, The 50th Art Directors Club Annual. National and International lecturer. Awards: Outstanding Achiever Award, School of Visual Arts Alumni Society; innumerable professional awards and honors. Currently graphic, interior and fashion designer and photographer.
Advice: Be passionate about what you do. It will see you through your most difficult hours.

Frank Anselmo | School of Visual Arts | Dean: Richard Wilde | Page: **18**
Biography: Frank Anselmo's unconventional thinking garnered every prestigious, global award during a ten year stint–rising to Creative Director at BBDO New York. He has since been hired by over 75 companies including Apple. As a Creative Leader, Anselmo cemented his place in history by leading young creatives to globally-awarded work in his "Unconventional Advertising" college program at SVA that's recognized as "The Most Awarded Ad Class In History." In 2018, The One Show ranked Anselmo #1 Most Awarded CD/Professor in the world. His ability to mentor, motivate, and inspire creatives has landed those working under him jobs at Google, Droga5, Disney, Apple, and more. His work has been featured on Fast Company's "100 Most Creative People In Business" issue.
Advice: Talent is a tad overrated. Talent is human. It gets lazy and distracted. But intense work ethic is beyond mortal beings.

Mel White | The Newhouse School, Syracuse University | Dean: Lorraine Branham | Pages: **19, 21, 23**
Biography: Mel White is a Professor of Practice of Advertising-Creative at The Newhouse School at Syracuse University. Since her arrival in 2015, there has been an increase in the number of creative students winning awards. Prior to her foray into academia, Mel gained more than 25 years of advertising experience, the last 17 years in New York City as a Creative Director/Art Director at Young & Rubicam, Ogilvy, Publicis, and DMB&B. She has worked on a range of accounts such as Microsoft, Land Rover, MINI Cooper, Sony, Crest, Dannon, and American Express. Having won several industry awards, Mel excels at creating strong visual solutions. Mel earned her B.F.A. in Advertising Art Direction from Syracuse University's College of Visual and Performing Arts.
Advice: To get better at art direction, look at your solution from different angles - above, below, from the side, from a drone.

Dong-Joo Park, Seung-Min Han | Hansung University of Design & Art Institute | Dean: Helen Haeryon Han | Page: **20**
Dong-Joo Park: Dong-Joo Park was born in Korea in 1979 and is a Graphic designer based in Seoul. Professor of Hansung University Design & Arts Institute, she received her MFA in Visual Communication Design at Ewha Womans University. She attended the Ph.D. program in IT Design Fusion Program at Seoul National University of Science & Technology. She has worked as marketing director for KT & G affiliate Youngjin Corporation and Ilshin New Drug Corporation Advertising Department. Dong-Joo Park was awarded Faculty Platinum Award in Graphis New Talent Annual 2018, the IDA design Awards-Gold and more.

Seung-Min Han: Seung-Min Han was born in Korea in 1976 and is a Graphic Designer and Fine Art Illustrator based in Seoul. Professor of Hansung University Design & Arts Institute, he received an MFA in Visual Communication Design at Kookmin University in Korea and a BFA in Visual Communication Design, Digital Media at Raffles College of Design and Commerce in Sydney, Australia. He was awarded more than 20 prizes including the Graphis Poster Annual 2018 (2 Silver) Graphis Design Annual 2019 (2 Silver), Faculty Platinum Award in Graphis New Talent Annual 2018, and more. He had 20 solo exhibitions and more than 60 selected exhibitions and served as Editorial Committee Member of Asia-Pacific Design No.12 in Guangzhou, China.
Advice: In order to be able to interpret images, we must constantly contemplate and try to think creatively.

Kevin O'Neill | The Newhouse School, Syracuse University | Dean: Lorraine Branham | Page: **21**
Kevin O'Neill: Kevin O'Neill fashioned a career of unusual dynamism and diversity: reporter, fiction writer, award-winning copywriter and creative director, advertising agency president, creative consultant to leading corporations and, now, Professor at the Newhouse School of Public Communications at Syracuse University. He is a graduate of Princeton University and earned an M.A. at Hollins College on a fiction-writing fellowship. He has been the senior creative executive at both globe-straddling networks and creative boutiques on an array of world-class brands including IBM, Johnson & Johnson, Sara Lee, Hanes, Panasonic, Lego, AT&T, Maybelline and Bacardi. His work has been recognized by virtually every creative award competition and he was featured in the Wall Street Journal's Creative Leaders Series, a distinction limited to the advertising industry's most accomplished practitioners.
Advice: Don't let anybody outwork you.

Josh Ege | Texas A&M University Commerce | Dean: William Wadley | Page: **22**
Biography: Joshua Ege is an Assistant Professor of Visual Communication at Texas A&M University-Commerce. He has served on the board of directors of the Dallas Society of Visual Communications (DSVC) for 13 years and is the current President of the DSVC Foundation. Throughout his 17 year career, Josh has produced work for a long list of clients including Fossil, BMW, Orrefors/Kosta Boda, Operation Kindness, and Dallas Center for Performing Arts. His work has been recognized by Print & HOW Magazines, American Institute of Graphic Arts, Graphis, American Advertising Federation, and Harper Collins, among others.
Advice: Do things you have have never done. Go places you've never been. These people, places and experiences are fuel for creativity.

Larry Gordon | Miami Ad School | Dean: Hank Richardson | Page: **24**
Biography: During the day Larry's 2Pac at an ad shop. That ad shop is currently 360i in New York, where he's a Senior Creative working on Champion and CarMax. He teaches at Miami Ad School NY, where he turns students into Idea Generators.
Advice: We are our happiest when we are making things. So keep feeding that cycle of inspiration and creation.

Alana Vitrian I Miami Ad School I Dean: Hank Richardson I Page: **16**
Biography: Alana was born in Venezuela and raised between Caracas and Madrid. She has a Bachelor's Degree in Mass Communication and Media from Monteavila University. Alana strongly believe in ideas that generate emotions and change behaviors. That's why she decided to pursue a degree in Art Direction in Miami Ad School. Alana is extremely curious, passionate about outdoor activities and her ukulele.

Abdelrahman Galal, Samar Singh I Miami Ad School Hamburg I Dean: Niklas Frings-Rupp I Page: **17**
Abdelrahman Galal: Abdelrahman is an Egyptian multidisciplinary Graphic Designer and Art Director currently living in Germany. He loves to create new ideas, play around with them, kill them, and then start all over again. He believes that the greatest ideas are yet to be discovered. Abdelrahman Galal goes wherever there might be chaos, where new opportunities exist, where passion grows and where dreams are born.

Samar Singh: Sam Singh is a copywriting student from Miami Ad School Hamburg. He is originally from India but is based in New York currently. Sam loves making prints ads because of how challenging they are. Print advertisements have been around for more than a hundred years. For that reason, it is not an easy task to come up with an original idea or to express something in a convincing way in the basic A4 format. That is what made Sam and his teammate participate in the Graphis competition.

Jae Wook Baik I School of Visual Arts I Dean: Richard Wilde I Page: **17**
Biography: Jacob Jaewook Baik is a Junior majoring in BFA Advertising at School of Visual Arts. He desired to learn his current major in SVA since he was a teenager. He is grateful that he has met many mentors in his dream school and is growing day by day. His attitude toward advertising is different from others. He firmly believes that Advertising should go a step further from a good idea and that it should fundamentally change people's lives.

Huiwen Ong, Yuran Won I School of Visual Arts I Dean: Richard Wilde I Page: **18**
Huiwen Ong: Huiwen Ong is an upcoming graduate from School of Visual Arts, majoring in Advertising. She is passionate about creative, strategic thinking and emotionally driven interaction design. Born and raised in Singapore, known for its rich cultural diversity, she was able to think from a unique, empathic point of view. Drawn towards the visual arts and its ability to build a deep emotional connection, Huiwen moved to New York in 2017 to pursue her dream in the advertising industry. With a diploma in Visual Communications (Photography) and the experience as a photography assistant for two years, she learned to finesse her craft and conceptual thinking, without losing that deeply rooted relationship she wishes to establish with her viewers through with her work.

Zhixin Fan I The Newhouse School, Syracuse University I Dean: Lorraine Branham I Page: **19**
Biography: Born and raised in Hubei, China, Fan is a senior currently studying Advertising Art Direction at the S. I. Newhouse School of Public Communications at Syracuse University, and this is her first creative advertising award. She was an Art Director Intern this past summer at McCann in Shanghai. She is fascinated with the process of creative advertising using the art of image and language with the result of engaging consumers. She focuses on creating interesting visual solutions that are based on either insights or benefits, and then gives it a twist. The element of surprise plays a big role in her work.

Su Bin Kim, Hong Ye Rim I Hansung University of Design & Art Institute I Dean: Helen Haeryon Han I Page: **20**
Su Bin Kim: Su Bin Kim is 21 years old and living in Bucheon, South Korea. She became very interested in advertising and has been learning about the field for about three years now. The Patagonia project gave her an opportunity to develop herself and allowed her to believe that she can show more of her designs to the world. Su Bin Kim also feels that she had the chance to prove her skills by winning this award.

Hong Ye Rim: Hong Ye Lim is 24 years old and lives in Seoul, South Korea. Starting in the Fine Arts, she decided to study design and has been doing so for five years. She is interested in advertising design and her major at school is Visual Design. Hong Ye Lim was confident that the Patagonia project would make her a better designer and considers the project a great achievement. Her goal is to be a more global advertising designer. She also hopes that people all over the world will become more interested in the environment through campaigns like hers.

Yuxin Xiong I The Newhouse School, Syracuse University I Dean: Lorraine Branham I Page: **21**
Biography: Yuxin Xiong grew up in a small town in South China. Xiong is now an advertising senior at S.I. Newhouse School of Public Communications at Syracuse University. She is pursuing a Bachelor's Degree in Advertising with an emphasis in Art Direction. Her awards include Communication Arts Advertising Annual, Communication Arts Showcase Winner, Creativity International Print and Packaging Design, two Silver Awards and one Bronze Award, Graphis New Talent Annual 2018 Merit Award, and selected works appear on Ads of the World. Her name means "bear" which is very fitting since she always creates wild ideas with a fearless attitude.

Nicole Glenn I Texas A&M University Commerce I Dean: William Wadley I Page: **22**
Biography: Originally from the Austin, Texas area, Nicole Glenn is a senior honors student in the Visual Communication program at Texas A&M University - Commerce. Her major emphasis is Art Direction and she minors in Equine Studies. In 2015, she was named the editor of Teen InFluential, a magazine that delivers trending editorials of interest to teens written by their peers. She currently lends her design skills to A&M Commerce Campus Recreations. In her spare time, she experiments with photography, trains her wild mustang, Valentine, and spends as much time in the outdoors as possible.

Keren Mevorach I The Newhouse School, Syracuse University I Dean: Lorraine Branham I Page: **23**
Biography: Keren Mevorach is a Canadian that doesn't say "eh" as much as you would expect. She's originally from Toronto, Ontario. Keren's pursuing a Bachelor's degree at Syracuse University's S.I. Newhouse School of Public Communications, and the Whitman School of Management. She's a senior double majoring in Advertising with an emphasis in Art Direction, and Finance. Keren has always had a passion for expressing herself creatively and she is very excited to begin her advertising career once she graduates.

Chase Harris I Miami Ad School I Dean: Hank Richardson I Page: **24**
Biography: Chase is a first-year art direction student at Miami Ad School in New York City. Born and raised in Arizona, he completed his undergraduate studies in Business Data Analytics and Marketing at Arizona State University before moving to New York. His campaigns are grounded in strategic thinking and elevated by meaningful storytelling. He believes the details make all the difference. In the off chance he isn't working on a design project, Chase can be found hiking, backpacking, or playing with dogs.

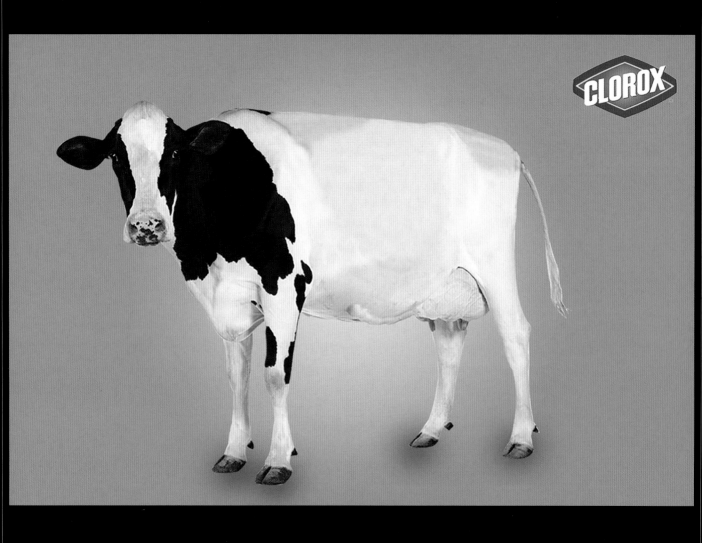

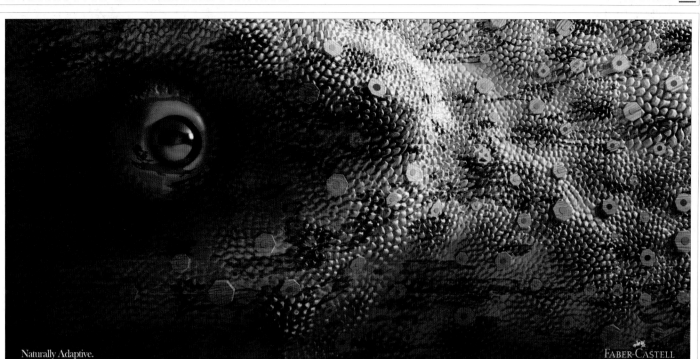

Naturally Adaptive.

FABER-CASTELL

Students: Abdelrahman Galal, Samar Singh | Miami Ad School Hamburg

Assignment: Make a print ad for Faber-Castell showing how their pencils use colours that have been extracted from nature.
Approach: We show how Faber-Castell pencils have colour ranges as authentic and vibrant as the skin of a chameleon.
Results: Student work.

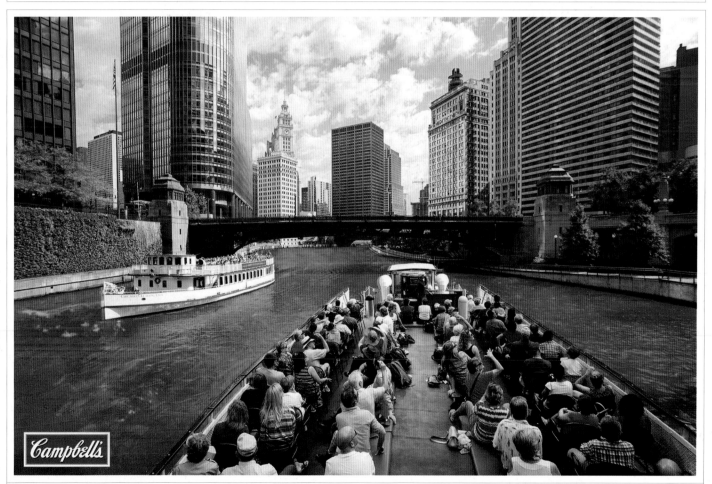

Campbell's

Student: Jae Wook Baik | School of Visual Arts

Assignment: Campbell's Soup likened to rivers that have the same depth.
Approach: A visual representation of the analogy that the deep taste and flavor of Campbell's Soup is like a deep river. I also tried to use the texture of red tomato soup, which is the opposite color in the existing blue river, to deliver to the audience a simple idea and visual entertainment.

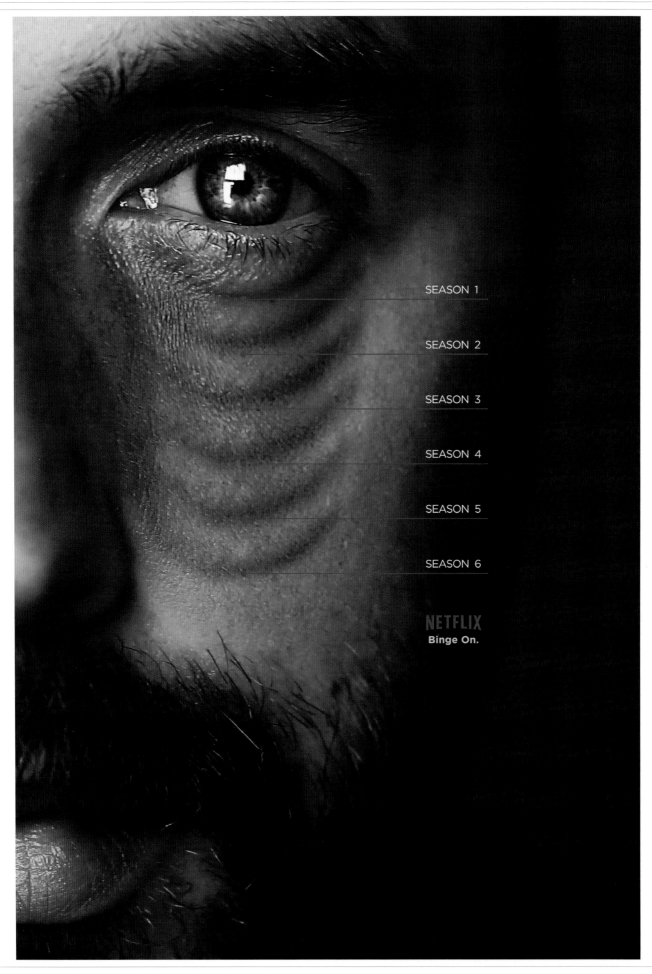

SEASON 1

SEASON 2

SEASON 3

SEASON 4

SEASON 5

SEASON 6

NETFLIX
Binge On.

Students: Huiwen Ong, Yuran Won | **School of Visual Arts**

Assignment: The strategy was to showcase the level of commitment you have when you are binge-watching on Netflix.
Approach: When I got this brief, all I could visualize in my head were the hours of sleep people would trade to watch their favorite shows.
Results: After all my hard work, my professor liked this final version and weeks after the semester ended, I decided to send it to competitions.

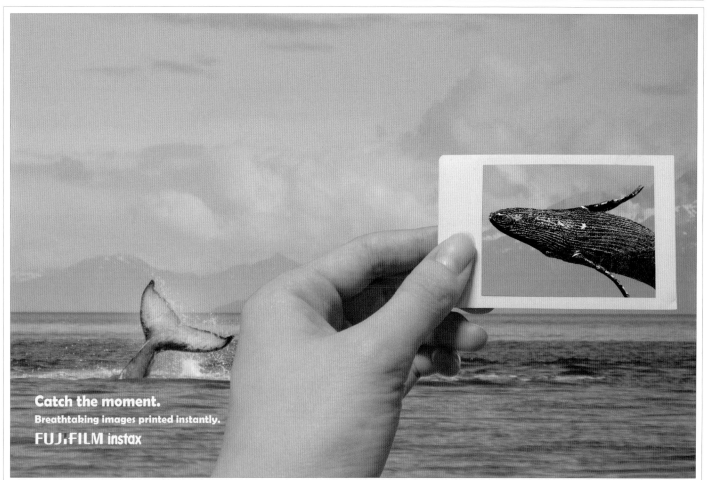

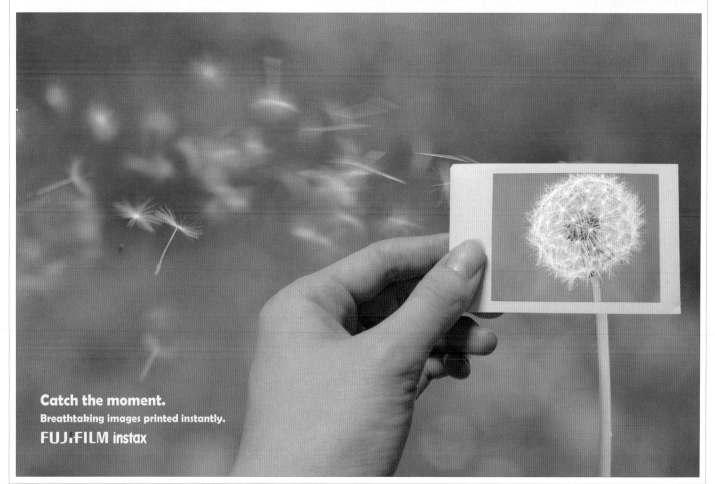

Student: Zhixin Fan | **The Newhouse School, Syracuse University**

Visit website to view full series

Assignment: Print ads for FUJIFILM Instax camera.
Approach: One of the great benefits of using this camera is the printed photos you get immediately after taking your shots.
Results: Breathtaking images printed instantly.

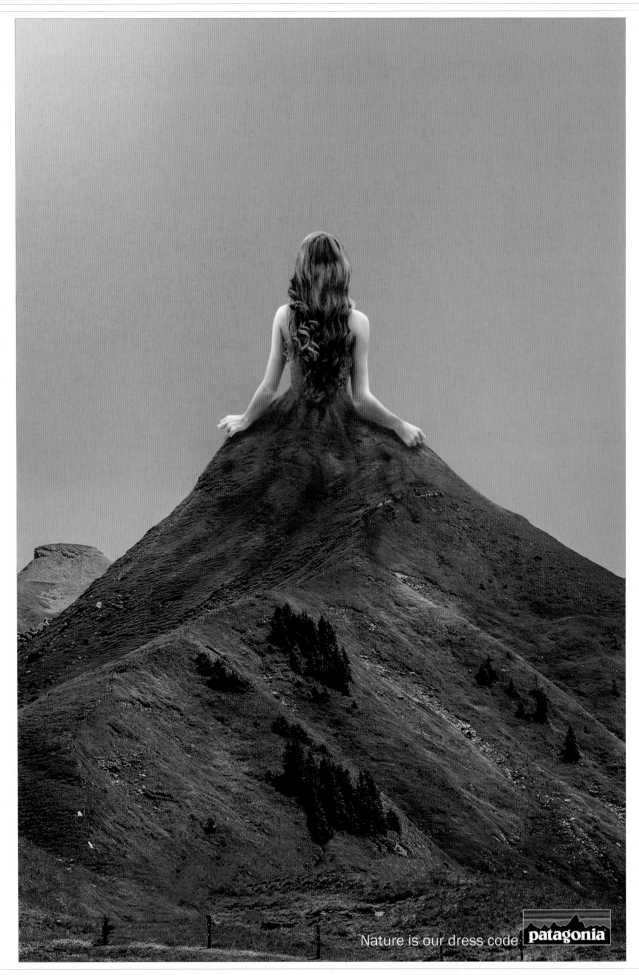

Nature is our dress code **patagonia**

Students: Su Bin Kim, Hong Ye Rim | **Hansung University of Design & Art Institute**

Assignment: This is a public relations poster for the outdoor brand Patagonia.
Approach: Make it easier for consumers to understand the goals of Patagonia.
Results: Eventually, we completed a project called "Our dress code is nature."

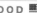

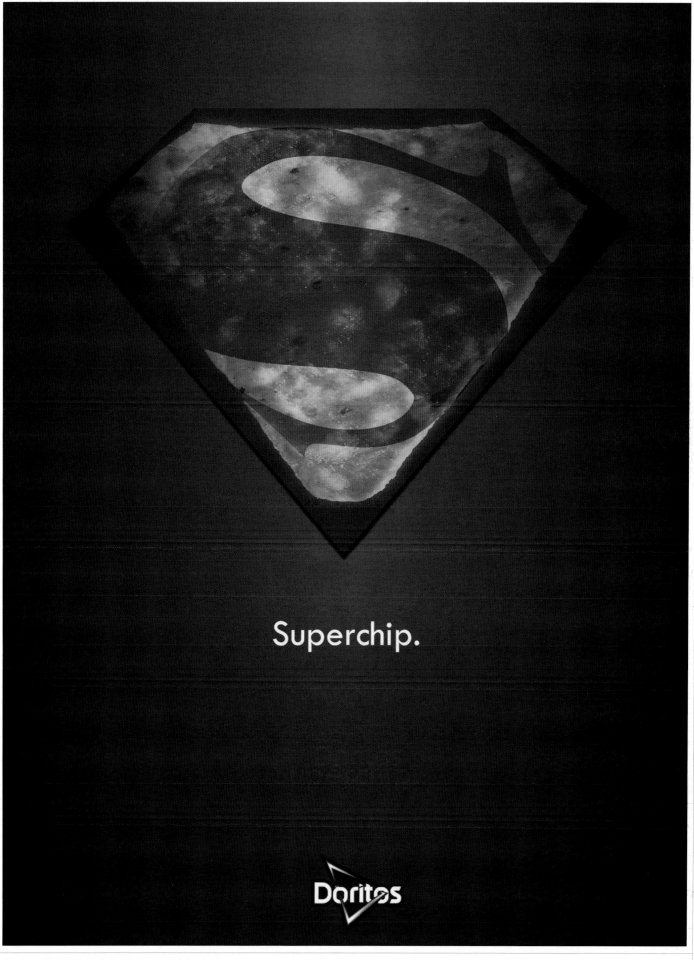

Student: Yuxin Xiong | **The Newhouse School, Syracuse University** Visit website to view full series

Assignment: Doritos is a snack that you can eat in different ways.
Approach: People would like to eat Doritos in interesting ways when they watch movies at home.
Results: Shows that Doritos can fit into different kinds of classic movie posters.

Student: Nicole Glenn | Texas A&M University Commerce

Assignment: The task was to create a poster promoting the largest and longest running horror film festival in the United States.
Approach: I wanted to approach this piece that ties film to horror in a very literal way using photography.
Results: Using a film reel to tie a noose and scratched typography in the walls, the work captures the full essence of a horror film.

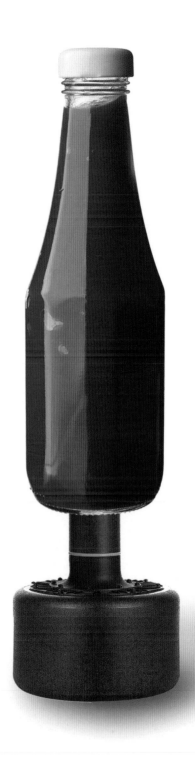

FIGHTS TOUGH STAINS

Assignment: Create a print ad for Tide to Go that shows its ability to remove stains.
Approach: People hate staining their clothing. With Tide to Go, people have the ability to fight their toughest stains.
Results: A ketchup bottle represented as a punching bag.

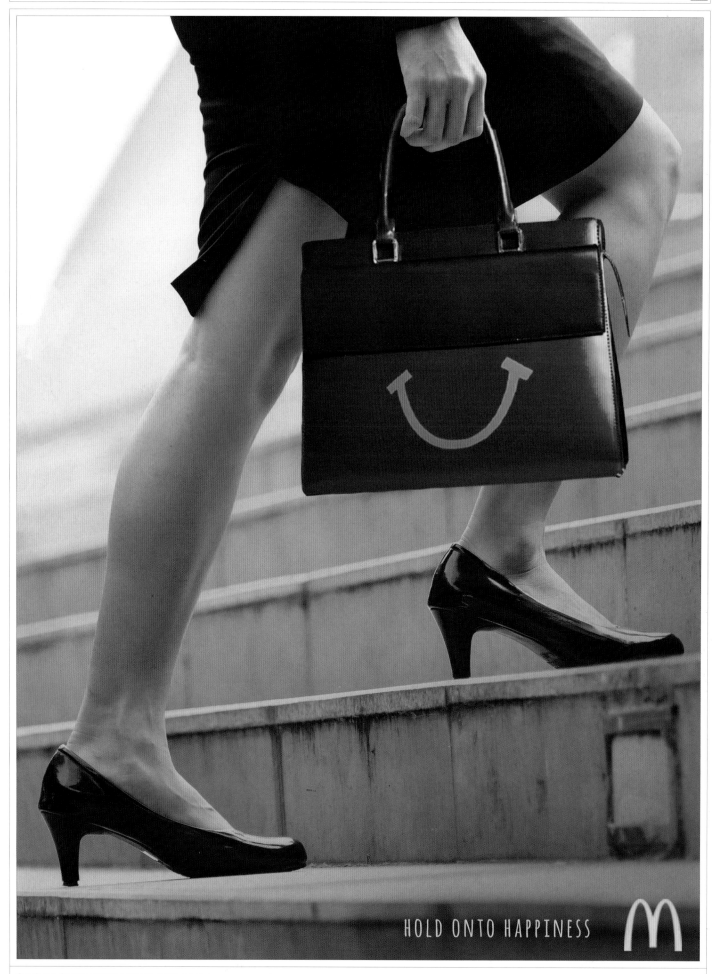

HOLD ONTO HAPPINESS

Student: Chase Harris | **Miami Ad School**

Visit website to view full series

Assignment: Create a unique and refreshing campaign for the McDonald's Happy Meal.
Approach: The "Hold Onto Happiness" campaign aims to help adults remember the simple joys of life by turning everyday objects into the iconic Happy Meal —representative of the uninhibited joy you felt as a child when you were handed that smiling red box.

INSTRUCTOR UNATTRIBUTED

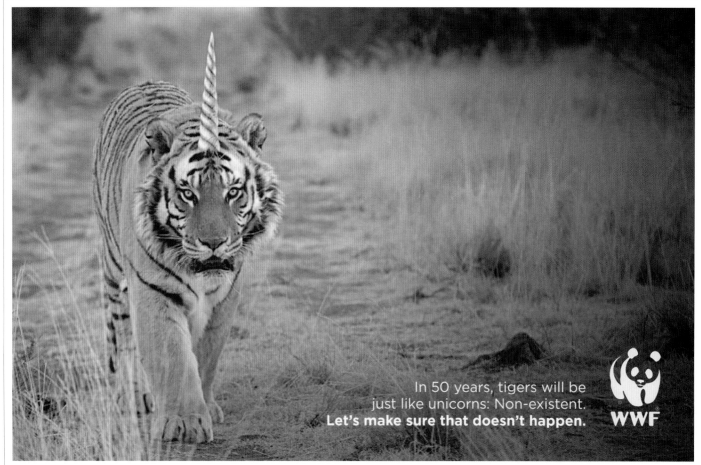

In 50 years, tigers will be
just like unicorns: Non-existent.
Let's make sure that doesn't happen.

WWF

Students: Peter Fox, Chris Serrano | Miami Ad School NY

INSTRUCTOR FRANK ANSELMO

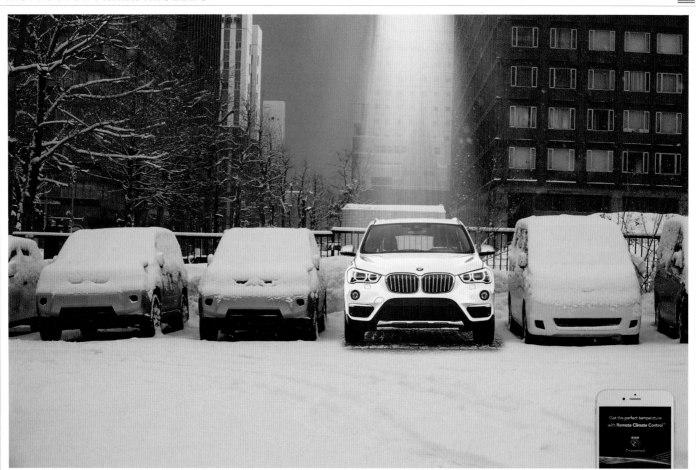

Get the perfect temperature
with **Remote Climate Control**™

Students: Jack Jungho Hwang, Han Meng | School of Visual Arts

Visit website to view full series

INSTRUCTORS **MEL WHITE, KEVIN O'NEILL**

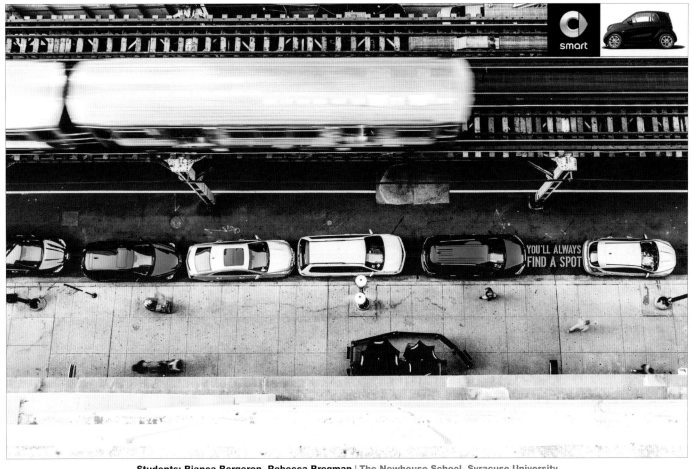

Students: **Bianca Bergeron, Rebecca Bregman** | The Newhouse School, Syracuse University

INSTRUCTOR **FRANK ANSELMO**

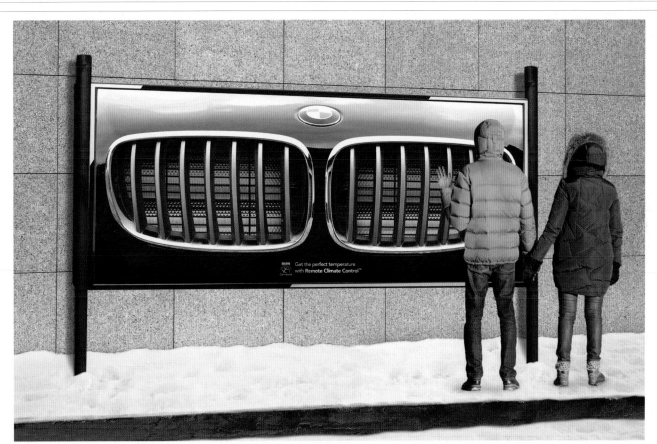

THE ICONIC BMW GRILL IS MADE INTO A HEATED BILLBOARD TO DEMONSTRATE THE PRECISION CLIMATE CONTROL FEATURE ON THE BMW CONNECTED APP.

Students: **Junho Lee, Evan Choi** | School of Visual Arts

Automotive | Advertising

INSTRUCTOR TOBIAS SCHWAIGER

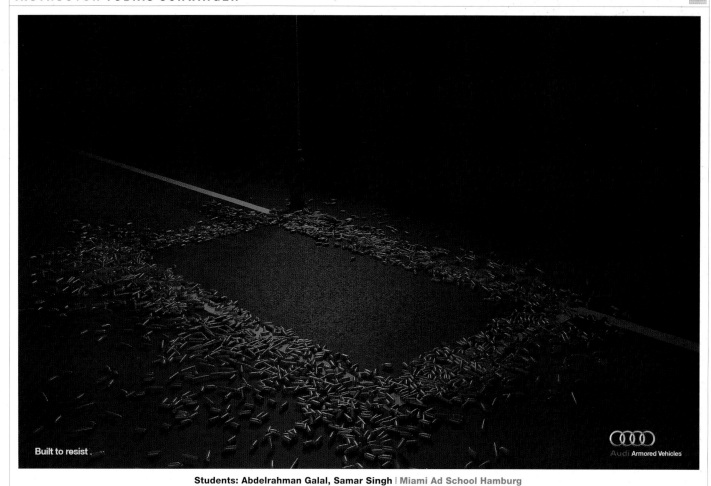

Built to resist.

Audi Armored Vehicles

Students: Abdelrahman Galal, Samar Singh | Miami Ad School Hamburg

INSTRUCTOR FRANK ANSELMO

AM 9:04:45.34022598

Hours Minutes Seconds Nanoseconds

STAY PRECISELY ON TIME
WITH THE BMW CONNECTED APP

Students: Rogier van der Galiën, Robin van Eijk, Jens Marklund, Jack Welles | School of Visual Arts Visit website to view full series

INSTRUCTOR **FRANK ANSELMO**

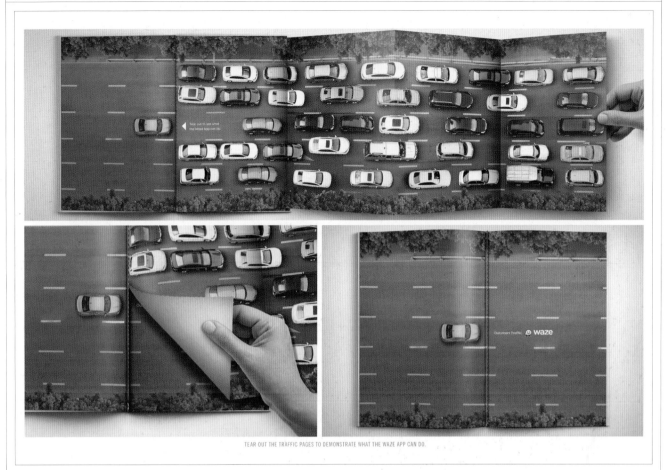

Students: **Jisoo Hong, Minyoung Park** | School of Visual Arts

INSTRUCTOR **FLORIAN WEITZEL**

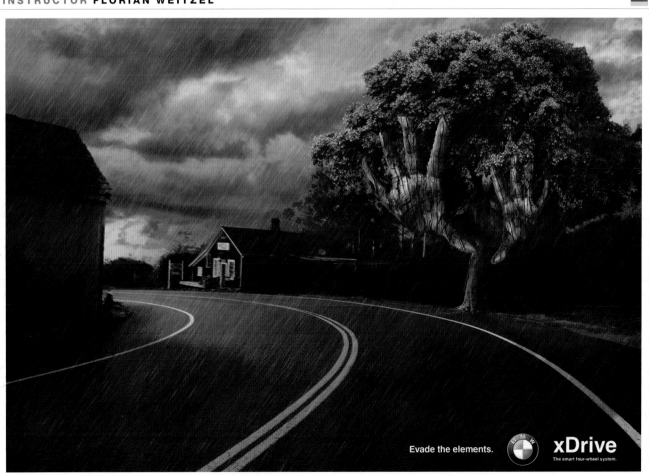

Students: **Claudio Castagnola, Jared Liebmann** | **Miami Ad School Europe** Visit website to view full series

BEAT *BRITTLE.* Shampoo that repairs dry, damaged hair **ogx**

BEAT *BRITTLE.* Shampoo that repairs dry, damaged hair **ogx**

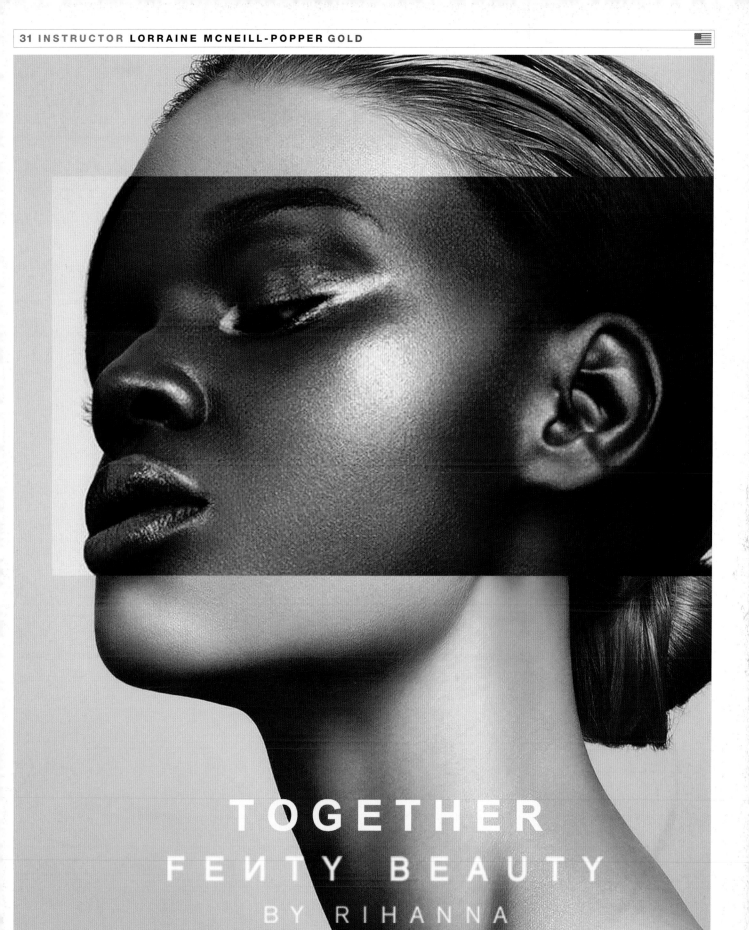

TOGETHER
FENTY BEAUTY
BY RIHANNA

Students: Hridaynag Kooretti, Tajj Badil-Abish

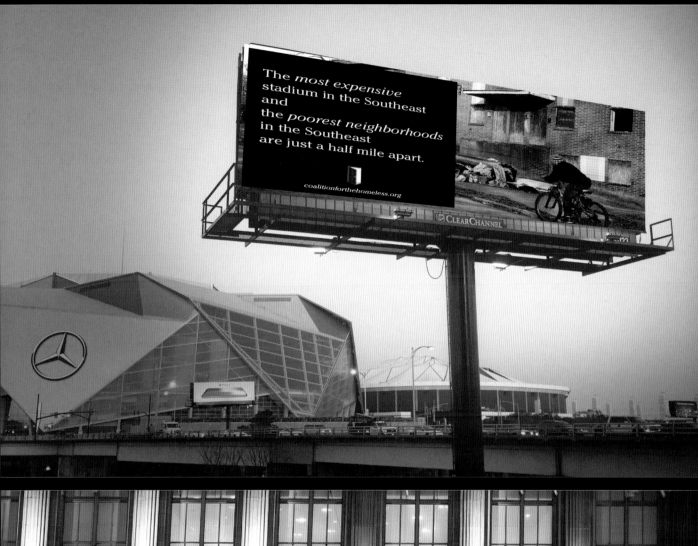

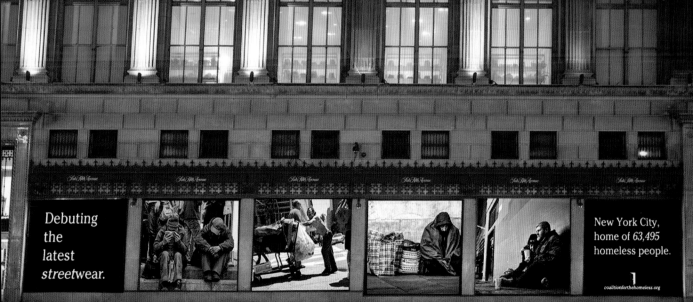

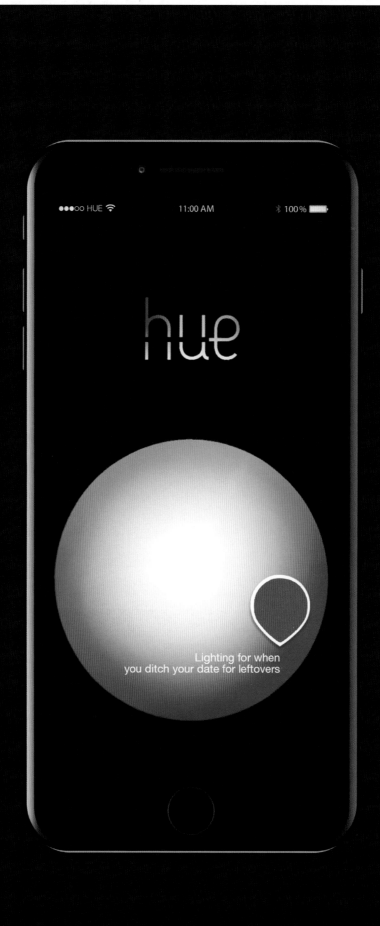

The stain we can't wash

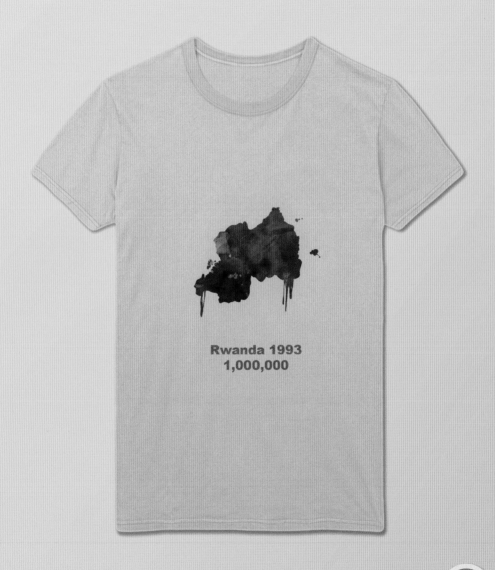

Rwanda 1993
1,000,000

The Rwandan genocide, also known as the genocide against the Tutsi,
was a mass slaughter of Tutsi in Rwanda during the Rwandan Civil War, which had started in 1990.
An estimated 1,000,000 Rwandans were killed by the end of 1993.

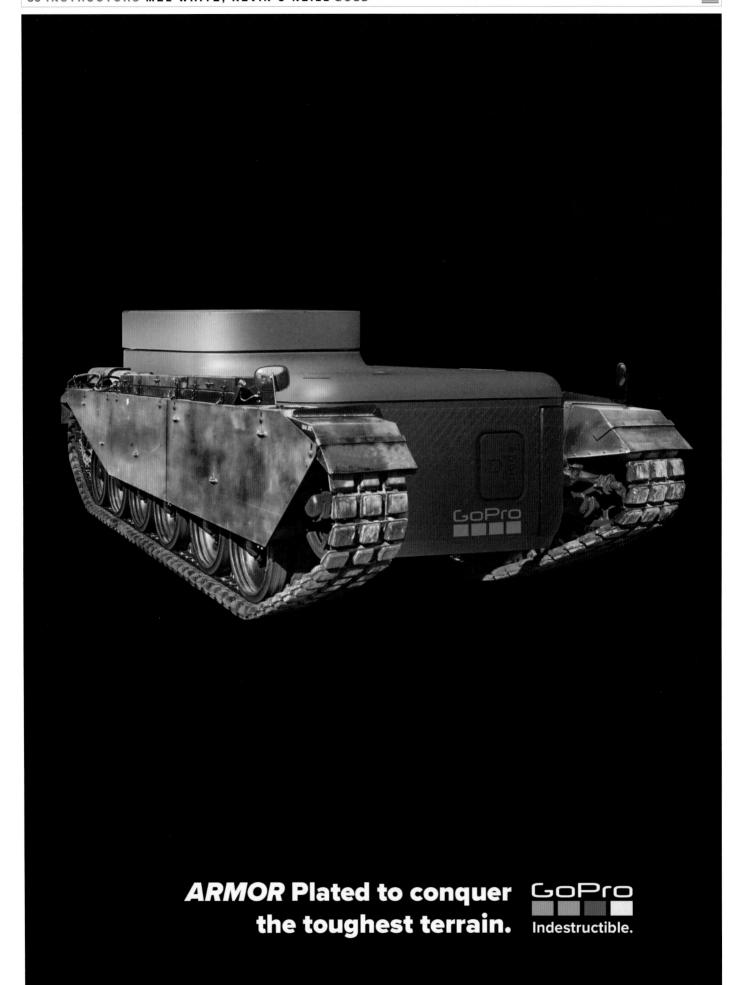

ARMOR Plated to conquer the toughest terrain.

GoPro

Indestructible.

Students: Andrew Celmins, Annie Turner | The Newhouse School, Syracuse University

"THE SOCIAL MEDIA"

Your grandparents were around when social media was a polaroid picture on the fridge. When sliding into the DM meant handing someone a note. So post a status update. When they can't like it, we'd recommend the easier path.

SEND SIMPLE

Students: Matias Cachiquis, Isaac Sorenson | **Miami Ad School**

Communications | Advertising

INSTRUCTOR **DONG-JOO PARK, SEUNG-MIN HAN**

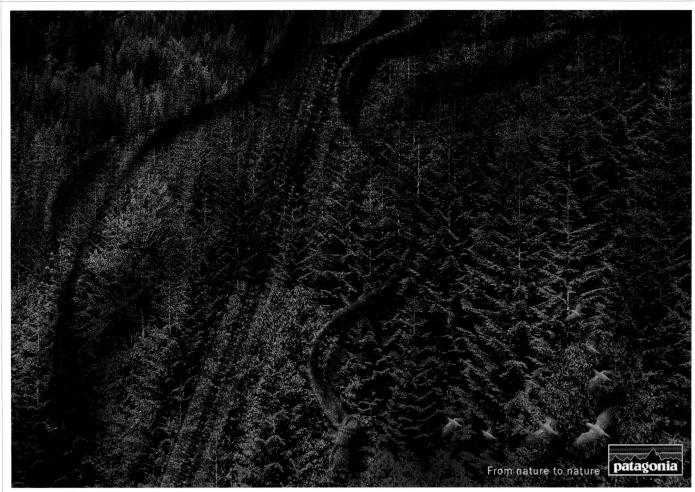

Students: Kim Su Bin, Hong Ye Rim | The Hansung University of Design & Art Institute

Visit website to view full series

INSTRUCTOR **MEL WHITE**

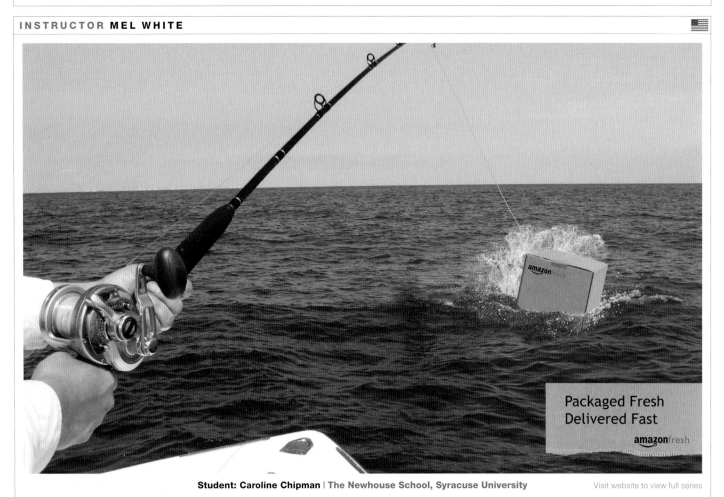

Student: Caroline Chipman | The Newhouse School, Syracuse University

Visit website to view full series

Advertising | Corporate, Delivery Services

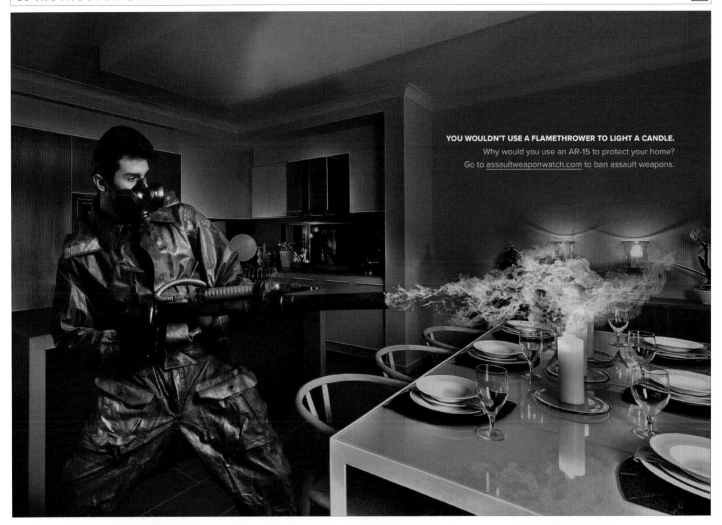

YOU WOULDN'T USE A FLAMETHROWER TO LIGHT A CANDLE.
Why would you use an AR-15 to protect your home?
Go to assaultweaponwatch.com to ban assault weapons.

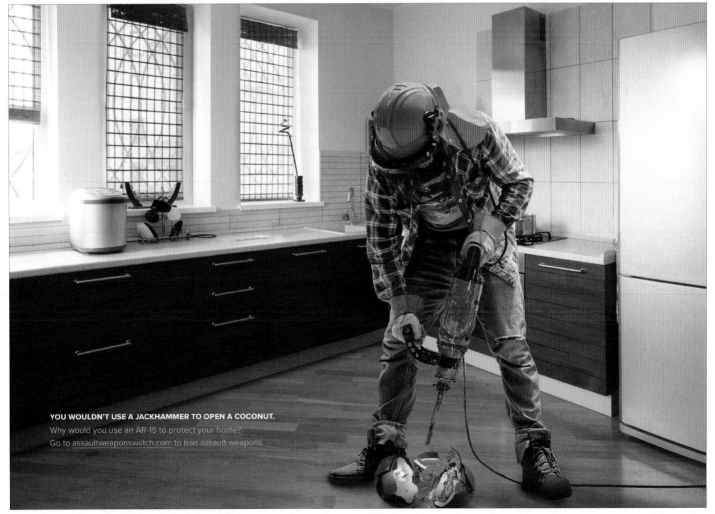

YOU WOULDN'T USE A JACKHAMMER TO OPEN A COCONUT.
Why would you use an AR-15 to protect your home?
Go to assaultweaponswatch.com to ban assault weapons.

Students: Tamara Yakov, Sujin Lim, Gaeun Oh | School of Visual Arts

Education | Advertising

INSTRUCTOR **MEL WHITE**

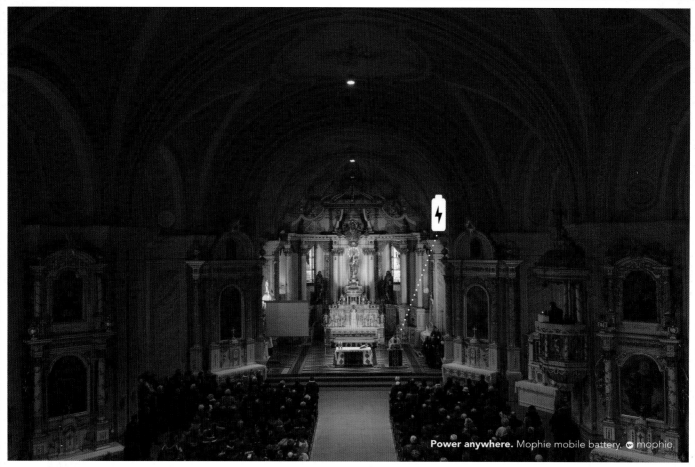

Student: Helena Starrs | The Newhouse School, Syracuse University

Visit website to view full series

INSTRUCTOR **UNATTRIBUTED**

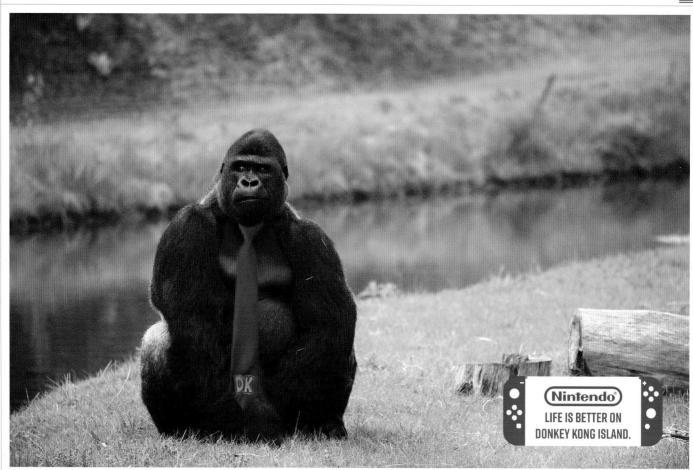

Student: Diane Danneels | Miami Ad School

Visit website to view full series

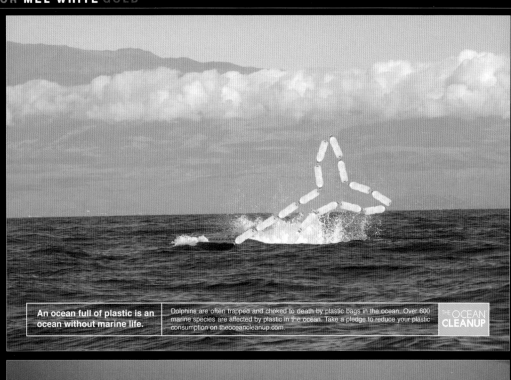

An ocean full of plastic is an ocean without marine life. Dolphins are often trapped and choked to death by plastic bags in the ocean. Over 600 marine species are affected by plastic in the ocean. Take a pledge to reduce your plastic consumption on theoceancleanup.com.

THE OCEAN CLEANUP

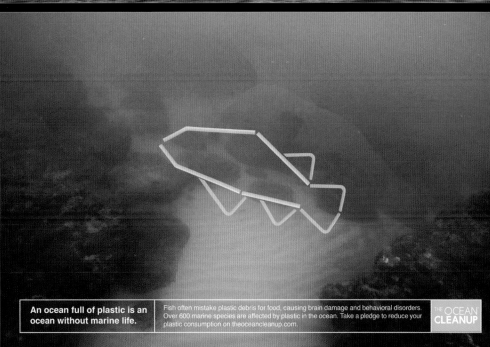

An ocean full of plastic is an ocean without marine life. Fish often mistake plastic debris for food, causing brain damage and behavioral disorders. Over 600 marine species are affected by plastic in the ocean. Take a pledge to reduce your plastic consumption on theoceancleanup.com.

THE OCEAN CLEANUP

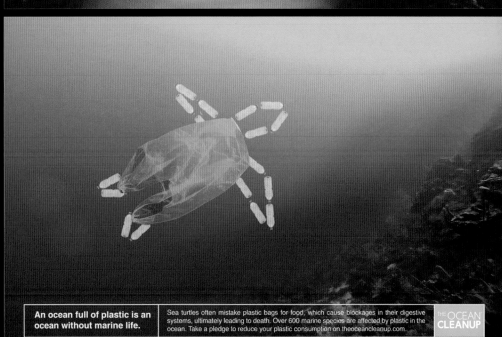

An ocean full of plastic is an ocean without marine life. Sea turtles often mistake plastic bags for food, which cause blockages in their digestive systems, ultimately leading to death. Over 600 marine species are affected by plastic in the ocean. Take a pledge to reduce your plastic consumption on theoceancleanup.com.

THE OCEAN CLEANUP

"*Beautiful*
CLEAN COAL"
—PRESIDENT TRUMP

COAL ENERGY IS INHERENTLY DIRTY.
THE CLEAN COAL PROCESS DOES NOT
REDUCE EMISSIONS, IT SIMPLY HIDES THEM.

COALITION FOR
CLEAN AIR

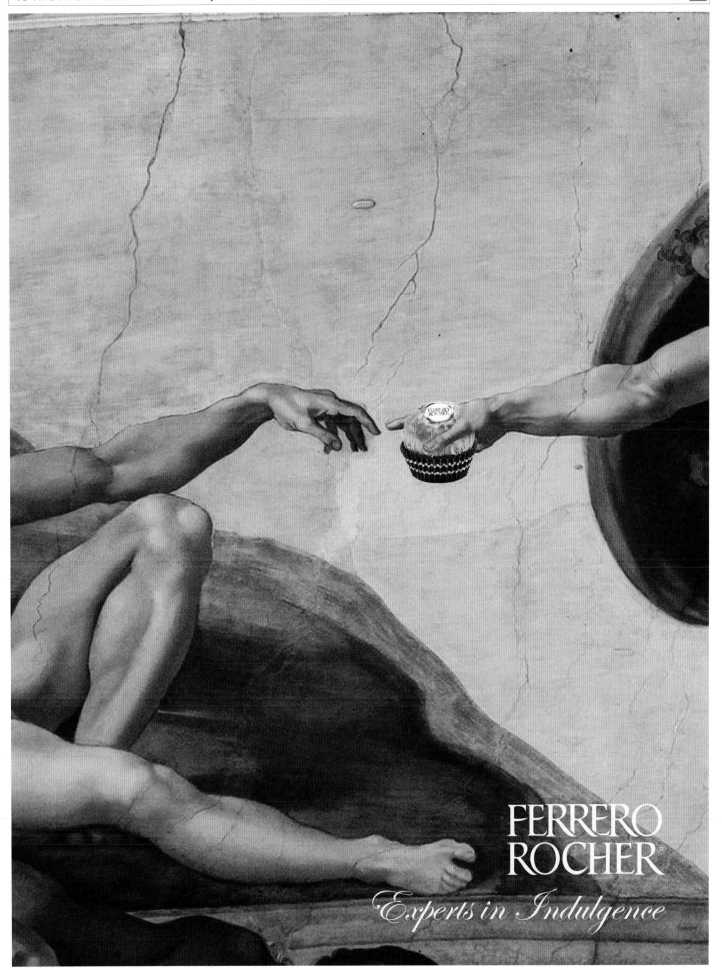

FERRERO
ROCHER®

Experts in Indulgence

INSTRUCTOR ZORAYMA GUEVARA

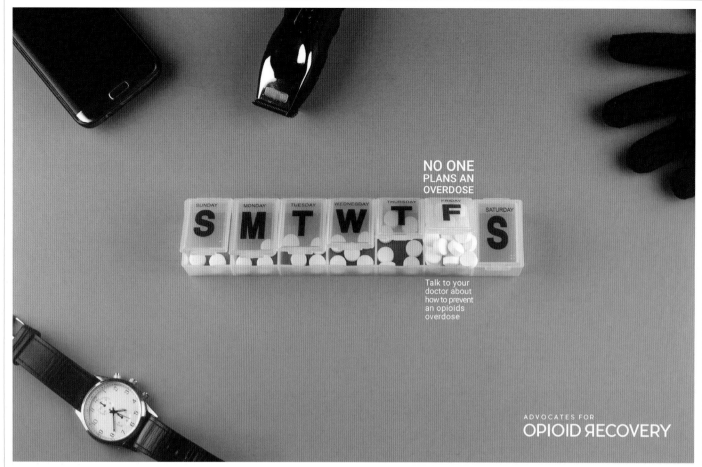

Students: Ana Miraglia, Diane Danneels | Miami Ad School

Visit website to view full series

INSTRUCTOR FRANK ANSELMO

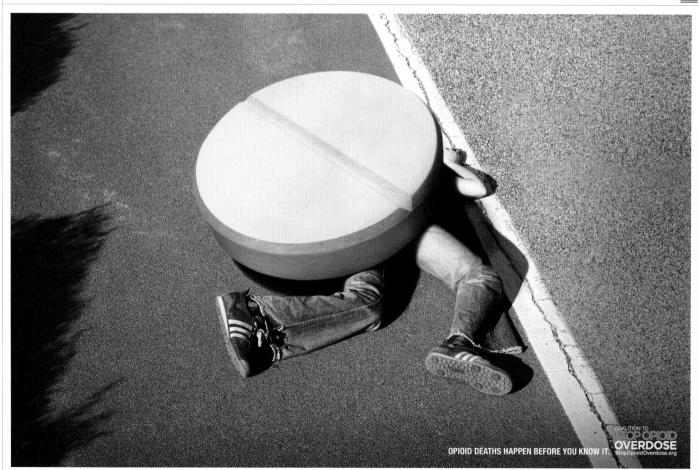

Students: Huiwen Ong, Yuran Won | School of Visual Arts

Visit website to view full series

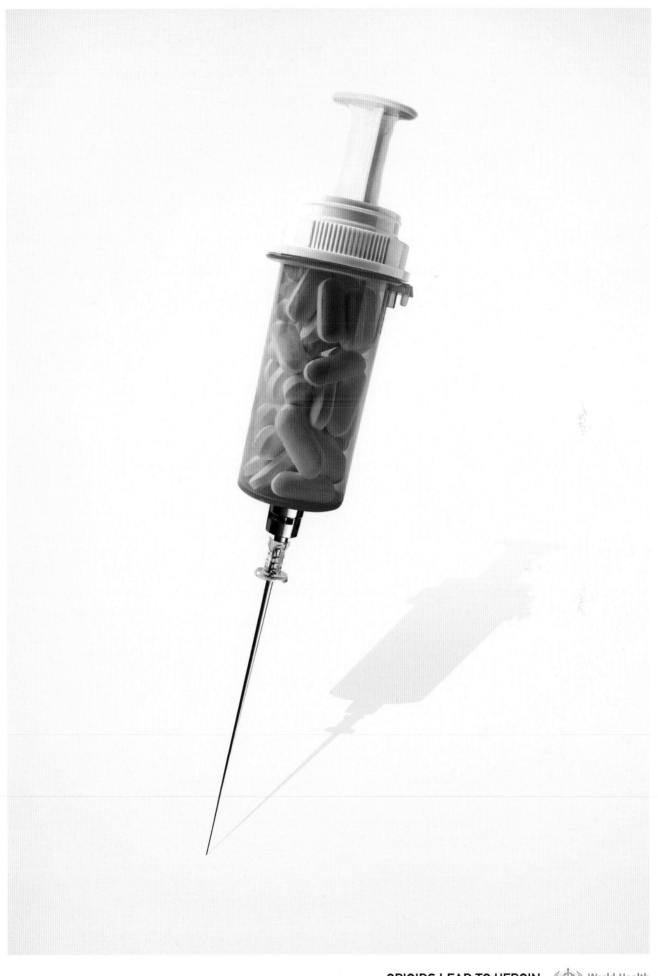

OPIOIDS LEAD TO HEROIN.
IF YOU'RE ADDICTED TO OPIOIDS VISIT WHO.ORG

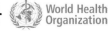 World Health Organization

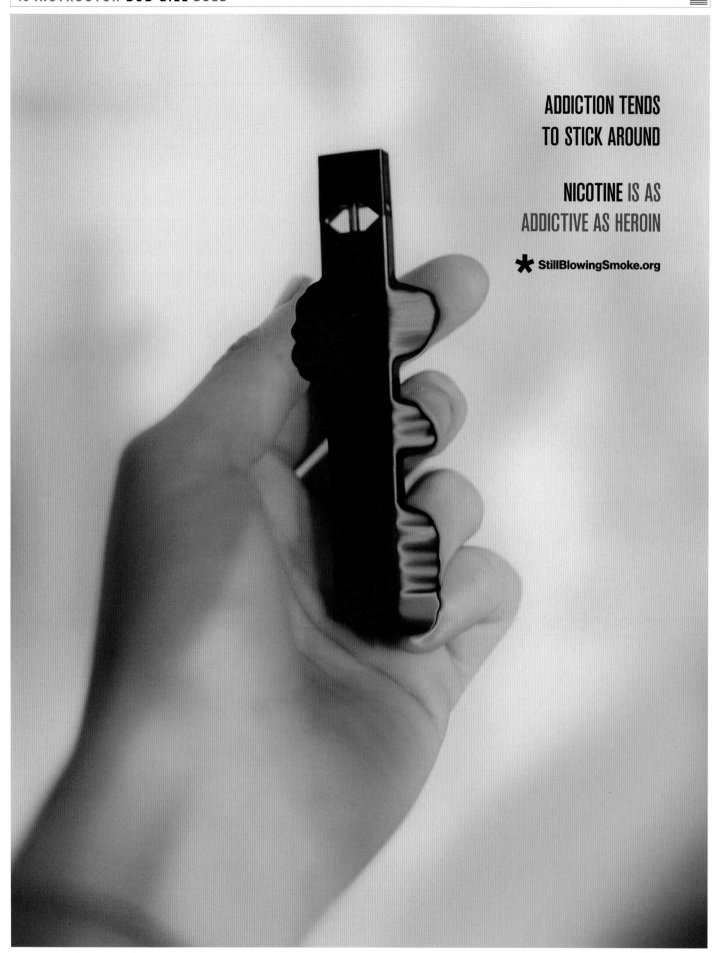

ADDICTION TENDS
TO STICK AROUND

NICOTINE IS AS
ADDICTIVE AS HEROIN

✱ StillBlowingSmoke.org

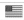

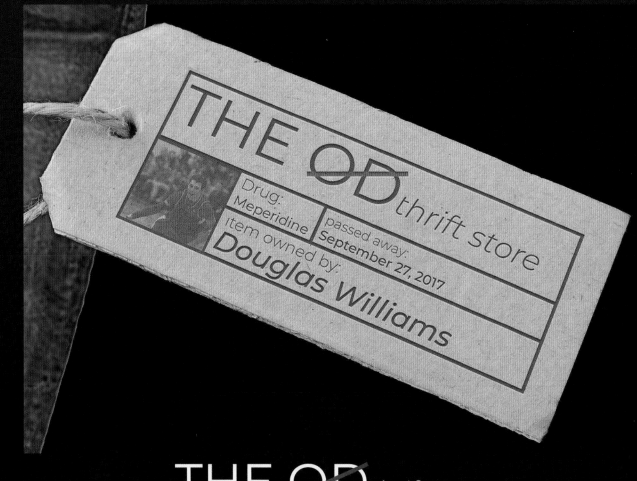

THE O̶D̶*thrift store*

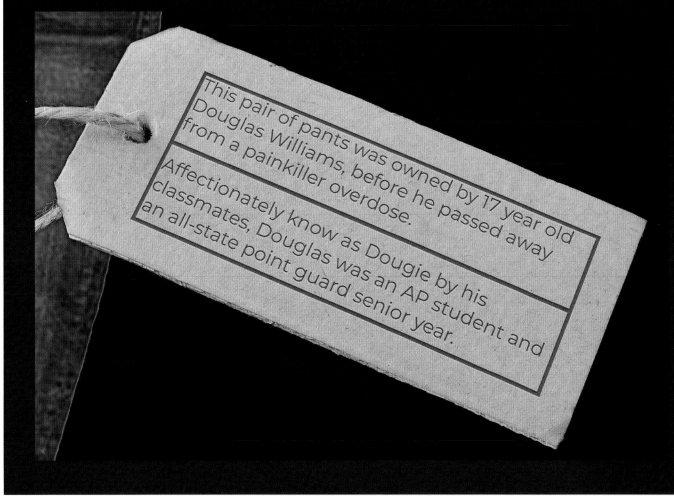

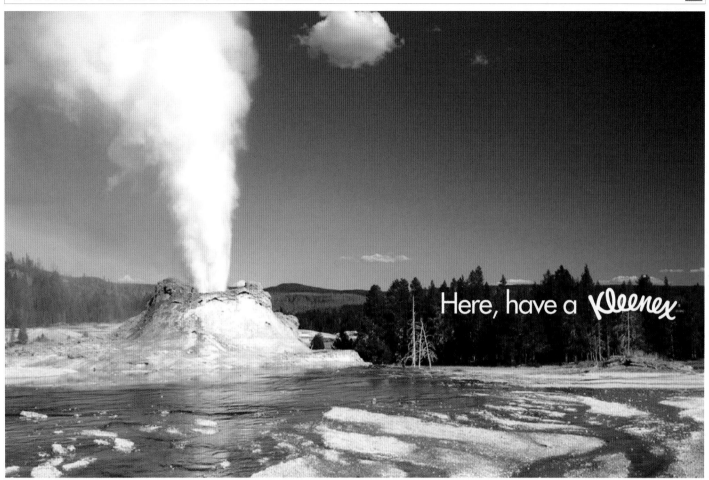

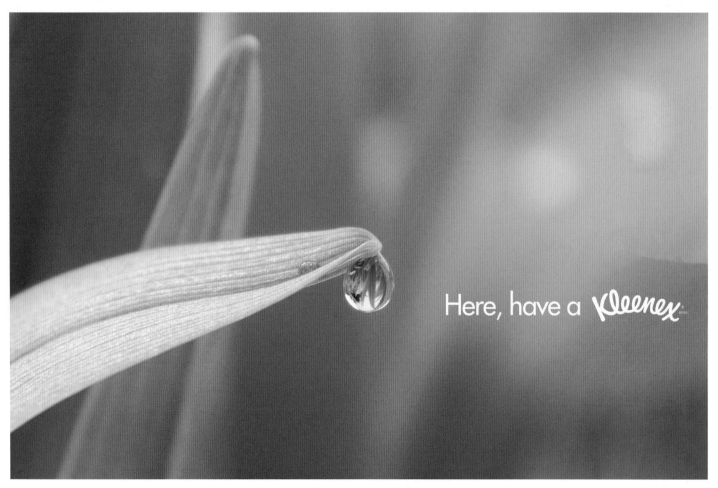

INSTRUCTOR **MEL WHITE**

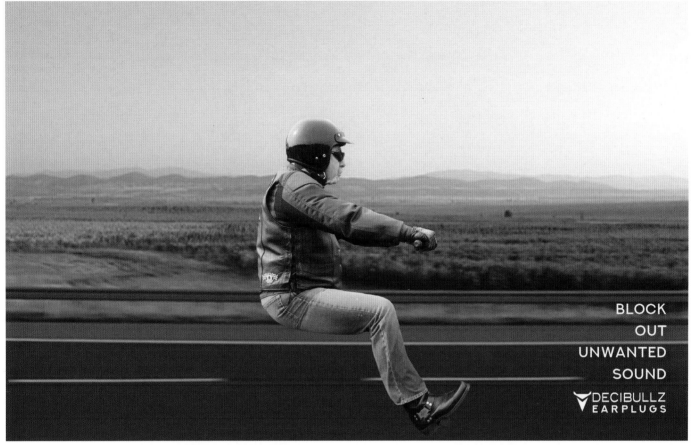

BLOCK
OUT
UNWANTED
SOUND

DECIBULLZ
EARPLUGS

Student: Caroline Chipman | **The Newhouse School, Syracuse University** Visit website to view full series

INSTRUCTOR **FRANK ANSELMO**

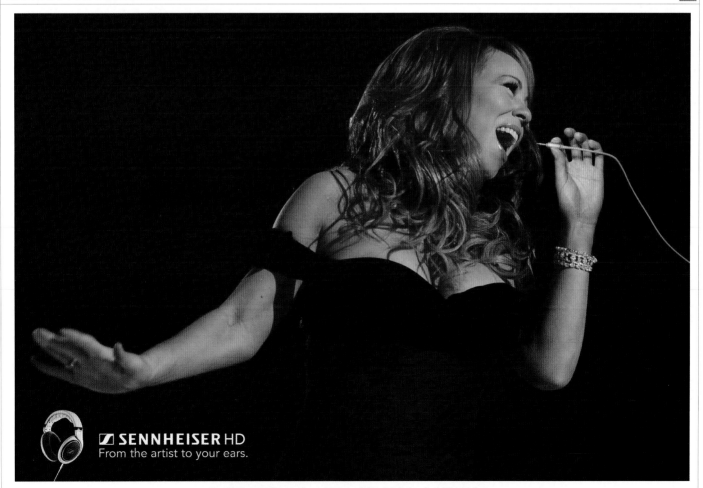

SENNHEISER HD
From the artist to your ears.

Students: Minjeong Lee, Eunseok Park | **School of Visual Arts** Visit website to view full series

INSTRUCTOR **MEL WHITE**

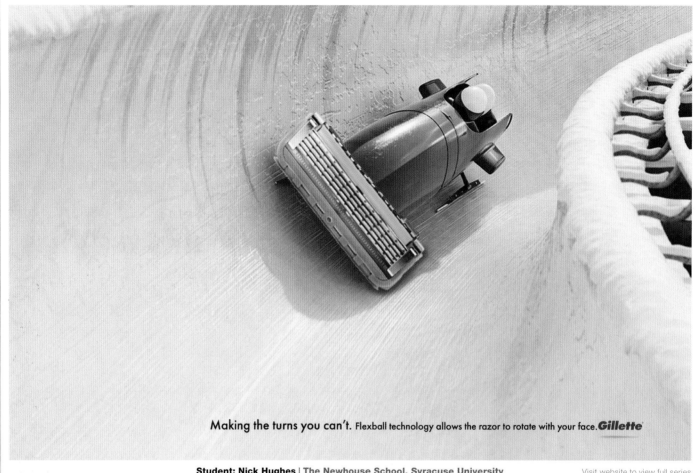

Making the turns you can't. Flexball technology allows the razor to rotate with your face. *Gillette*

Student: Nick Hughes | The Newhouse School, Syracuse University

Visit website to view full series

INSTRUCTOR **MEL WHITE**

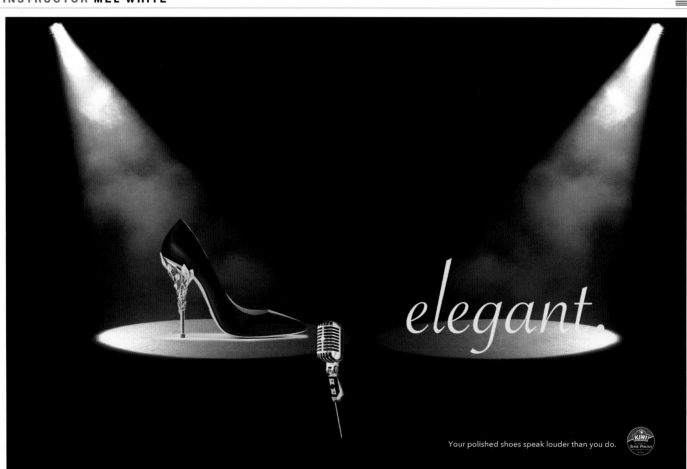

elegant.

Your polished shoes speak louder than you do.

Student: Yuchien Wang | The Newhouse School, Syracuse University

Visit website to view full series

INSTRUCTOR **KEVIN O'NEILL**

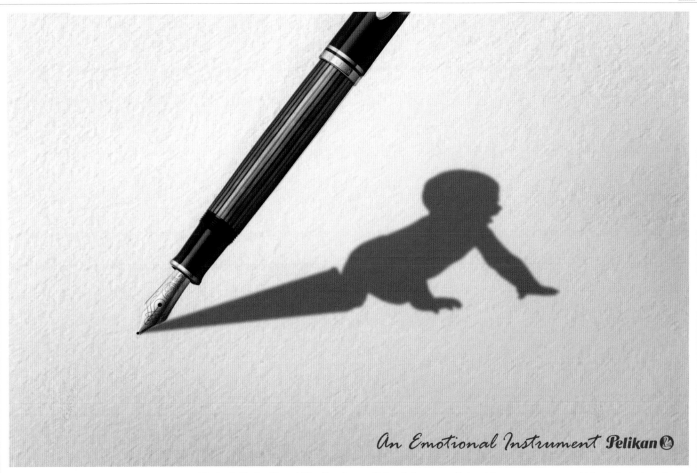

An Emotional Instrument *Pelikan*

Student: Yuxin Xiong | The Newhouse School, Syracuse University

Visit website to view full series

INSTRUCTOR **MEL WHITE**

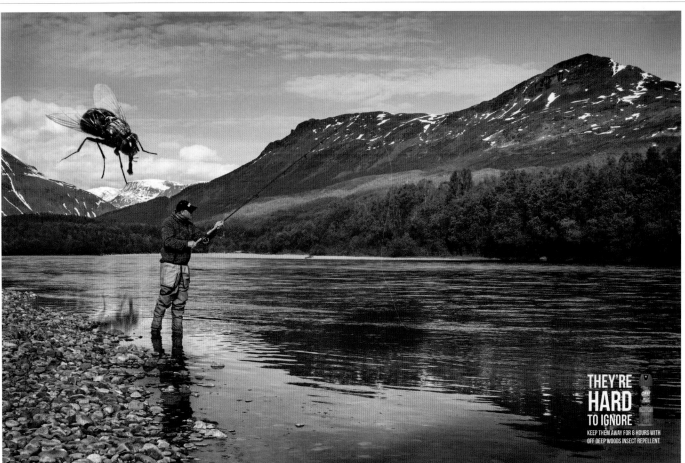

THEY'RE **HARD** TO IGNORE

KEEP THEM AWAY FOR 8 HOURS WITH OFF DEEP WOODS INSECT REPELLENT.

Student: Corinne Baker | The Newhouse School, Syracuse University

Visit website to view full series

Product | Advertising

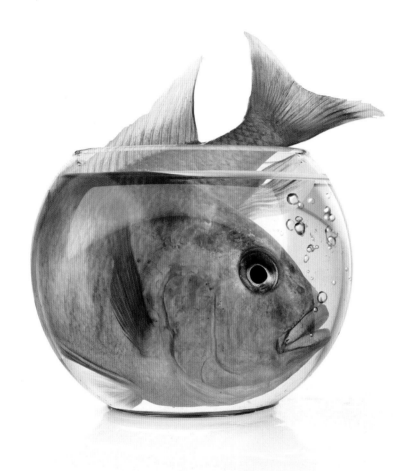

Sometimes smaller is better.

Detergent, brightener, & stain remover. All in one small pod.

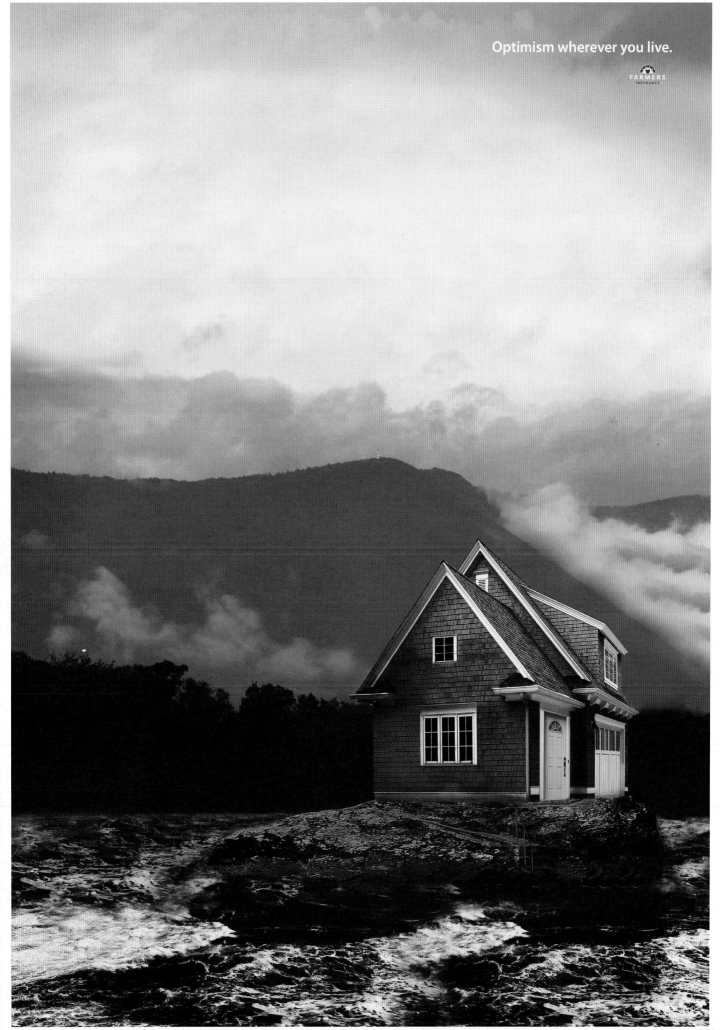

Optimism wherever you live.

FARMERS
INSURANCE

Students: Sujin Lim, Taekyoung Debbie Park | School of Visual Arts **Professional Services | Advertising**

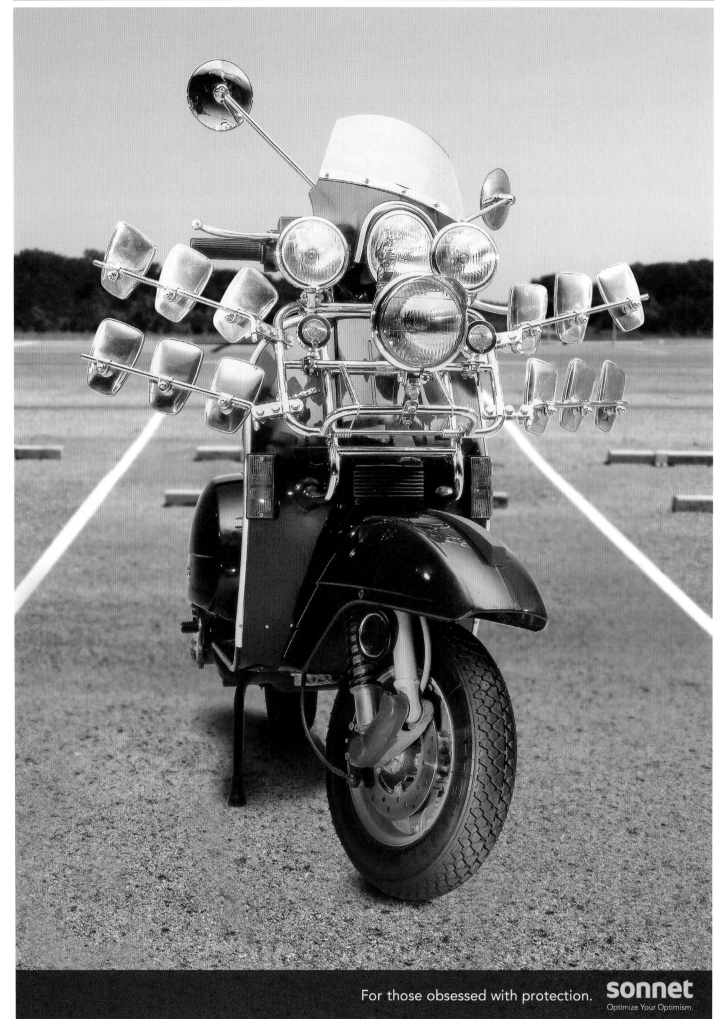

For those obsessed with protection. **sonnet**
Optimize Your Optimism.

Students: Cindy Hernandez, Tut Pinto, Minjeong Lee, Eunseok Park | School of Visual Arts

Visit website to view full series

INSTRUCTOR **FRANK ANSELMO**

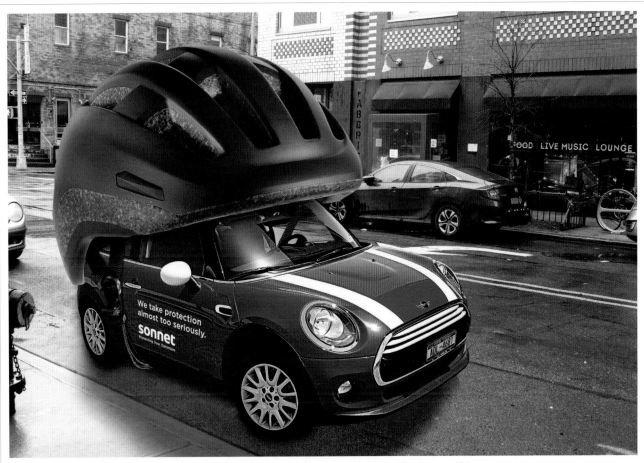

Students: Huiwen Ong, Yuran Won, HyunJin Stella Kim, Tamara Yakov, Sujin Lim, Taekyoung Debbie Park | School of Visual Arts

Visit website to view full series

INSTRUCTOR **FRANK ANSELMO**

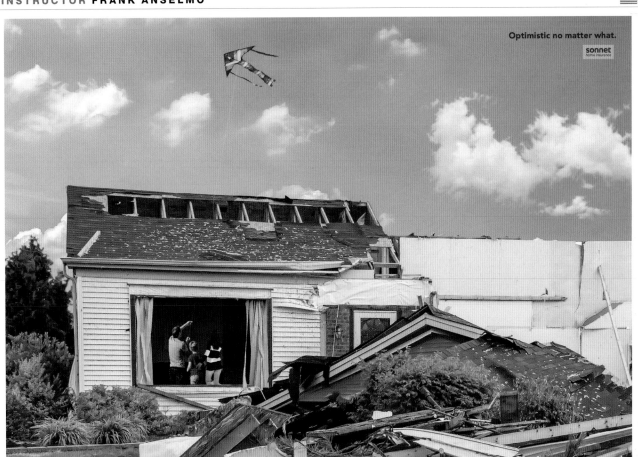

Optimistic no matter what.

Students: Hyeon-A Kim, Minjeong Lee, Eunseok Park, HyunJin Stella Kim, Tamara Yakov, Pierre Fort | School of Visual Arts

Visit website to view full series

IN 2020,
CHOOSE OPRAH

OPRAH WINFREY
★ ★ 2020 ★ ★

INSTRUCTOR **KIRAN KOSHY**

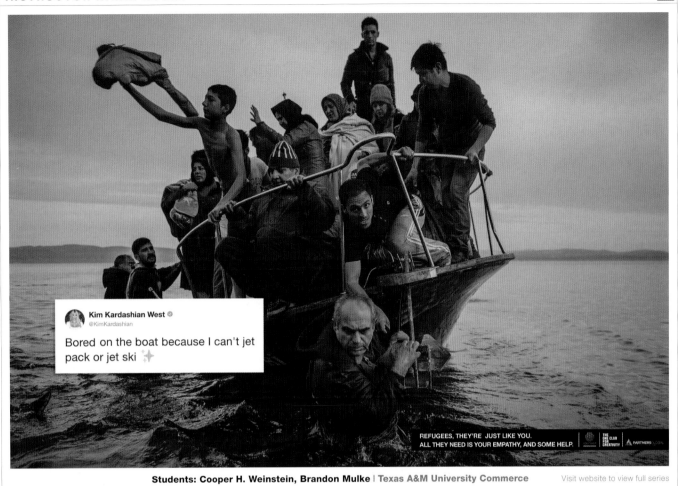

Students: Cooper H. Weinstein, Brandon Mulke | **Texas A&M University Commerce** Visit website to view full series

INSTRUCTOR **FRANK ANSELMO**

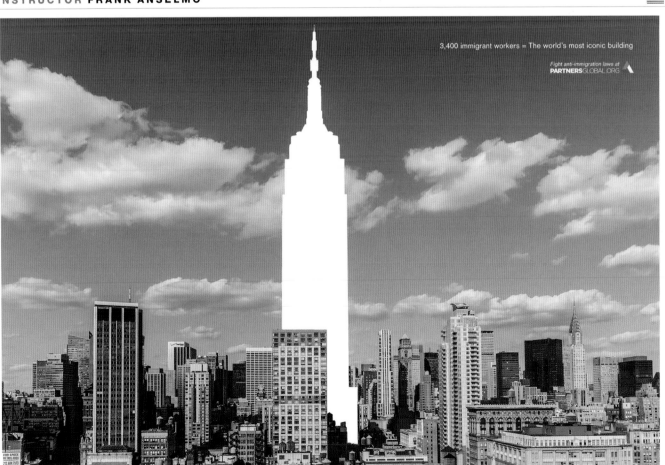

Students: Josi Liang Matson, Seona Kim | **School of Visual Arts** Visit website to view full series

Social Services | Advertising

INSTRUCTOR FRANK ANSELMO

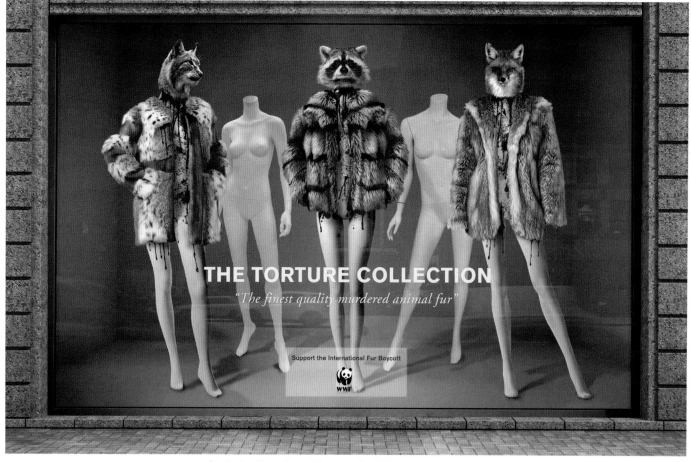

Students: Jisoo Hong, Minyoung Park | School of Visual Arts

INSTRUCTOR FRANK ANSELMO

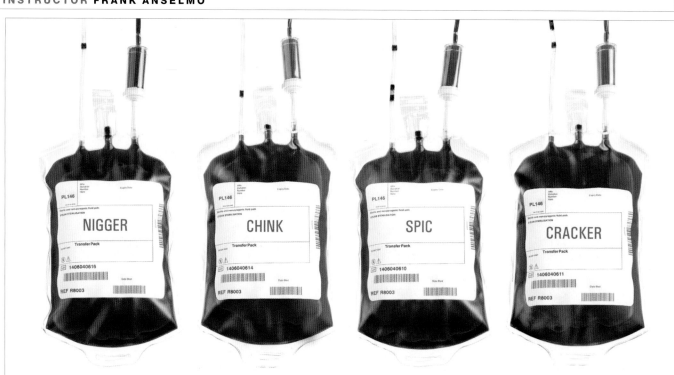

Students: Cindy Hernandez, Tut Pinto | School of Visual Arts

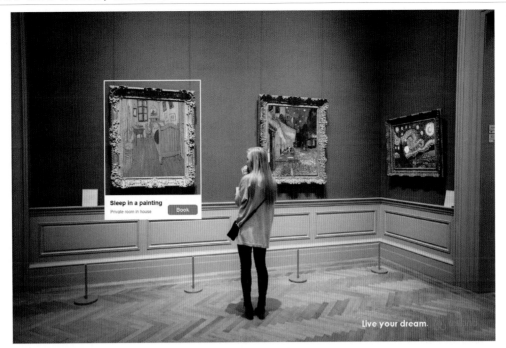

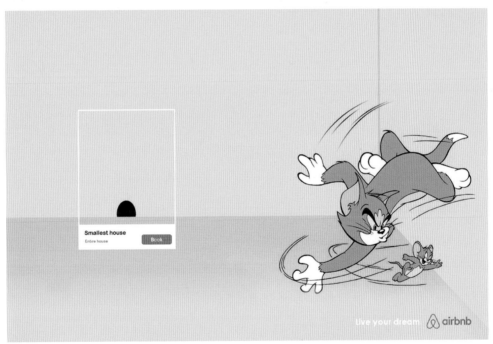

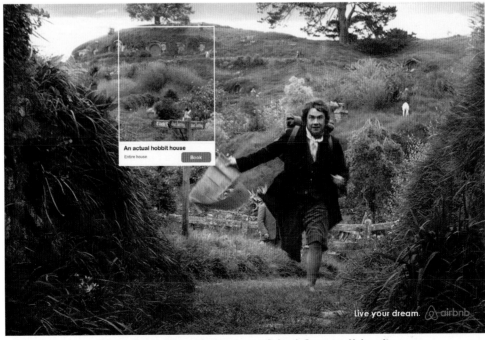

Student: Ning Zeng | **The Newhouse School, Syracuse University**

Travel | Advertising

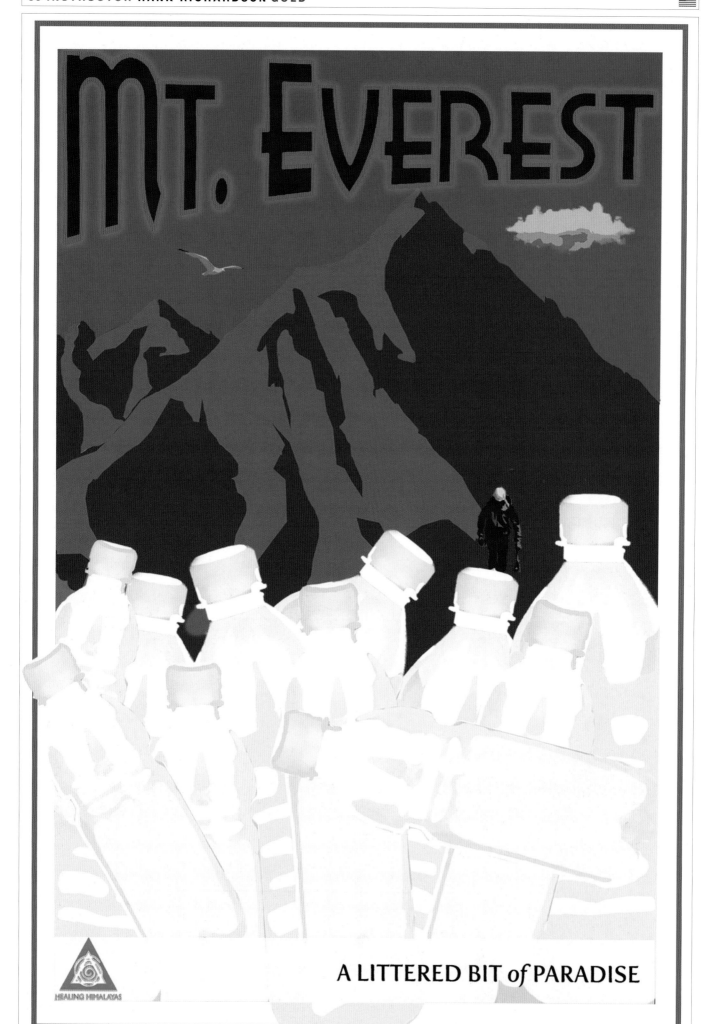

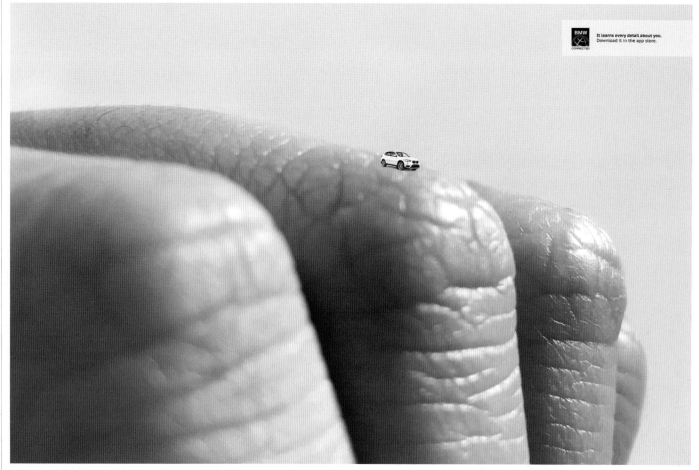

Students: Jake Blankenship, Yifei You | School of Visual Arts

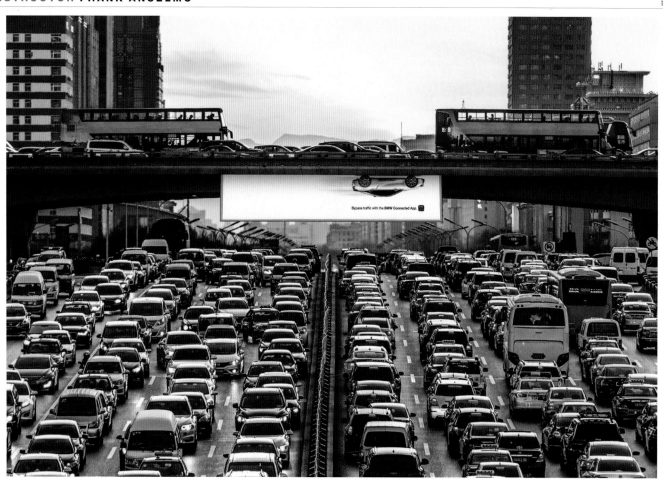

Students: Junho Lee, Evan Choi | School of Visual Arts

HYUNDAI OFFICIAL SPONSOR OF THE NFL

Student: Ana Miraglia | Miami Ad School

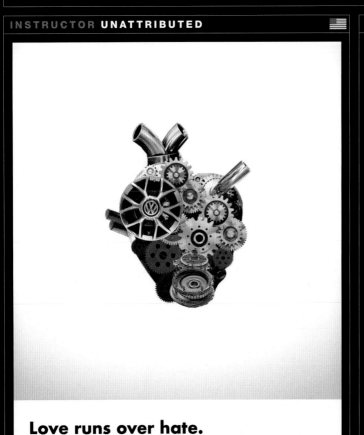

Love runs over hate.

Heartbeats change. Whether you're nervous, afraid, happy, or falling in love. It beats faster and slower accommodating to your every need. Just like a VW. Accommodation might as well be our middle name. When you're nervous lean back and breathe deep, when you've found the one turn Celine Dion all the way up, and start singing near, far, wherever you are.

Peace By Pieces

Students: Hridaynag Kooretti, Cody Turk | Miami Ad School

Connect to the perfect in-car climate.

BMW | BMW Connected

Students: Josi Liang Matson, Seona Kim | School of Visual Arts

INSTRUCTOR KEVIN O'NEILL

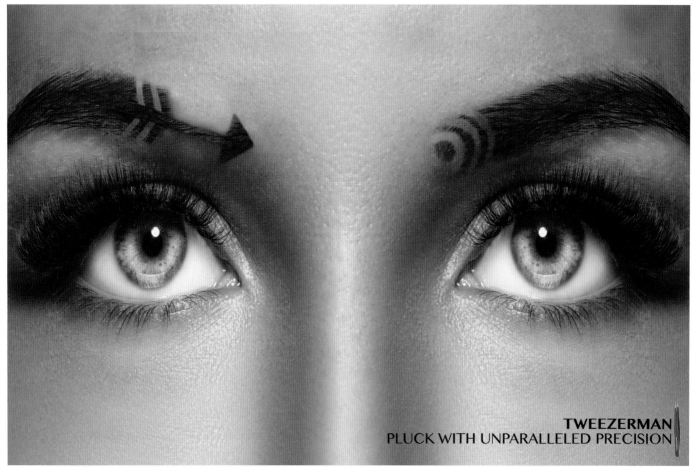

Student: Nicole Framm | The Newhouse School, Syracuse University

INSTRUCTOR MEL WHITE

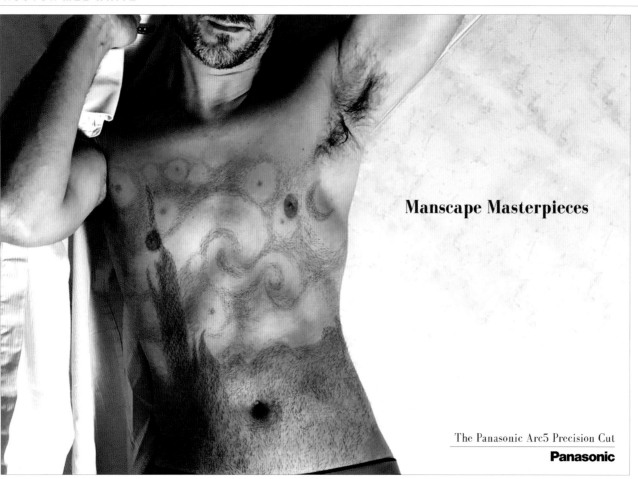

Students: Chi-Ching Ada Lam, Danika Petersen | The Newhouse School, Syracuse University

INSTRUCTOR MEL WHITE

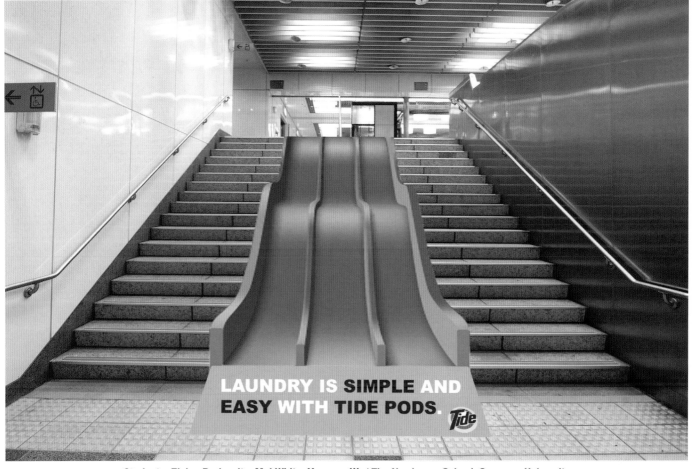

Students: **Elaina Berkowitz, Mel White, Yunxuan Wu** | The Newhouse School, Syracuse University

INSTRUCTOR LARRY GORDON

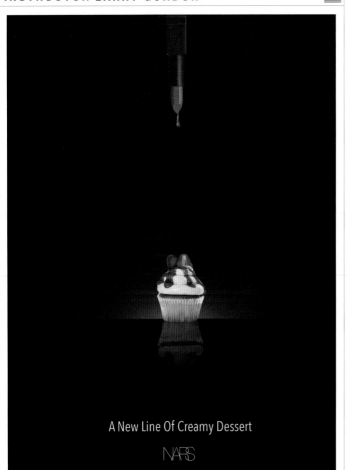

Student: **Kaiqi Cai** | Miami Ad School

INSTRUCTOR BOB GILL

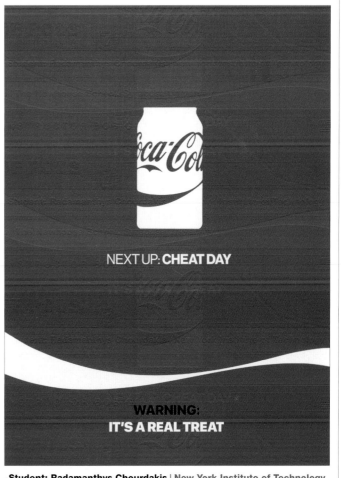

Student: **Radamanthys Chourdakis** | New York Institute of Technology

INSTRUCTOR UNATTRIBUTED

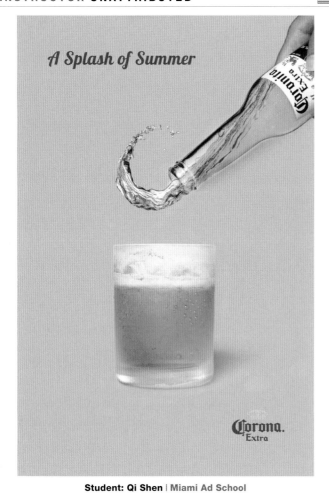

Student: Qi Shen | Miami Ad School

INSTRUCTOR KEVIN O'NEILL

Student: Edan Michener | The Newhouse School, Syracuse University

INSTRUCTOR KEVIN O'NEILL

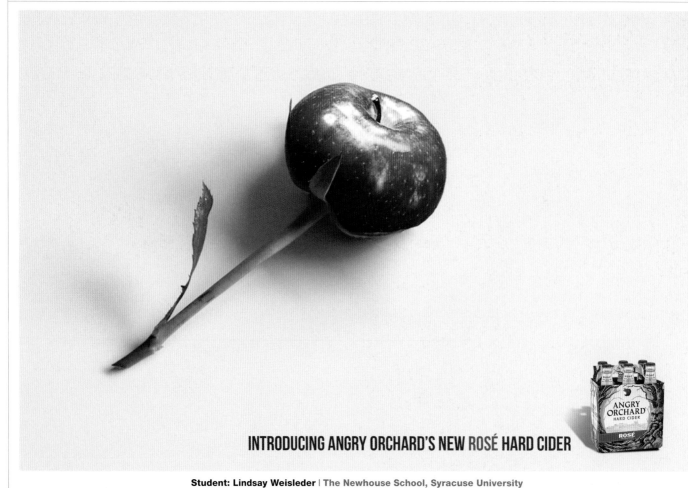

Student: Lindsay Weisleder | The Newhouse School, Syracuse University

INSTRUCTORS MEL WHITE, KEVIN O'NEILL

AMAZIFYING.

Amazing and satisfying. Strawberry and lemon combined in a tea so incredible, they haven't invented a word for it yet. It's Tazo, the most fruitful tea on Earth, made from blending ingredients so unexpected and interesting, you'll just have to try it yourself.

TAZO.

Students: Samantha Spellman, Isabel Drukker | The Newhouse School, Syracuse University

INSTRUCTOR EILEEN HEDY SCHULTZ

Student: Jae Wook Baik | School of Visual Arts

INSTRUCTOR HANK RICHARDSON

The ultimate magic trick!

FAIRY

Student: Alana Vitrian | Miami Ad School

INSTRUCTOR UNATTRIBUTED

Students: Abdelrahman Galal, Samar Singh | Miami Ad School Hamburg

INSTRUCTOR CARLOS RONCAJOLO

Student: Alana Vitrian | Miami Ad School Wynwood

INSTRUCTOR EILEEN HEDY SCHULTZ

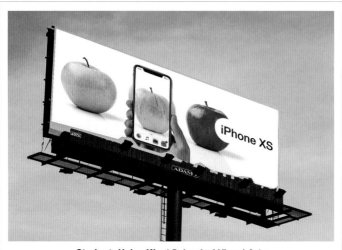

Student: Haley Kim | School of Visual Arts

INSTRUCTOR UNATTRIBUTED

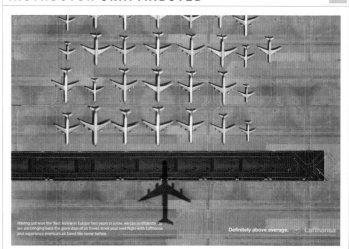

Students: Abdelrahman Galal, Samar Singh | Miami Ad School Hamburg

INSTRUCTOR UNATTRIBUTED

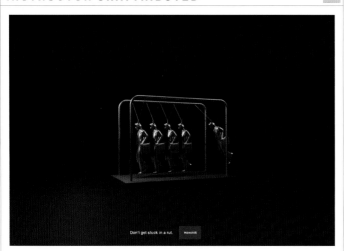

Students: Abdelrahman Galal, Samar Singh | Miami Ad School Hamburg

INSTRUCTOR HANK RICHARDSON

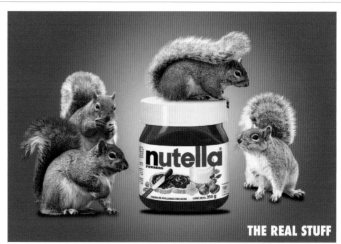

Student: Alana Vitrian | Miami Ad School Wynwood

INSTRUCTOR DAVID HAKE

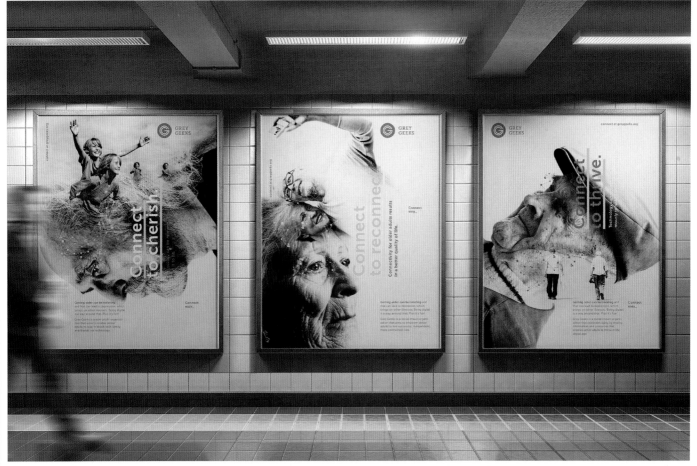

Student: Krishapriya (KP) Dutta Gupta | Academy of Art University

INSTRUCTORS MEL WHITE, KEVIN O'NEILL

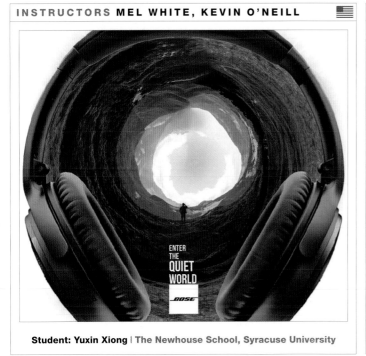

Student: Yuxin Xiong | The Newhouse School, Syracuse University

INSTRUCTOR BRYAN DODD

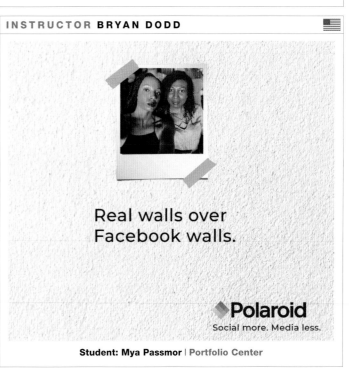

Student: Mya Passmor | Portfolio Center

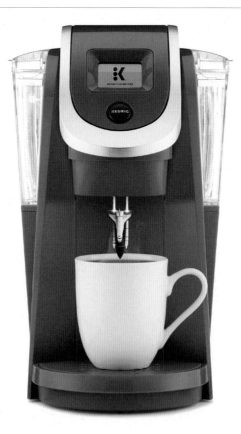

Not-so-instant instant coffee. Brewed coffee, tea, and hot chocolate in under a minute. **KEURIG**

Student: Keren Mevorach | The Newhouse School, Syracuse University

THE "CANNED BEANS" OF BATTERIES.

Fresh batteries for up to ten years in storage with Duracell's Duralock technology. DURACELL

Student: Karen Miranda | The Newhouse School, Syracuse University

INSTRUCTOR SUMMER DOLL-MYERS

Student: Caleb Finn | **Kutztown University of Pennsylvania**

INSTRUCTOR CASSIE HESTER

Student: Canaan Griffin | **Mississippi State University**

INSTRUCTOR ZORAYMA GUEVARA

Student: Ana Miraglia | **Miami Ad School**

INSTRUCTOR MEL WHITE

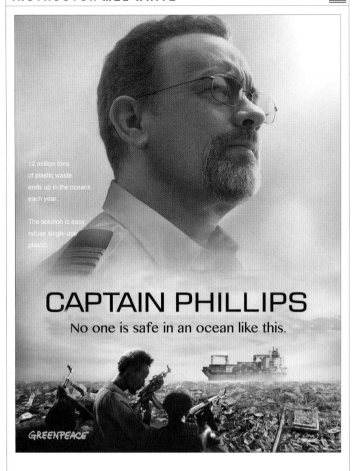

Student: Yuchien Wang | The Newhouse School, Syracuse University

INSTRUCTOR NIKLAS FRINGS-RUPP

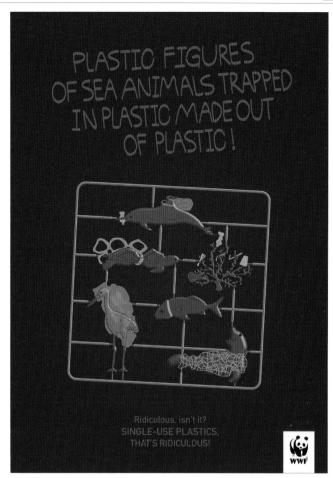

Student: Ana Karen Jiménez Barba | Miami Ad School Europe

INSTRUCTOR BRYAN DODD

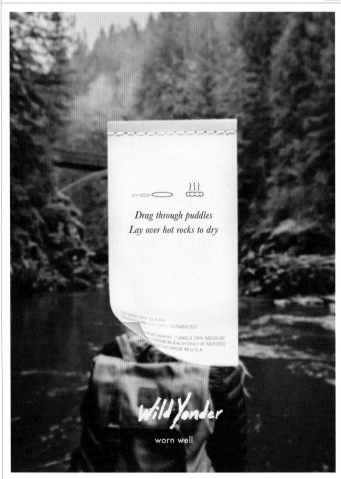

Students: Mya Passmore, Jessica Pester, Clive Neish | Portfolio Center

INSTRUCTOR KEVIN O'NEILL

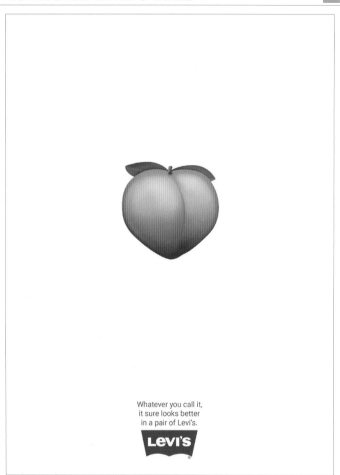

Student: Audra Linsner | The Newhouse School, Syracuse University

INSTRUCTOR UNATTRIBUTED

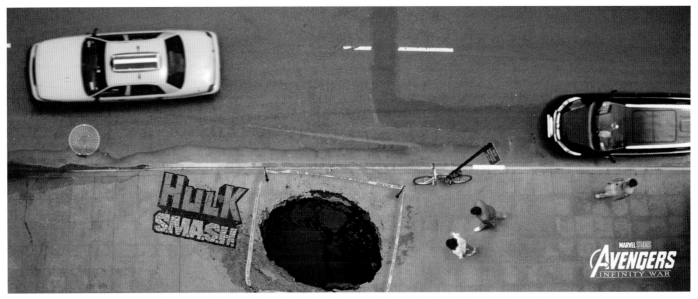

Students: Hridaynag Kooretti, Vaidehi Mewawalla, Deepika Desai | Miami Ad School

INSTRUCTOR KEVIN O'NEILL

Student: Yuxin Xiong
The Newhouse School, Syracuse University

INSTRUCTOR KEVIN O'NEILL

Student: Annie Turner
The Newhouse School, Syracuse University

INSTRUCTOR LANCE MORALES

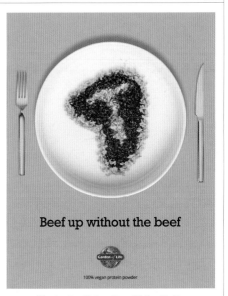

Students: Peter Fox, Myka Betts
Miami Ad School NY

INSTRUCTOR DAVID ELIZALDE

Student: Abbey Dean
Texas Christian University

INSTRUCTOR FRANK ANSELMO

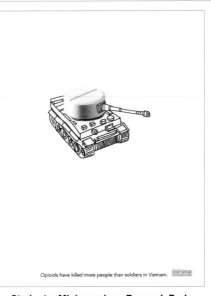

Students: Minjeong Lee, Eunseok Park
School of Visual Arts

INSTRUCTOR DAVID ELIZALDE

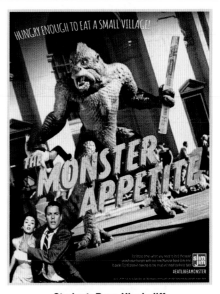

Student: Ryan Hinchcliff
Texas Christian University

INSTRUCTOR FLORIAN WEITZEL 🇩🇪

Students: Claudio Castagnola, Marwan Ibrahim
Miami Ad School Europe

INSTRUCTOR UNATTRIBUTED 🇺🇸

Student: Marcus Lim
School of Visual Arts

INSTRUCTOR FLORIAN WEITZEL 🇩🇪

Students: Anna Dedi, Theresa Kaußner
Miami Ad School Europe

INSTRUCTORS BILL GALYEAN, JACK SUMMERFORD 🇺🇸

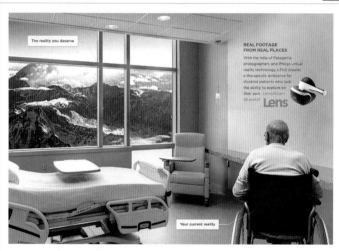

Student: Michele Farren | Texas Christian University

INSTRUCTOR FRANK ANSELMO 🇺🇸

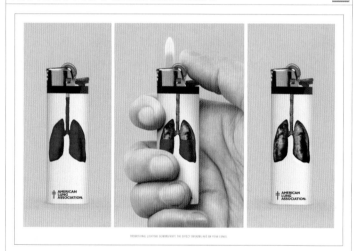

Students: Jens Marklund, Jack Welles | School of Visual Arts

INSTRUCTOR FRANK ANSELMO 🇺🇸

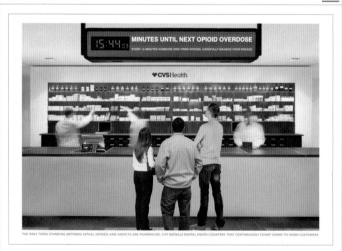

Students: Jens Marklund, Jack Welles | School of Visual Arts

INSTRUCTOR FRANK ANSELMO 🇺🇸

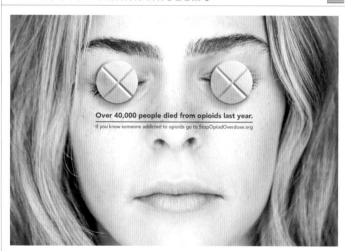

Students: Jake Blankenship, Yifei You, Joe Chong | School of Visual Arts

INSTRUCTOR FRANK ANSELMO

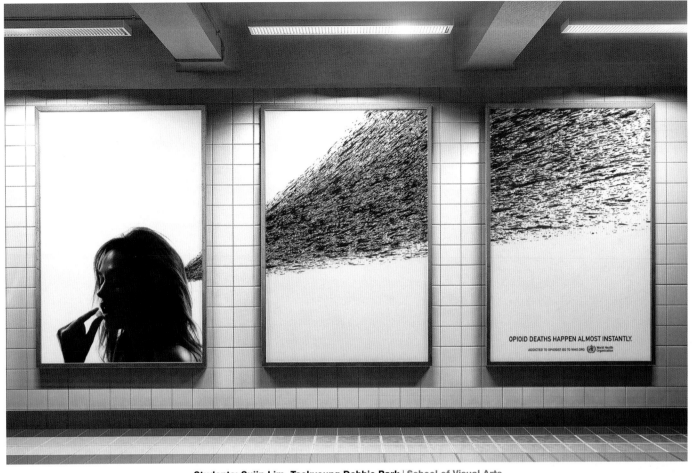

Students: Sujin Lim, Taekyoung Debbie Park | School of Visual Arts

INSTRUCTOR MEL WHITE

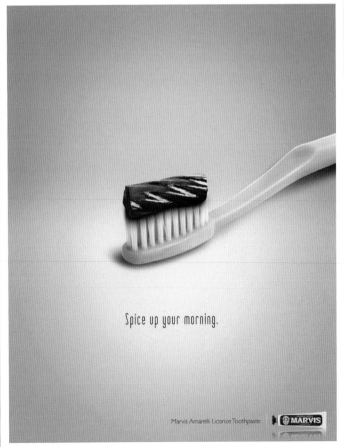

Student: Sarah Whaley | The Newhouse School, Syracuse University

INSTRUCTOR KEVIN O'NEILL

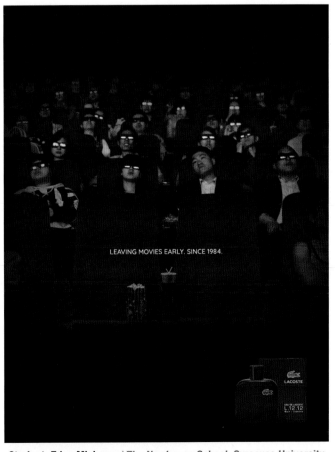

Student: Edan Michener | The Newhouse School, Syracuse University

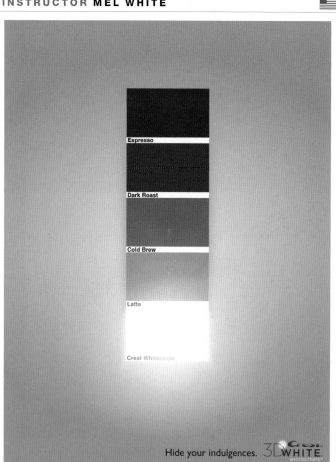

Espresso

Dark Roast

Cold Brew

Latte

Crest Whitestrips

Hide your indulgences. 3D **WHITE** WHITESTRIPS

Students: Sarah Whaley, Amy Schwartz
The Newhouse School, Syracuse University

Summer's not forever.
Sharpie is.

Sharpie

Students: Samantha Spellman, Isabel Drukker
The Newhouse School, Syracuse University

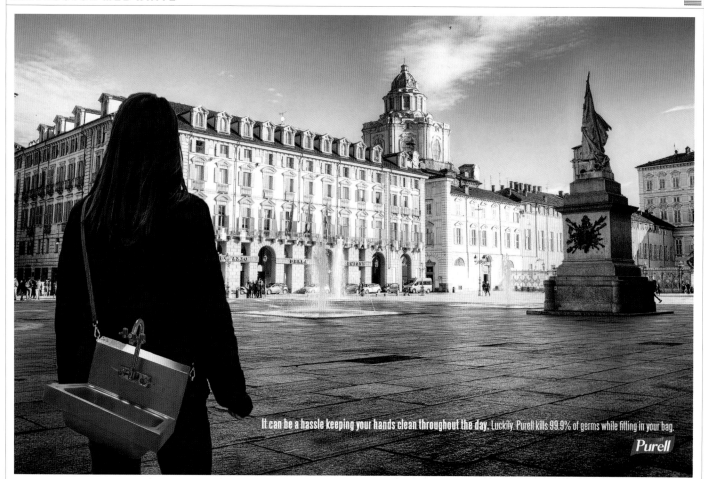

It can be a hassle keeping your hands clean throughout the day. Luckily. Purell kills 99.9% of germs while fitting in your bag.

Purell

Student: Marta Lala | The Newhouse School, Syracuse University

INSTRUCTOR **LARRY GORDON**

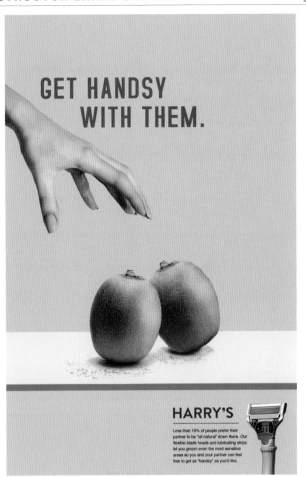

Student: **Chase Harris** | Miami Ad School

INSTRUCTOR **LEE WHITMARSH**

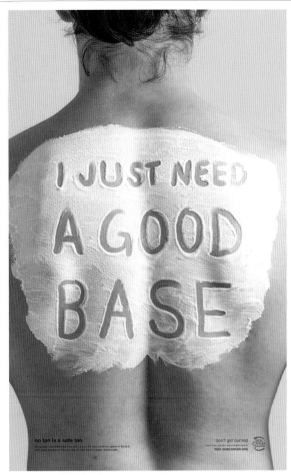

Student: **Monica Williams** | Texas A&M University Commerce

INSTRUCTOR **BILL WOSAR**

Students: **Landon Watnick, Christian Harkna, Thiago Narvaez**
Texas A&M University Commerce

INSTRUCTOR **KEVIN O'NEILL**

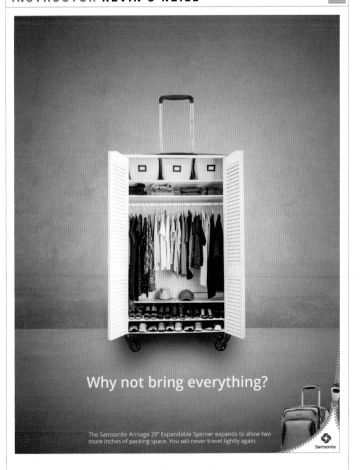

Student: **Sarah Whaley**
The Newhouse School, Syracuse University

INSTRUCTOR KEVIN O'NEILL

Student: Yuchien Wang
The Newhouse School, Syracuse University

INSTRUCTOR DAVID ELIZALDE

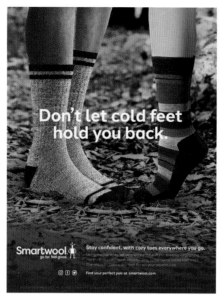

Don't let cold feet hold you back.

Smartwool

Student: Emma Heinz
Texas Christian University

INSTRUCTOR FRANK ANSELMO

PLAY
inside / outside
SEAMLESSLY

Students: Hunwoo Choi, Ein Jung
School of Visual Arts

INSTRUCTOR FRANK ANSELMO

Small but Powerful.
Beats Pill

Students: Joe Chong, Mo Ku | School of Visual Arts

INSTRUCTOR FLORIAN WEITZEL

febreze

Student: Claudio Castagnola | Miami Ad School Europe

INSTRUCTORS DONG-JOO PARK, SEUNG-MIN HAN

Can't help falling in love with

Students: Chaeun Park, Hyosun Park, Sunhee Ann
Hansung University of Design & Art Institute

INSTRUCTOR MEL WHITE

U-HAUL
DO-IT-YOURSELF MOVING

Student: Ivor Guest
The Newhouse School, Syracuse University

INSTRUCTOR FRANK ANSELMO

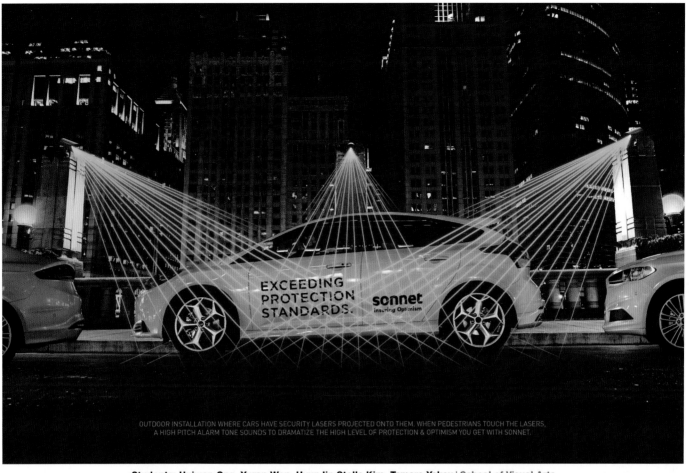

Students: **Huiwen Ong, Yuran Won, HyunJin Stella Kim, Tamara Yakov** | School of Visual Arts

INSTRUCTOR FRANK ANSELMO

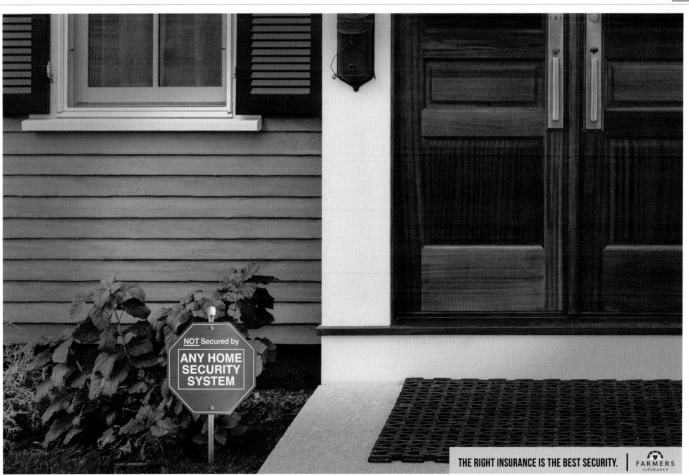

Students: **Jake Blankenship, Yifei You, Joe Chong** | School of Visual Arts

INSTRUCTOR FRANK ANSELMO

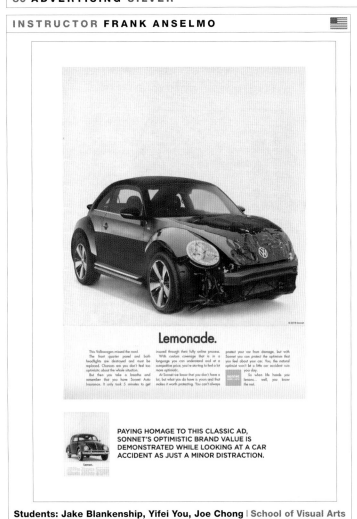

Lemonade.

PAYING HOMAGE TO THIS CLASSIC AD, SONNET'S OPTIMISTIC BRAND VALUE IS DEMONSTRATED WHILE LOOKING AT A CAR ACCIDENT AS JUST A MINOR DISTRACTION.

Students: Jake Blankenship, Yifei You, Joe Chong | School of Visual Arts

INSTRUCTOR EILEEN HEDY SCHULTZ

¡HOLA!

Student: Jae Wook Baik | School of Visual Arts

INSTRUCTOR KELVIN O'NEILL

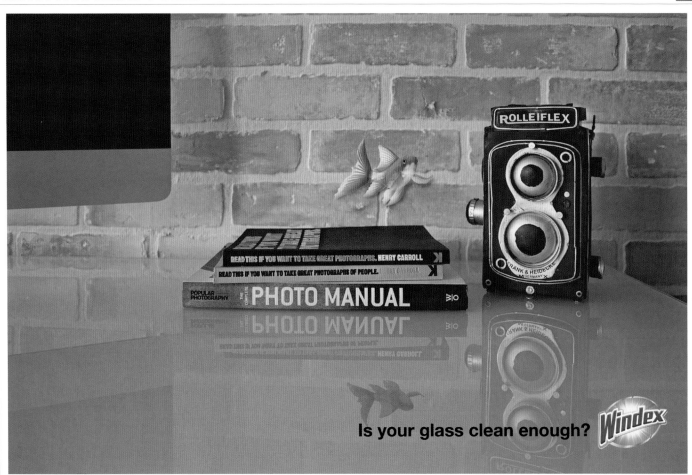

Is your glass clean enough?

Student: Ting Peng | The Newhouse School, Syracuse University

INSTRUCTOR **BILL GALYEAN**

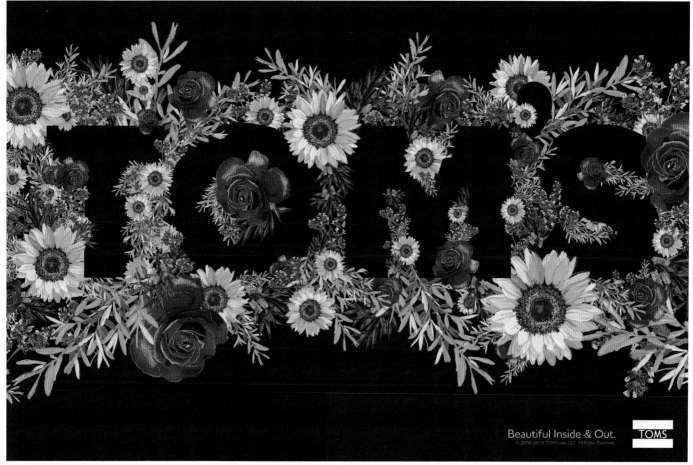

Student: Kahla Watkins | Texas Christian University

INSTRUCTOR **RAJATH RAMAMURTHY**

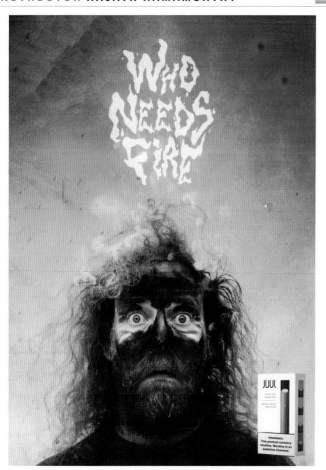

Students: Ashutosh Thakkar, Bader Salahuddin
Miami Ad School New York

INSTRUCTOR **FRANK ANSELMO**

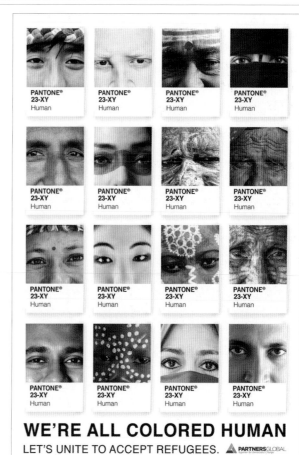

Students: Jake Blankenship, Yifei You, Joe Chong
School of Visual Arts

INSTRUCTOR **FRANK ANSELMO**

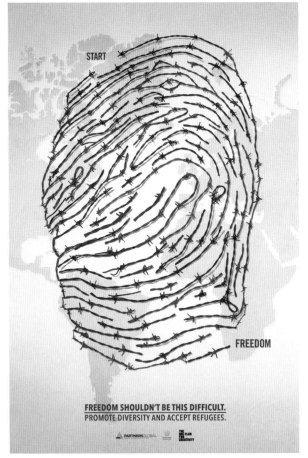

FREEDOM SHOULDN'T BE THIS DIFFICULT.
PROMOTE DIVERSITY AND ACCEPT REFUGEES.

Students: Jake Blankenship, Yifei You, Joe Chong
School of Visual Arts

INSTRUCTOR **FRANK ANSELMO**

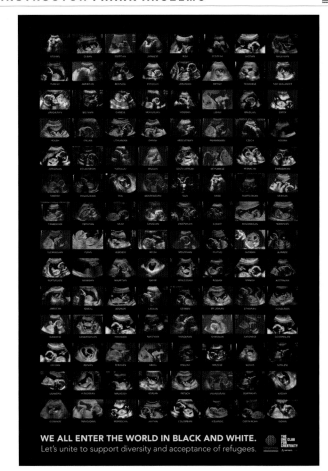

WE ALL ENTER THE WORLD IN BLACK AND WHITE.
Let's unite to support diversity and acceptance of refugees.

Students: Cindy Hernandez, Tut Pinto
School of Visual Arts

INSTRUCTOR **EILEEN HEDY SCHULTZ**

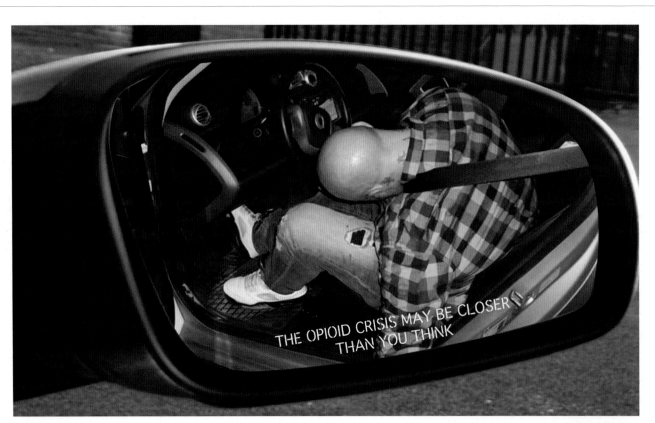

THE OPIOID CRISIS MAY BE CLOSER
THAN YOU THINK

It only takes a prescription to lose everything.

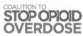
COALITION TO
STOP OPIOID
OVERDOSE

Students: Jae Wook Baik, Yun Hwa Lee | School of Visual Arts

INSTRUCTOR FRANK ANSELMO

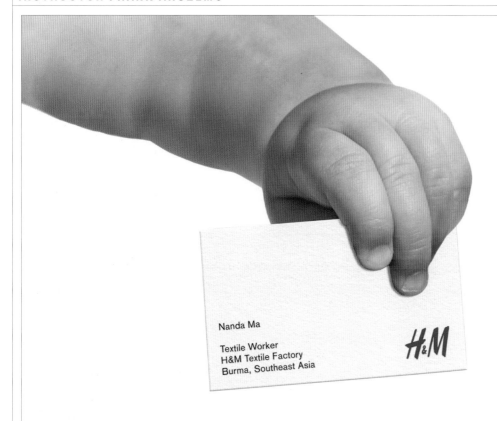

Students: Josi Liang Matson, Seona Kim | School of Visual Arts

INSTRUCTORS MEL WHITE, KEVIN O'NEILL

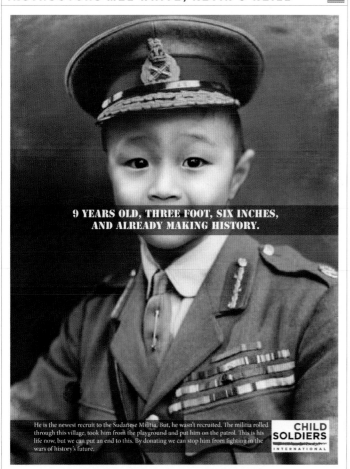

Students: Carrie Kaiser, Will Milowsky
The Newhouse School, Syracuse University

INSTRUCTORS DONG-JOO PARK, SEUNG-MIN HAN

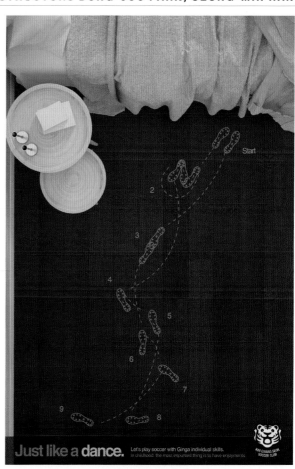

Student: Kim Ji Yul
Hansung University of Design & Art Institute

INSTRUCTOR JERROD NEW AUTOMOTIVE

Students: Cristina Marquez, Junggle Kim, Maddie Rosenberg, Ela Kallonen, Marcelo Shalders | Miami Ad School

INSTRUCTOR ZORAYMA GUEVARA AUTOMOTIVE

How can we prove that autonomous cars are more trustworthy than human drivers?

Students: Ana Miraglia, Max Cohen | Miami Ad School

INSTRUCTOR DAVID URIBE AUTOMOTIVE PRODUCTS

Student: Ashutosh Thakkar | Miami Ad School Wynwood

INSTRUCTORS FRANK GARCIA, GIULIA MAGALDI BEAUTY & FASHION

Students: Ana Miraglia, Lorran Schoechet, Jienne Alhaideri | Miami Ad School

INSTRUCTOR **BRYAN DODD** BEVERAGE

Students: Alexa Lyons, Mya Passmore | Portfolio Center

INSTRUCTOR **MEL WHITE** COMMUNICATIONS

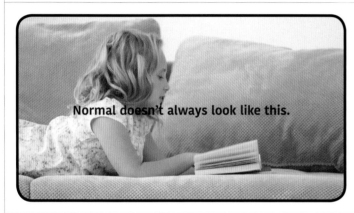

Normal doesn't always look like this.

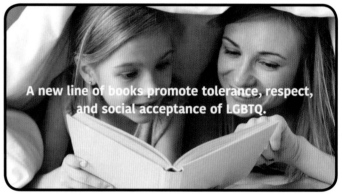

A new line of books promote tolerance, respect, and social acceptance of LGBTQ.

Students: Yunxuan Wu, Elaina Berkowitz | The Newhouse School, Syracuse University

INSTRUCTOR **MATT MORESCO** COMMUNICATIONS

FOR YOUR DIRTY WORK

Students: Paola Delgado Cornejo, Amber Jolly | Miami Ad School San Francisco

INSTRUCTOR **JERROD NEW** ELECTRONICS

Students: Cristina Marquez, Junggle Kim, Chaeyeong Seo | Miami Ad School

INSTRUCTOR **UNATTRIBUTED** ELECTRONICS

Students: **Nick Arzhantsev, Andrea Martinez, Alex Gerber, Cali McGovern** | Miami Ad School

INSTRUCTOR **FRANK ANSELMO** ELECTRONICS

Students: **Tamara Yakov, HyunJin Kim, Taekyoung Debbie Park** | School of Visual Arts

INSTRUCTOR **JERROD NEW** ELECTRONICS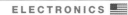

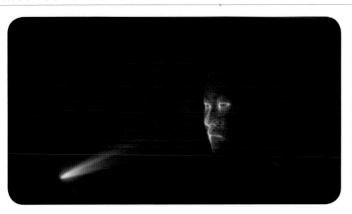

Students: **Cristina Marquez, Junggle Kim, Maddie Rosenberg, Ela Kallonen** | Miami Ad School

INSTRUCTOR **HANK RICHARDSON** ELECTRONICS

Students: **Alana Vitrian, Andrea Baridon, Marta Iglesias** | Miami Ad School

INSTRUCTOR **FRANK ANSELMO** ENVIRONMENTAL 🇺🇸

 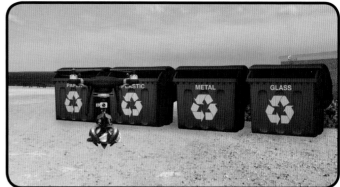

Students: Sujin Lim, Taekyoung Debbie Park | School of Visual Arts

INSTRUCTOR **BRENT SLONE** ENVIRONMENTAL 🇺🇸

 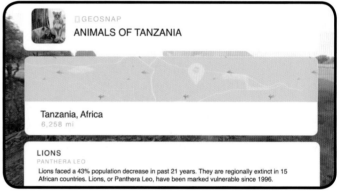

Students: Anna Cevallos, Raquel Chisholm | Miami Ad School

INSTRUCTOR **ZORAYMA GUEVARA** ENVIRONMENTAL 🇺🇸

Students: Ana Miraglia, Diane Danneels | Miami Ad School

INSTRUCTORS **PEDRO ROSAS, AUGUSTO CORREIA, BRUNO ALMEIDA, LUIS PAULO GATTI** EVENTS

 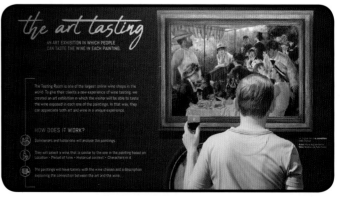

Students: Luiz Henrique Costa, Tiago Daltro, Igor Pontes, Raquel Segal, Gabriel Moraes | Miami Ad School Brazil

INSTRUCTOR RAJATH RAMAMURTHY

FILM

Students: Matias Cachiquis, Isaac Sorenson | Miami Ad School

INSTRUCTOR ZORAYMA GUEVARA

FINANCIAL SERVICES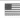

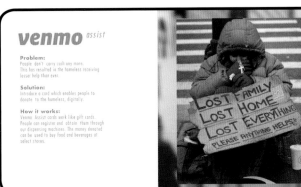 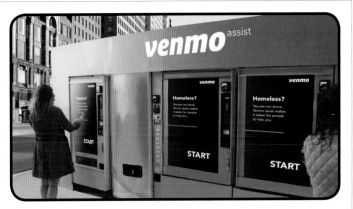

Students: Vaidehi Mewawalla, Hridaynag Kooretti, Matteo Angione, Axel Livijn Carlman | Miami Ad School

INSTRUCTOR YOUJEONG KIM

FOOD

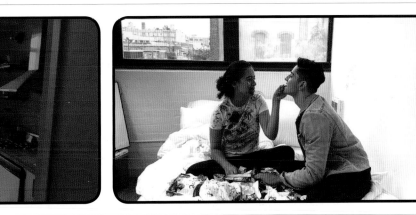

Student: Radamanthys Chourdakis | New York Institute of Technology

INSTRUCTOR HANK RICHARDSON

FOOD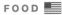

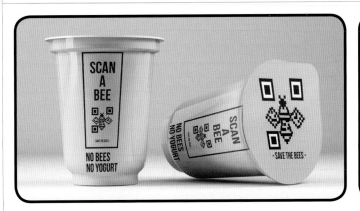 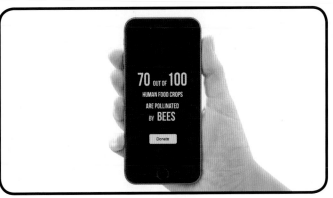

Students: Alana Vitrian, Claudia Dompe | Miami Ad School

INSTRUCTOR **BRENT SLONE** HEALTHCARE 🇺🇸

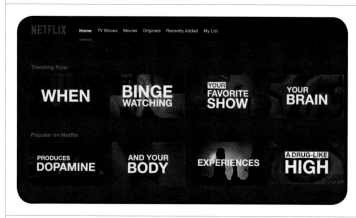 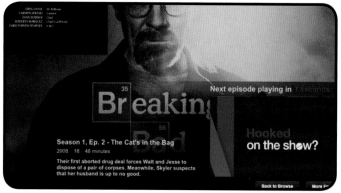

Students: Nidal Koteich, Daniel Pujol, Lisette Azulay, Agustina Lavignasse | Miami Ad School

INSTRUCTOR **MANOLO GARCIA** HEALTHCARE 🇺🇸

Students: Hatem El Akad, Donghoon Lee, Paola Delgado Cornejo | Miami Ad School San Francisco

INSTRUCTOR **MARLON KOSTER-VON FRANQUEMONT** HEALTHCARE 🇺🇸

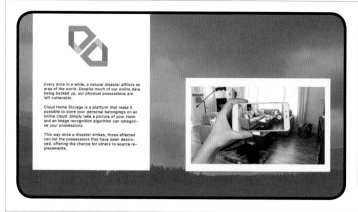

Students: Axel Livijn Carlman, Marlon Von Franquemont, Niklas Frings-Rupp, Alessandra Gorla | Miami Ad School

INSTRUCTOR **BRENT SLONE** MUSEUM 🇺🇸

Students: Anna Cevallos, Oliver Permut, Tuhin Pahri | Miami Ad School

INSTRUCTOR FRANK ANSELMO PHARMACEUTICALS

Students: Jake Blankenship, Joe Chong, Yifei You | School of Visual Arts

INSTRUCTOR ZORAYMA GUEVARA PRODUCT

 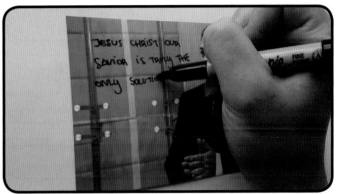

Student: Ana Miraglia | Miami Ad School

INSTRUCTOR JUAN MUNOZ PRODUCT

Student: Alana Vitrian | Miami Ad School

INSTRUCTOR FRANK ANSELMO PRODUCT

Students: Jake Blankenship, Yifei You | School of Visual Arts

INSTRUCTOR MEL WHITE PRODUCT

Students: Chi-Ching Ada Lam, Danika Petersen | The Newhouse School, Syracuse University

INSTRUCTOR JONATHAN CASTRO PROFESSIONAL SERVICES

Students: Natalia Serur, Christian Harkna, Nico Gandrup, Justin Hoover | Miami Ad School

INSTRUCTOR FRANK ANSELMO PROMOTION

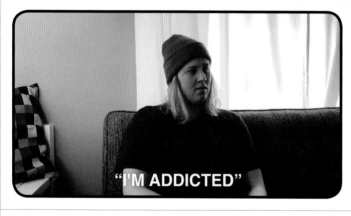

Students: Ezequiel Consoli, Jack Welles | School of Visual Arts

INSTRUCTOR FRANK ANSELMO PROMOTION

Students: HyunJin Stella Kim, Tamara Yakov | School of Visual Arts

INSTRUCTOR FRANK ANSELMO CATEGORY

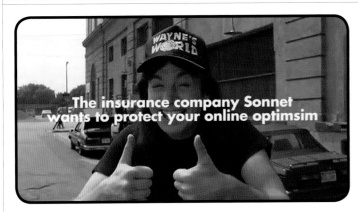

Students: Jake Blankenship, Yifei You | School of Visual Arts

INSTRUCTOR FRANK ANSELMO PROMOTION

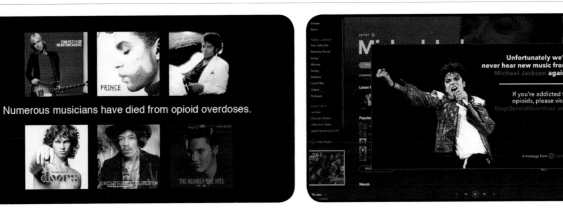

Students: Jake Blankenship, Yifei You | School of Visual Arts

INSTRUCTOR FRANK ANSELMO SOCIAL SERVICES

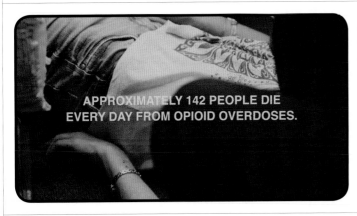

Students: HyunJin Stella Kim, Tamara Yakov | School of Visual Arts

INSTRUCTOR YOUJEONG KIM SOCIAL SERVICES

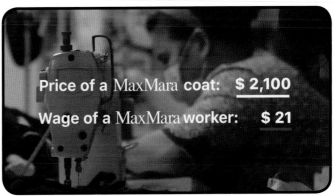

Student: Radamanthys Chourdakis | New York Institute of Technology

INSTRUCTORS FRANK GARCIA, GIULIA MAGALDI

SOCIAL SERVICES 🇺🇸

Student: **Diane Danneels** | Miami Ad School

INSTRUCTOR UNATTRIBUTED

SOCIAL SERVICES 🇺🇸

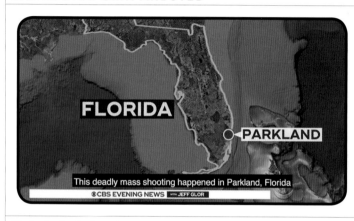

Students: **Paula Gete-Alonso, Claudio Castagnola, Tadgh Ennis** | Miami Ad School

INSTRUCTOR MARK EDWARDS

SPORTS 🇺🇸

Students: **Max Gawell, Frans Ahlberg, Sam Salehian** | Academy of Art University

INSTRUCTOR FRANK ANSELMO

SPORTS 🇺🇸

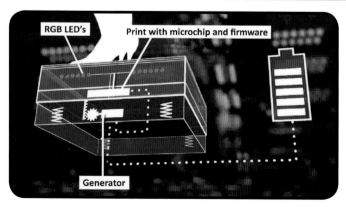

Students: **Sujin Lim, Taekyoung Debbie Park** | School of Visual Arts

INSTRUCTOR **ZORAYMA GUEVARA**

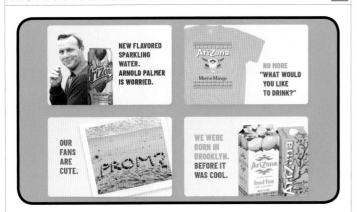

Students: **Ana Miraglia, Marina Ferraz** | Miami Ad School

INSTRUCTOR **MEL WHITE**

Students: **Y. Wu, E. Berkowitz** | The Newhouse School, Syracuse University

INSTRUCTOR **BILL WOSAR**

Student: **Landon Watnick** | Miami Ad School Wynwood

INSTRUCTOR **FRANK ANSELMO**

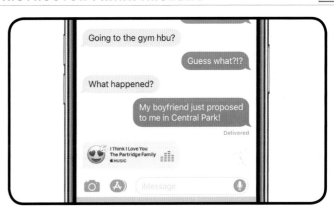

Students: **T. Yakov, H. Kim, T. D. Park** | School of Visual Arts

INSTRUCTOR **KIMBERLY CAPRON GONZALEZ**

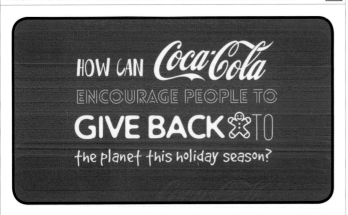

Students: **Ashutosh Thakkar, Ranjana Naik, Qi Shen** | Miami Ad School

INSTRUCTOR **RALPH BUDD**

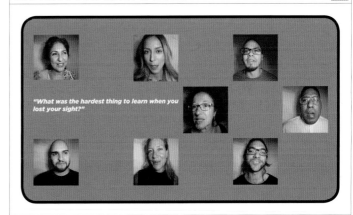

Students: **Elisa Sain, Cris Cordero** | Miami Ad School

INSTRUCTOR **CHUS RASINES**

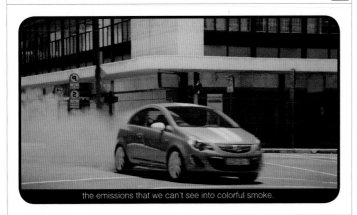

Student: **Lucia Mendezona** | Miami Ad School Madrid

INSTRUCTOR **UNATTRIBUTED**

Students: **Ching Ting, Katy Huang** | Miami Ad School

INSTRUCTOR **CARLOS RONCAJOLO**

Students: **Bader Salahuddin, Qi Shen** | Miami Ad School Wynwood

INSTRUCTOR **JERROD NEW**

Students: **Matias Cachiquis, Jessica Simmons** | Miami Ad School

INSTRUCTOR **SHANNON SANON**

Students: **L. Watnick, S. Sanon, R. Naik** | Miami Ad School Wynwood

INSTRUCTOR **MANOLO GARCIA**

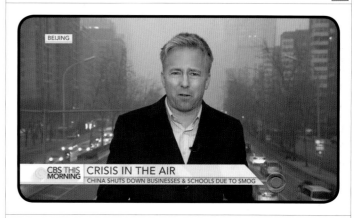

Students: **Nutnicha Achavakulthep, Deepika Desai** | Miami Ad School

INSTRUCTOR **FRANK ANSELMO**

Students: **Cindy Hernandez, Tut Pinto** | School of Visual Arts

INSTRUCTOR **HANK RICHARDSON**

Students: **A. Vitrian, N. Koteich, V. Spielberger** | Miami Ad School

INSTRUCTORS **FRANK GARCIA, GIULIA MAGALDI**

Student: **Diane Danneels** | Miami Ad School

INSTRUCTOR **FRANK ANSELMO**

Gender Discrimination
Skin Color Discrimination
Age Discrimination
Religion Discrimination

Student: **Yifei You** | School of Visual Arts

Ryan Russell I Pennsylvania State University I Dean: Kelleann Foster I **Page: 100**
Biography: Ryan received a BA in Graphic Design from Saint Norbert College in 2004 and an MFA in Graphic Design from Penn State University in 2006. He serves as an Associate Professor of Graphic Design and Design Entrepreneurship Teaching Fellow at Penn State. Ryan founded Russell & Russell, Co, a creative studio dedicated to crafting focused brand experiences. His work has been reproduced in publications such as Graphis New Talent, Print's Regional Design Annual, UCDA Designer Magazine, Communication Arts, and various Graphis Annuals. His work is found in collections like the Jan Kaniorek Gallery, Muzeum Plakatu w Wilanowie, Warsaw; and more.
Advice: Take risks! This inevitably leads to exciting new solutions.

Kristin Sommese I Pennsylvania State University I Dean: Kelleann Foster I **Page: 101** I **Photo by Taylor Shipton**
Biography: Professor Kristin Breslin Sommese received her MFA in Graphic Design from Temple University's Tyler School of Art in 1989 and began teaching at Penn State University immediately afterward. In 1990, she became the founding partner of the award-winning firm Sommese Design with her husband Lanny. Sommese Design specializes in corporate identity, print, poster, and packaging design. Breslin Sommese was featured in many publications such as Communication Arts and Print. In addition, she has been featured in Graphis and Novum magazines. She received numerous Awards of Excellence from design venues like the AIGA, Communication Arts, Print Magazine, and the Art Directors' Club of New York. Her posters have been included in numerous prestigious national and international exhibitions. In 2009, she designed and edited the book, "Lanny Sommese: X-Ray Vision."
Advice: Be articulate and concise when explaining your concepts.

Eszter Clark I Academy of Art University I Dean: Mary Scott I **Page: 102**
Biography: Ezster Clark graduated from AAU in 2003. Prior to that she earned a degree in Biology and worked as a research associate at UC Berkeley in the plant biology department. She worked at Templin Brink Design as a designer for about four years and followed creative director Joel Templin to Hatch Design, where she worked for nine years as a senior designer and a design director. Her and her partner opened Olio Studio in 2015 where they focus solely on the food industry, providing brand strategy and packaging design.

Adrian Pulfer I Brigham Young University I Dean: Sarah Westerberg I **Page: 103**
Biography: As a textile designer, Adrian has created fabrics and wallpapers for Knoll International and F. Schumacher, New York. As an art director, he produced the "Are You A Cardmember?" and "Make Life Rewarding" campaigns for American Express. Adrian also designed and art directed the award-winning campaigns for Crate & Barrel and launched their CB2 stores. As a designer, he set the standard for a number of corporations from Georgia-Pacific's Hopper Papers to Sundance. Since 2009, Adrian has served as Design Director for The Propeller Group, an LA-based agency and since 1985, served as head of the Graphic Design Department at Brigham Young University. Adrian's work has been recognized by the Advertising Club of New York, AIGA, Communication Arts, Graphis, U&lc, Typographic Design, Type Directors' Club, Society of Publication Designers and more.
Advice: Mastering the principles that make design design can and will be an arduous journey, one that requires effort and sacrifice.

Carin Goldberg I School of Visual Arts I Dean: Richard Wilde I **Page: 104**
Biography: Carin Goldberg was born in New York City and studied at The Cooper Union School of Art. She began her career as a staff designer at CBS Television, CBS Records, and Atlantic Records before establishing her own firm in 1982. Her image making expanded to book jacket design, publication/book design, brand consulting, editorial illustration, authorship/curation, and poster design. Carin served as president of the New York Chapter of the American Institute of Graphic Arts and is a member of Alliance Graphique Internationale. In 2014, she was awarded The Rome Prize for Design. Carin has taught design at the School of Visual Arts in New York City since 1982 and is one of the first recipients of the Art Directors Club Grandmasters Award for Excellence in Education.
Advice: Typography. Typography. Typography.

Marvin Mattelson I School of Visual Arts I Dean: Richard Wilde I **Page: 105**
Biography: Marvin Mattelson is an award winning oil portrait painter who draws on over forty years of professional experience as an artist and educator. Marvin's paintings are included in the permanent collection of the National Portrait Gallery at the Smithsonian Institution and the Metropolitan Museum of Art. His portraits hang in both private and corporate collections around the world. His commissions include portraits for Velcro Industries, Met Life, the Board of Directors of MBNA, and the Archbishop of New York, Edward Cardinal Egan. Prior to portraiture Marvin had a career as an illustrator with clients like Time Inc., Newsweek, Dreamworks, IBM, and more.
Advice: Choose teachers who are interested in you becoming the very best version of yourself and not a mere clone of themselves.

Brad Bartlett I Art Center College of Design I Dean: Sean Adams I **Page: 106**
Biography: Brad Bartlett earned his Masters Degree in Design from the Cranbrook Academy of Art in 1998, graduating with the highest honors. He also holds a Bachelor's Degree in Graphic Design from North Carolina State University. His graduate work, exploring the relationship of media and culture, was presented at MIT and Fabrica of Benetton in Italy. He has been an educator at Art Center College of Design since 1999 and was awarded Great Teacher in 2003 and 2014. Brad is also the Director of Transmedia in the Graphic Design Department. His LA-based design studio has won several awards and been widely published. Twice his work was awarded the Frances Smyth-Ravenel Grand Prize for Excellence in Design by the American Alliance of Museums.
Advice: Meaning is not found in the objects we create or the artifacts we design, but in the relationships we share.

Dong-Joo Park, Seung-Min Han I Hansung University of Design & Art Institute I Dean: Helen Haeryon Han I **Pages: 107, 108**
See page 14 for their biographies and advice.

Kevin O'Callaghan I School of Visual Arts I Dean: Kevin O'Callaghan I **Page: 109**

Devan Carter I Portfolio Center I Dean: Hank Richardson I **Page: 110**
Biography: Born and raised in Atlanta, Devan Carter is the retail designer for the Atlanta Hawks. Devan graduated from Florida A&M University with a degree in architecture. After realizing there was more to design yet undiscovered, he returned home to attend the Portfolio Center. Today, he develops creative campaigns and strategic marketing in retail for the Hawks. When he's not at work, you can find him watching his favorite sports teams or reading a good publication in one hand with an Old Fashioned in the other.
Advice: Stop thinking about the type of design you want to do when you graduate and think more about the environment you want to work in. The projects will always come, but how much headspace a company is willing to give you to grow isn't always certain.

Nick Wilson, Amelia Ball, Noemi Noullet I **Pennsylvania State University** I **Dean: Kelleann Foster** I **Page: 100**

Nick Wilson: Nick Wilson is a senior at Penn State University majoring in graphic design. He will be graduating in May of 2019. His passion for design originated from his love of fashion, shoes, and streetwear that he acquired at a young age. His other interests include photography and music. Having an interest in fashion, he plans to pursue a career that involves branding and product storytelling within the clothing field. Some creatives that he looks up to as role models are Ronnie Fieg of Kith, Virgil Abloh of Off-White and Louis Vuitton, as well as Teddy Santisof Aimé Leon Dore.

Amelia Ball: Amelia Ball is a senior at Penn State University majoring in graphic design. She will be graduating in May of 2019. Her love of graphic design began at a young age when she spent her afternoons in her aunt's graphic design studio every day after grade school. Amelia is most interested in brand identity, creating logos, and print collateral. She carries out her passion for graphic design through her volunteer work with the Penn State Dance Marathon and other organizations in her community. Amelia plans to begin her career upon graduation at Odessa Design, Inc.

Noemi Noullet: Noemie Noullet is a senior at Penn State University majoring in graphic design. She will be graduating in May 2019. Along with her passion for design, she is passionate about running, and pursues her athletic career on the Penn State cross country and track & field team. She draws inspiration from the work produced by artists and firms like Seth Clark, Anagrama, and Collins and tries to emulate their attention to emotion and detail in her work. She would like to pursue a career that focuses on experiential and environmental design.

Graphic Design Class of 2019 I **Pennsylvania State University** I **Dean: Kelleann Foster** I **Page: 101**

Pauline Capote I **Academy of Art University** I **Dean: Mary Scott** I **Page: 102**

Biography: Pauline Capote is a New York born designer with a passion for changing the way we see things. After she completed her Associates degree at San Diego City College, she decided to immerse herself in the Graphic Design program at AAU. Pauline fascinates over graphic design because she believes it is an intensely powerful way to get an important message across–and there are countless ways to express it. She hopes that with her design skills and experience drawn from AAU, she will be able to make a positive impact towards the precious environment we live in.

Todd McAllister I **Brigham Young University** I **Dean: Sarah Westerberg** I **Page: 103**

Biography: Todd McAllister is a graphic designer from Lehi, Utah. He will graduate from Brigham Young University in 2019 with a BFA in graphic design. Although he enjoys almost any type of design, he is particularly passionate about branding, packaging, and motion design. When he is not busy with a design project, you can usually find him spending time with family and friends, making music, or doing almost anything outside. His advice is to remember that you are improving with each attempt, whether it's successful or unsuccessful.

Yunchung Chung I **School of Visual Arts** I **Dean: Richard Wilde** I **Page: 104**

Biography: Yunchung Chung is a designer focusing on visual and interaction design based in New York City. She is currently a student who is majoring in BFA Design at School of Visual Arts. Born and raised in Seoul, South Korea, she moved to NYC for her dream of becoming a designer. Her goal is providing a better life for people through her design. The two big things that she considers when she designs are simplicity and purpose.

Anyu Wu I **School of Visual Arts** I **Dean: Richard Wilde** I **Page: 105**

Charles Lin I **Art Center College of Design** I **Dean: Sean Adams** I **Page: 106**

Biography: Charles Lin is a BFA candidate at ArtCenter College of Design, where he is currently investigating the intersections of design and performance. He is intrigued by the application of theater training methodologies to graphic design practices and pedagogy. Annie, Brad, Chris, Clive, Danielle, Gloria, Miles, Nik, Ramone, River, Sean, Simon, Stephen, Steve, Tyrone — a deep, sincere thank you for this educational experience and all the mentorship.

Yeji Kim I **Hansung University of Design & Art Institute** I **Dean: Helen Haeryon Han** I **Page: 107**

Biography: Yeji Kim is a student of the Department of Visual Design at Hansung University in Seongbuk-gu, Seoul. When she was young, she dreamed of becoming a designer because she was exposed to art and was always meticulous when it came to design. Therefore, her design philosophy is to think constantly and keep wondering about the work. Yeji Kim strives to make all of her work have meaning.

Jumi Park I **Hansung University of Design & Art Institute** I **Dean: Helen Haeryon Han** I **Page: 108**

Biography: Born and raised in Seoul, South Korea, Jumi Park is 21 years old and majors in Visual Design at Hansung University. She is interested in various fields and likes to share ideas and talk to people to learn about their stories. In addition, she is always passionate about getting to know other people's cultures. Jumi is always keeping an open mind and feels that there is no end to learning. Her motto is, "The real person is the law everyone knows." Jumi Park looks forward to her future and expects many people to recognize her work.

Fernando Alvarenga I **School of Visual Arts** I **Dean: Richard Wilde** I **Page: 109**

Biography: After graduating the School of Visual Arts, Fernando began working as a fabricator at Spaeth Design in Woodside, Queens creating window displays for the Christmas season for Tiffany's & Co., Bergdorf Goodman, and Bloomingdales. He loves creating with his hands. If you check out his portfolio, you'll see the handmade quality in each piece of work he makes. People can see the difference in handmade work, which makes a designer stand out.

Danner Washburn I **Portfolio Center** I **Dean: Hank Richardson** I **Page: 110**

Biography: Danner Washburn was born and raised in Pfafftown, North Carolina. He attended Furman University in Greenville, South Carolina, where he graduated in 2016 with a degree in studio art. He went on to attend the Portfolio Center in Atlanta, Georgia, graduating from their design program in the fall of 2018. Danner currently resides in Atlanta, GA.

Visit our Credits & Commentary section in the back of the book to read the full assignments, approaches, and results from this year's Platinum Winners.

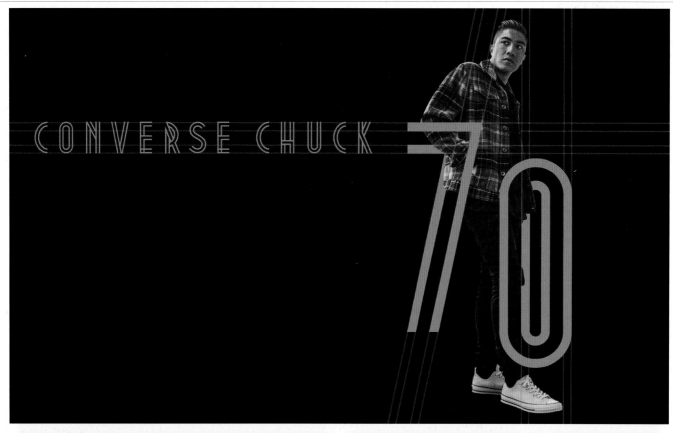

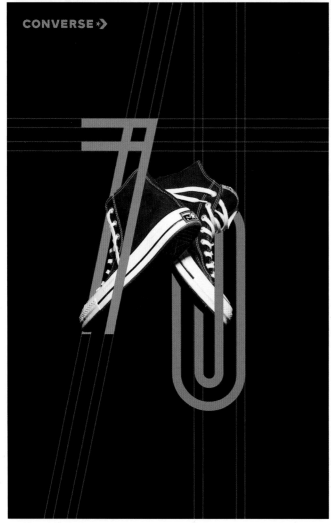

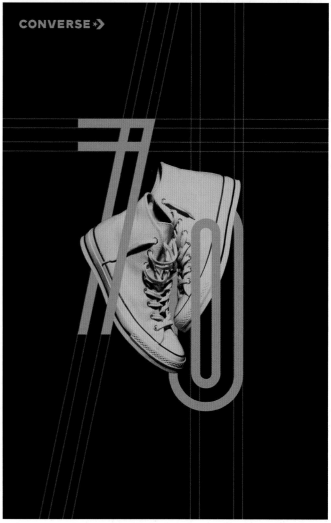

Students: Nick Wilson, Amelia Ball, Noemi Noullet | **Pennsylvania State University**

Assignment: This project covers a full branding campaign for the release of the Converse Chuck70 High Top Sneaker.
Approach: Through research, we came up with the mission to focus on the specific demographic.
Results: We completed this project with the development of social media content, billboard and poster designs, a logo, copy, and merchandise.

Graphic Design Class of 2019 | Kristin Sommese

Assignment: The assignment was to create a design experience for an audience.
Approach: All nineteen students in our class broke up into teams and worked collaboratively.
Results: This resulted in a successful show with a great turnout.

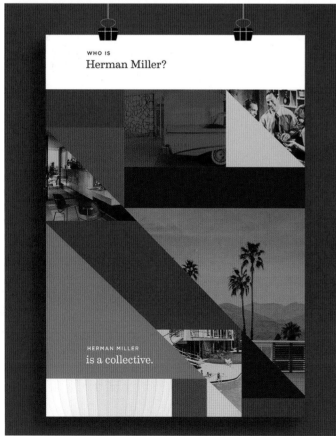

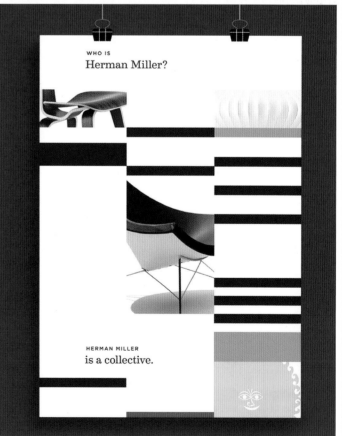

Student: Pauline Capote | Academy of Art University

Visit website to view full series

Assignment: Choose an existing company to create a brochure for. Along with the brochure, additional forms of media must accompany it.
Approach: The brand selected was Herman Miller because of their standout style and timeless presence.
Results: Once the brochure was completed, it expanded into a series of additional deliverables.

dwell

Student: Todd McAllister | Brigham Young University

Visit website to view full series

Assignment: The assignment was to re-design an existing magazine.
Approach: My approach to designing the covers of Dwell Magazine was to elevate the visual identity of the magazine.
Results: The result of this process was a successful solution to the original goals of the assignment.

A History of Humanity told through *Genetic*. by Misha Angrist. A Brief History of Everyone Who ever *Lived*. The Human Story Retold Through Our Genes. by Adam Rutherford. 416 pp. The Experiment. $25.95.

Illustrated by Randy Mora

A recent and, even by its own lofty standards, especially hilarious and cringingly tasteless episode of "South Park" features the passionate and petulant schlimazel, middle-aged dad Randy Marsh, watching TV, when a comercial for a fictional consumer genetics company comes on the screen. "Wouldn't you like to know the story of you?"

(continued on page 3)

Student: Anyu Wu | School of Visual Arts

Student: Charles Lin | Art Center College of Design

Assignment: Poster campaign for re-branding of the performing arts organization, Performa based in NY. Founded by RoseLee Goldberg in 2004, Performa is the leading organization dedicated to exploring the critical role of live performance in the history of twentieth-century art and to encouraging new directions in performance for the twenty-first century.

Student: Yeji Kim | Hansung University of Design & Art Institute

Assignment: It is a Poster reflecting the spirit of salpuri dance, a Korean dance.

Approach: There is sorrowful resentment in Korean emotion. There is a salpuri dance that expresses this. The shape of the black cloth in the poster represents one of the salpuri dances as a Chinese character.

Student: Jumi Park | Hansung University of Design & Art Institute

Assignment: This poster is about the exhibition of East Asia Feminism.
Approach: Equality is my highlight, as women should have fair treatment in the workplace.
Results: If our efforts work, then our society will changed.

Student: Fernando Alvarenga | School of Visual Arts

Visit website to view full series

Assignment: Create a chair from what inspires you in your work.

Approach: As a kid, my Saturday mornings were filled with cartoons like the Jetsons and Duck Rodgers. They captured my imagination and so did the rocket ships that were featured.

Student: Danner Washburn | Portfolio Center

Assignment: Representative of person-to-person communication, this table's visually-shifting form and vibrant colors serves to reclaim and reorient meal times toward conversation and, ultimately, a more wholesome experience of community.

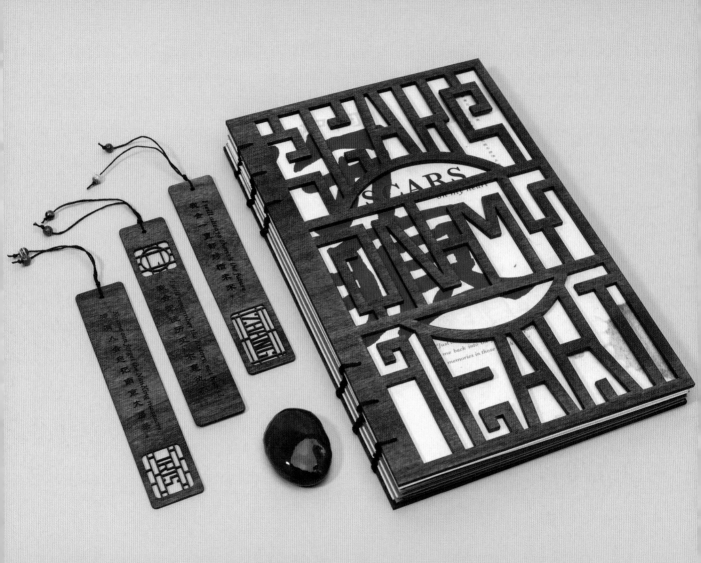

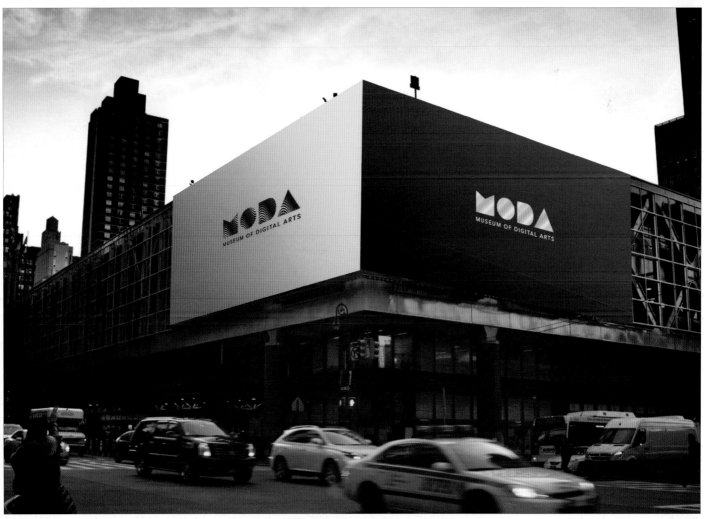

Visit website to view full series · **Student: Woohyun Kim** | School of Visual Arts · **Branding | Design**

A-24 BANSHEE

ARMY AIR FORCE
US NAVY
MARINE CORPS

42-54654

MODEL SBD-5B-6

SPECIFICATIONS

MANUFACTURER	DOUGLAS
ENGINE	RADIAL ENGINE
CREW	2
WING SPAN	42' 0"
LENGTH	33'
HEIGHT	8'
CREW	2
DATE FIRST BUILT	1940
MISSION	RECONNAISSANCE
SERIAL NO	42-54682

PERFORMANCE

HORSEPOWER	1,000 HP
TOP SPEED	255 MPH
RANGE	1,205 MI
SERVICE CEILING	25,530 FT (7,780 M)

DESIGN:
ED HEINEMANN
FOR NORTHROP BT

Lorem ipsum dolor sit amet, consectetuer adipiscing elit, sed diam nonummy nibh euismod tincidunt ut laoreet dolore magna aliquam erat volutpat. Ut wisi enim ad minim veniam, quis nostrud exerci tation ullamcorper suscipit lobortis nisl ut aliquip ex ea commodo consequat. Duis autem vel eum iriure dolor in hendrerit in vulputate velit esse molestie consequat, vel illum dolore eu feugiat nulla facilisis at vero eros et accumsan et iusto odio dignissim qui blandit praesent luptatum zzril delenit augue duis dolore te feugait nulla facilisi.

Lorem ipsum dolor sit amet, cons ectetuer adipiscing elit, sed diam nonummy nibh euismod tincidunt ut laoreet dolore magna aliquam erat volutpat. Ut wisi enim ad minim veniam, quis nostrud exerci tation ullamcorper suscipit lobortis nisl ut aliquip ex ea commodo consequat.

Lorem ipsum dolor sit amet, consectetuer adipiscing elit, sed diam nonummy nibh euismod tincidunt ut laoreet dolore magna aliquam erat volutpat. Ut wisi enim ad minim veniam, quis nostrud exerci tation ullamcorper suscipit lobortis nisl ut aliquip ex ea commodo consequat. Duis autem vel eum iriure dolor in hendrerit in vulputate velit esse molestie consequat, vel illum dolore eu feugiat nulla facilisis at vero eros et accumsan et iusto odio dignissim qui blandit praesent luptatum zzril delenit augue duis.

PIMA
AIR MUSEUM

PIMAAIR.ORG 32.1415037-110.873588197

PRESERVE PRESENT

ONLINE GUIDE

80 ACRES OF LAND
DEDICATED TO THE
HISTORY OF FLIGHT

LOCATED IN TUSCON
ARIZONA

OUR MISSION AND YOUR EXPERIENCE

Pima Air Museum is one of the world's largest aviation and space museums that is independently funded. We display over 350 historical aircrafts, from an old Wright Flyer to the 787 Dreamliner. Sitting on over 80 acres, the museum opened its doors to the public in May of 1976. Over the past forty years, the Pima Air Museum has immensely grown and today is comprised of six unique indoor exhibit hangars. Docent-led walking tours and museum ground Tram Tours are offered daily. The museum offers bus tours of the 2,600-acre old Aircraft Boneyard on a daily basis.

THE BONEYARD TOUR
Bus tours of maintenance yard are docent narrated. This tour lasts 75 minutes.

TRAM TOURS
Tram tours cover all outside aircraft exhibits. This tour lasts about one hour.

WALKING TOURS
Walking tour covers indoor hanars. This tour last about one hour.

GENERAL ADMISSION
All exhibits are open to guests from 9:00 to 17:00. Hangars close at 16:30.

6000 E. Valencia rd
Tuscon, Arizona 85706
Mon-Sun 9:00 TO 17:00

SHAPE GUIDE.

SQUARE
Military aircraft

TRIANGLE
Civilian aircraft

CIRCLE
Helicopters

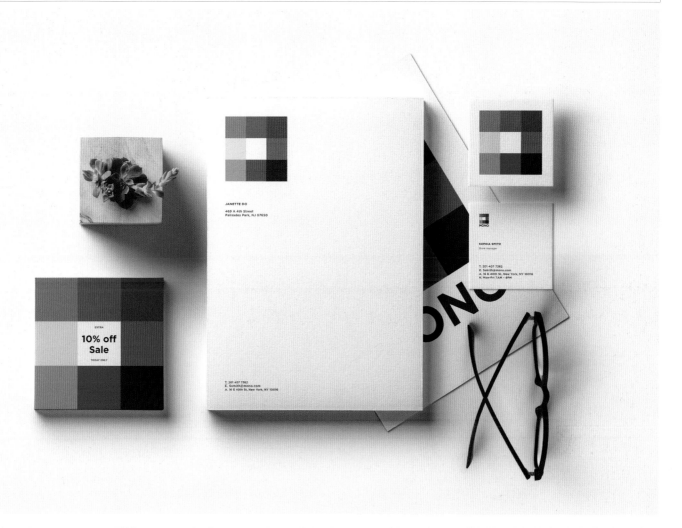

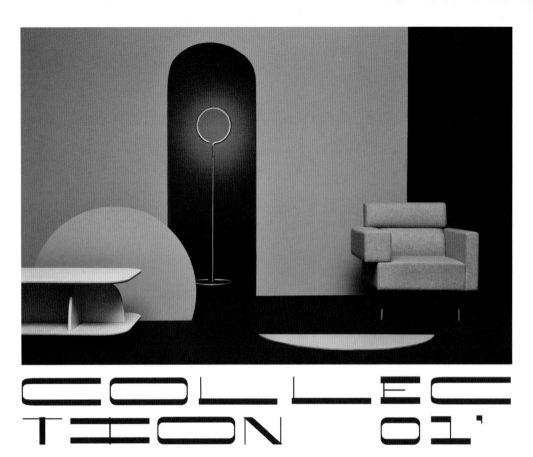

COLLEC
TION 01'

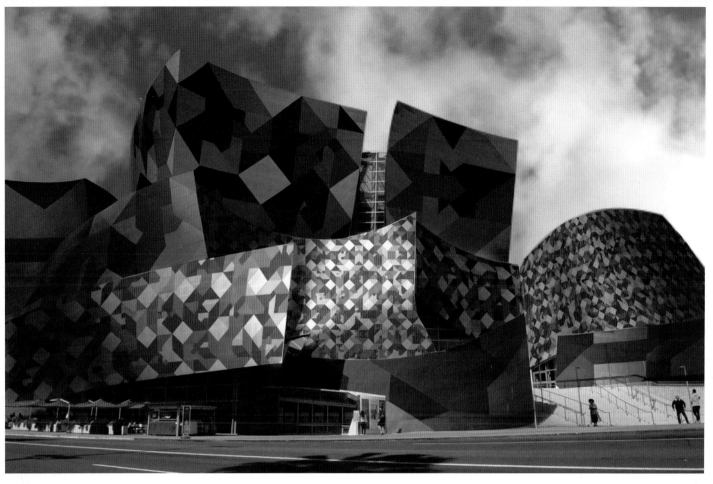

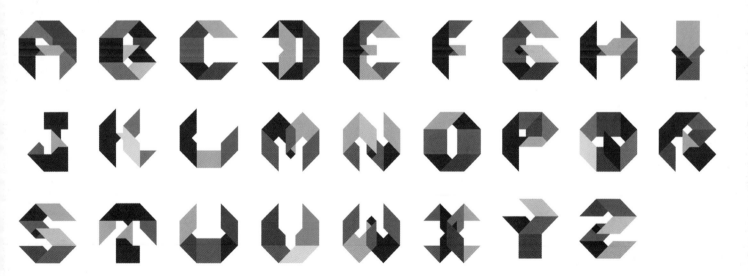

Student: Fazel Sayeh | Art Center College of Design

Branding | Design

FRI 6

GUIDED MEDITATION	MOSES SUMNEY	FUTURE ISLANDS
SUNO DEKO	SOLANGE	NICOLAS JAAR
JULIE BYRNE	SURVIVE	JAMES BLAKE
NONAME	XXYYXX	KING KRULE
KAITLYN SURELIA SMITH	FATHER JOHN MISTY	KENDRICK LAMAR

SAT 7

MORNING MEDITATION	SAINT HERONIE HOUSE	HUERCO S
SCENIC YOGA	SOUND AND SPACIAL	MITSKI
INDY NYLES	THE HOTELIER	CHLSEA WOLFE
ARCOSANTI GENESIS	HOW TO DRESS WELL	DEAFHEAVEN
RYAN KLEEMAN	VIEWUX FARKA TOURE	KING

SUN 8

SWITCH CRAFT	TIMBER TIMBER	OMAR SOULEYMAN
MORNING MEDITATION	MOUNT EERIE	TYCHO
SCENIC YOGA	HEALTH	BING AND RUTH
BIRDS OF RHYTHM	WEYES BLOOD	THUNDERCAT
HOLLY HERNDON	KELSEY LU	HUNDRED WATERS

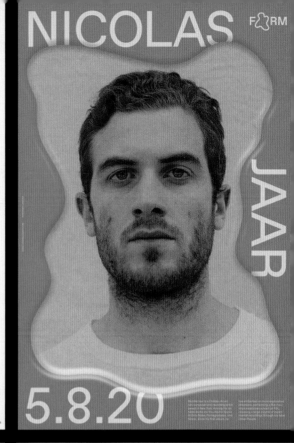

NICOLAS JAAR

FORM

5.8.20

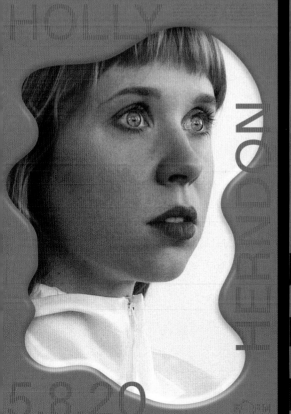

HOLLY HERNDON

5.8.20

FORM

Q&A

WITH HUMAN RIGHTS CAMPAIGN

ARCO SANTI AZ

MAY 7TH 2020

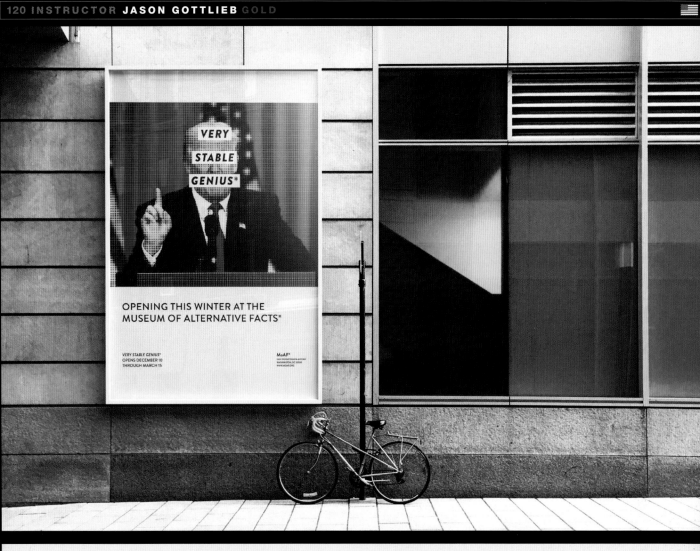

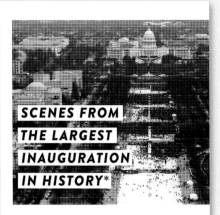

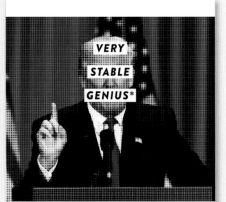

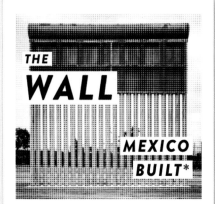

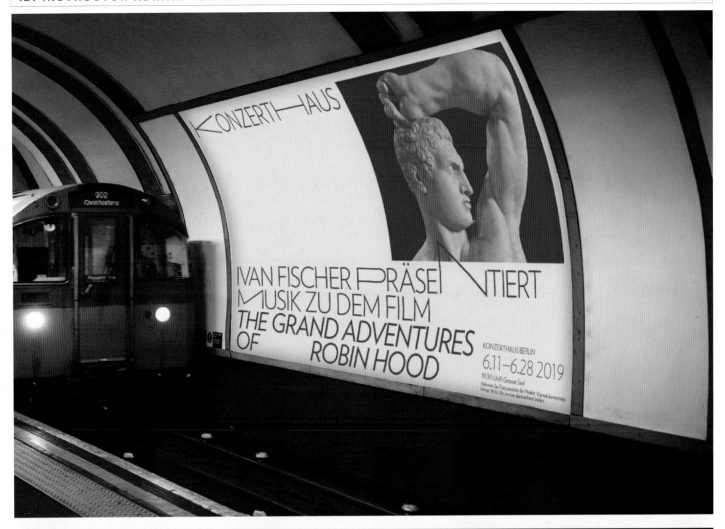

Student: Dallin Diehl | Brigham Young University

Branding | Design

INSTRUCTOR **ABBY GUIDO**

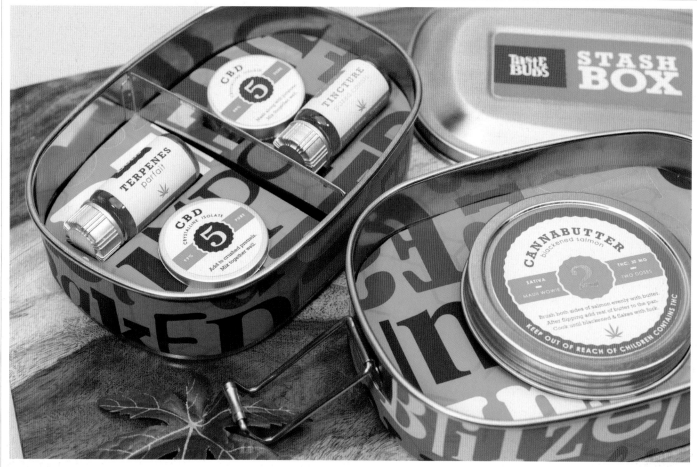

Student: Sarah Demers | Temple University

Visit website to view full series

INSTRUCTOR **NATHAN SAVAGE**

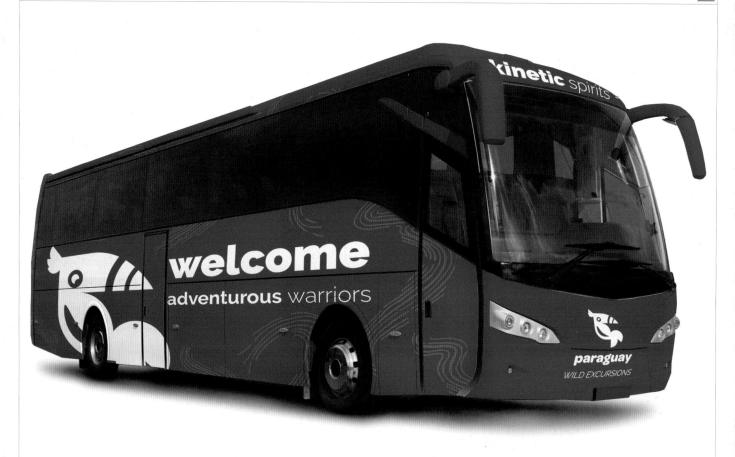

Student: Diego Mancilla | Portland Community College

Visit website to view full series

FISHER HOUSE
foundation

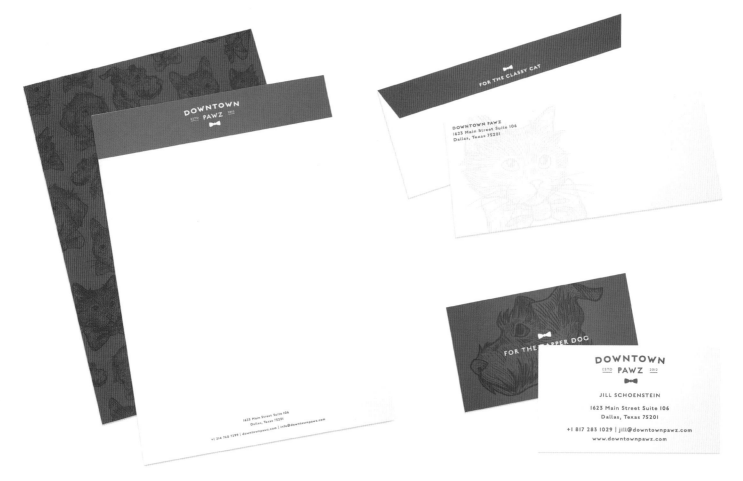

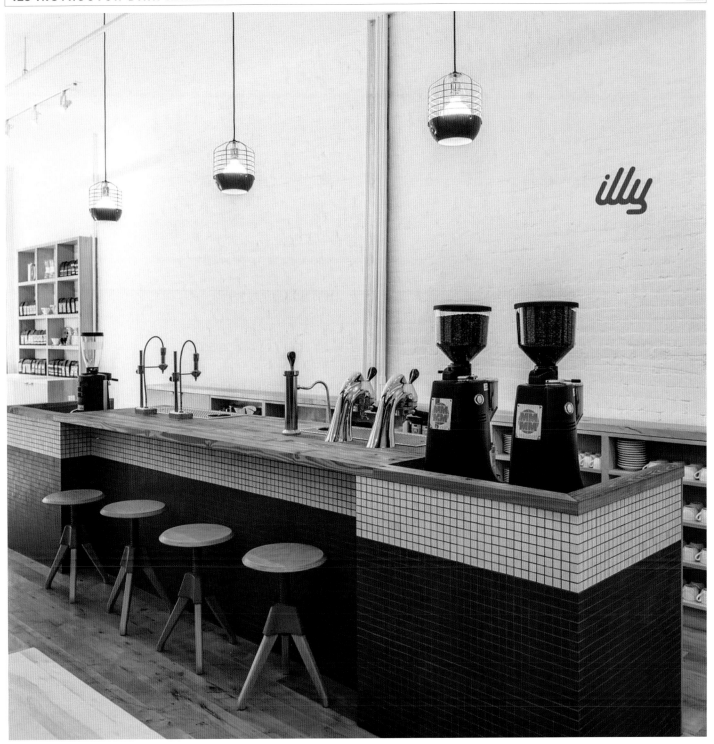

Student: Min Kyung Kim | School of Visual Arts

Branding | Design

Student: Jae Wook Baik | School of Visual Arts

FALL / WINTER ISSUE 7

KING KONG

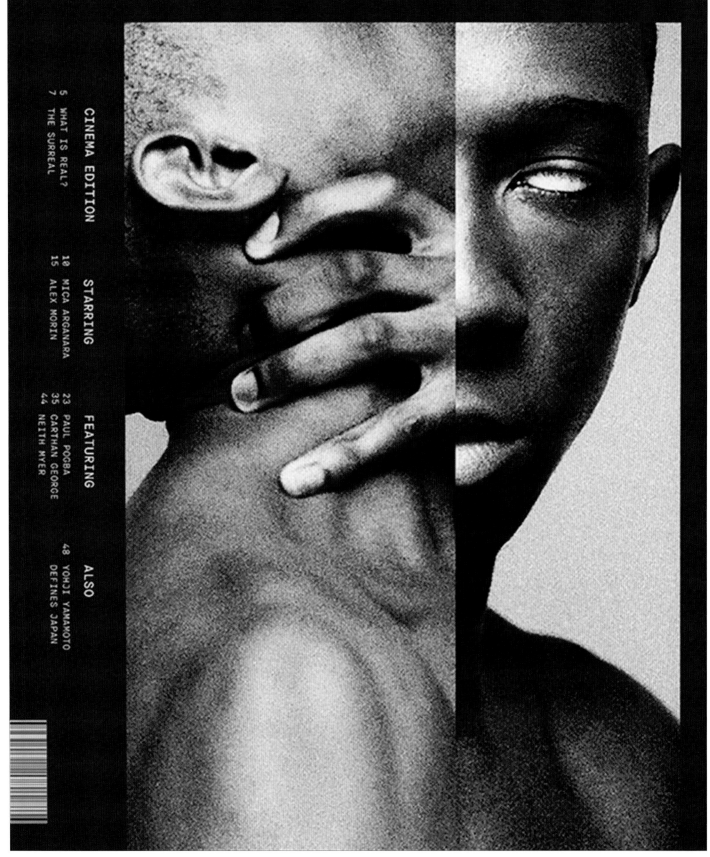

CINEMA EDITION

5 WHAT IS REAL?
7 THE SURREAL

STARRING

10 MICA ARGANARA
15 ALEX MORIN

FEATURING

23 PAUL POOBA
35 CARTHAN GEORGE
44 NEITH MYER

ALSO

48 YOHJI YAMAMOTO
DEFINES JAPAN

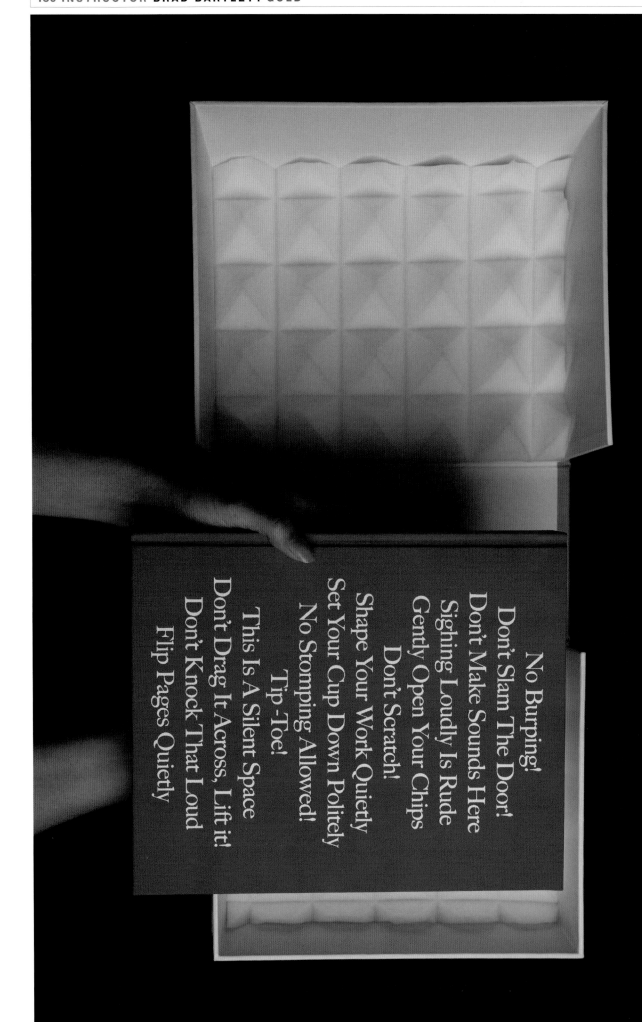

Student: Priscilla Chong | Art Center College of Design Visit website to view full series

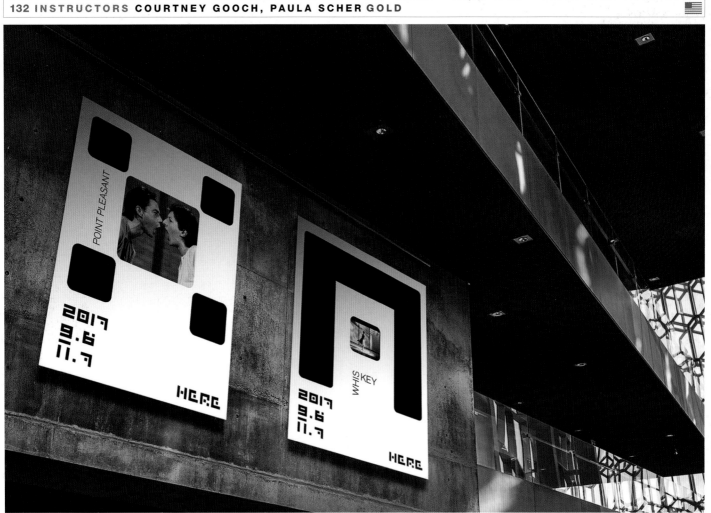

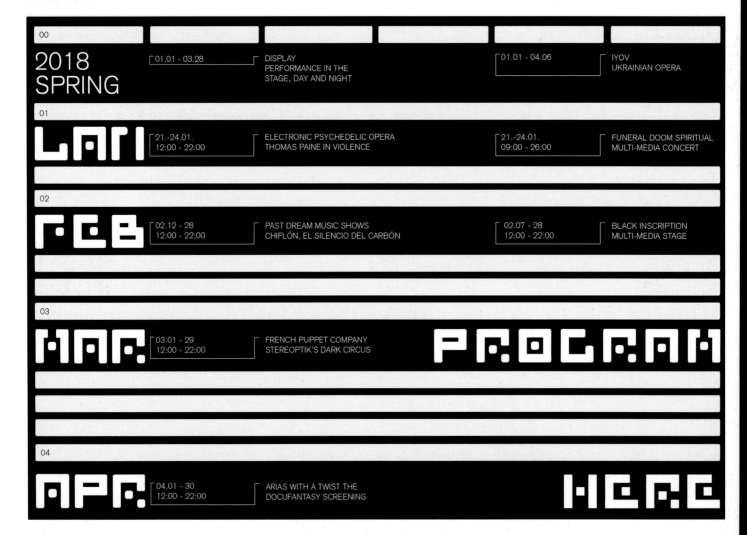

Student: Siyi Hemu | School of Visual Arts

Student: Siyi Hemu | School of Visual Arts

Student: Yang Du | School of Visual Arts

Illustration | Design

SHOPPING EFFICIENCY

A calculation of the most time and energy efficient way to navigate the downtown Corvallis Safeway to gather all the food items currently stocked in my pantry.

These are all the possible routes to take from one point in the store to the next. Each number represents a location in the store with specific foods. There are 21 possible route choices from each spot with 3.41 x 10^29 routes generated to collect all the food items. The thickest line is the shortest and most efficient path to take between spots.

These are the shortest path lengths with the total calories burned to push the food items from one point to the next, taking static and kinetic friction into account.

All total paths and their lengths

POSSIBLE PATH SHORTEST PATH

+ 0 – 10 m ● 10 – 20 m ▲ 20 – 30m PATH

WEIGHT OF FOOD (Kg)

ENERGY USED (KCAL)

DISTANCE (m)

SAFEWAY MAP

The aerial map of the downtown Corvallis Safeway shows the shortest route taken from start to end with a thin white line, while circled numbers indicate the stop number and aisle position of specific food items found in my pantry.

Student: Dan Anecito | Oregon State University

Visit website to view full series

Student: Ray Yeunsu Shin | *California Institute of the Arts*

Interactive Design | **Design**

INSTRUCTOR MIKAELA BUCK

Student: Logan Brannen | Texas State University

INSTRUCTOR VIC RODRIGUEZ

Student: Kaitlyn Tostado | Texas State University

INSTRUCTOR M.C. COPPAGE

Student: Sarah Wood | Portfolio Center

INSTRUCTOR EILEEN HEDY SCHULTZ

Student: Hai Nguyen | School of Visual Arts

INSTRUCTOR JOSH EGE

Student: Jiyun Park | Texas A&M University Commerce

INSTRUCTOR BENJAMIN DOLEZAL

Student: Noel Ramos | University of Texas at Arlington

INSTRUCTOR MIKE KELLY

Student: Courtney Jacobs | Portfolio Center

INSTRUCTOR MIKE KELLY

Student: Rowan Griscom | Portfolio Center

INSTRUCTOR MIKAELA BUCK

Student: Logan Brannen | Texas State University

INSTRUCTOR MIKE KELLY

Student: Aaron Blake Navarro | Portfolio Center

INSTRUCTOR GENARO SOLIS RIVERO

Student: Juliana Ratchford | Texas State University

INSTRUCTOR GENARO SOLIS RIVERO

Student: Juliana Ratchford | Texas State University

INSTRUCTOR MIKE KELLY

Student: Carsyn Ciuba | Portfolio Center

INSTRUCTOR **GENARO SOLIS RIVERO**

Student: Noah Lewis | Texas State University

INSTRUCTOR **MIKE KELLY**

Student: Jackson Watkins | Portfolio Center

INSTRUCTOR **ADRIAN PULFER**

Student: Ian Sullivan | Brigham Young University

INSTRUCTOR **MIKE KELLY**

Student: Jackson Watkins | Portfolio Center

INSTRUCTOR **ELIZABETH KELLEY**

Student: Rafael Villasana | Portfolio Center

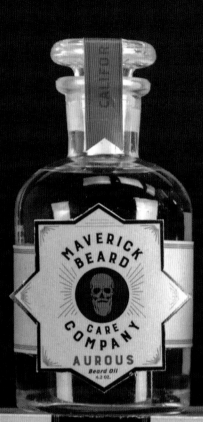

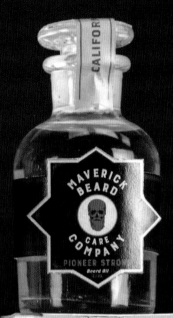

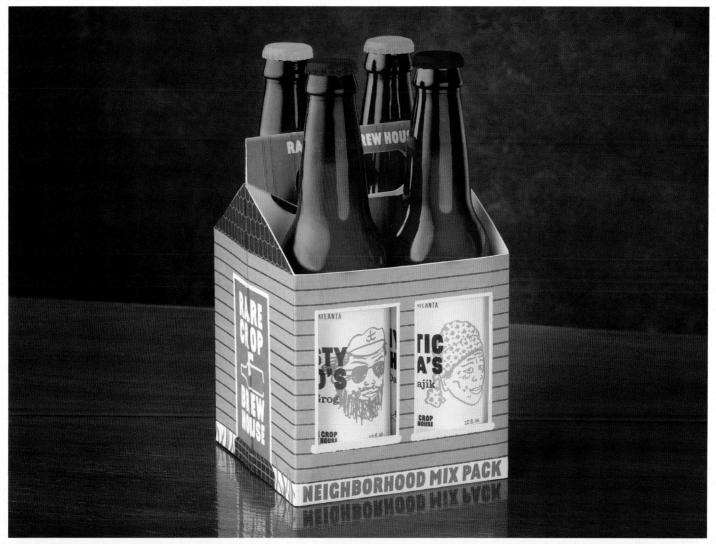

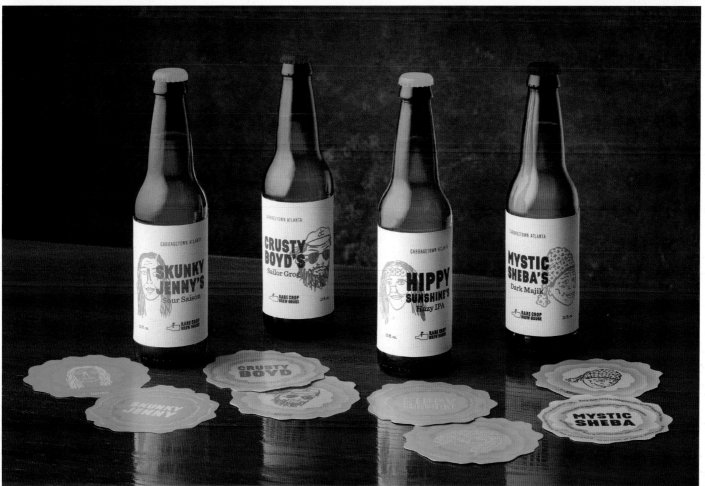

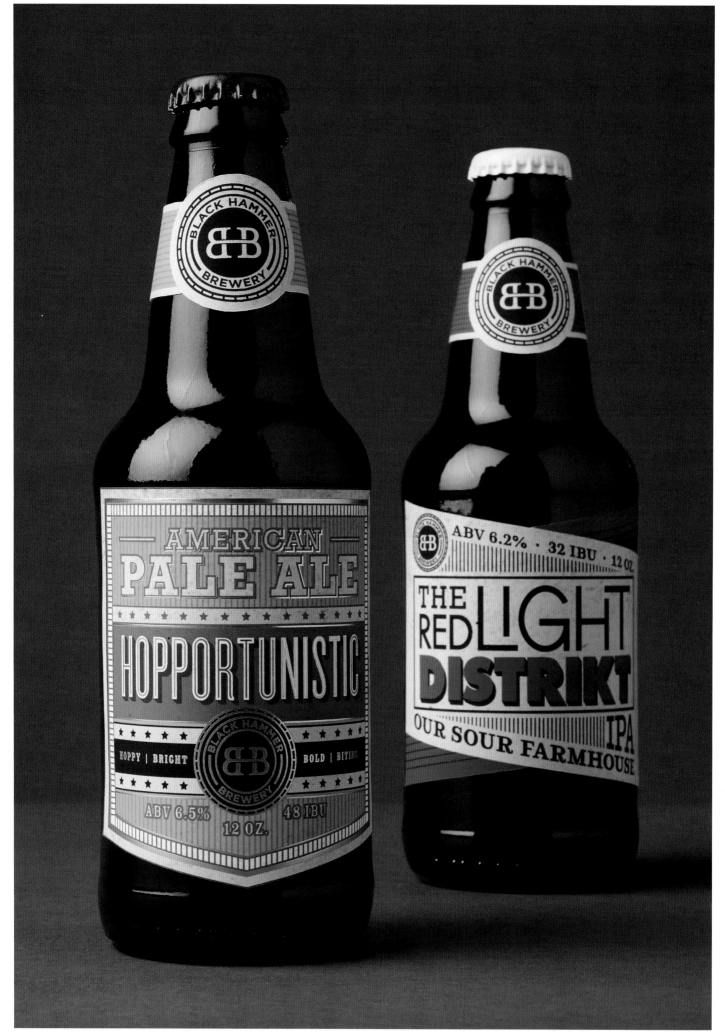

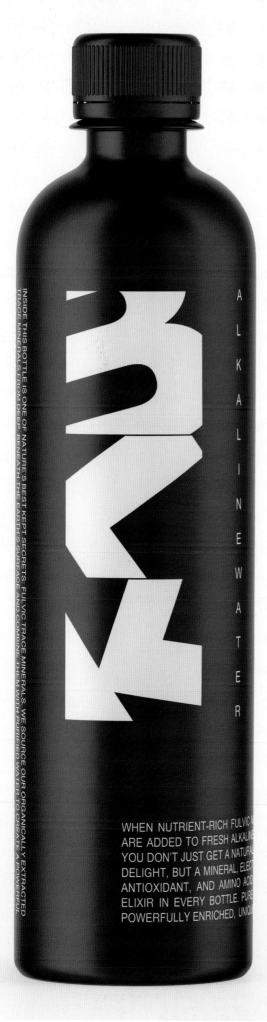

INSIDE THIS BOTTLE IS ONE OF NATURE'S BEST KEPT SECRETS. FULVIC TRACE MINERALS. WE SOURCE OUR ORGANICALLY EXTRACTED TRACE MINERALS FROM DEEP BENEATH THE EARTH'S SURFACE AND COMBINE THEM WITH PURIFIED WATER TO CREATE A POWERFUL

A L K A L I N E W A T E R

WHEN NUTRIENT-RICH FULVIC M
ARE ADDED TO FRESH ALKALIN
YOU DON'T JUST GET A NATURA
DELIGHT, BUT A MINERAL, ELECT
ANTIOXIDANT, AND AMINO ACID
ELIXIR IN EVERY BOTTLE. PURE
POWERFULLY ENRICHED. UNIQU

IC MINERALS
LINE WATER,
RALLY DARK
ECTROLYTE,
CID-PACKED
RE WATER,
IQUELY BLK.

SERVING SIZE 1 BOTTLE (500 ML)

	MG/%
CALORIES	0/0
TOTAL FAT	0/0
SODIUM	0/0
TOTAL CARBOHYDRATE	0/0
PROTIEN	0/0

INGREDIENTS: PURIFIED WATER

PRODUCT OF U.S.A

INSTRUCTOR **DONG-JOO PARK**

Student: Su In Kim | Hansung University of Design & Art Institute

Visit website to view full series

INSTRUCTOR **CHRISTINE GEORGE**

Student: Pauline Capote | Academy of Art University

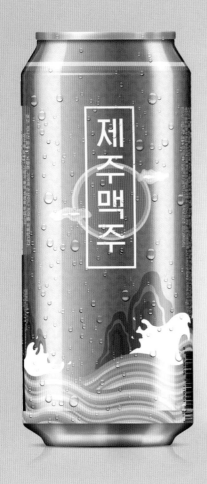
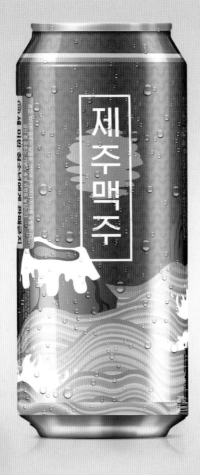
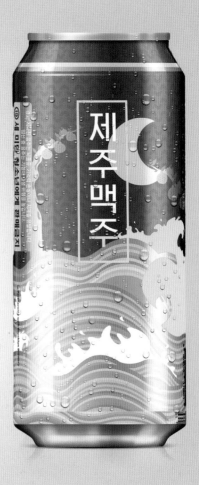

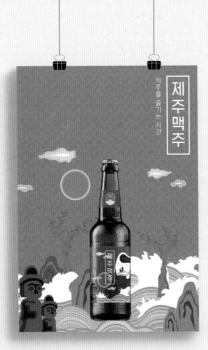
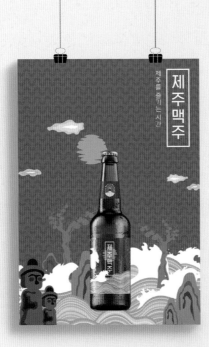
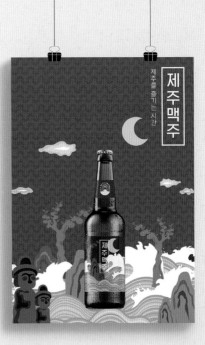

Design | Packaging — **Students: Park Yuna, Kim Subin | Hansung University of Design & Art Institute** — Visit website to view full series

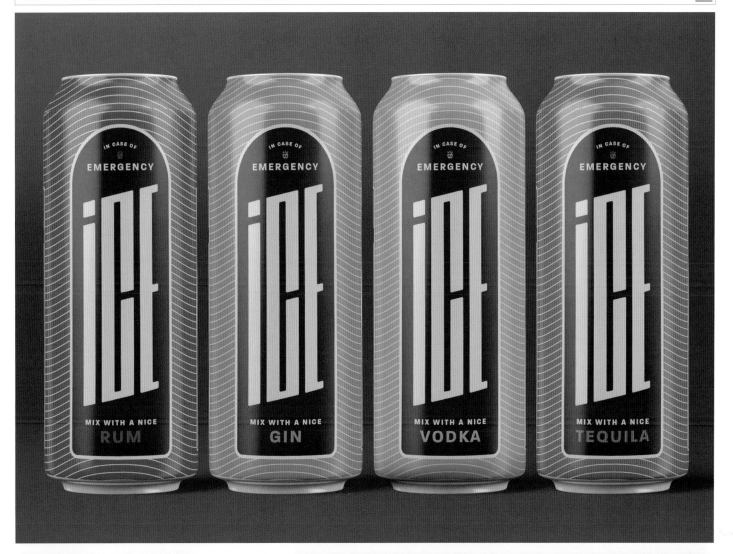

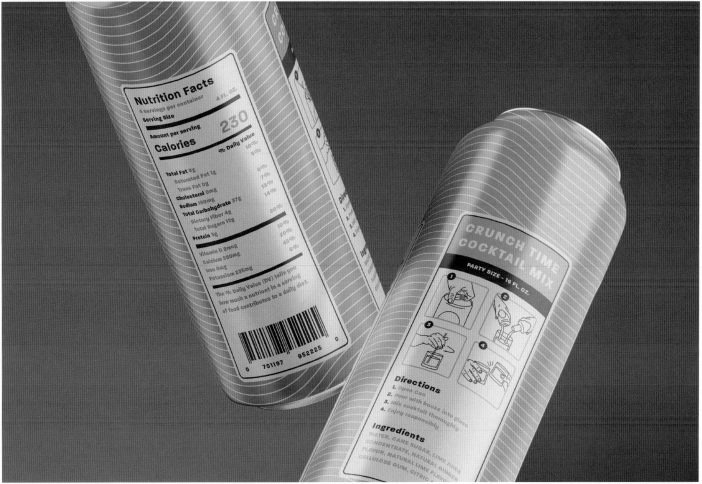

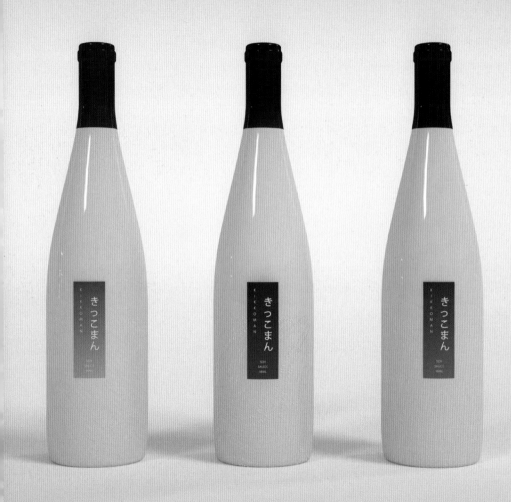

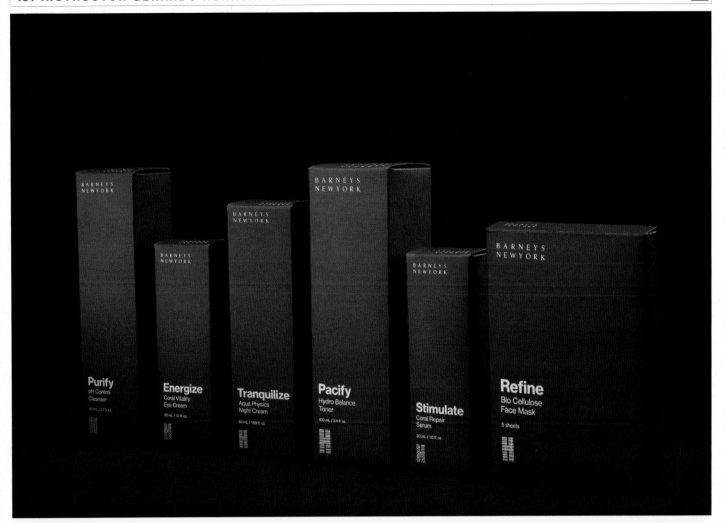

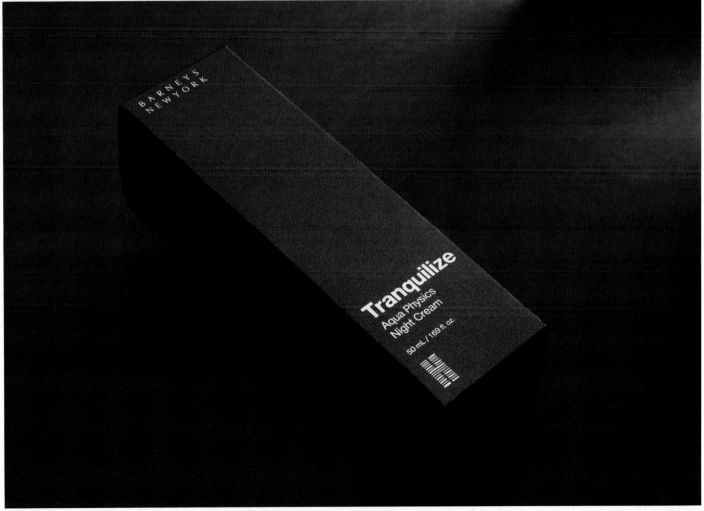

Student: Hyek Im | **Art Center College of Design**

Packaging | Design

INSTRUCTOR UNATTRIBUTED

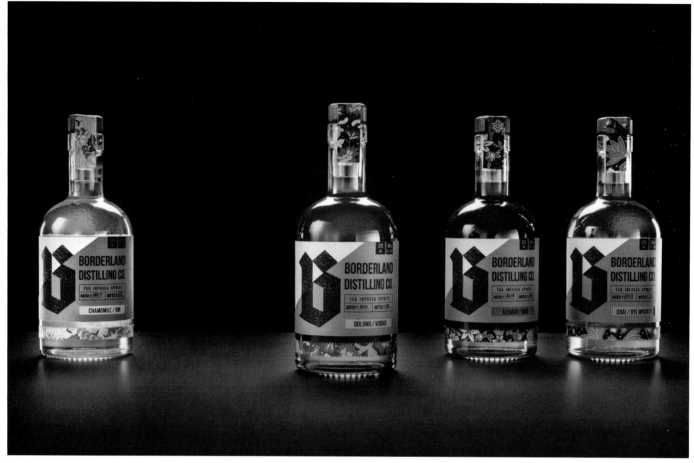

Student: Erin Reeves | The Newhouse School, Syracuse University Visit website to view full series

INSTRUCTOR ALICE CHAOSURAWONG

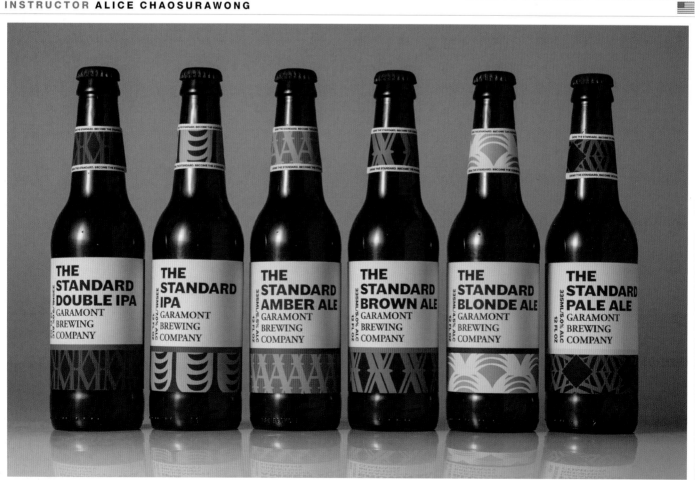

Student: Rowan Griscom | Portfolio Center Visit website to view full series

INSTRUCTOR DAN HOY

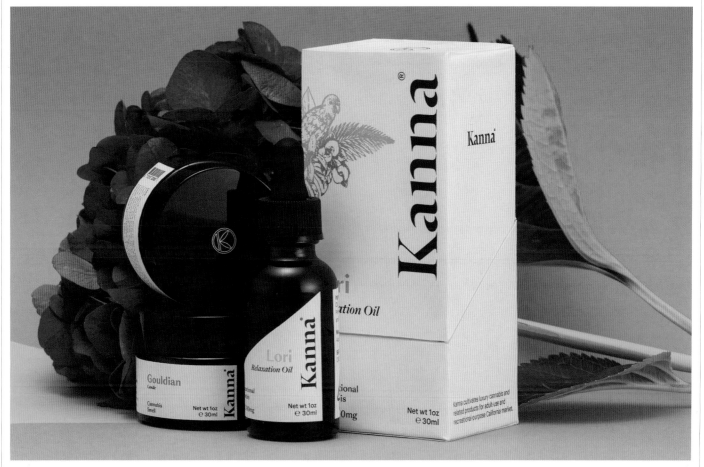

Student: Yi Mao | **Art Center College of Design**

Visit website to view full series

INSTRUCTOR GERARDO HERRERA

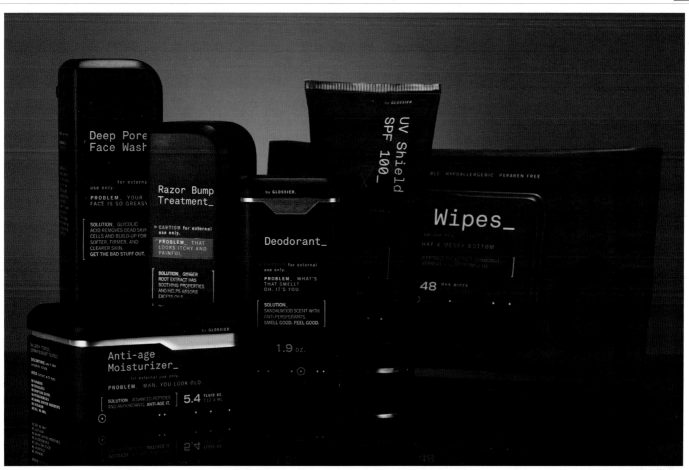

Student: Yvonne Tseng | **Art Center College of Design**

Visit website to view full series

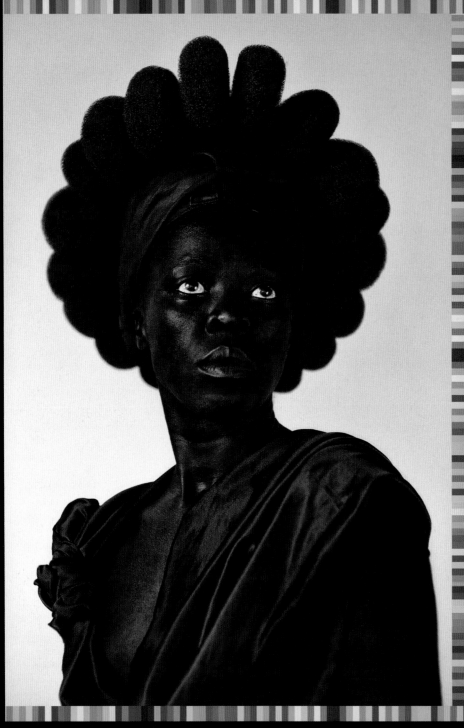

ZANELE MUHOLI

WWW.PERFORMA.COM

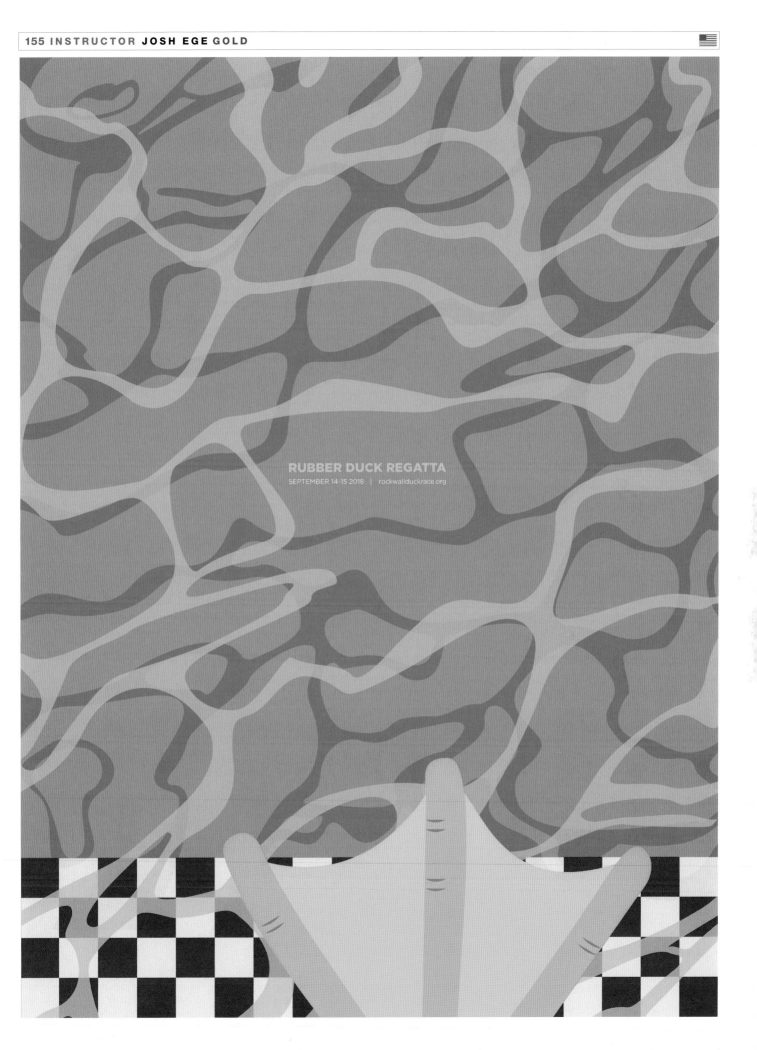

RUBBER DUCK REGATTA

SEPTEMBER 14-15 2018 | rockwallduckrace.org

THIS IS NOT A REBELLION.

Liberty Leading the People is a painting by
Eugène Delacroix commemorating the
July Revolution of 1830, which toppled King
Charles X of France.

rebelle

Rebelle w/ Eugène Delacroix
05/2019 ©

**Explaining a
new-era's belief**

'm
not
'nv's ble

How you feel is not who you are.

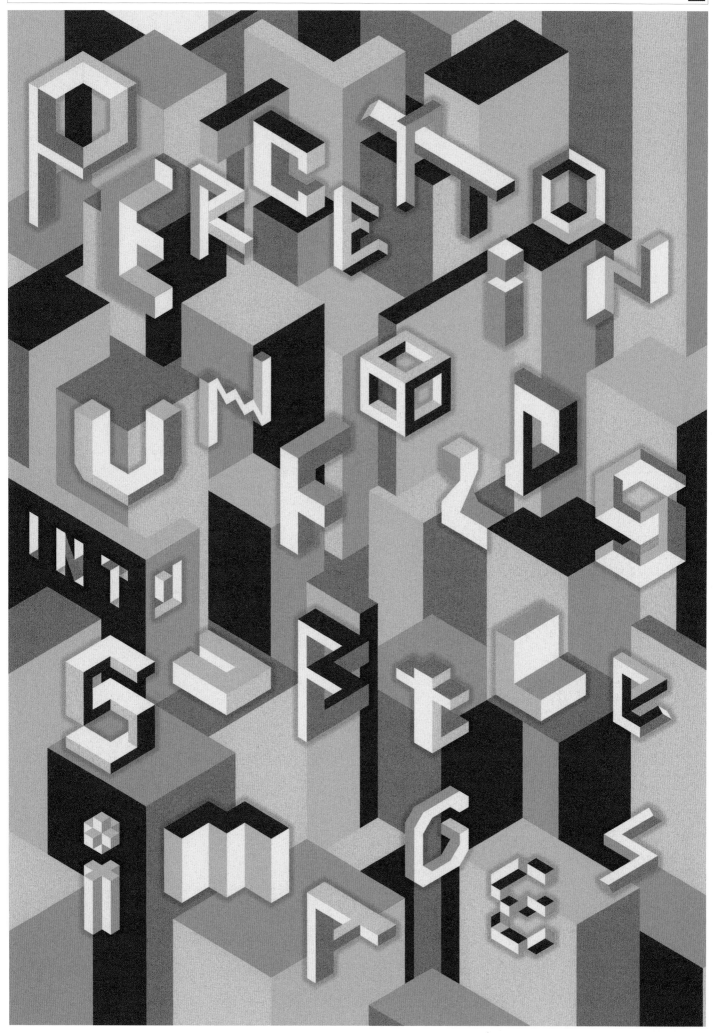

Student: Tristan Danino | Royal Melbourne Institute of Technology University

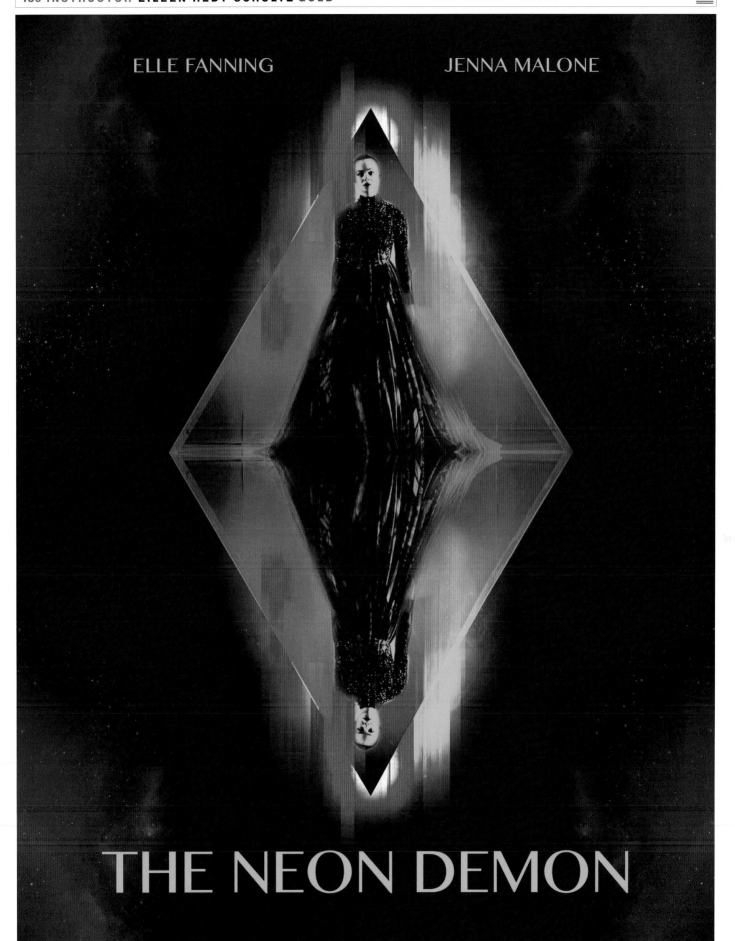

Student: Gisell Bastidas Jaramillo | School of Visual Arts **Poster | Design**

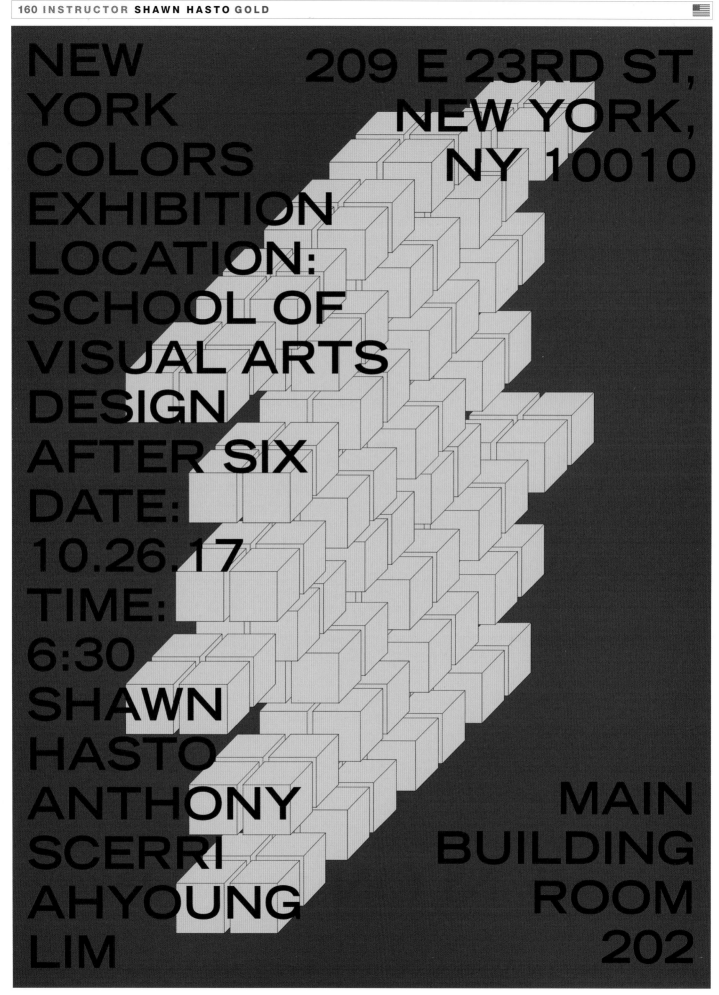

NEW YORK COLORS EXHIBITION LOCATION: SCHOOL OF VISUAL ARTS DESIGN AFTER SIX DATE: 10.26.17 TIME: 6:30 SHAWN HASTO ANTHONY SCERRI AHYOUNG LIM

209 E 23RD ST, NEW YORK, NY 10010

MAIN BUILDING ROOM 202

Student: Ahyoung Lim | School of Visual Arts

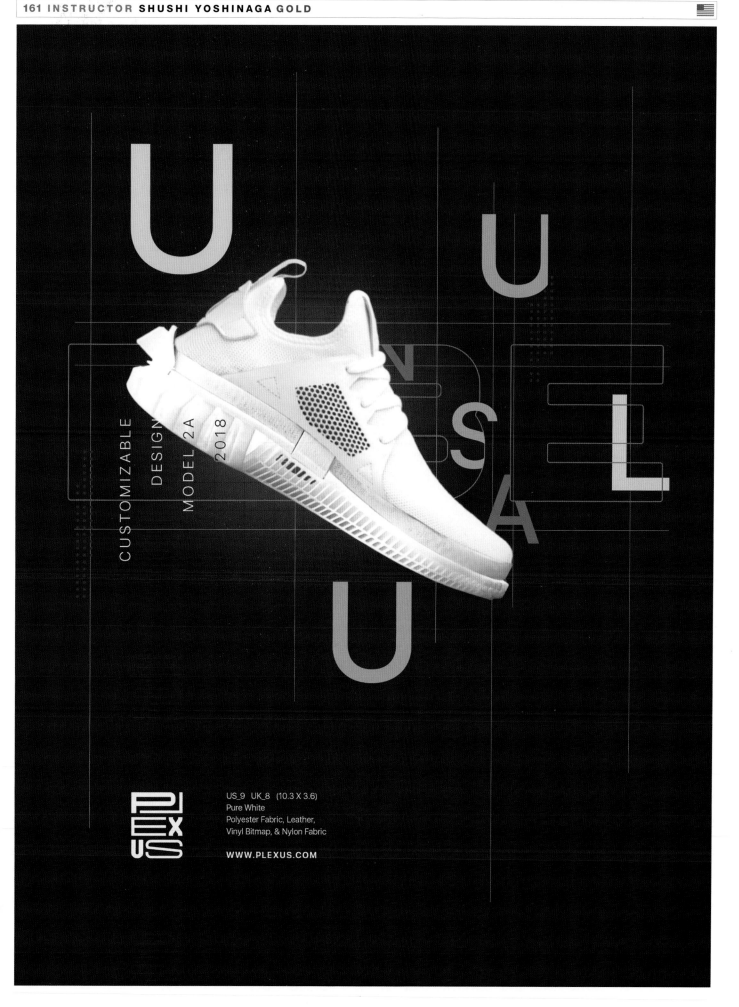

Manhattan
Directed by
Woody Allen
Music by
George Gershwin
Museum
of the
Moving Image
October 25, 2017
8:00 pm
36-01 35th Ave,
Queens, NY

Admission is free

Starring Woody Allen, Diane Keaton, Michael Murphy, Mariel Hemingway, Meryl Streep, Anne Byrne

Student: Soohyun Kim | School of Visual Arts

Poster | Design

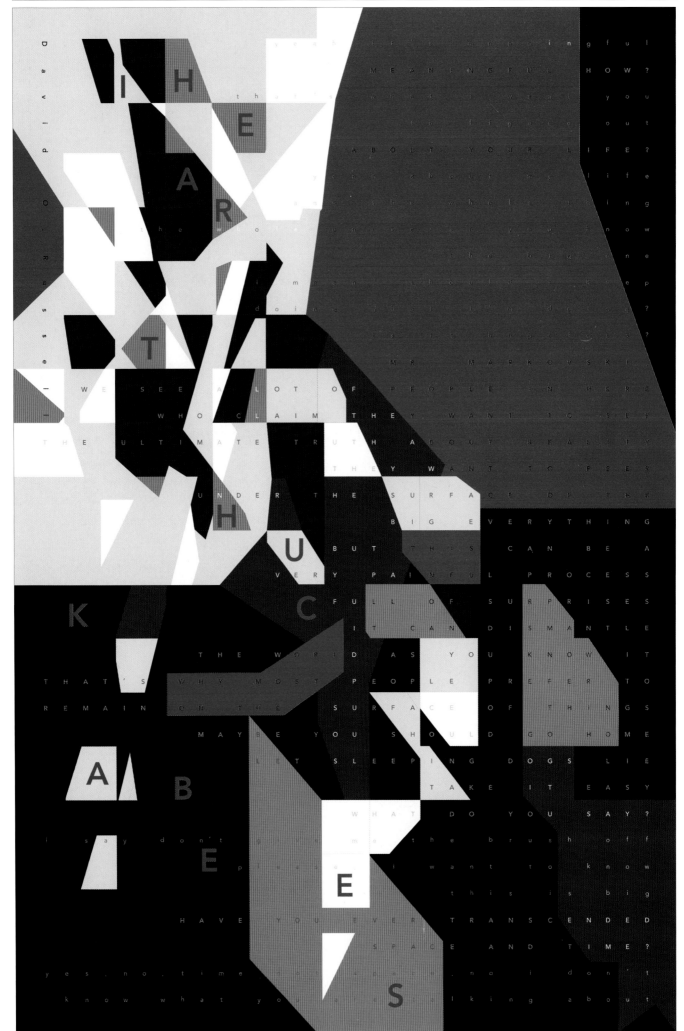

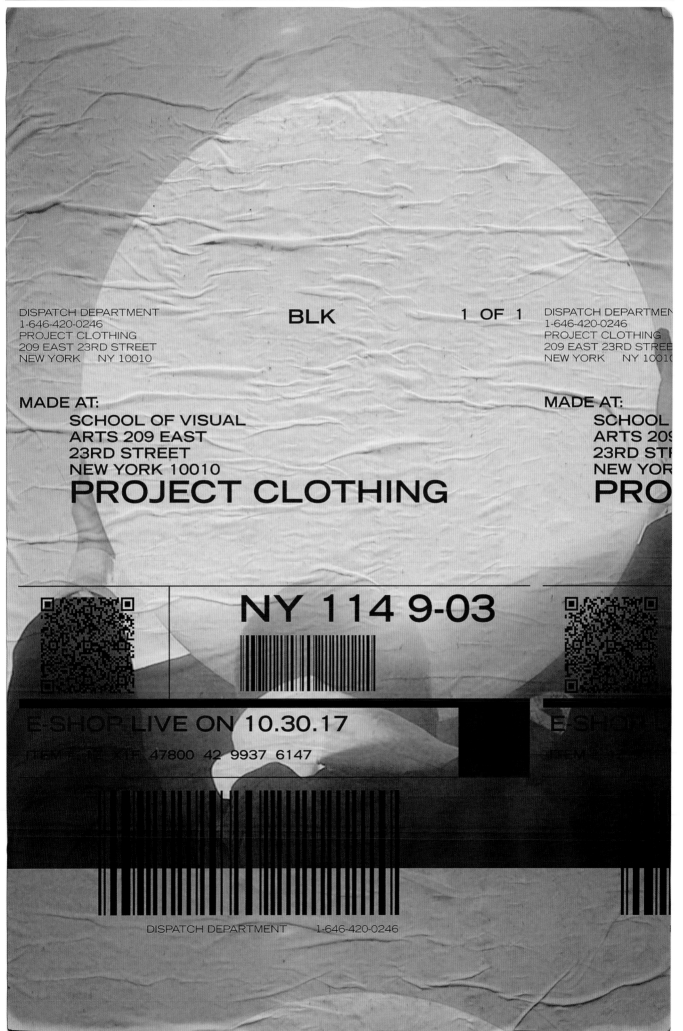

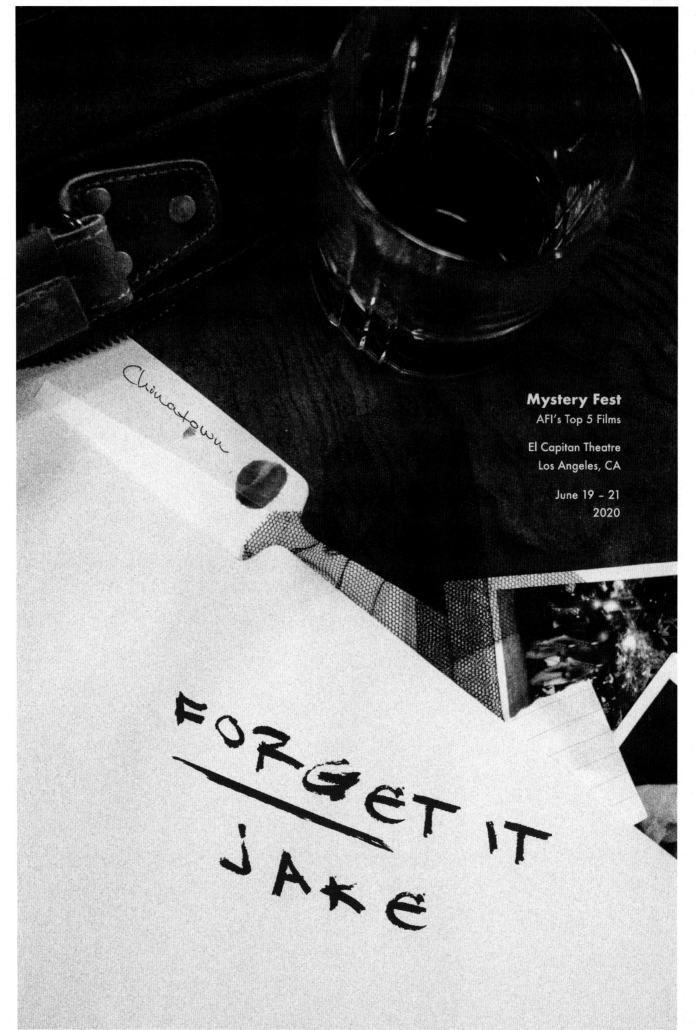

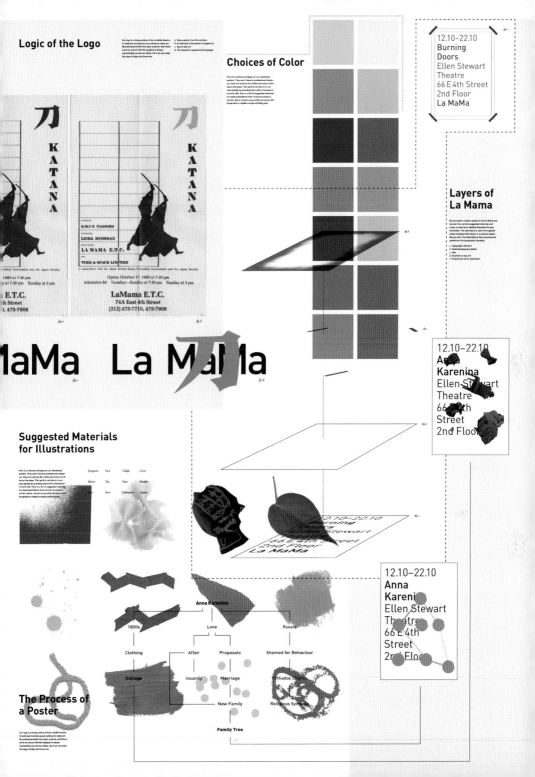

Logic of the Logo

Our logo is a living archive of the La MaMa Theatre. It continues to evolve as we continue to make art. By pulling elements from past, present, and future work we ensure that the logotype is always representing us and our ideals. All of us can make the logo of today and tomorrow.

A Take a poster from the archive
B An element of the poster is singled out
C Type is laid out
D The element is applied to the logotype

刀

KATANA

KIKUE TASHIRO
directed by
LINDA MUSSMAN
presented by
LA MAMA E.T.C.
and
TIME & SPACE LIMITED
in association with the Japan-United States Friendship Commission and the Japan Society

Opens: October 17, 1980 at 7:30 pm
Admission $6 Tuesday—Sunday at 7:30 pm Sunday at 3 pm

LaMama E.T.C.
74A East 4th Street
(212) 475-7710, 475-7908

fig. b

MaMa La MaMa fig. d

Choices of Color

Part of La MaMas heritage are our handmade posters. They aren't done by professional designers, they are made by the artists and actors working on the plays. This spirit is carried on in our new identity by providing them with a framework to work with. Here a list of suggested materials to create illustrations from. It is by no means a set list, add or remove as you wish. As long as the typography is legible enough anything goes.

12.10–22.10
Burning
Doors
Ellen Stewart
Theatre
66 E 4th Street
2nd Floor
La MaMa

Layers of La Mama

All you need to create a poster is here in this (brand name). You can find suggested materials and colors, as well as an idealize flowchart for poster creation. The first step is to cut out the supplied poster template with vellum or a sheet of plastic, then go nuts. The illustration is then scanned and pasted over the typographic template.

A Typographic element
B Vellum/transparent plastic
C Tape
D Illustrate on top of it
E Properly set up for illustration

12.10–22.10
Anna
Karenina
Ellen Stewart
Theatre
66 E 4th
Street
2nd Floor

Suggested Materials for Illustrations

Part of La Mamas heritage are our handmade posters. They aren't done by professional designers, they are made by the artist and actors working on the plays. This spirit is carried on in our new identity by providing them with a framework to work with. Here is a list of suggested materials to create illustrations from. It is by no means a set list, add or remove as you wish. As long as the typography is legible enough anything goes.

Spraypaint Food Collage Leaves
Splatter Tape Paper Branches
Paint Perforations Crayon

12.10–22.10
Burning
Doors
Ellen Stewart
66 E 4th Street
2nd Floor
La MaMa

The Process of a Poster

Our logo is a living archive of the La MaMa Theatre. It continues to evolve as we continue to make art. By pulling elements from past, present, and future work we ensure that the logotype is always representing us and our ideals. All of us can make the logo of today and tomorrow.

Anna Karenina

1800s Love Russia

Clothing Affair Proposals Shamed for Behaviour

Collage Insanity Marriage Orthodox Church

New Family Religious Symbols

Family Tree

12.10–22.10
Anna
Karenina
Ellen Stewart
Theatre
66 E 4th
Street
2nd Floor

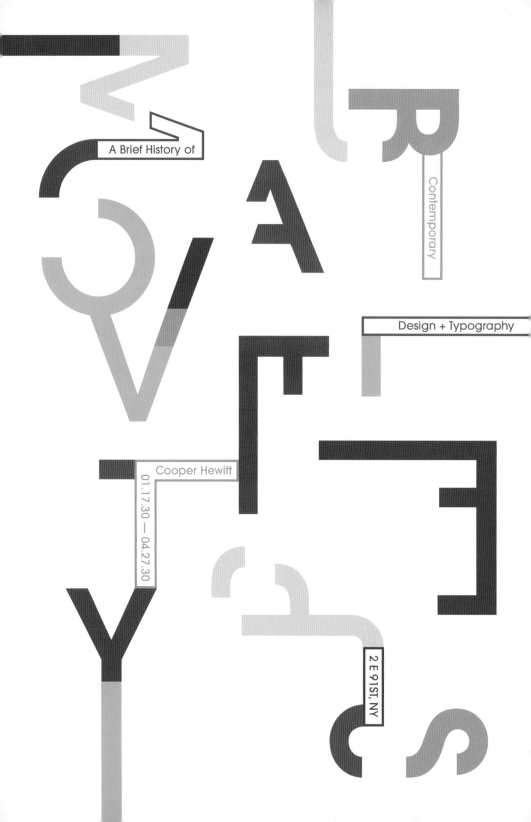

A Brief History of

Contemporary

Design + Typography

Cooper Hewitt

01.17.30 — 04.27.30

2 E 91ST, NY

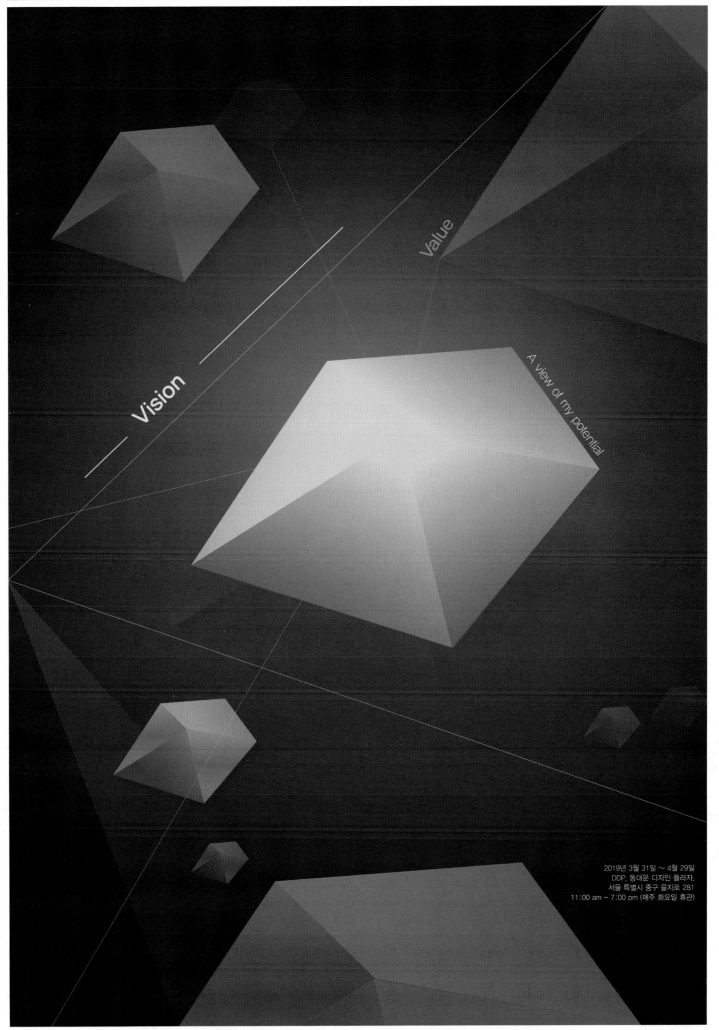

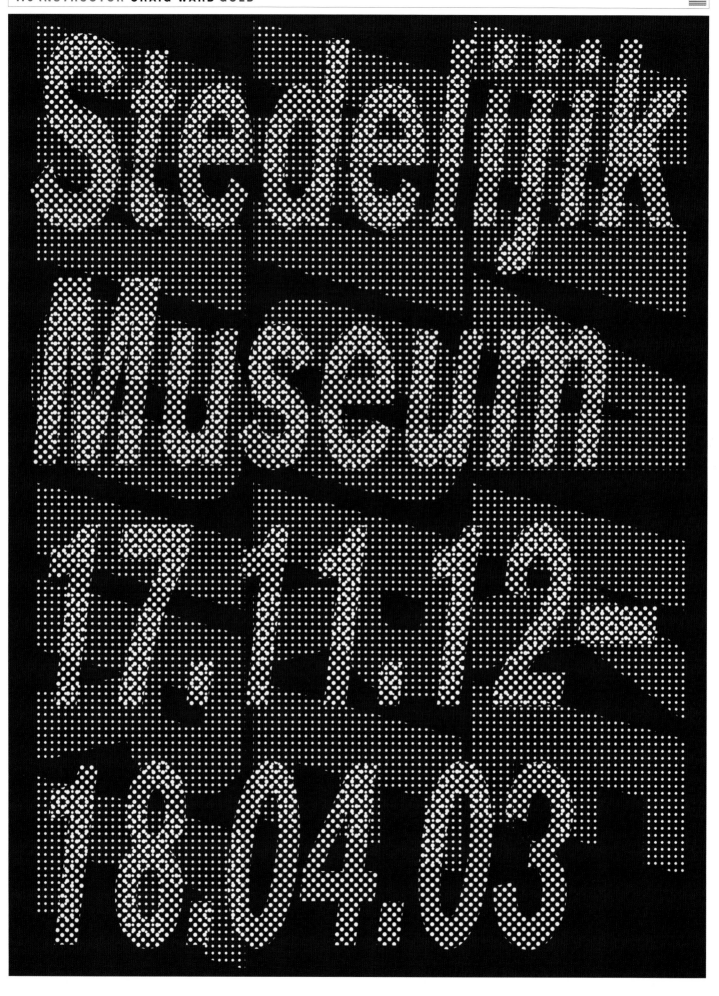

Student: Lindmarker Axel | School of Visual Arts

INSTRUCTORS **DONG-JOO PARK, SEUNG-MIN HAN**

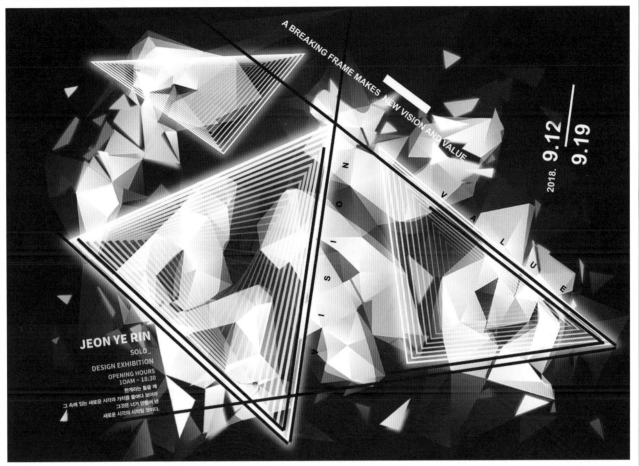

Student: Ye Rin Jeon | Hansung University of Design & Art Institute

INSTRUCTOR **BILL GALYEAN**

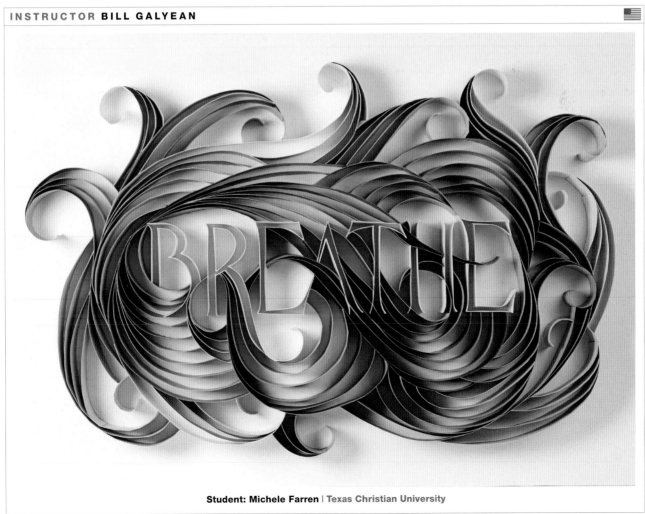

Student: Michele Farren | Texas Christian University

Poster | Design

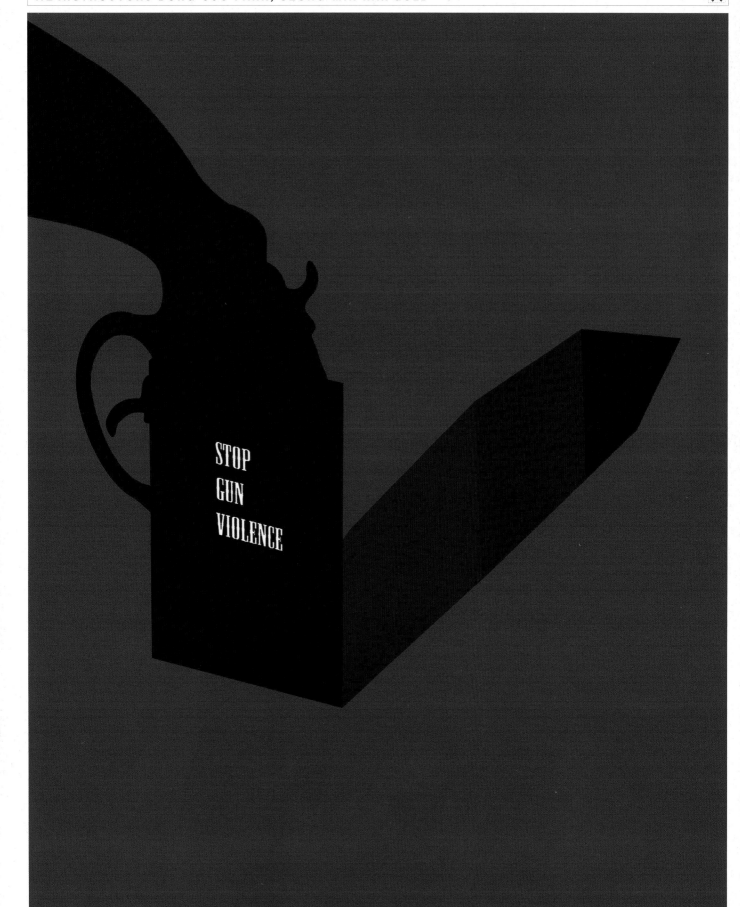

STOP
GUN
VIOLENCE

GUN VIOLENCE
AWARENESS

End Gun Violence initiative
Design can help change the things that matter.

Student: Hee Jung Lee | Hansung University of Design & Art Institute

USA FOREVER

CALDER

WALL SCULPTURE

USA FOREVER

CALDER

HANGING MOBILE

USA FOREVER

CALDER

WIRE SCULPTURE

USA FOREVER

CALDER

MONUMENTAL SCULPTURE

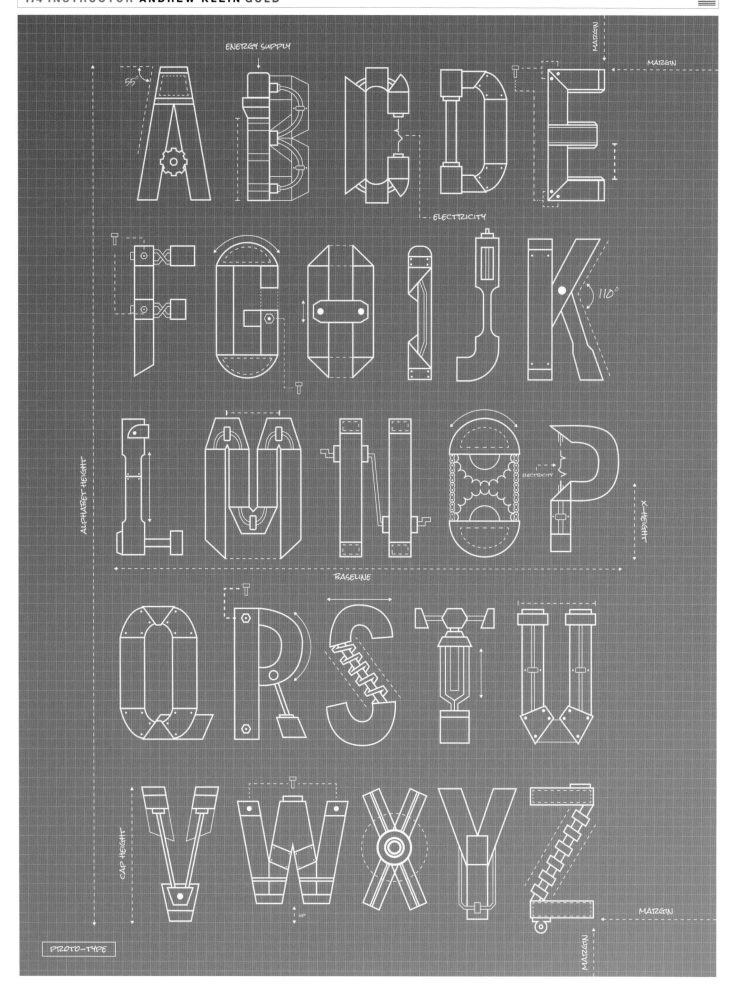

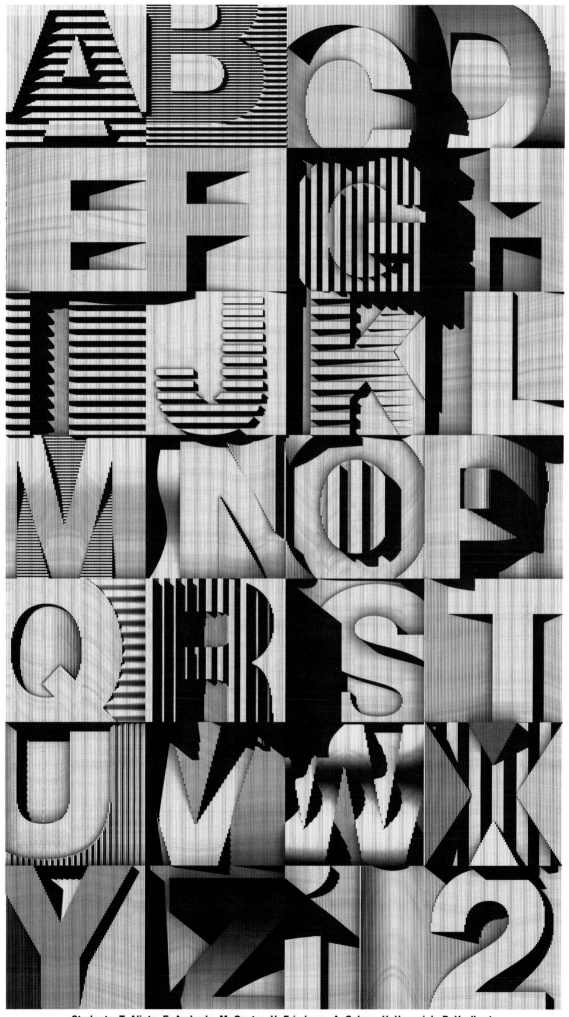

Students: T. Alioto, E. Andrade, M. Castro, H. Friedman, A. Galvan, H. Hasanieh, B. Hurlbert, M. Kwiatkowski, E. Mendez, D. Mujagić, C. Ortiz, K. Richmond, N. Schmidt, K. Smith, J. Stabner, J. Taylor, D. Truong, T. Webb, A. Yepez. | University of Illinois at Chicago

Type Fonts A-Z | Design

ABCDEFGHIJKL
MNOPQRSTUV
WXYZ abcdefghijk
lmnopqrstuvwxyz
1234567890/!?$&

Student: Potch Auacherdkul | Maryland Institute College of Art

KKKKK

Student: Ryoko Kondo | School of Visual Arts

Visit website to view full series

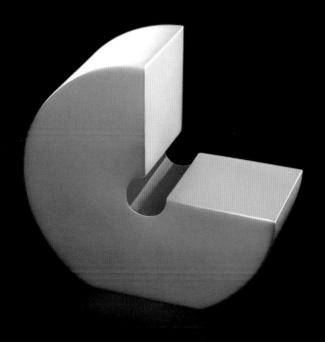

INSTRUCTOR BARBARA DEWILDE

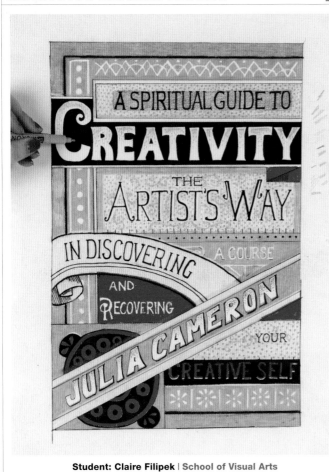

Student: Claire Filipek | School of Visual Arts

INSTRUCTOR PABLO DELCAN

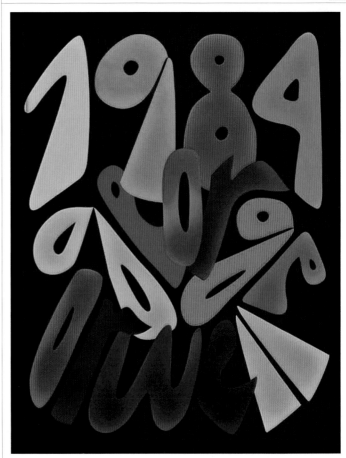

Student: Davina Hwang | School of Visual Arts

INSTRUCTOR KAREN WATKINS

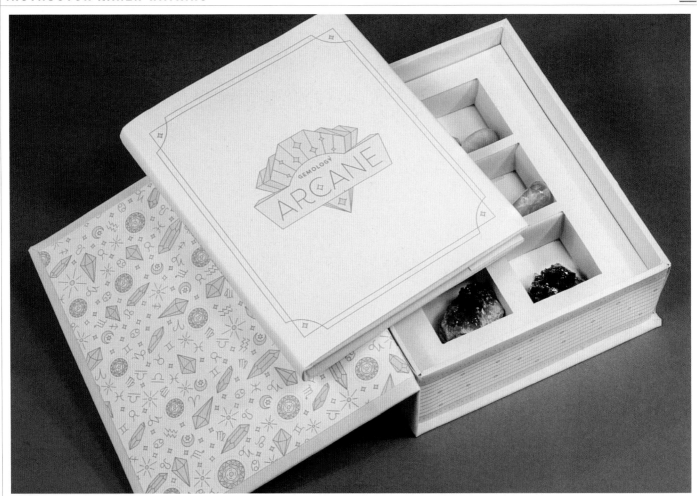

Student: Amber O'Brien | West Chester University

INSTRUCTOR HANK RICHARDSON 🇺🇸

Student: Mckenzie Martin | Portfolio Center

INSTRUCTOR HANK RICHARDSON 🇺🇸

Student: Katie Tynes | Portfolio Center

INSTRUCTOR HANK RICHARDSON 🇺🇸

Student: Laura McMullan | Portfolio Center

INSTRUCTOR KRISTIN SOMMESE 🇺🇸

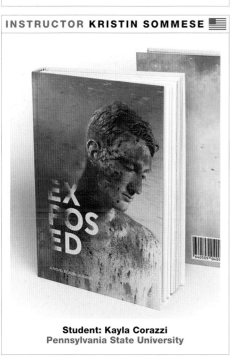

Student: Kayla Corazzi
Pennsylvania State University

INSTRUCTOR IVAN CHERMAYEFF 🇺🇸

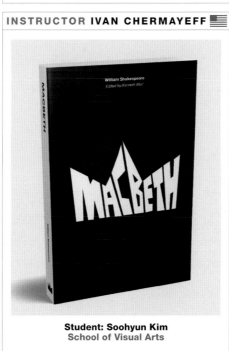

Student: Soohyun Kim
School of Visual Arts

INSTRUCTOR KRISTIN SOMMESE 🇺🇸

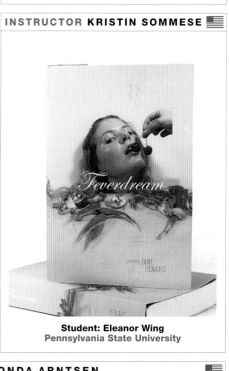

Student: Eleanor Wing
Pennsylvania State University

INSTRUCTOR CHRISTOPHER RYPKEMA 🇺🇸

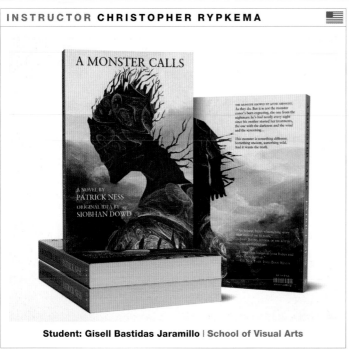

Student: Gisell Bastidas Jaramillo | School of Visual Arts

INSTRUCTOR RHONDA ARNTSEN 🇺🇸

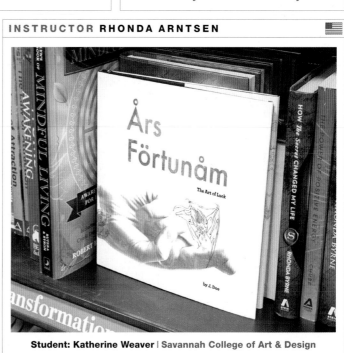

Student: Katherine Weaver | Savannah College of Art & Design

INSTRUCTOR UNATTRIBUTED

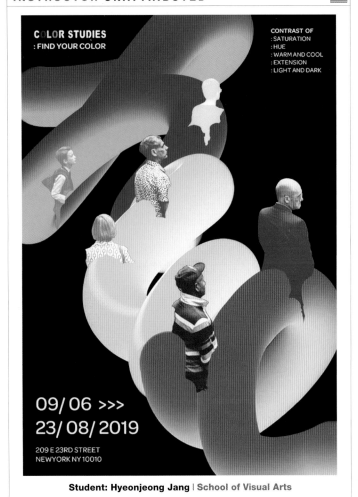

Student: **Hyeonjeong Jang** | School of Visual Arts

INSTRUCTOR SHAWN HASTO

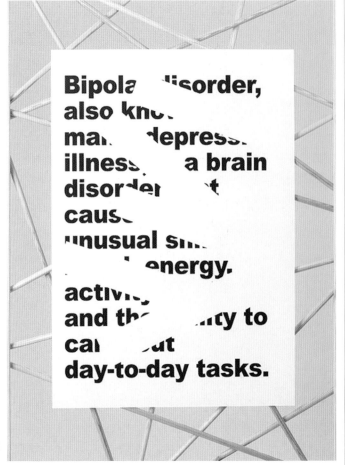

Student: **Yuo Ning Chien** | School of Visual Arts

INSTRUCTOR PETER AHLBERG

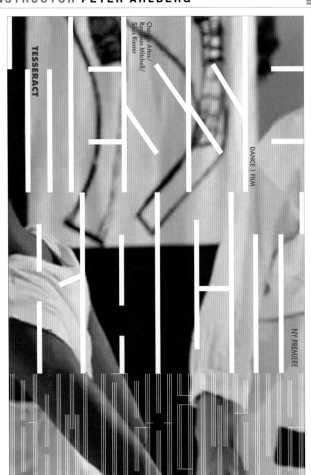

Student: **Donglin Huang** | School of Visual Arts

INSTRUCTOR SIMON JOHNSTON

Student: **Mansi Soni** | Art Center College of Design

INSTRUCTOR **JOSH EGE**

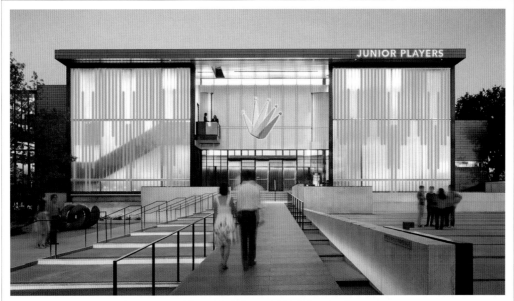

Student: Haebinna Choi | Texas A&M University Commerce

INSTRUCTORS **KENNETH DEEGAN, BRANKICA HARVEY**

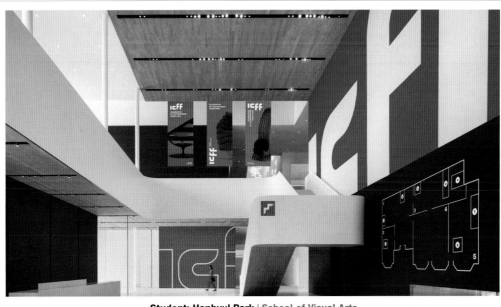

Student: Hanbyul Park | School of Visual Arts

INSTRUCTOR **GERARDO HERRERA**

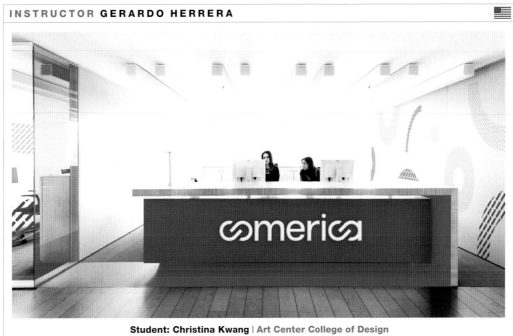

Student: Christina Kwang | Art Center College of Design

INSTRUCTORS NATASHA JEN, JOSEPH HAN

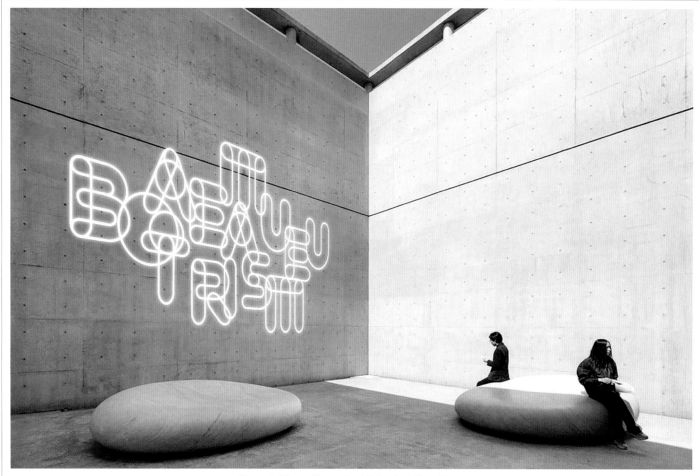

Student: Zhang Shengying | School of Visual Arts

INSTRUCTOR HANK RICHARDSON

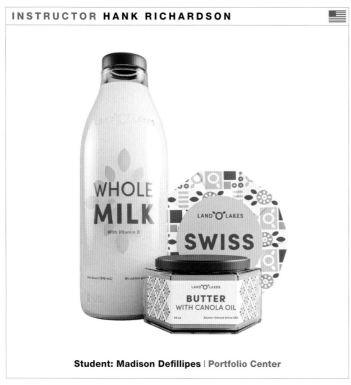

Student: Madison Defillipes | Portfolio Center

INSTRUCTOR BILL MEEK

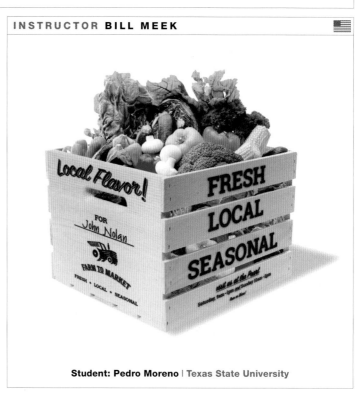

Student: Pedro Moreno | Texas State University

INSTRUCTOR **ERIC BAKER**

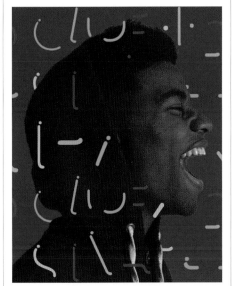

Student: Min Jeong Kim
School of Visual Arts

INSTRUCTOR **PETER AHLBERG**

Student: Dongjun Woo
School of Visual Arts

INSTRUCTOR **NAME**

Student: Lulubi Garcia
Art Center College of Design

INSTRUCTOR **DEANNA GIBSON**

Student: Noel Ramos | University of Texas at Arlington

INSTRUCTORS **PAULA SCHER, COURTNEY GOOCH**

Student: Seoyoung Lee | School of Visual Arts

INSTRUCTOR **JOHN DUFRESNE**

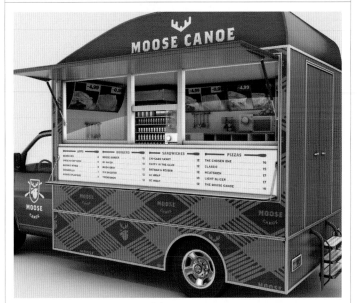

Student: Matthew Sullivan | Concordia University

INSTRUCTOR **HANK RICHARDSON**

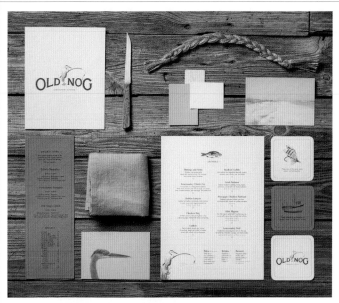

Student: Casey Lovegrove | Portfolio Center

INSTRUCTOR LORYN O'DONNELL

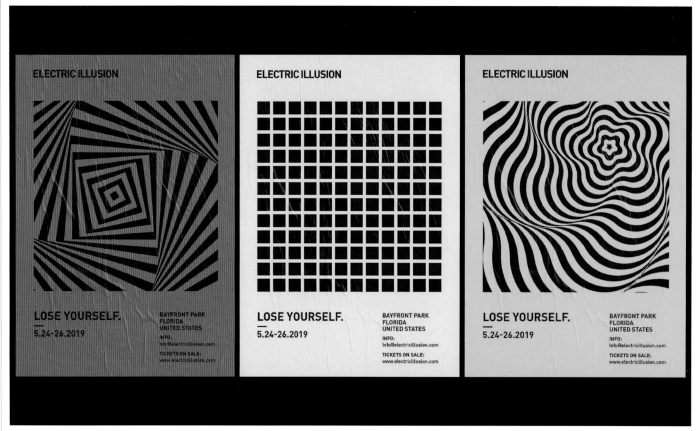

Student: Noel Ramos | University of Texas at Arlington

INSTRUCTOR ADRIAN PULFER

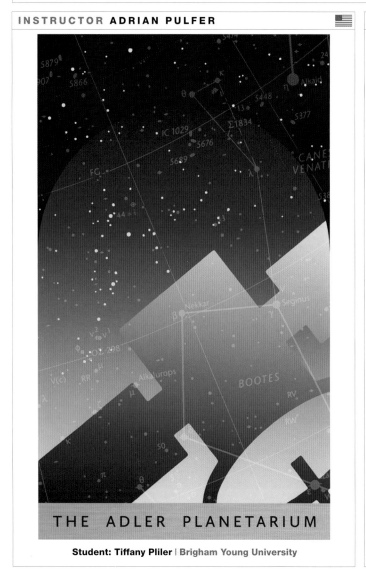

Student: Tiffany Pliler | Brigham Young University

INSTRUCTOR CHERI GRAY

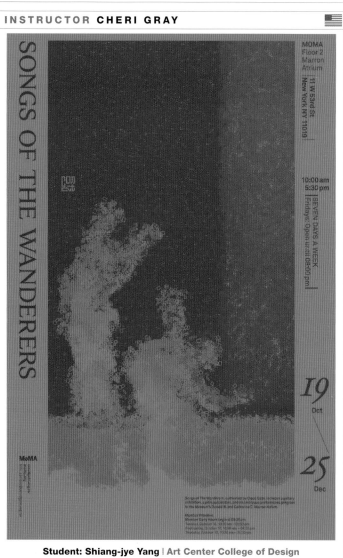

Student: Shiang-jye Yang | Art Center College of Design

INSTRUCTORS **DONG-JOO PARK, SEUNG-MIN HAN**

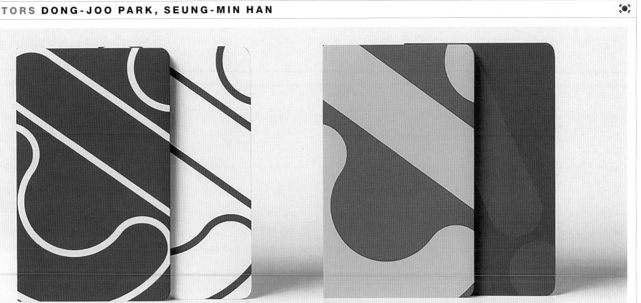

Students: **Jang Yeon Woo, Lee Sun Hee, Kang Ju Yeon** | Hansung University of Design & Art Institute

INSTRUCTOR **ADRIAN PULFER**

Student: **Laura Ann McNeill** | Brigham Young University

INSTRUCTOR **JOSH EGE**

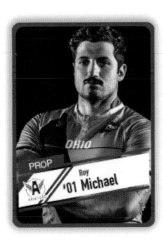
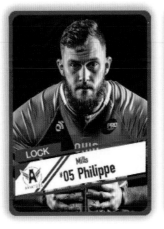

Student: **Solbinna Choi** | Texas A&M University Commerce

INSTRUCTOR GENARO SOLIS RIVERO

Student: Emily Castillo | Texas State University

INSTRUCTOR DAVID BECK

Student: Solbinna Choi | Texas A&M University Commerce

INSTRUCTOR JON KUDOS

Student: Jiwon Lee | School of Visual Arts

INSTRUCTOR KRISTEN CHON

Student: Gerardo Herrera | Art Center College of Design

INSTRUCTOR GENARO SOLIS RIVERO

Student: Vanessa Kerr | Texas State University

INSTRUCTOR TRACEY ULLOM

Student: Anthony J Mottola | Portland Community College

INSTRUCTOR JAN BALLARD

Student: **Michele Farren** | Texas Christian University

INSTRUCTOR ADRIAN PULFER

Student: **Emmie Brower** | Brigham Young University

INSTRUCTOR SAM ECKERSLEY

Student: **McKenzie Martin** | Portfolio Center

INSTRUCTOR EILEEN HEDY SCHULTZ

Student: **Hai Nguyen** | School of Visual Arts

INSTRUCTOR ABBY GUIDO

Student: **Leigh Menkevich** | Temple University

INSTRUCTOR HUNTER WIMMER

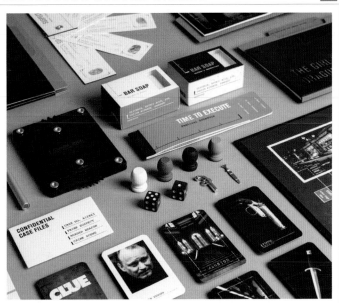

Student: **Raymond Monsada** | Academy of Art University

INSTRUCTOR **VERONICA VAUGHAN**

Student: Noel Ramos | University of Texas at Arlington

INSTRUCTOR **IAN GREGORY**

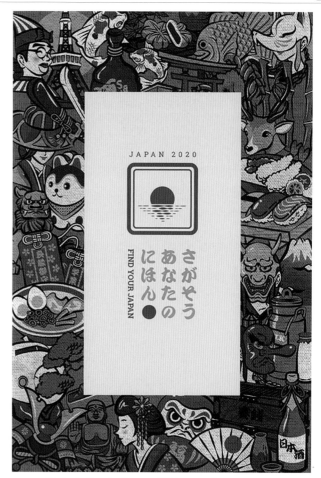

Student: Yusuke Yamazaki | George Brown College

INSTRUCTOR **PIPPA SEICHRIST**

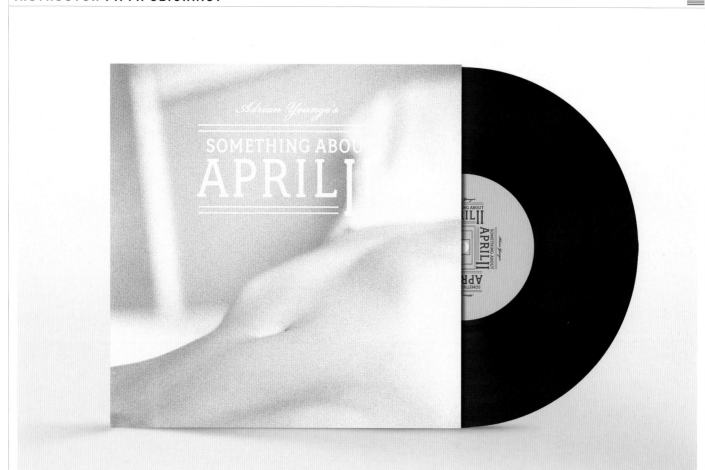

Student: Justin Tompkins | Portfolio Center

INSTRUCTOR YOUNG SUN COMPTON

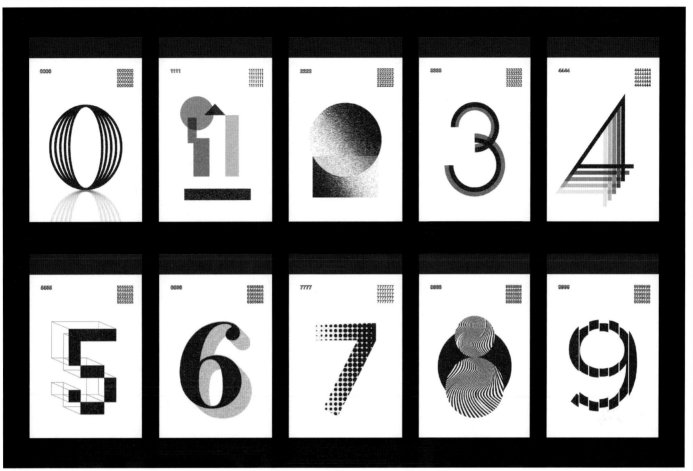

Student: Chaei Mo | School of Visual Arts

INSTRUCTOR CHERI GRAY

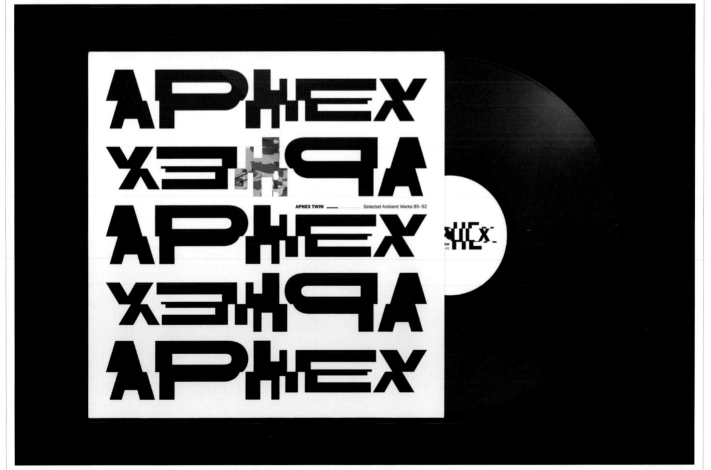

Student: Shiang-jye Yang | Art Center College of Design

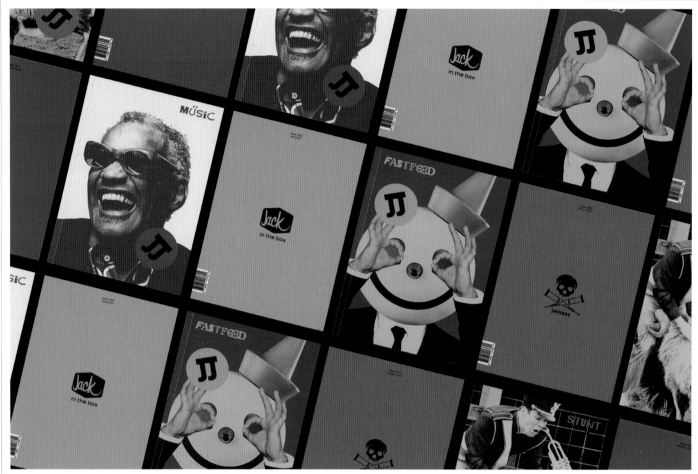

Student: Sam Yen | Art Center College of Design

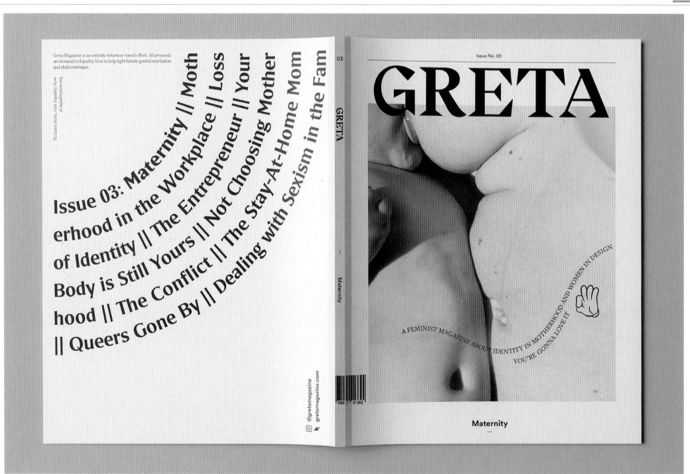

Student: Sadie Williams | Academy of Art University

INST. CARIN GOLDBERG

Student: Julia Yu
School of Visual Arts

INST. ADRIAN PULFER

Student: Ian Sullivan
Brigham Young University

INST. ADRIAN PULFER

Student: Laura Ann McNeill
Brigham Young University

INST. ADRIAN PULFER

Student: Abby DeWitt
Brigham Young University

INST. CARIN GOLDBERG

Student: Yunchung Chung
School of Visual Arts

INST. ADRIAN PULFER

Student: Erica Bevan
Brigham Young University

INST. KRISTIN SOMMESE

Student: Emily Adar
Pennsylvania State University

INST. JERRI JOHNSON

Student: Patrick Blanchard
George Brown College

INSTS. G. VILLA JR., S. BLOYD-PESHKIN

Student: Echo Design Team
Columbia College of Chicago

INSTRUCTOR CARIN GOLDBERG

Student: Soohyun Kim | School of Visual Arts

INSTRUCTORS COURTNEY GOOCH, PAULA SCHER

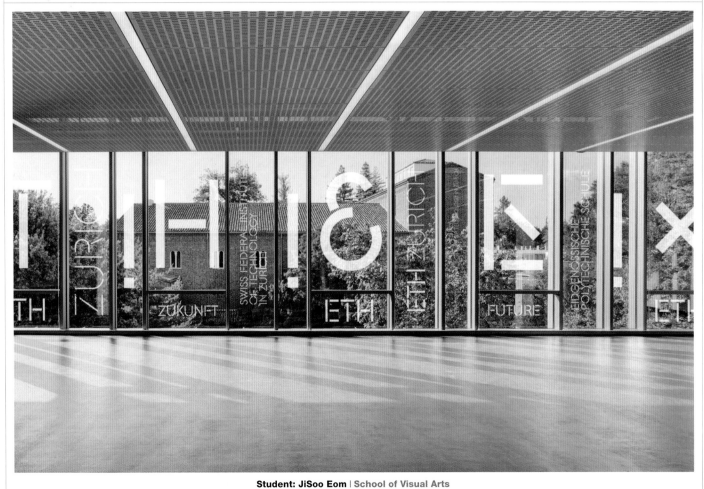

Student: JiSoo Eom | School of Visual Arts

INSTRUCTOR LAUREN BERNSTEIN

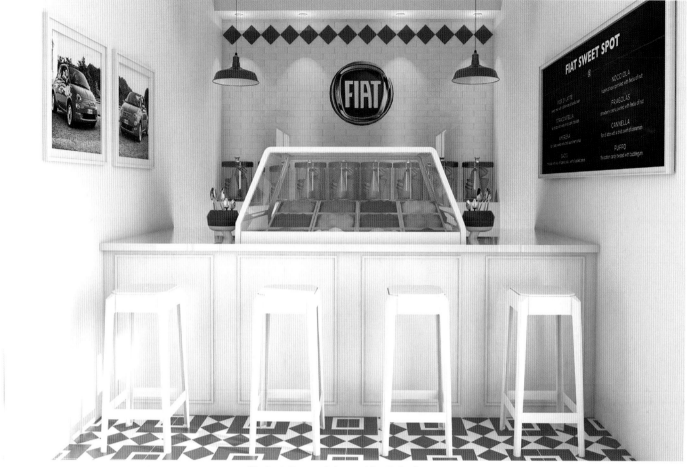

Student: Rowan Griscom | Portfolio Center

INSTRUCTOR MELISSA KUPERMINC

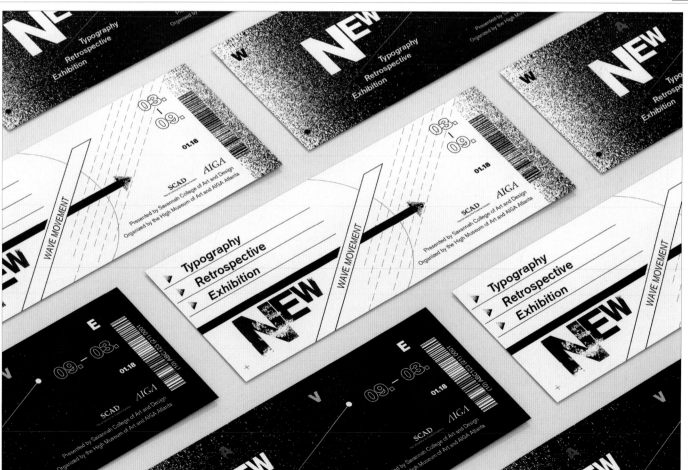

Student: Puxi Yang | Savannah College of Art and Design

Student: Tae Gyung Kang | School of Visual Arts

Student: Tae Gyung Kang | School of Visual Arts

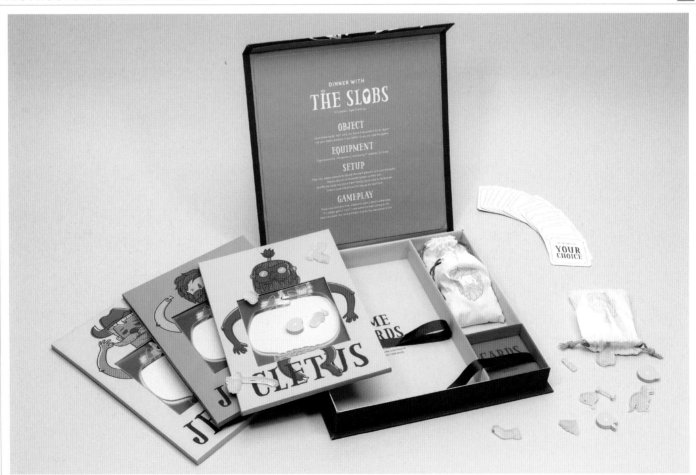

Student: Ying Ying Zhang | Temple University

INSTRUCTORS **CHRIS BUZELLI, YUKO SHIMIZU**

Student: Lydia Kassinos | School of Visual Arts

INSTRUCTOR **HENRIK DRESCHER**

Student: Grace Milk | School of Visual Arts

INSTRUCTOR **AYA KAKEDA**

Student: Cindy Kang | School of Visual Arts

INSTRUCTORS **MARCOS CHIN, YUKO SHIMIZU**

Student: Seung Won Chun | School of Visual Arts

INSTRUCTOR MARVIN MATTELSON

Student: Yutong Wu | School of Visual Arts

INSTRUCTOR MARVIN MATTELSON

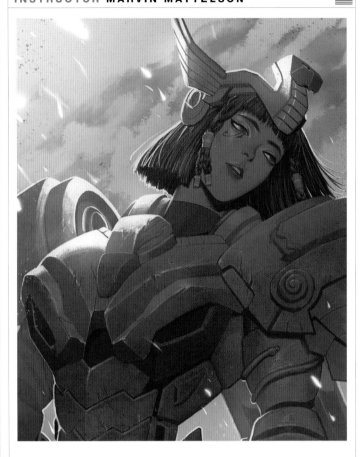

Student: Siyi Hemu | School of Visual Arts

INSTRUCTOR HENRIK DRESCHER

Student: Sasha Brodski | School of Visual Arts

INSTS. T.M. DAVY, T. WOODRUFF 🇺🇸

Student: **Brianna Yovino** | School of Visual Arts

INST. STEVE BRODNER 🇺🇸

Student: **Tianxin Yu** | School of Visual Arts

INST. MARVIN MATTELSON 🇺🇸

Student: **Yutong Wu** | School of Visual Arts

INST. MARVIN MATTELSON 🇺🇸

Student: **A. Tolstokulakova** | School of Visual Arts

INSTS. T.M. DAVY, T. WOODRUFF 🇺🇸

Student: **Yang Tzu Chung** | School of Visual Arts

INST. AYA KAKEDA 🇺🇸

Student: **Linda Shi** | School of Visual Arts

INSTS. C. BUZELLI, Y. SHIMIZU 🇺🇸

Student: **Brian Scagnelli** | School of Visual Arts

INST. HENRIK DRESCHER 🇺🇸

Student: **Grace Milk** | School of Visual Arts

INST. STEVE BRODNER 🇺🇸

Student: **Annabelle Doan** | School of Visual Arts

INSTS. **MARCOS CHIN, YUKO SHIMIZU** 🇺🇸

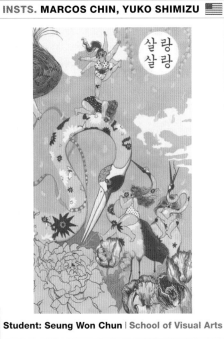

Student: **Seung Won Chun** | School of Visual Arts

INSTS. **MARCOS CHIN, YUKO SHIMIZU** 🇺🇸

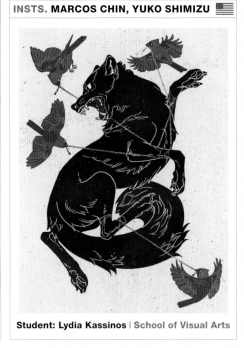

Student: **Lydia Kassinos** | School of Visual Arts

INSTS. **T.M. DAVY, T. WOODRUFF** 🇺🇸

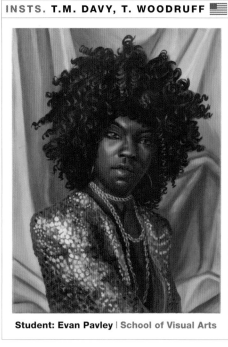

Student: **Evan Pavley** | School of Visual Arts

INSTS. **MARCOS CHIN, YUKO SHIMIZU** 🇺🇸

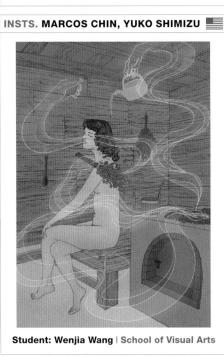

Student: **Wenjia Wang** | School of Visual Arts

INST. **STEVE BRODNER** 🇺🇸

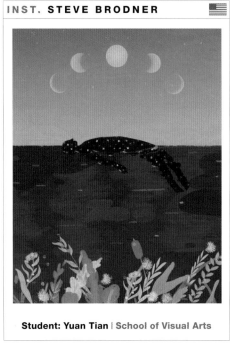

Student: **Yuan Tian** | School of Visual Arts

INSTS. **MARCOS CHIN, YUKO SHIMIZU** 🇺🇸

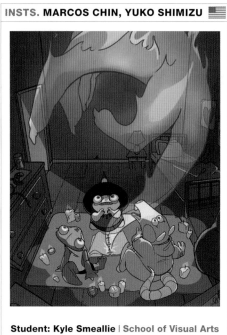

Student: **Kyle Smeallie** | School of Visual Arts

INSTS. **CHRIS BUZELLI, YUKO SHIMIZU** 🇺🇸

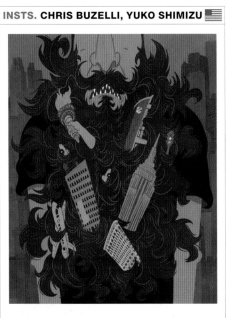

Student: **Brian Scagnelli** | School of Visual Arts

INST. **HENRIK DRESCHER** 🇺🇸

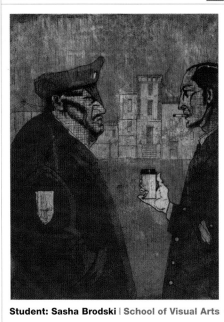

Student: **Sasha Brodski** | School of Visual Arts

INST. **JON KUDOS** 🇺🇸

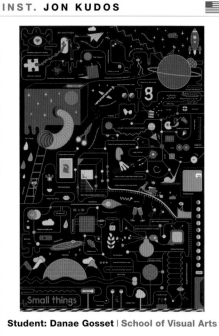

Student: **Danae Gosset** | School of Visual Arts

INSTRUCTOR CAROLINA TRIGO

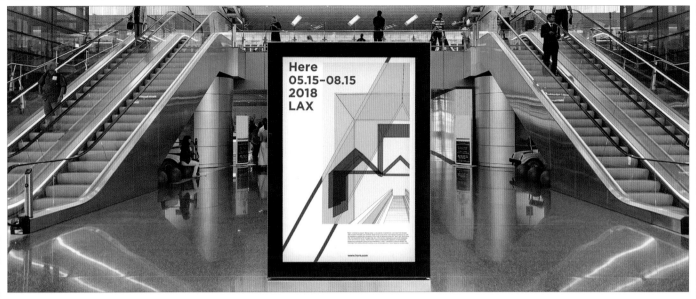

Student: Na Yeon Kim | Art Center College of Design

INSTRUCTOR PETER WONG

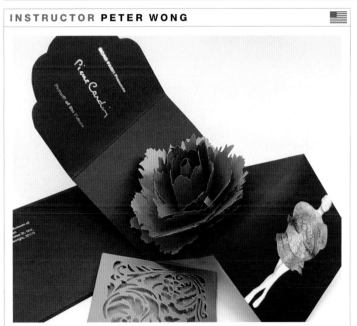

Student: Hazel Hwang | Savannah College of Art & Design

INSTRUCTOR KATIE KITCHENS

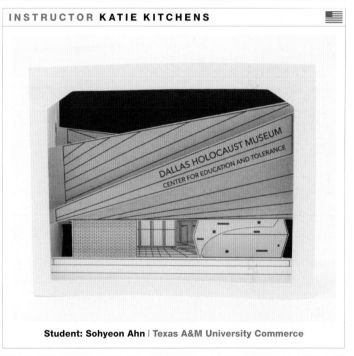

Student: Sohyeon Ahn | Texas A&M University Commerce

INSTRUCTOR ABBY GUIDO

Student: Luke Harding | Temple University

INSTRUCTOR KATIE KITCHENS

Student: Brandi Hamilton | Texas A&M University Commerce

INST. HANK RICHARDSON 🇺🇸

Student: Katie Tynes
Portfolio Center

INST. ABBY GUIDO 🇺🇸

Student: Michaela Williams
Temple University

INST. JOSH EGE 🇺🇸

Student: Jisu Jung
Texas A&M University Commerce

INST. DUSTY CROCKER 🇺🇸

Student: Kahla Watkins
Texas Christian University

INST. MIKE KELLY 🇺🇸

Student: Rowan Griscom
Portfolio Center

INST. GENARO SOLIS RIVERO 🇺🇸

Student: Stephan Tynes
Texas State University

INST. GENARO SOLIS RIVERO 🇺🇸

Student: Jazmine Beatty
Texas State University

INST. GENARO SOLIS RIVERO 🇺🇸

Student: Noah Lewis
Texas State University

INST. GENARO SOLIS RIVERO 🇺🇸

Student: Haley Buckner
Texas State University

INST. GENARO SOLIS RIVERO 🇺🇸

Student: Tracy Hang
Texas State University

INST. CARRIE OSGOOD 🇺🇸

Student: Devon Iredale
Metropolitan State University of Denver

INST. GENARO SOLIS RIVERO 🇺🇸

Student: Noah Lewis
Texas State University

INST. **UNATTRIBUTED**

Student: Bronte Giardina
Texas State University

INST. **GENARO SOLIS RIVERO**

Student: Mia Rendon
Texas State University

INST. **JOSH EGE**

Student: Stephanie Williams
Texas A&M University Commerce

INST. **MIKE KELLY**

Student: Aaron Blake Navarro
Portfolio Center

INST. **GENARO SOLIS RIVERO**

Student: Lauren Zawodni
Texas State University

INST. **GENARO SOLIS RIVERO**

Student: Jazmine Beatty
Texas State University

INST. **NATHAN SAVAGE**

Student: Dante Stewart
Portland Community College

INST. **JOSH EGE**

Student: Sohyeon Ahn
Texas A&M University Commerce

INST. **ZACHARY VERNON**

Student: Jose Moreno
Texas State University

INST. **JEFF DAVIS**

Student: Paul Davis
Texas State University

INST. **MIKE KELLY**

Student: Aaron Blake Navarro
Portfolio Center

INST. **MIKE KELLY**

Student: Jackson Watkins
Portfolio Center

INSTRUCTOR YVONNE CAO

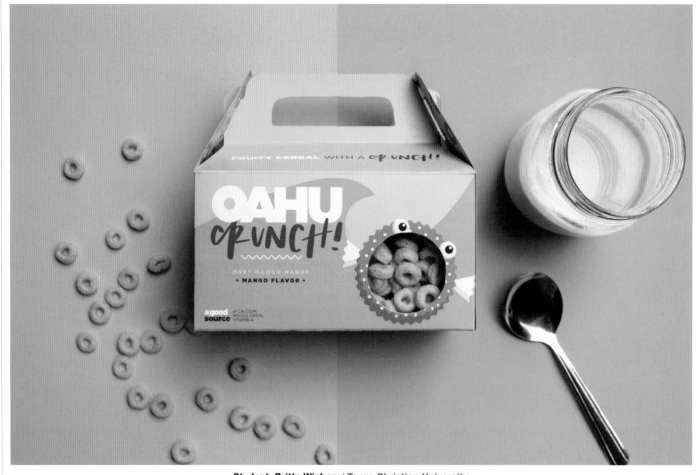

Student: Britta Wichary | Texas Christian University

INSTRUCTOR DONG-JOO PARK

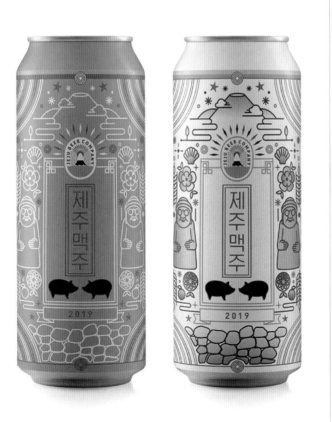

Student: Minseo Ji | Hansung University of Design & Art Institute

INSTRUCTOR ANIA BORYSIEWICZ

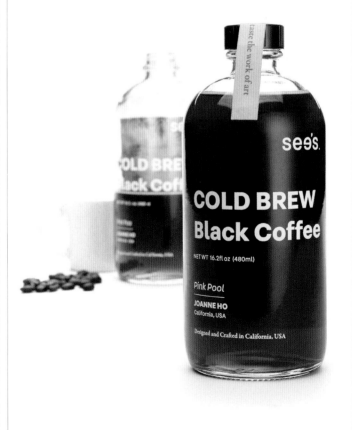

Student: Cid W. Lee | Art Center College of Design

INSTRUCTOR THOMAS MCNULTY

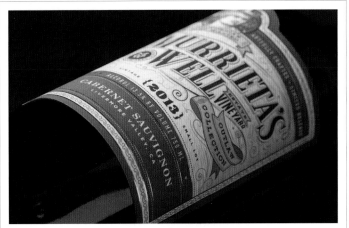

Student: Yvonne Anaya
Academy of Art University

INSTRUCTOR THOMAS MCNULTY

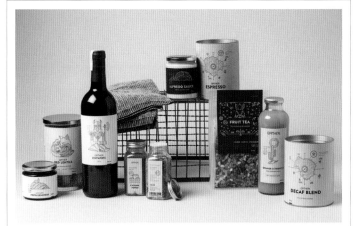

Students: Silvia Abruzzese, Maria Wong Chang, Jason de Cruz,
Lucy Tsai, Tiffany Byrd, Jonathan Biehl | Academy of Art University

INSTRUCTOR BRYAN SATALINO

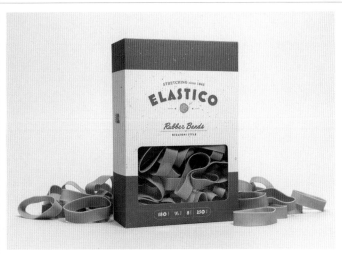

Student: Alex Bruce | Temple University

INSTRUCTOR LOUISE FILI

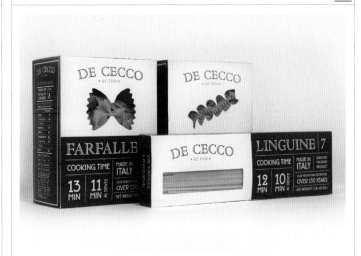

Student: Isabella Cuda | School of Visual Arts

INSTRUCTOR DONG-JOO PARK

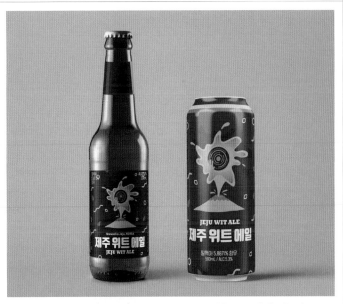

Student: Ji Yun Kim | Hansung University of Design & Art Institute

INSTRUCTOR JERRI JOHNSON

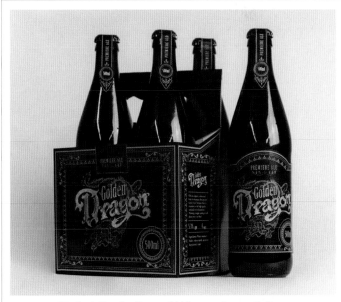

Student: Yusuke Yamazaki | George Brown College

INSTRUCTOR ALICE CHAOSURAWONG

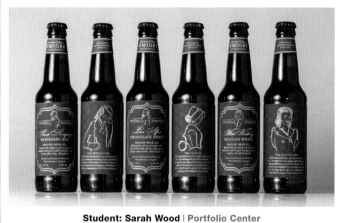

Student: **Sarah Wood** | Portfolio Center

INSTRUCTOR THOMAS MCNULTY

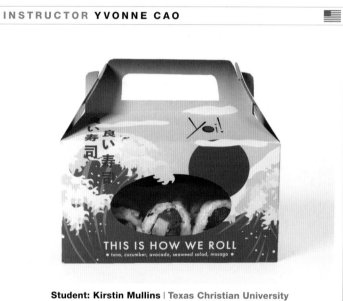

Student: **Zhenni Duan** | Academy of Art University

INSTRUCTOR VICKI MELONEY

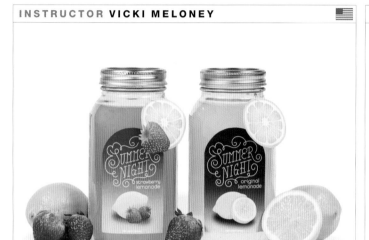

Student: **Lily Stamm** | Kutztown University of Pennsylvania

INSTRUCTOR YVONNE CAO

Student: **Kirstin Mullins** | Texas Christian University

INSTRUCTOR THOMAS MCNULTY

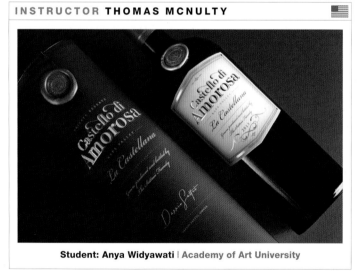

Student: **Anya Widyawati** | Academy of Art University

INSTRUCTOR HANK RICHARDSON

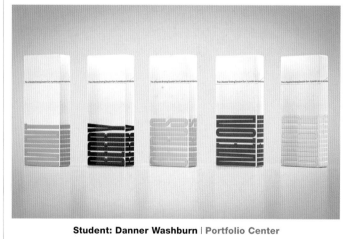

Student: **Danner Washburn** | Portfolio Center

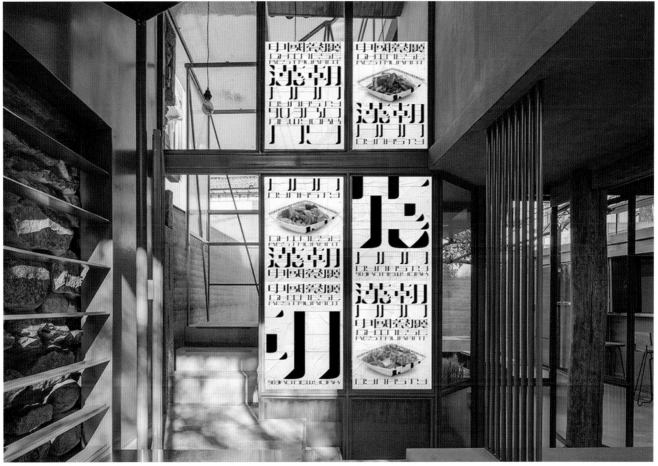

Student: Ji Soo Eom | School of Visual Arts

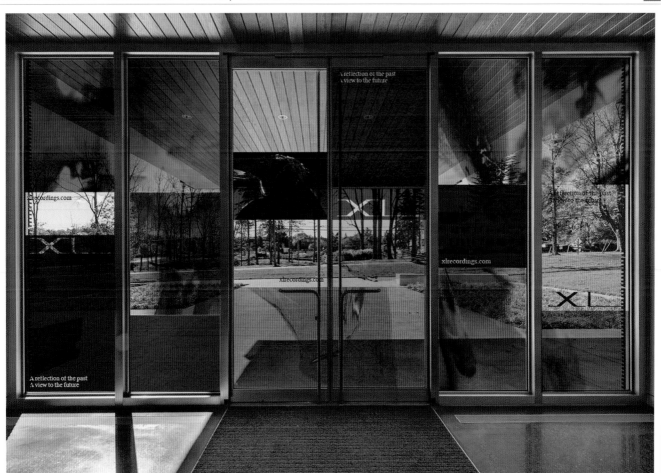

Student: Ji Soo Eom | School of Visual Arts

INSTRUCTORS PABLO DELCAN, BEN GRANDGENETT

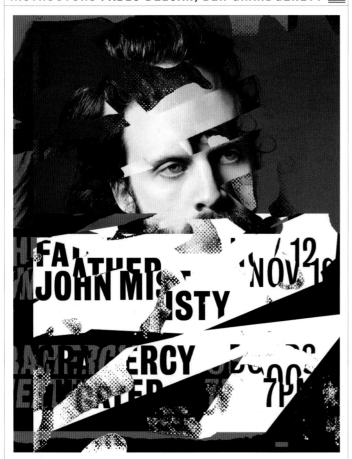

Student: Jay Giraldo | School of Visual Arts

INSTRUCTOR PETER WONG

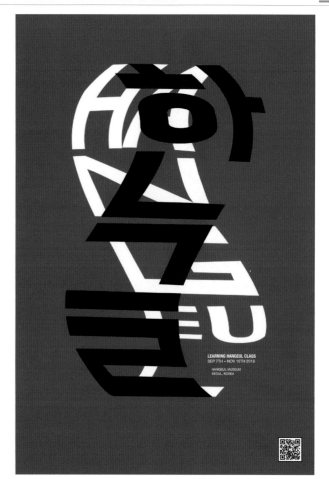

Student: Rosa Sung | Savannah College of Art & Design

INSTRUCTOR CARLOS RONCAJOLO

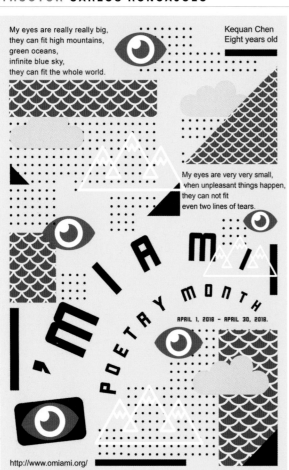

Student: Qi Shen | Miami Ad School Wynwood

INSTRUCTOR RUSSELL KERR

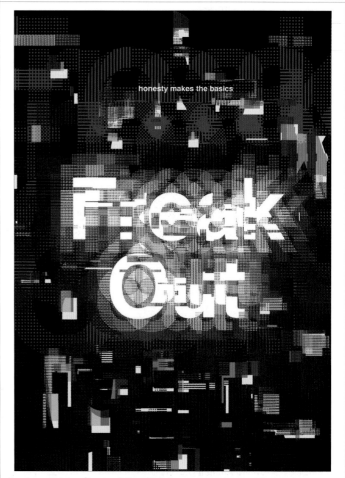

Student: Tristan Danino | Royal Melbourne Institute of Technology Univ.

INST. **PETER AHLBERG**

Student: Manchanda Noora
School of Visual Arts

INST. **HANK RICHARDSON**

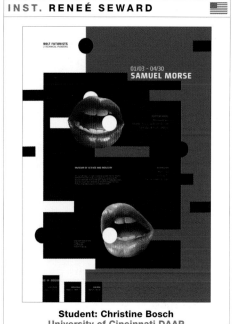

Student: Alex Somoza
Miami Ad School

INST. **RENEÉ SEWARD**

Student: Christine Bosch
University of Cincinnati DAAP

INST. **UNATTRIBUTED**

Student: Hridaynag Kooretti
Miami Ad School

INST. **SANTIAGO CARRASQUILLA**

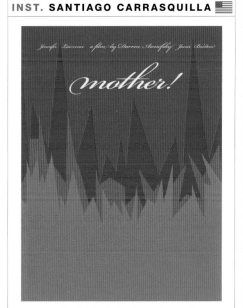

Student: Gisell Bastidas Jaramillo
School of Visual Arts

INST. **RICK GAVOS**

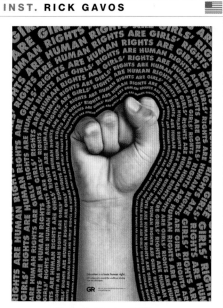

Student: Monica Williams
Texas A&M University Commerce

INST. **RUSSELL KERR**

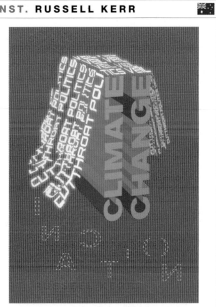

Student: Chiara Ananda Croserio
Royal Melbourne Institute of Technology Univ.

INST. **EILEEN HEDY SCHULTZ**

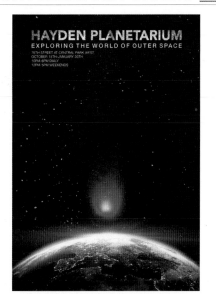

Student: Gisell Bastidas Jaramillo
School of Visual Arts

INST. **PIPPA SEICHRIST**

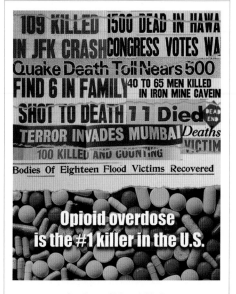

Student: Shivani Shah
Portfolio Center

INST. PAULA SCHER

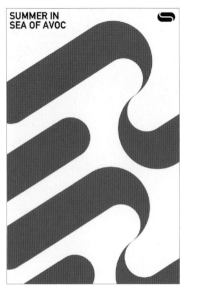

Student: Haejung Jun
School of Visual Arts

INST. HANK RICHARDSON

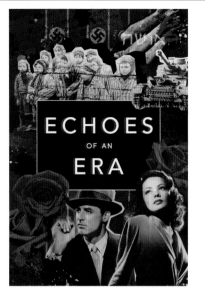

Student: Esther Lee
Miami Ad School

INST. CARIN GOLDBERG

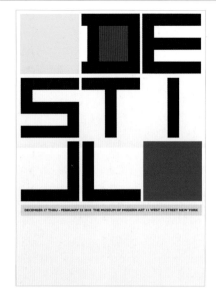

Student: Soohyun Kim
School of Visual Arts

INSTS. D. PARK, S. HAN

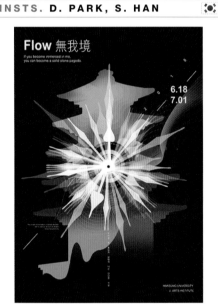

Student: Jeon Min Gyeong
Hansung University of Design & Art Institute

INST. FLORIAN WEITZEL

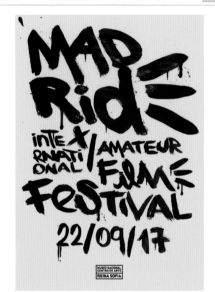

Student: Claudio Castagnola
Miami Ad School Europe

INST. REBEKAH ALBRECHT

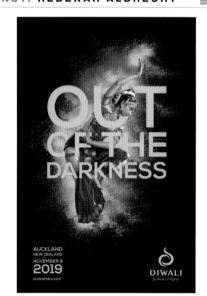

Student: Genesis Huchim
Woodbury University

INST. RUSSELL KERR

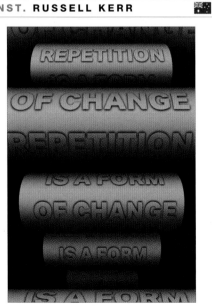

Student: Adrian Franzese
Royal Melbourne Institute of Technology Univ.

INSTS. D. PARK, S. HAN

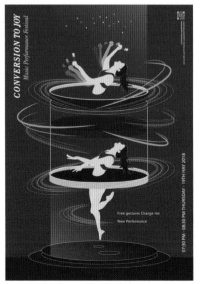

Student: Su In Kim
Hansung University of Design & Art Institute

INST. KRISTIN SOMMESE

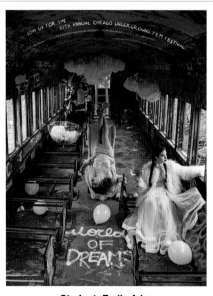

Student: Emily Adar
Pennsylvania State University

INST. KAREN WATKINS

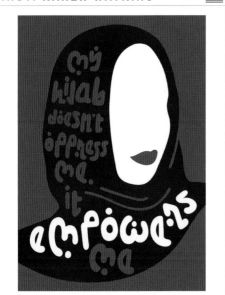

Student: Kelsey Dowling
West Chester University

INST. HANK RICHARDSON

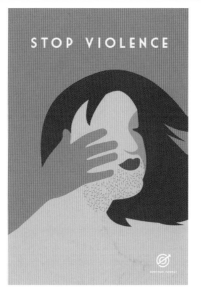

Student: Nidal Koteich
Miami Ad School

INST. HANK RICHARDSON

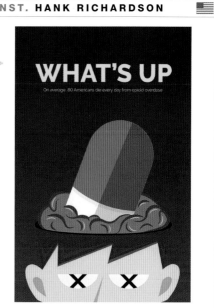

Student: Laura McMullan
Portfolio Center

INSTS. KENNETH DEEGAN, BRANKICA HARVEY

Student: Seowoo Han | School of Visual Arts

INSTS. DONG-JOO PARK, SEUNG-MIN HAN

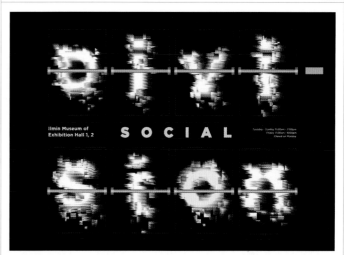

Student: Jang Yeon Woo | Hansung University of Design & Art Institute

INSTRUCTOR EILEEN HEDY SCHULTZ

Student: Nuri Park | School of Visual Arts

INSTRUCTOR SHAWN MEEK

Student: Jack Grupe | Metropolitan State University of Denver

INST. PETER AHLBERG

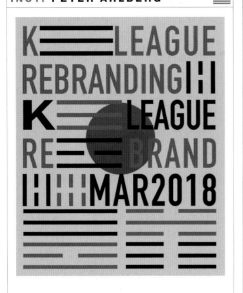

Student: Dongjun Woo
School of Visual Arts

INST. PETER AHLBERG

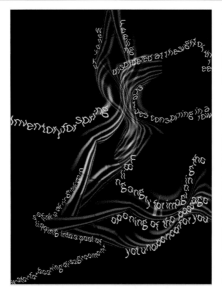

Student: Min Kyung Kim
School of Visual Arts

INST. KAREN WATKINS

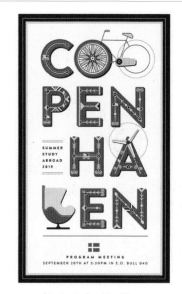

Student: Sophie Olson
West Chester University

INST. BRAD BARTLETT

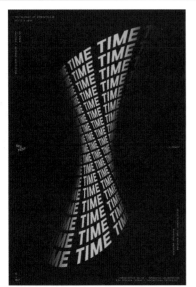

Student: Alpha Lung
Art Center College of Design

INST. DOUGLAS RICCARDI

Student: Hai Nguyen
School of Visual Arts

INST. NDREW LOESEL

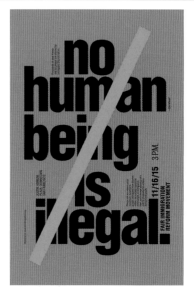

Student: Krishnapriya Dutta Gupta
Academy of Art University

INSTRUCTOR ELLEN LUPTON

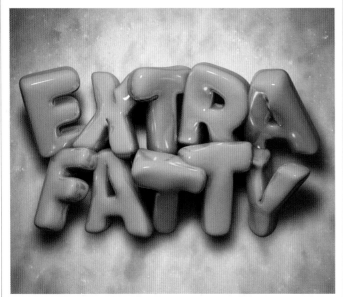

Student: Jenna Klein | Maryland Institute College of Art

INSTRUCTORS JUNGIN YUN, BRIAN BOWMAN

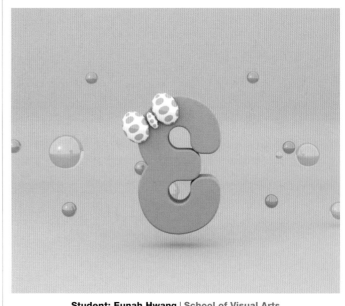

Student: Eunah Hwang | School of Visual Arts

INST. RANDALL SEXTON

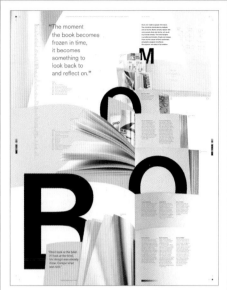

Student: **Marina Menéndez-Pidal**
San Jose State University

INST. JOSH EGE

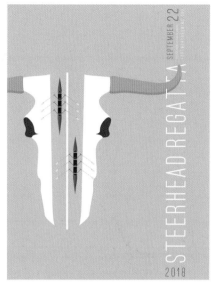

Student: **Jiyun Park**
Texas A&M University Commerce

INST. SHUSHI YOSHINAGA

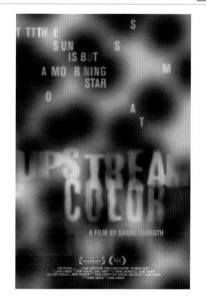

Student: **Jenna Lecours**
Drexel University

INST. CARRIE OSGOOD

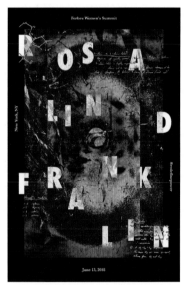

Student: **Eleeza Palmer**
Metropolitan State University of Denver

INST. ELLEN LUPTON

Student: **Jenna Klein**
Maryland Institute College of Art

INST. KEVIN O'CALLAGHAN

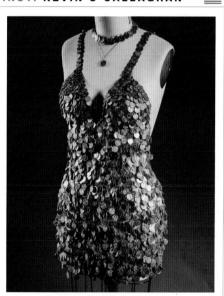

Student: **Mert Avadya**
School of Visual Arts

INSTRUCTOR KEVIN O'CALLAGHAN

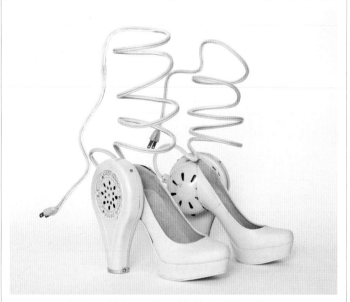

Student: **Nakyung Youn** | **School of Visual Arts**

INSTRUCTOR SHAWN MEEK

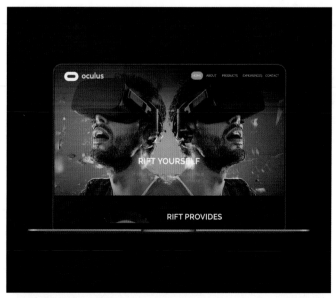

Student: **Klovit Kikanga** | **Metropolitan State University of Denver**

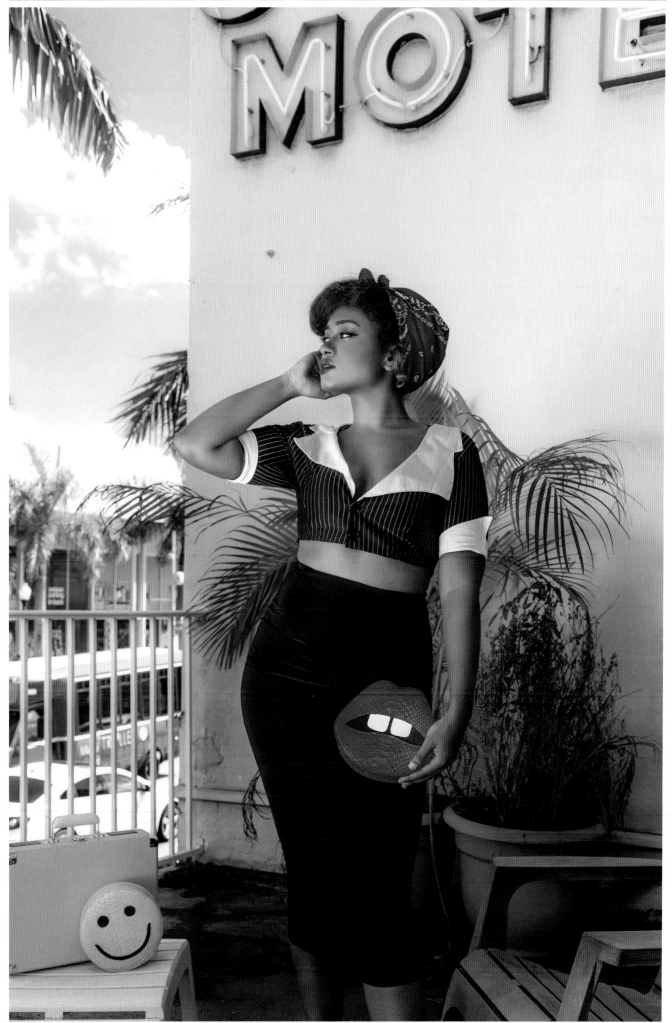

Students: Yasmine Nur, Annie Bardhwaj, Tierra Armstrong
Miami Ad School Wynwood

Beauty & Fashion | Photography

INSTRUCTOR TAYLOR BAREFORD

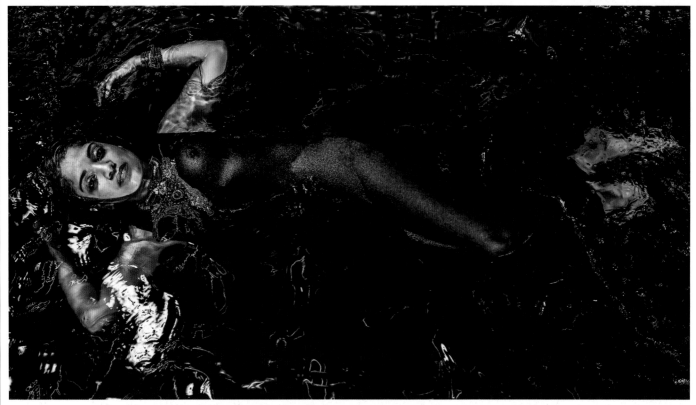

Student: Kristopher Burris | Art Institute of Atlanta

INSTRUCTOR HANK RICHARDSON

Student: Amaya De Vleeschauwer | Miami Ad School Visit website to view full series

Student: Andrew Segovia | **Art Institute of Atlanta** Portraits | Photography

Student: Alexandra Sheaffer | Art Institute of Atlanta

INSTRUCTOR DUSTY CROCKER

Student: Mackenzie Malpass | Texas Christian University

INSTRUCTOR TAYLOR BAREFORD

Student: Marisa Bedard | Art Institute of Atlanta

INSTRUCTOR LYNDA GREEN

Student: Tyler King | Art Institute of Atlanta

INSTRUCTOR **PIPPA SEICHRIST**

Students: Shivani Shah, De`ja Pocahontas Mays | Portfolio Center

INSTRUCTOR **GINNY DIXON**

Student: Ryan Blackmon | Miami Ad School

INSTRUCTOR **PIPPA SEICHRIST**

Student: Justin Tompkins | Portfolio Center

INSTRUCTOR LYNDA GREEN

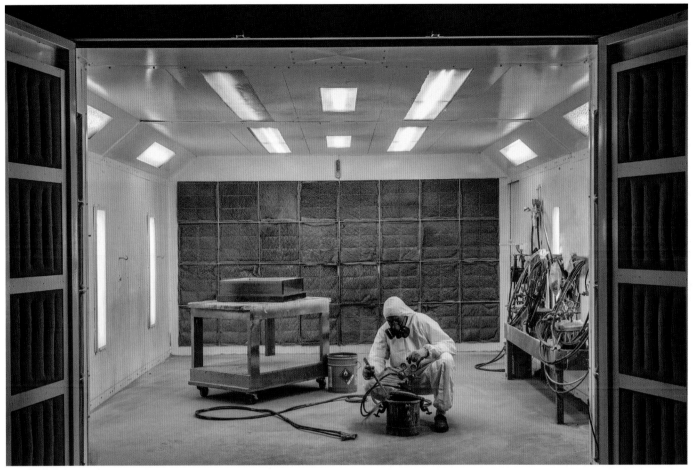

Student: Tyler King | Art Institute of Atlanta

INSTRUCTOR ZORAYMA GUEVARA

Student: Ana Miraglia | Miami Ad School

INSTRUCTOR LYNDA GREEN

Student: Marisa Bedard | Art Institute of Atlanta

INSTRUCTOR RYAN RUSSELL FILM TITLES

Student: Daniel Ziegler | Pennsylvania State University

INSTRUCTOR RYAN RUSSELL FILM TITLES

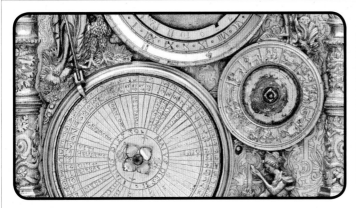

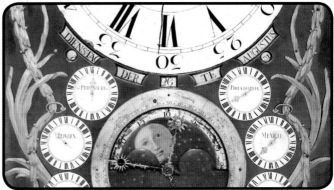

Student: Colleen Wade | Pennsylvania State University

INSTRUCTOR ORI KLEINER FILM TITLES

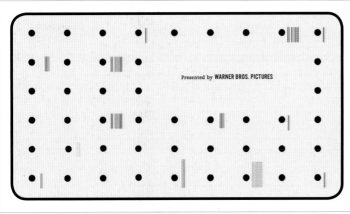

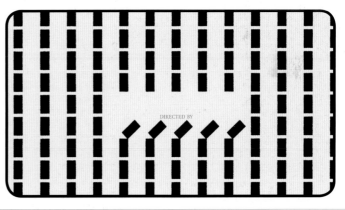

Student: Julia Yu | School of Visual Arts

INSTRUCTOR RYAN RUSSELL FILM TITLES

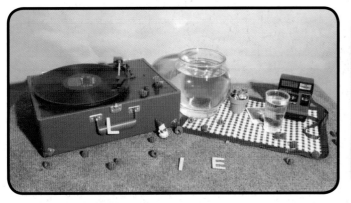

Student: Emily Adar | Pennsylvania State University

INSTRUCTOR RYAN RUSSELL FILM TITLES 🇺🇸

Student: Eleanor Wing | Pennsylvania State University

INSTRUCTOR MARK WILLIE INTERACTIVE DESIGN 🇺🇸

Student: Natalie Vaughan | Drexel University

INSTRUCTOR ADAM GAULT MOTION GRAPHICS 🇺🇸

Student: Will Jin | School of Visual Arts

INSTRUCTOR HYE SUNG PARK MOTION GRAPHICS 🇺🇸

Student: Park So Hyun | School of Visual Arts

INSTRUCTOR ORI KLEINER MOTION GRAPHICS

Student: **Daris Dazhi Wang** | School of Visual Arts

INSTRUCTOR ORI KLEINER MOTION GRAPHICS

Student: **Lisa Kim** | School of Visual Arts

INSTRUCTOR ORI KLEINER MOTION GRAPHICS

Student: **Yewon Lee** | School of Visual Arts

INSTRUCTOR HYE SUNG PARK MOTION GRAPHICS

Student: **Lynn Hwirin Park** | School of Visual Arts

INSTRUCTOR JUNGIN YUN MOTION GRAPHICS

Student: Minha Kim | School of Visual Arts

INSTRUCTOR ADAM GAULT MOTION GRAPHICS

 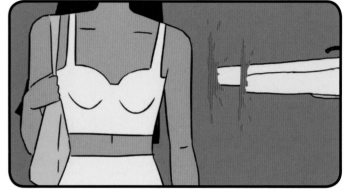

Student: Connie Van | School of Visual Arts

INSTRUCTOR ORI KLEINER MOTION GRAPHICS

Student: Hsiaopu Chang | School of Visual Arts

INSTRUCTOR ORI KLEINER MOTION GRAPHICS

Student: Yijia Xu | School of Visual Arts

INSTRUCTOR ORI KLEINER MOTION GRAPHICS

Student: Yijia Xie | School of Visual Arts

INSTRUCTOR ORI KLEINER MOTION GRAPHICS

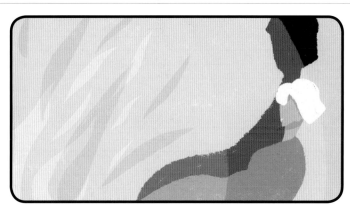

Student: Qiuyu Guo | School of Visual Arts

INSTRUCTOR EDUARD ČEHOVIN MOTION GRAPHICS

Student: Rok Malovrh | Academy of Fine Arts and Design

INSTRUCTOR JUNGIN YUN MOTION GRAPHICS

Student: Luella Mendoza | School of Visual Arts

INSTRUCTOR ADAM GAULT　　　　　　　　　　MOTION GRAPHICS

Student: Nina Tsur | School of Visual Arts

INSTRUCTOR HYE SUNG PARK　　　　　　　　　MOTION GRAPHICS

Student: Seongjin Yoon | School of Visual Arts

INSTRUCTOR CHRISTOPHER PALAZZO　　　　　MOTION GRAPHICS

Student: Shiyi Xiang | School of Visual Arts

INSTRUCTOR JUNGIN YUN　　　　　　　　　　MOTION GRAPHICS

Student: Zuleika Ishrak | School of Visual Arts

INSTRUCTOR ORI KLEINER | MOTION GRAPHICS

Student: Keiko Hirakawa | School of Visual Arts

INSTRUCTOR GERALD SOTO | MOTION GRAPHICS

Student: Elizabeth Galian | School of Visual Arts

INSTRUCTOR ORI KLEINER | MOTION GRAPHICS

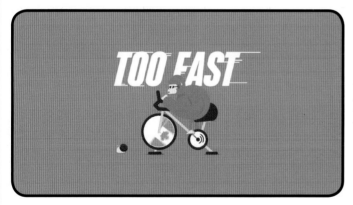 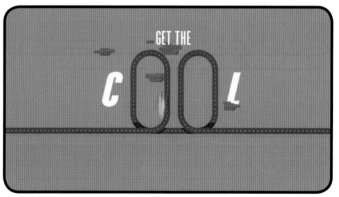

Student: Hyungjin Park | School of Visual Arts

INSTRUCTOR DONG-JOO PARK | MOTION GRAPHICS

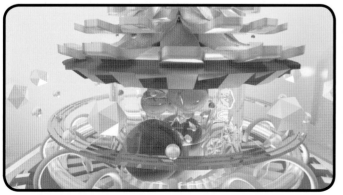 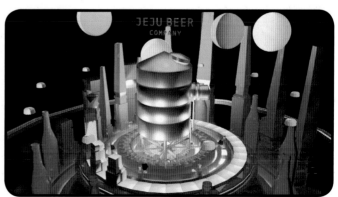

Student: Heejin Jung | Hansung University of Design & Art Institute

INSTRUCTOR HYE SUNG PARK MOTION GRAPHICS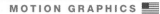

Student: So Hyun Lee | School of Visual Arts

INSTRUCTOR JUNGIN YUN MOTION GRAPHICS

Student: Gina Lee | School of Visual Arts

INSTRUCTOR UNATTRIBUTED PROMOTIONAL

Students: Nicolas Perez-Molina, Mauricio Borda, Martin Otero | Miami Ad School

INSTRUCTOR STACEY FENSTER PROMOTIONAL

Student: Ashutosh Thakkar | Miami Ad School

INSTRUCTOR **COURTNEY WINDHAM** PROMOTIONAL

Student: Heidi Kieffer | Auburn University

INSTRUCTORS **JEREMY HOLMES, KAREN WATKINS** SHORT FILMS

Student: Daniel Rodgers | West Chester University

INSTRUCTOR **UNATTRIBUTED** SHORT FILMS

Students: Yasmine Nur, Annie Bardhwaj, Tierra Armstrong | Miami Ad School Wynwood

INSTRUCTOR **RAJATH RAMAMURTHY** TV/WEB COMMERCIALS

Student: Ashutosh Thakkar | Miami Ad School

INSTRUCTOR PAULA SCHER

Student: Hae Jung Jun | School of Visual Arts

INSTRUCTOR MARK WILLIE

Student: Jenna Lecours | Drexel University

INSTRUCTOR ADAM GAULT

Student: Jonghoon Kang | School of Visual Arts

INSTRUCTOR HYE SUNG PARK

Student: Jae Yearn Kim | School of Visual Arts

INSTRUCTOR JUNGIN YUN

Student: Jihye Kang | School of Visual Arts

INSTRUCTOR JUNGIN YUN

Student: Ryoko Kondo | School of Visual Arts

INSTRUCTOR CHRISTOPHER PALAZZO

Student: Won Joon Khil | School of Visual Arts

INSTRUCTOR ORI KLEINER

Student: Yumin Kwon | School of Visual Arts

INSTRUCTOR CHRISTOPHER PALAZZO

Student: Darius Pippi | School of Visual Arts

INSTRUCTOR JUNGIN YUN

Student: Jihye Kang | School of Visual Arts

INSTRUCTOR HYE SUNG PARK

Student: Koki Kobori | School of Visual Arts

INSTRUCTOR HYE SUNG PARK

Student: Koki Kobori | School of Visual Arts

INSTRUCTOR JUNGIN YUN

Student: Ryoko Kondo | School of Visual Arts

INSTRUCTOR GERALD SOTO

Student: Seulgi Kim | School of Visual Arts

INSTRUCTOR GERALD SOTO

Student: Seulgi Kim | School of Visual Arts

INSTRUCTOR ORI KLEINER

Student: Tianyu Jin | School of Visual Arts

INSTRUCTOR ORI KLEINER

Student: Xuening E | School of Visual Arts

INSTRUCTOR ORI KLEINER

Student: Sarah Ji-Won Kim | School of Visual Arts

INSTRUCTOR HYE SUNG PARK

Student: Wooyoung Kim | School of Visual Arts

INSTRUCTOR ORI KLEINER

Student: Sarah Ji-Won Kim | School of Visual Arts

INSTRUCTOR ORI KLEINER

Student: Jung Eun Han | School of Visual Arts

INSTRUCTOR ORI KLEINER

Student: Hyewon Lee | School of Visual Arts

INSTRUCTOR ORI KLEINER

Student: Se Jin Joo | School of Visual Arts

INSTRUCTOR CHRISTOPHER PALAZZO

Student: Anelisa Rosario | School of Visual Arts

INSTRUCTOR HYE SUNG PARK 🇺🇸

Student: Min Jae Lee | School of Visual Arts

INSTRUCTOR RENÉE STEVENS 🇺🇸

Students: A. Wortz, L. Naland, C. Lee, J. Sheldon | Syracuse University

INSTRUCTOR GERALD SOTO 🇺🇸

Student: Elizabeth Galian | School of Visual Arts

INSTRUCTOR ORI KLEINER 🇺🇸

Student: Dorothy Tang | School of Visual Arts

INSTRUCTOR GERALD SOTO 🇺🇸

Student: Christopher Owen George | School of Visual Arts

INSTRUCTOR HYE SUNG PARK 🇺🇸

Student: Jenny Mascia | School of Visual Arts

INSTRUCTOR JUNGIN YUN 🇺🇸

Student: Ryoko Kondo | School of Visual Arts

INSTRUCTOR HOON-DONG CHUNG ◉

Student: Soobin Yeo | Dankook University

INSTRUCTOR BRIAN BOYLE

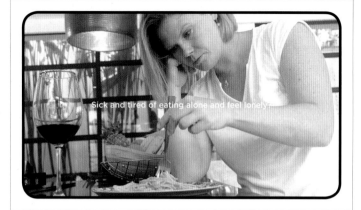

Student: **Na Yeon Kim** | Art Center College of Design

INSTRUCTOR KIMBERLY CAPRON GONZALEZ

Student: **Naadiya Mills** | Miami Ad School

INSTRUCTOR PIPPA SEICHRIST

Student: **Justin Tompkins** | Portfolio Center

INSTRUCTOR ZORAYMA GUEVARA

Student: **Vanessa Bittante** | Miami Ad School

INSTRUCTOR TU PHAN

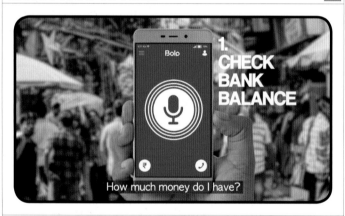

Students: **D. Lee, P. Tabah, D. Desai** | Miami Ad School

INSTRUCTOR KIMBERLY CAPRON GONZALEZ

Student: **Alexandra Floresmeyer** | Miami Ad School

INSTRUCTOR CARLOS RONCAJOLO

Student: **Bader Salahuddin, Qi Shen** | Miami Ad School Wynwood

INSTRUCTOR BILL GALYEAN

Student: **Jessica Dawson** | Texas Christian University

ADVERTISING:

Jorel Dray | Art Director | Jorel Dray
Biography: Jorel is an instructor of graphic design at Madison College and creative director/partner for Levee Labs—a small, but mighty, web design and software development agency. He has nearly 10 years of experience from his time at Hiebing, where he started as an entry-level interactive designer and left a senior art director/partner. Jorel's self-proclaimed lifelong learner with a broad skill-set ranging from traditional print and branding to website design, animation, and just about anything in between. He's a sucker for great ideas with beautiful executions regardless of the medium. His work has been featured in Graphis, thedieline.com, and Comm Arts.
Commentary: It's been an honor to participate as a judge for the New Talent Competition. All the heart, soul and passion put into the work was clearly visible. The social services category was particularly impressive—showcasing some very timely and thought provoking ideas. Great job, everyone!

John Fairley | Creative Director | Curious Productions
Biography: With over 25 years as a Designer, Art Director and Creative Director, John has overseen integrated advertising campaigns across emerging channels, TV, print, digital and social, as well as leading rebranding and design for large scale, corporate identity systems. He has worked and consulted for clients such as Adidas, American Express, BBC, Castrol, Emirates, Estée Lauder, Nike, Paramount Pictures, Parker Pens, Penguin Random House, Sony, Unipart, Universal Pictures, Vodafone, and the Warner Music Group. "Make great creative work. Collaborate with the very best and be genuine and kind to people in the process" has always been his mantra. Working directly with his clients, John has developed strong relationships that have consistently delivered strategic and emotionally resonant creative work, as well as successfully achieving rewarding business outcomes.
Commentary: I've had the great privilege to judge this year's New Talent and I thank Graphis for the opportunity to see the early work of those who will no doubt go on to have long and successful careers in the creative industries. It's wonderful to do something that you love and a lot of the inventive work I judged showed great passion, commitment and devotion to the pursuit of strong, impactful and meaningful ideas. The concepts on display throughout a wide range of categories has been extremely broad, rich and diverse and it pleased me greatly to see such a high level of craft in many of the executions on show. The calibre of talent submitted into the competition this year has been fantastic and I congratulate everyone who's entered.

Ashleigh Maule-Ffinch | Art Director | Red Square
Biography: Ashleigh finds beauty in honest design that reconnects people to the present. Having studied and worked between Paris, Montpellier, London, and San Francisco over the last 12 years, she's picked up some useful insights into different cultures. She holds a Masters in Visual Communications from University of the Arts London, where she focused on visual culture and design for sustainability. Since then, she's worked with companies such as Greenpeace, Futerra, Unilever, The London Legacy Development Corporation, Danone, Engine Advocacy, and The Hattery. Currently, she heads up the brand design team at Flipboard. Her career path has been shaped by the belief that all businesses have the power and responsibility to make the world a more beautiful place, and that the best way to predict the future, is to help design it (Thanks Bucky).

Michael Schillig | Creative Director | PPK
Biography: Michael has been with PPK for over 13 years and has created many award-winning campaigns for diverse local, regional and national clients. He's worked with Circle K, Tires Plus, Pirelli Tires, Sweetbay Supermarket, Tampa Bay Rays, GTE Financial, Big Boy Restaurants, Wichita Brewing Company, and Touch Vodka, just to name a few. However, he has received the most gratification from helping several nonprofits gain national creative acclaim, such as Big Cat Rescue, Metropolitan Ministries, ASPCA, the National Pediatric Cancer Foundation, Jailhouse Fire Hot Sauce, and the Florida Aquarium. In the process, his work has been showcased in the Graphis Advertising Annual for 12 years in a row, including being a seven-time winner of the coveted Graphis Platinum Award. He's also been honored multiple times in the International Radio Mercury Awards, OBIE Awards, National ADDY Awards, Communications Arts, Lürzer's International Archive, How International Design, Print Regional Design, and ADWEEK, among others. When he's not writing, Michael is probably spending time with his wonderful wife, Gisela, or enjoying his other strong love – tennis.
Commentary: I have to be honest. Some of the ideas were so good, so inventive and so well executed, they even inspired a seasoned creative director like myself. And made me little envious too.

DESIGN:

Masahiro Aoyagi | Designer | Toppan Printing Co., Ltd.
Biography: Born in 1975, Masahiro Aoyagi studied the concept of visual transmission of design at Chiba University's Faculty of Engineering, Department of Industrial Design (presently the Department of Design Science). He subsequently joined Toppan Printing Co., Ltd. after graduating in 1998. He currently belongs to the Toppan Idea Center, primarily working in the field of corporate communications handling art direction for calendars issued by contracting companies. Aoyagi also participates in calendar productions using paintings, pictures, typography, and various other motifs as subject matter, seeking new forms of printing expressions using unconventional processing, decorative printing, and collaborations with creators from Japan and abroad.
Commentary: I examined the categories in my specialized field and it all felt very fresh. The work that the students came up with had an undoubtedly new perspective that was indeed very interesting. They clearly designed their works with free expression, seldom taken hold by tradition. The work was simply outstanding.

Rikke Hansen | Creative Director | Toppan | Biography: Born in Denmark in 1975, Rikke is a Graphic Designer, Educator and owner of a letterpress studio. She works and teaches in a field in the intersection between language, culture and space. She has a passion for graphic design and typography and for working with design methods that provide students with ways to fundamentally understand society and its stakeholders' needs, and how to drive these processes to useful results. For several years she has been working with product development, branding, and consulting for companies and organizations. She has been exhibiting work and giving lectures and workshops internationally in Europe, Middle East, Asia and America.
Commentary: It is always a pleasure to see student work from around the world. As a student, you are still on a development process on the road to becoming a professional designer. In the review I looked for works that had something new and edgy, and generally if the product corresponded to the purpose and the described task, goals and context. Congrats to all the winners.

Jennifer Morla | Creative Director | Morla Design
Biography: Jennifer Morla is President and Creative Director of Morla Design, a multi-disciplinary design firm located in San Francisco. With over 300 awards of excellence, her work has been recognized by virtually every organization in the field of visual communication. Jennifer lectures and judges internationally, has taught at California College of the Arts, and is the recipient of graphic design's most honored awards: The Cooper Hewitt, Smithsonian National Design Museum Award, and the AIGA Medal. Her upcoming book, Morla: Design, offers insight into her creative process and shares over 150 of her studio's projects in print, branding, packaging, web, and retail store design. https://www.indiegogo.com/projects/morla-design#/.
Commentary: The quality of the work submitted to the New Talent Annual was superb. It was refreshing to see many unique solutions that did not result in stylistic cliches.

Kevin Shaw | *Founder, Creative Director* | *Stranger & Stranger*
Biography: Kevin founded Stranger and Stranger in 1994 to specialize in alcoholic beverage packaging. Stranger is now one of the leading firms in the field with studios in London, New York, and San Francisco and advises everyone from huge corporations like Bacardi and Treasury, on global brands like Jack Daniels and Lindemans, all the way down to one man startups. Stranger labels up over a billion bottles and cans every year, winning hundreds of awards along the way and has created brands worth hundreds of millions of dollars.
Commentary: It's always interesting judging college talent. On the one hand, you're aware that these people are very young. On the other hand, you're mindful that this time in their lives should be the most creative they will ever be: no difficult clients, no silly deadlines, no budget constraints, no production restrictions, no consumer research. So I'm always looking for solutions that don't look like they exist already. After all, everything that exists already was actually designed a while back, and in this competition I found a few things that I actually wish I'd done myself. I can't be more complimentary than that.

Bryan Tsai | *Designer* | *3N6 Communications*
Biography: Bryan Tsai, was born in 1978 in Yunlin, Taiwan. Tsai is engaged in advertising creativity, image vision, brand design and other work. While serving customers, he enjoys embodying a unique perspective in the work. During his time studying politics and advertising, he found that there were many similarities between the two. For personal reasons, advertising design matters to him more than political affairs.
Commentary: As the name suggests, visual design pays attention to the layout of the eyes. Complex information needs to be refined into sublime images or compositions. High scores are usually simplified, pure or complex masterpieces!

PHOTOGRAPHY:

Athena Azevedo | *Photographer, Creative Strategist* | *IF Studio*
Biography: Athena Azevedo is a photographer, art director, producer, and curator. Her photographs are often bold, colorful and highly graphic, rooted in journalism and fine art. As the in-house photographer at IF Studio, Athena's work has won numerous awards since 2014. Athena's photography has been featured in ad campaigns in Vanity Fair, Architectural Digest, New York Magazine, and the Wall Street Journal. She has photographed top models Bobby Roache and Tereza Bouchalova, internationally renowned Chef Nobu, as well as portraits of significant emerging and established artists, such as composer João MacDowell, virtual reality filmmaker Eliza McNitt, painter Kristin Simmons, and choreographer Regina Miranda.

Ricardo de Vicq de Cumptich | *Photographer*
Biography: Ricardo de Vicq de Cumptich began his career in photography in the 1970s, portraying artists for album covers, featuring Bossa Nova icons. Living and working in São Paulo since the 1980s, he has been one of the biggest names in Brazilian culinary photography. He works for advertising, design, and magazine publishing agencies. His work in Fine Art has been exhibited in collective and individual exhibitions, both national and international, in Rio de Janeiro, São Paulo, New York, Paris, Florence, Los Angeles, Vermont, Chicago, Berlin, among others.
Commentary: It was a pleasant surprise to see good work in different categories of photography in Graphis New Talent Annual 2019. Having the courage to try is important to the success of a good photographer. Photography comes from experience. This is how we develop and discover new horizons. With the revelation of new talent, we can continue on the paths of those who preceded them.

Dave Krovblit | *Photographer*
Biography: Krovblit's work is an experience, both visual and cerebral. Each new piece exhibits well-crafted, colourful images steeped in highly conceptual, contemporary themes. Working with a wide variety of mediums, including photography, collage, sculpture and printmaking, he expresses fresh and provocative stories. Currently living in California, David was born and raised in Toronto, Canada. He studied photography at Ryerson University. His career spans over a decade. He has worked professionally as an advertising photographer, shooting many national and international brands and campaigns. He has won numerous awards and recognition for his work in the field.
Commentary: It is very exciting to be given the opportunity to spot the next visionaries of our time. The work that I had the pleasure of judging showed promise. I look forward to following the careers of these young pioneers.

The students' work, both technically and emotionally advanced, is proof that the next generation thinks multidimensionally.

Athena Azevedo, *Photographer, Creative Strategist, IF Studio*

It is very exciting to be given the opportunity to spot the next visionaries of our time.

Dave Krovblit, *Photographer*

PLATINUM ADVERTISING WINNERS:

16 NATURAL WHITENESS | School: Miami Ad School
Instructor/Professor: Hank Richardson | Student: Alana Vitrian
Assignment: Create poster concepts related to a product: CLOROX.
Approach: I found that there is nothing more whitening than CLOROX. The idea is to show the power of CLOROX in the most natural setting. And what is more natural than animals?

17 FABER-CASTELL - NATURALS | School: Miami Ad School Hamburg | Instructor/Professor: Patrik Hartmann | Art Director: Abdelrahman Galal | Copywriter: Samar Singh
Assignment: Make a print ad for Faber-Castell showing how their pencils use colours that have been extracted from nature.
Approach: We show how Faber-Castell pencils have colour ranges as authentic and vibrant as the skin of a chameleon.

17 THE CAMPBELL SOUP | School: School of Visual Arts
Instructor/Professor: Eileen Hedy Schultz | Student: Jae Wook Baik
Assignment: Campbell's Soup likened to rivers that have the same depth.
Approach: A visual representation of the analogy that the deep taste and flavor of Campbell's Soup is like a deep river. I also tried to use the texture of red tomato soup, which is the opposite color in the existing blue river, to deliver to the audience a simple idea and visual entertainment.

18 NETFLIX BINGE ON | School: School of Visual Arts | Instructor/Professor: Frank Anselmo | Students: Huiwen Ong, Yuran Won
Assignment: This was an assignment for Frank Anselmo's class, Unconventional Advertising. The strategy was to "Binge On," and to showcase the level of commitment you have when you are binge-watching on Netflix. "Binge" is commonly described as negative, but Frank wanted us to associate it with something positive.
Approach: I recalled my personal experience with bingeing and how I refused to sleep because I could not get my eyes away from my laptop. This idea inspired the "eyebags" in this visual. Having these eyebags might seem negative, but my take to this was that the bags are a form of achievement.
Result: After all my hard work, my professor liked this final version and weeks after the semester ended, I decided to send it to competitions.

19 FUJIFILM INSTAX: CATCH THE MOMENT | School: The Newhouse School, Syracuse University | Instructor/Professor: Mel White | Student: Zhixin Fan
Assignment: Print ads for FUJIFILM Instax camera.
Approach: One of the great benefits of using this camera is the printed photos you get immediately after taking your shots.
Result: Breathtaking images printed instantly.

20 OUR DRESS CODE IS NATURE | School: Hansung University of Design & Art Institute
Instructors/Professors: Dong-Joo Park, Seung-Min Han | Students: Su Bin Kim, Hong Ye Rim
Assignment: This is a public relations poster for the outdoor brand Patagonia. At a moment when conservation has become a social issue, I wanted to show the Patagonia philosophy of a building a company for nature.
Approach: In order to make it easier for consumers to understand the goals of Patagonia, I approached it as an idea using mountains, which are symbols of nature.
Result: Eventually, we completed a project called, "Our dress code is nature."

21 DORITO POSTER | School: The Newhouse School, Syracuse University
Instructor/Professor: Kevin O'Neill | Student: Yuxin Xiong
Assignment: Doritos is a snack that you can eat in different ways.
Approach: People would like to eat Doritos in interesting ways when they watch movies at home. Doritos is good company for whatever kinds of movies you watch.
Result: Shows that Doritos can fit into different kinds of classic movie posters.

22 SCREAMFEST | School: Texas A&M University Commerce
Instructor/Professor: Josh Ege | Student: Nicole Glenn
Assignment: The task was to create a poster promoting the largest and longest running horror film festival in the United States, the Screamfest Horror Film Festival.
Approach: A common theme of horror films is death, so I wanted to approach this piece that ties film to horror in a very literal way using photography.
Result: Using a film reel to tie a noose and scratched typography in the walls, the work captures the full essence of a horror film.

23 TIDE TO GO PRINT AD | School: The Newhouse School, Syracuse University
Instructor/Professor: Mel White | Student: Keren Mevorach
Assignment: Create a print ad for Tide to Go that shows its ability to remove stains.
Approach: People hate staining their clothing. With Tide to Go, people have the ability to fight their toughest stains.
Result: A ketchup bottle represented as a punching bag. This demonstrates the fact that Tide to Go has the ability to fight the toughest stain makers out there.

24 MCDONALD'S—HOLD ONTO HAPPINESS | School: Miami Ad School
Instructor/Professor: Larry Gordon | Student: Chase Harris
Assignment: Create a unique and refreshing campaign for the McDonald's Happy Meal.
Approach: As we grow older, we often forget—and even, stifle—the small experiences that bring us joy. The "Hold Onto Happiness" campaign aims to help adults remember the simple joys of life by turning everyday objects into the iconic Happy Meal—representative of the joy you felt as a child when you were handed that smiling red box.

ADVERTISING GOLD WINNERS:

26 WWF: LIKE A UNICORN | School: Miami Ad School NY
Instructor/Professor: Unattributed | Student: Peter Fox | Art Director: Chris Serrano
Assignment: Create a campaign for WWF to raise awareness for an endangered species.
Approach: Flip the notion of endangered species on its head. If we do nothing, these animals will be remembered the same way we remember mythical creatures. The metaphor captures people's attention in a way that makes them stop.
Result: The ad makes a simple yet cogent PSA for raising awareness for this issue.

26 BMW CLIMATE CONTROL PRINT | School: School of Visual Arts
Instructor/Professor: Frank Anselmo | Students: Jack Jungho Hwang, Han Meng

27 SMART CAR | School: The Newhouse School, Syracuse University | Instructors/Professors: Mel White, Kevin O'Neill | Copywriter: Rebecca Bregman | Art Director: Bianca Bergeron
Assignment: Create a print ad for Smart Car
Approach: Parking spots are hard to find, but when you have a smart car your parking options are endless.
Result: Parking spaces just for smart car, indicated by "You'll always find a spot."

27 BMW HEATED BILLBOARD | School: School of Visual Arts
Instructor/Professor: Frank Anselmo | Students: Junho Lee, Evan Choi

28 AUDI - BULLETPROOF | School: Miami Ad School Hamburg | Instructor/Professor: Tobias Schwaiger | Art Director: Abdelrahman Galal | Copywriter: Samar Singh
Assignment: Make a print ad for Audi armoured vehicles showing how it provides protection to diplomats and businessman against attacks.
Approach: Show the aftermath of a gun attack on an Audi, which escapes unharmed.
Result: Student work.

28 BMW PIN-POINT SCHEDULING | School: School of Visual Arts
Instructor/Professor: Frank Anselmo | Students: Rogier van der Galiën, Robin van Eijk, Jens Marklund, Jack Welles

29 WAZE OUTSMART TRAFFIC | School: School of Visual Arts
Instructor/Professor: Frank Anselmo | Students: Jisoo Hong, Minyoung Park

29 EVADE THE ELEMENTS | School: Miami Ad School Europe | Instructor/Professor: Florian Weitzel | Art Director: Claudio Castagnola | Copywriter: Jared Liebmann
Assignment: Create awareness for BMW xDrive— the new, smart four-wheel system.
Approach: People drive selfishly. The thing is, they're not the only ones afraid to get hit– and it's time they come to that realization.
Result: xDrive vehicles have skyrocketed in sales, while providing exceptional safety that has placed BMW above the industry average.

30 OGX SHAMPOO - 'BEAT BRITTLE' | School: The Newhouse School, Syracuse University | Instructor/Professor: Mel White | Student: Zantore Buoy
Assignment: Create visual solution ad for a beauty product company of our choice. I decided on OGX Shampoo.
Approach: I feel that the tagline 'Beat Brittle' works well with this campaign. Animals tend to have unkempt, brittle hair, so they were perfect for this tagline and print ad.
Result: Three visual solution print ads. Including a Lion, Sheep and Porcupine.

31 FENTY BEAUTY – TOGETHER | School: Miami Ad School
Instructor/Professor: Lorraine McNeill-Popper | Student: Jules Masson
Assignment: Create an ad campaign for a brand of your choice.
Approach: I combined imagery from two different FENTY models to create a seamless whole, showcasing the brand ideals of unity and equal representation.
Result: These print ads are a striking way to highlight the FENTY values and raise awareness about inequality in the beauty industry.

32 ANCHOR STEAM | School: Miami Ad School | Instructor/Professor: unattributed
Student: Hridaynag Kooretti | Copywriter: Tajj Badil-Abish
Assignment: A Print series for Anchor Steam. The Anchor Brewing Company has a century-and-a-half long history in the San Francisco brewing scene.
Approach: Showcase Anchor Steam as an integral part of San Francisco.
Result: We haven't been given the key to the city… Yet. But you've heard about us ever since you arrived.

33 COALITION FOR THE HOMELESS | School: Portfolio Center
Instructor/Professor: Theo Rudnak | Student: Mark Hyde
Assignment: Take a social cause and create a campaign that increases donations.
Approach: I chose the Coalition for the Homeless. Inspired by the photographic work of Jacob Riis, I chose stark black and white photography matched with witty, location-specific copy to execute this work.
Result: The instructor thought the rationale and inspiration were right on the money, creating a campaign that is simple but powerful.

34 PHILIPS HUE | School: School of Visual Arts
Instructor/Professor: Eileen Hedy Schultz | Student: Nuri Park
Assignment: To choose a product and create a series of print ads for the brand.
Approach: The name of the product I chose was Hue by Philips. Hue is a lamp that allows the users to change the colors of lights by an application. I wanted to show that Hue is a good platform to express one's mood.
Result: I came up with various moods that can be applied at any time.

35 THE STAIN WE CAN'T WASH | School: Miami Ad School
Instructor/Professor: Zorayma Guevara | Student: Lorenzo Della Giovanna
Assignment: A series of print ads with an impactful and meaningful message.
Approach: Research a brand that has the power to convey a strong message but that doesn't often do so.
Result: The contrast between the welcoming color and startling message left the audience interested in the topic and raised a conversation about often forgotten facts.

36 GOPRO INDESTRUCTIBLE | School: The Newhouse School, Syracuse University | Instructors/Professors: Mel White, Kevin O'Neill | Art Director: Andrew Celmins | Copywriter: Annie Turner
Assignment: Create a print campaign that differentiates GoPro from other cameras in an increasingly saturated market.
Approach: GoPro must prove that they are truly indestructible, and the only camera durable enough for a thrill seeker's adventurous lifestyle.
Result: This print campaign will compare the GoPro camera to the toughest, most durable objects in the world, proving that the camera is truly indestructible.

37 USPS - SEND SIMPLE | School: Miami Ad School | Instructor/Professor: Rajath Ramamurthy | Student: Matias Cachiquis | Copywriter: Isaac Sorenson
Assignment: As communication technology moves forward, older generations are starting to feel more and more removed from the conversation.
Approach: USPS wanted to create a series of print ads to remind us that sometimes new technology can be intimidating and new communication can be isolating.

38 FROM NATURE TO NATURE | School: Hansung University of Design & Art Institute
Instructors/Professors: Dong-Joo Park, Seung-Min Han | Students: Kim Su Bin, Hong Ye Rim
Assignment: At a moment when conservation has become a social issue, I wanted to show the Patagonia philosophy of a building a company for nature.
Approach: In order to make it easier for consumers to understand the goals of Patagonia, I approached it with the idea of being mixed up with nature.
Result: With a concept of conservation from beginning to end, it was decided that we would create a project that would start with nature and return to nature.

38 AMAZON FRESH | School: The Newhouse School, Syracuse University
Instructor/Professor: Mel White | Student: Caroline Chipman
Assignment: Create a print campaign for Amazon Fresh.

Approach: Emphasize how your food/produce will always be fresh, even when it's delivered to your house.
Result: The combination of Amazon and Whole Foods has created a way for the freshest foods to be delivered faster.

39 BAN ASSAULT WEAPONS | School: School of Visual Arts
Instructor/Professor: Unattributed | Students: Tamara Yakov, Sujin Lim, Gaeun Oh
Assignment: Make an ad that helps end gun violence.
Approach: We wanted to show the absurdity of having an assault weapon in your home by comparing that to using ridiculous tools for menial tasks. If you wouldn't use a flamethrower to light a candle, why would you use an AR-15 to protect your home?
Result: A campaign showing three different ways having an assault weapon in your home is dangerous and unnecessary.

40 MOPHIE POWER ANYWHERE | School: The Newhouse School, Syracuse University
Instructor/Professor: Mel White | Student: Helena Starrs
Assignment: Execute a series of print ads to show the convenience of Mophie batteries.
Approach: Convey the product benefit (ease of use) by displaying how mobile devices can be charged anywhere at any time.
Result: Three print ads depicting a user charging their phone in front of a church congregation, in the air parasailing, and atop a rollercoaster.

40 NINTENDO - REAL LIFE IS BORING | School: Unattributed
Instructor/Professor: Unattributed | Student: Diane Danneels
Assignment: Nintendo characters live interesting lives in their video games, but if they were brought into the real world their life would not be as exciting.
Approach: We took recognizable Nintendo characters such as Mario, Donkey Kong, and Ash Ketchum, and imagined what their lives would be like if they were in the real world.

41 THE OCEAN CLEANUP CAMPAIGN | School: The Newhouse School, Syracuse University | Instructor/Professor: Mel White | Student: Keren Mevorach
Assignment: Create a print campaign for The Ocean Cleanup.
Approach: People have a hard time imagining the future effects plastic has on marine life. Plastic in the ocean severely harms various species of marine animals.
Result: Marine animals made out of the plastic that continues to pollute the oceans.

42 HUMAN RIGHTS POSTER | School: Texas A&M University Commerce
Instructor/Professor: Rick Gavos | Student: Skyler Wheeler
Assignment: For this assignment, my Creative Thinking class was given a Human Rights issue for which we had to visually depict in a poster design.
Approach: I used a dark muted illustration to depict the reality of coal plants in contrast to President Trump's comment on the clean coal process.
Result:My professor commented, "Beautiful illustration and color palette."

43 EXPERTS IN INDULGENCE | School: The Newhouse School, Syracuse University
Instructors/Professors: Mel White, Kevin O'Neill | Student: Emma Bhayani

44 NO ONE PLANS AN OVERDOSE | School: Miami Ad School
Instructor/Professor: Zorayma Guevara | Students: Ana Miraglia, Diane Danneels
Assignment: Raise awareness around opioid addiction.
Approach: A visual way of showing that when it comes to opioids, no one is in.

44 STOPOPIOIDOVERDOSE.ORG CRUSHED | School: School of Visual Arts
Instructor/Professor: Frank Anselmo | Students: Huiwen Ong, Yuran Won

45 WORLD HEALTH ORGANIZATION PILL CONTAINER NEEDLE
School: School of Visual Arts | Instructor/Professor: Frank Anselmo
Students: Huiwen Ong, Yuran Won, Sujin Lim, Taekyoung Debbie Park

46 ANTI-VAPING/STILLBLOWINGSMOKE.ORG
School: New York Institute of Technology | Instructor/Professor: Bob Gill
Students: Georgios Radamanthys Chourdakis, Louis D'Amato
Assignment: Create a PSA about a vice that Generation Z faces today.
Approach: Juuling is so addictive that users often feel like it is becoming a physical part of them. We wanted to show users and potential users that this new trend will have long term implications and while it is hard to quit an addiction; they can do it.
Result: The professor loved it, and our test audience, mostly 16-21 year old vape users, felt that it spoke to them and they could relate to this feeling of unbreakable addiction.

47 THE OD THRIFT STORE | School: Portfolio Center
Instructor/Professor: Pippa Seichrist | Student: Mark Hyde
Assignment: Combat America's opioid crisis in a way that is engaging and impactful.
Approach: We collected belongings of those who died from an opioid overdose and allowed anyone to buy them. They don't know what they're buying until see the hangtag.
Result: In various shopping centers, we'll open "OD Thrift Stores" and stock each store with clothes, shoes, electronics anything that once belonged to someone who died at the hands of opioids. Each item will have a tag, including a story of the last owner of the object, revealing the story behind the product.

48 HERE, HAVE A KLEENEX | School: The Newhouse School, Syracuse University
Instructors/Professors: Mel White, Kevin O'Neill | Art Director: Ricky Santos
Assignment: Create a print ad campaign for Kleenex.
Approach: Come up with a creative way of depicting the use of Kleenex without showing the product itself. I also wanted to lean on the familiarity of the product with how people tend to use the word "Kleenex" to mean "tissue."
Result: I used nature to convey the human feeling of sneezing, blowing your nose, and crying with a geyser, a volcano and a dewy leaf.

49 DECIBULLZ EARPLUGS | School: The Newhouse School, Syracuse University
Instructor/Professor: Mel White | Student: Caroline Chipman
Assignment: Create a print campaign for Decibullz Earplugs which will clearly show the product benefits in a unique way.
Approach: To do this, I visually explored how Decibullz Earplugs can make everyday, noisy tasks more enjoyable to the average consumer.
Result: I visually blocked out the source of the sound to show how consumers feel when wearing Decibullz Earplugs.

49 SENNHEISER TO YOUR EARS | School: School of Visual Arts
Instructor/Professor: Frank Anselmo | Students: Minjeong Lee, Eunseok Park

50 GILLETTE FUSION PROGLIDE 5 RAZOR CAMPAIGN | School: The Newhouse School, Syracuse University | Instructor/Professor: Mel White | Art Director: Nick Hughes
Assignment: Create a print campaign expressing the benefits of the Gillette Fusion ProGlide 5 Razor to the avergae consumer who may not know the upsides.

Approach: Flexball technology allows the razor to turn with your face, which led to the transformation of objects known for making sharp turns into razors.
Result: This campaign transforms skates, a bobsled, and a race car into razors. My goal was to emphasize the objects' turning ability in comparison to the razor's.

50 KIWI SHOE POLISH | School: The Newhouse School, Syracuse University
Instructor/Professor: Mel White | Student: Yuchien Wang
Assignment: Create print ads for KIWI shoe polish.
Approach: Emphasize the fact that people judge on the first impression.
Result: Two print ads showcasing what a pair of polished shoes can say about a person.

51 AN EMOTIONAL INSTRUMENT | School: The Newhouse School, Syracuse University
Instructor/Professor: Kevin O'Neill | Student: Yuxin Xiong
Assignment: Show the beauty of the fountain pens.
Approach: People use those beautiful fountain pens to write and record the beautiful moments of their life. People establish an emotional attachment with their pen.
Result: In order show the beauty of the fountain pens, the ad substitutes the shadow of pen with the shadow of the beautiful moments that people would like to write about.

51 OFF DEEP WOODS BUG REPELLENT CAMPAIGN | School: The Newhouse School, Syracuse University | Instructor/Professor: Mel White | Student: Corinne Baker
Assignment: Create three print ads that show the many benefits of using OFF Deep Woods Insect Repellent when insects become a nuisance.
Approach: Focus on the insight that once you see a bug you can't ignore it and the fact that, even though it might be physically small, a bug's presence is large.
Result: A series of images that graphically show how large a bug's presence really is.

52 TIDE PODS | School: The Newhouse School, Syracuse University | Instructor/Professor: Mel White | Student: Sarah Whaley
Assignment: Create a print advertisement for Tide Pods.
Approach: Doing laundry is a hassle, but Tide Pods makes it easier. Tide Pods delivers all of your laundry needs in one compact pod.
Result: Visually express how size matters.

53 FARMERS WHEREVER YOU LIVE | School: School of Visual Arts
Instructor/Professor: Frank Anselmo | Students: Sujin Lim, Taekyoung Debbie Park

54 SONNET OBSESSED WITH PROTECTION | School: School of Visual Arts
Instructor/Professor: Frank Anselmo | Students: Cindy Hernandez, Minjeong Lee, Tut Pinto, Eunseok Park

55 SONNET CAR HELMETS | School: School of Visual Arts
Instructor/Professor: Frank Anselmo | Students: Huiwen Ong, Yuran Won, Tamara Yakov, HyunJin Stella Kim, Sujin Lim, Taekyoung Debbie Park

55 SONNET OPTIMISTIC NO MATTER WHAT | School: School of Visual Arts
Instructor/Professor: Frank Anselmo | Students: Hyeon-A Kim, Minjeong Lee, Pierre Fort, Eunseok Park, HyunJin Stella Kim, Tamara Yakov

56 IN 2020, CHOOSE OPRAH | School: Miami Ad School
Instructor/Professor: Zorayma Guevara | Students: Mariana Coelho, Ana Miraglia
Assignment: To come up with ideas for Oprah Winfrey's 2020 presidential campaign.
Approach: To show people that no matter the what the circumstances are, the best option is always Oprah Winfrey.
Result: Clever lines that show that no one else has better qualities than Oprah Winfrey.

57 #EMPATHY | School: Texas A&M University Commerce
Instructor/Professor: Kiran Koshy | Students: Cooper H. Weinstein, Brandon Mulke
Approach: Throughout our day, most of us are faced with menial problems and frustrations that are easy for us to share online through social media. We wanted to put these minor inconveniences in perspective and find a way to bridge the gap of understanding between ordinary people and refugees. These posters are a way to communicate that a refugee may be feeling the same inconveniences you are, but on a far greater scale.

57 PG IMMIGRANT LANDMARKS | School: School of Visual Arts
Instructor/Professor: Frank Anselmo | Students: Josi Liang Matson, Seona Kim

58 WWF THE TORTURE COLLECTION | School: School of Visual Arts
Instructor/Professor: Frank Anselmo | Students: Jisoo Hong, Minyoung Park

58 PARTNERS GLOBAL BLOOD BAGS | School: School of Visual Arts
Instructor/Professor: Frank Anselmo | Students: Cindy Hernandez, Tut Pinto

59 AIRBNB: LIVE YOUR DREAM | School: School of Visual Arts | Instructors/Professors: Mel White, Kevin O'Neill | Art Director: Ning Zeng | Copywriter: Ning Zeng
Assignment: Create a campaign for a brand.
Approach: Airbnb provides people with interesting and exciting accommodations.
Result: The series of Airbnb print ads shows some iconic TV/painting living rooms that you can actually find on Airbnb.com. With Airbnb, people can live their dream.

60 HEALING HIMALAYAS POSTER CAMPAIGN | School: Miami Ad School
Instructor/Professor: Hank Richardson | Student: Neha Biluve
Assignment: Design a campaign for an NGO.
Approach: Bring the reality in the visuals.
Result: Beauty of the mountains is submerged with the harsh reality of littered plastic in the serenity of the Himalayan mountains.

ADVERTISING SILVER WINNERS:
62 BMW HANDS | School: School of Visual Arts
Instructor/Professor: Frank Anselmo | Students: Jake Blankenship, Yifei You

62 BMW BRIDGE BILLBOARD | School: School of Visual Arts
Instructor/Professor: Frank Anselmo | Students: Junho Lee, Evan Choi

63 HYUNDAI NFL | School: Miami Ad School
Instructor/Professor: Zorayma Guevara | Student: Ana Miraglia

63 PEACE BY PIECES | School: Miami Ad School
Instructor/Professor: Unattributed | Students: Hridaynag Kooretti, Cody Turk

63 BMW LOGO DIAGRAMS | School: School of Visual Arts
Instructor/Professor: Frank Anselmo | Students: Josi Liang Matson, Seona Kim

64 PLUCK WITH PRECISION | School: The Newhouse School, Syracuse University
Instructor/Professor: Kevin O'Neill | Student: Nicole Framm

64 MANSCAPE MASTERPIECES | School: The Newhouse School, Syracuse University
Instructor/Professor: Mel White | Students: Chi-Ching Ada Lam, Danika Petersen

65 TIDE SLIDE | School: The Newhouse School, Syracuse University
Instructor/Professor: Mel White | Students: Elaina Berkowitz, Mel White, Yunxuan Wu

65 NARS POSTERS | School: Miami Ad School
Instructor/Professor: Larry Gordon | Student: Kaiqi Cai

65 COCA COLA - IT'S A REAL TREAT | School: New York Institute of Technology
Instructor/Professor: Bob Gill | Student: Radamanthys Chourdakis

66 CORONA PRINT AD | School: Miami Ad School
Instructor/Professor: Unattributed | Student: Qi Shen

66 YUENGLING BREWERY | School: The Newhouse School, Syracuse University
Instructor/Professor: Kevin O'Neill | Student: Edan Michener

66 ANGRY ORCHARD ROSÉ PRINT AD | School: The Newhouse School, Syracuse
University | Instructor/Professor: Kevin O'Neill | Student: Lindsay Weisleder

67 TAZO, THE MOST FRUITFUL TEA ON EARTH. | School: The Newhouse School,
Syracuse University | Instructors/Professors: Mel White, Kevin O'Neill
Art Director: Samantha Spellman | Copywriter: Isabel Drukker

67 NETFLIX POSTER | School: School of Visual Arts
Instructor/Professor: Eileen Hedy Schultz | Student: Jae Wook Baik

67 THE ULTIMATE MAGIC TRICK | School: Miami Ad School
Instructor/Professor: Hank Richardson | Student: Alana Vitrian

68 ORAL-B BURNOUT | School: Miami Ad School Hamburg | Instructor/Professor:
Unattributed | Art Director: Abdelrahman Galal | Copywriter: Samar Singh

68 FED EXPRESS | School: Miami Ad School Wynwood
Instructor/Professor: Carlos Roncajolo | Student: Alana Vitrian

68 IPHONE XS | School: School of Visual Arts
Instructor/Professor: Eileen Hedy Schultz | Student: Haley Kim

68 LUFTHANSA - SHADOWS | School: Miami Ad School Hamburg | Instructor/Professor:
Unattributed | Art Director: Abdelrahman Galal | Copywriter: Samar Singh

68 MONSTER - DESK TOYS | School: Miami Ad School Hamburg | Instructor/Professor:
Unattributed | Art Director: Abdelrahman Galal | Copywriter: Samar Singh

68 THE REAL STUFF | School: Miami Ad School Wynwood
Instructor/Professor: Hank Richardson | Student: Alana Vitrian

69 GREY GEEKS | School: Academy of Art University | Instructor/Professor: David Hake
Student: Krishapriya (KP) Dutta Gupta

69 ENTER THE QUITE WORLD | School: The Newhouse School, Syracuse University
Instructors/Professors: Mel White, Kevin O'Neill | Student: Yuxin Xiong

69 POLAROID. SOCIAL MORE. MEDIA LESS. | School: Portfolio Center
Instructor/Professor: Bryan Dodd | Student: Mya Passmore

70 KEURIG CAMPAIGN | School: The Newhouse School, Syracuse University
Instructor/Professor: Mel White | Student: Keren Mevorach

70 10 YEARS. STILL FRESH. | School: The Newhouse School, Syracuse University
Instructor/Professor: Mel White | Student: Karen Miranda

71 HAYDEN PLANETARIUM - #ASTRONOMYLIVE | School: Kutztown University of
Pennsylvania | Instructor/Professor: Summer Doll-Myers | Student: Caleb Finn

71 NPR PODCAST INVISIBILIA | School: Mississippi State University
Instructor/Professor: Cassie Hester | Student: Canaan Griffin

71 ARE YOU STILL WATCHING? | School: Miami Ad School
Instructor/Professor: Zorayma Guevara | Student: Ana Miraglia

72 GREENPEACE | School: The Newhouse School, Syracuse University
Instructor/Professor: Mel White | Student: Yuchien Wang

72 RIDICULOUS PLASTIC | School: Miami Ad School Europe
Instructor/Professor: Niklas Frings-Rupp | Student: Ana Karen Jiménez Barba

72 WILD YONDER | School: Portfolio Center | Instructor/Professor: Bryan Dodd
Student: Mya Passmore | Strategists: Danielle McKinley, Krissy Sanchez
Art Directors: Jessica Pester, Clive Neish | Copywriter: Mya Passmore

72 WHATEVER YOU CALL IT | School: The Newhouse School, Syracuse University
Instructor/Professor: Kevin O'Neill | Student: Audra Linsner

73 THE AVENGERS | School: Miami Ad School | Instructor/Professor: Unattributed
Students: Hridaynag Kooretti, Vaidehi Mewawalla, Deepika Desai

73 CHARGE WITH DELICIOUS | School: The Newhouse School, Syracuse University
Instructor/Professor: Kevin O'Neill | Student: Yuxin Xiong

73 SKIPPY SMOOOTH | School: The Newhouse School, Syracuse University
Instructor/Professor: Kevin O'Neill | Student: Annie Turner

73 GARDEN OF LIFE: BEEF UP WITHOUT THE BEEF | School: Miami Ad School NY
Instructor/Professor: Lance Morales | Student: Peter Fox | Art Director: Myka Betts

73 TOSTITOS ADVERTISEMENT | School: Texas Christian University
Instructor/Professor: David Elizalde | Student: Abbey Dean

73 STOPOPIOIDOVERDOSE.ORG KILLS MORE THAN | School: School of Visual Arts
Instructor/Professor: Frank Anselmo | Students: Minjeong Lee, Eunseok Park

73 SLIM JIM - MONSTER APPETITE | School: Texas Christian University
Instructor/Professor: David Elizalde | Student: Ryan Hinchcliff

74 LET'S TALK | School: Miami Ad School Europe | Instructor/Professor: Florian Weitzel
Art Director: Claudio Castagnola | Copywriter: Marwan Ibrahim

74 3M EARPLUGS: CONVERSATIONS | School: School of Visual Arts
Instructor/Professor: Unattributed | Student: Marcus Lim

74 100% COVERED | School: Miami Ad School Europe
Instructor/Professor: Florian Weitzel | Students: Anna Dedi, Theresa Kaußner

74 LENS VIRTUAL REALITY CAMPAIGN | School: Texas Christian University
Instructors/Professors: Bill Galyean, Jack Summerford | Student: Michele Farren

74 ALA LUNG LIGHTER | School: School of Visual Arts
Instructor/Professor: Frank Anselmo | Students: Jens Marklund, Jack Welles

74 OPIOID DEATH COUNTER | School: School of Visual Arts
Instructor/Professor: Frank Anselmo | Students: Jake Blankenship, Yifei You, Joe Chong

74 OPIOID EYEPIOIDS | School: School of Visual Arts
Instructor/Professor: Frank Anselmo | Students: Minjeong Lee, Eunseok Park

75 WORLD HEALTH ORGANIZATION PILLSHOT | School: School of Visual Arts
Instructor/Professor: Frank Anselmo | Students: Sujin Lim, Taekyoung Debbie Park

75 MARVIS TOOTHPASTE | School: The Newhouse School, Syracuse University
Instructor/Professor: Mel White | Student: Sarah Whaley

75 LACOSTE MEN'S COLOGNE | School: The Newhouse School, Syracuse University
Instructor/Professor: Kevin O'Neill | Student: Edan Michener

76 CREST 3D WHITESTRIPS | School: The Newhouse School, Syracuse University
Instructor/Professor: Mel White | Art Director: Sarah Whaley | Copywriter: Amy Schwartz

76 SHARPIE IS FOREVER. | School: The Newhouse School, Syracuse University
Instructors/Professorsr: Mel White, Kevin O'Neill | Art Director: Samantha Spellman
Copywriter: Isabel Drukker

76 PURELL-SINKS AREN'T ALWAYS AROUND | School: The Newhouse School,
Syracuse University | Instructor/Professor: Mel White | Student: Marta Lala

77 HARRY'S - GET HANDSY WITH IT | School: Miami Ad School
Instructor/Professor: Larry Gordon | Student: Chase Harris

77 SKIN CANCER CAMPAIGN | School: Texas A&M University Commerce
Instructor/Professor: Lee Whitmarsh | Student: Monica Williams

77 NIKE VOCALCOACH | School: Texas A&M University Commerce
Instructor/Professor: Bill Wosar | Art Director: Landon Watnick
Copywriters: Christian Harkna, Thiago Narvaez

77 WHY NOT BRING EVERYTHING? | School: The Newhouse School, Syracuse University
Instructor/Professor: Kevin O'Neill | Art Director: Sarah Whaley | Copywriter: Sarah Whaley

78 FABER CASTELL | School: The Newhouse School, Syracuse University | Instructor/
Professor: Kevin O'Neill | Art Director: Yuchien Wang | Copywriter: Yuchien Wang

78 SMARTWOOL—COLD FEET | School: Texas Christian University
Instructor/Professor: David Elizalde | Student: Emma Heinz

78 NINTENDO SWITCH IN & OUT | School: School of Visual Arts
Instructor/Professor: Frank Anselmo | Students: Hunwoo Choi, Ein Jung

78 BEATS PILL SMALL BUT POWERFUL | School: School of Visual Arts
Instructor/Professor: Frank Anselmo | Students: Joe Chong, Mo Ku

78 THE PERFECT COVER | School: Miami Ad School Europe
Instructor/Professor: Florian Weitzel | Art Director: Claudio Castagnola

78 A FASCINATING SCENT | School: Hansung University of Design & Art Institute
Instructors/Professors: Dong-Joo Park, Seung-Min Han
Students: Chaeun Park, Hyosun Park, Sunhee Ann

78 U-HAUL "DO-IT-YOURSELF" MOVING | School: The Newhouse School, Syracuse
University | Instructor/Professor: Mel White | Art Director: Ivor Guest | Copywriter: Ivor Guest

79 SONNET MAJOR LASERS | School: School of Visual Arts | Instructor/Professor:
Frank Anselmo | Students: Huiwen Ong, Yuran Won, HyunJin Stella Kim, Tamara Yakov

79 FARMERS SECURITY SIGNS | School: School of Visual Arts
Instructor/Professor: Frank Anselmo | Students: Jake Blankenship, Yifei You, Joe Chong

80 SONNET-VWLEMONADE | School: School of Visual Arts
Instructor/Professor: Frank Anselmo | Students: Jake Blankenship, Yifei You, Joe Chong

80 HISPANIC MUSEUM SHOPPING BAG | School: School of Visual Arts
Instructor/Professor: Eileen Hedy Schultz | Student: Jae Wook Baik

80 ISN'T YOUR GLASS CLEAN ENOUGH. | School: The Newhouse School, Syracuse
University | Instructor/Professor: Kelvin O'Neill | Art Director: Ting Peng

81 TOMS ADVERTISEMENT | School: Texas Christian University
Instructor/Professor: Bill Galyean | Student: Kahla Watkins

81 WHO NEEDS FIRE TO SMOKE? | School: Miami Ad School New York
Instructor/Professor: Rajath Ramamurthy | Student: Ashutosh Thakkar
Copywriter: Bader Salahuddin

81 PARTNERS GLOBAL PANTONE | School: School of Visual Arts
Instructor/Professor: Frank Anselmo | Students: Jake Blankenship, Yifei You, Joe Chong

82 PARTNERS GLOBAL BARBED WIRE FINGERPRINT | School: School of Visual Arts
Instructor/Professor: Frank Anselmo | Students: Jake Blankenship, Yifei You, Joe Chong

82 PARTNERS GLOBAL ULTRASOUND | School: School of Visual Arts
Instructor/Professor: Frank Anselmo | Students: Cindy Hernandez, Tut Pinto

82 THE OPIOID CRISIS MAY BE CLOSER THAN YOU THINK | School: School of Visual
Arts | Instructor/Professor: Eileen Hedy Schultz | Students: Jae Wook Baik, Yun Hwa Lee

83 PG SLAVE CHILDREN BUSINESS CARDS | School: School of Visual Arts
Instructor/Professor: Frank Anselmo | Students: Josi Liang Matson, Seona Kim

83 THE FACES WARFARE | School: The Newhouse School, Syracuse University | Instructors/
Professors: Mel White, Kevin O'Neill | Art Director: Carrie Kaiser | Copywriter: Will Milowsky

83 KGS SOCCER CLUB TEAM | School: Hansung University of Design & Art Institute
Instructors/Professors: Dong-Joo Park, Seung-Min Han | Student: Kim Ji Yul

ADVERTISING FILM/VIDEO GOLD WINNERS:
85 UBER ABLE | School: Miami Ad School | Instructor/Professor: Jerrod New | Students:
Cristina Marquez, Junggle Kim, Maddie Rosenberg, Ela Kallonen, Marcelo Shalders
Assignment: Connect an audience to a brand that wasn't possible three years ago.
Approach: There are people out there who are unemployed or underemployed because
of a physical condition. Meanwhile, there are new ways everyday to make money
independently. To bring these groups together, Uber will implement a new service
with their self-driving fleet that makes it easier for people with physical disabilities to
drive and earn an income.
Result:Its a student project, but we hope this can be a reality when the self driving fleet
becomes implemented for everyone.

85 AUTONOMUS SELF DRIVING CAR | School: Miami Ad School
Instructor/Professor: Zorayma Guevara | Students: Ana Miraglia, Max Cohen
Assignment: Convince people that they can trust self-driving cars.
Approach: We compared the self-driving car to an average human driver.
Result: We tried to shift people's views of self-driving cars.

85 UBER FIX | School: Miami Ad School Wynwood | Instructor/Professor: David Uribe
Student: Ashutosh Thakkar | Art Director: Qi Shen | Copywriter: Jessica Idarraga

85 ALWAYS WITH ME | School: Miami Ad School | Instructors/Professors: Frank Garcia,
Giulia Magaldi | Students: Ana Miraglia, Lorran Schoechet, Jienne Alhaideri
Assignment: Carters wanted to raise awareness about third-hand smoking.
Approach: We created a new clothing line with an unique pattern that showed the
dangers of third-hand smoking.
Result: Found a creative way to show how the chemicals of cigarettes could linger on
clothes and affect your kids.

86 HOW A 16 YEAR-OLD THINKS ALMONDS ARE MILKED | School: Portfolio Center
Instructor/Professor: Bryan Dodd | Art Director: Alexa Lyons | Copywriter: Mya Passmore
Animator: Alexa Lyons
Assignment: Change the perception of Califia Farms' almond milk. No longer is almond
milk just a health food product meant for vegans, vegetarians, and those who are lactose
intolerant. Almond milk has gone from health food product to "tasty" food product.
Approach: Tell short stories about how different people believe an almond is milked.

86 FAIRY TALES WITH A TWIST | School: The Newhouse School, Syracuse University
Instructor/Professor: Mel White | Students: Yunxuan Wu, Elaina Berkowitz
Assignment: Our assignment was to create a campaign to promote a charity organization.
Approach: We decided to target the message that LGBTQ is natural and normal to the
younger generations. We wanted to do so in a relatable and understandable way.
Result: We twisted common fairytale stories to make the couples same sex.

86 LYSOL, FOR YOUR DIRTY WORK | School: Miami Ad School San Francisco | Instructor/
Professor: Matt Moresco | Student: Paola Delgado Cornejo | Copywriter: Amber Jolly
Assignment: This is a commercial for Lysol under the concept that Lysol is there for
your dirty work even if it is about cleaning an entire city.
Approach: Through a catchy song that has the title of the message I wanted to deliver
a funny, spontaneous vibe.

86 HUSH | School: Miami Ad School | Instructor/Professor: Jerrod New
Students: Cristina Marquez, Junggle Kim, Chaeyeong Seo
Assignment: Connect an audience with a brand in a way that couldn't have been pos-
sible three years ago.
Approach: Apple is a brand that always innovates, and Siri is an assistant that was the
first of its kind. With this in mind, we decided to use Siri's new deep learning technol-
ogy to help victims of abuse that won't place 911 calls because they fear their offender.
Result: This project has been very well received and has been shared in social media to
a point where people tag Apple and ask them why is this not a reality yet.

87 IDEA FACES | School: Miami Ad School | Instructor/Professor: Unattributed | Student:
Nick Arzhantsev | Art Director: Andrea Martinez | Copywriters: Alex Gerber, Cali McGovern
Result: An online video for Microsoft that shows the moment when inspiration strikes.

87 EMOJIC | School: School of Visual Arts | Instructor/Professor: Frank Anselmo
Students: Tamara Yakov, HyunJin Kim, Taekyoung Debbie Park

87 THE INVISIBLE UPDATE | School: Miami Ad School | Instructor/Professor:
Jerrod New | Students: Cristina Marquez, Junggle Kim, Maddie Rosenberg, Ela Kallonen
Assignment: Connect an audience with a brand in a way that perhpas wasn't possible
three years ago.
Approach: Apple is an innovative company, and there are many benefits to the increas-
ing use of technology which may include saving your life. With new facial recognition
software, Apple Health wants to help catch early warning signs of a stroke.

87 CHROMASHIFT | School: Miami Ad School | Instructor/Professor: Hank Richardson
Student: Alana Vitrian | Art Directors: Andrea Baridon, Marta Iglesias

88 SHORE DRONE | School: School of Visual Arts | Instructor/Professor: Frank Anselmo
Students: Sujin Lim, Taekyoung Debbie Park

88 GEOSNAP | School: Miami Ad School | Instructor/Professor: Brent Slone
Student: Anna Cevallos | Copywriter: Raquel Chisholm | Account Director: Leslie John
Assignment: Millennials and Gen Z feel a disconnect between themselves and large-
scale issues affecting our planet, such as the endangerment of animals and ecosystems.
How do we connect with environmental issues that, more often than not, are out of
sight out of mind?
Approach: Integrate a campaign that the younger generations utilize.
Result: Increased awareness of endangered animals and ecosystems. Increased local
volunteerism. Increased donations.

88 NEXT STEP | School: Miami Ad School | Instructor/Professor: Zorayma Guevara
Students: Ana Miraglia, Diane Danneels
Assignment: Educate people about recycling.
Approach: Add a next step to cooking tutorials, teaching people how to recycle.
Result: We taught people how to properly throw away the packages of the ingredients
that they'd just opened.

88 THE ART TASTING | School: Miami Ad School Brazil
Instructors/Professors: Pedro Rosas, Augusto Correia, Bruno Almeida, Luis Paulo Gatti
Students: Luiz Henrique Costa, Tiago Daltro, Igor Pontes, Raquel Segal, Gabriel Moraes

89 THE NEW YORKER - WATCH. READ. ACT. | School: Miami Ad School | Instructor/
Professor: Rajath Ramamurthy | Student: Matias Cachiquis | Copywriter: Isaac Sorenson
Assignment: Create a video for The New Yorker using only existing media in order to
increase subscribers and readership.
Approach: Satirical cartoons are created to push viewers into thought-provoking pos-
sibilities. But more and more, we see reality push even further than cartoonists could
imagine. The New Yorker wanted to create a digital video to bring in a new generation
of readers by calling attention to the blurring lines between cartoon satire and reality.

89 VENMO ASSIST | School: Miami Ad School
Instructor/Professor: Zorayma Guevara | Student: Vaidehi Mewawalla
Art Directors: Hridaynag Kooretti, Matteo Angione, Axel Livijn Carlman
Assignment: The problem: People don't carry cash anymore. This has resulted in the
homeless receiving less help than ever.
Approach: Introduce a card which enables people to donate to the homeless, digitally.
Venmo assist cards works like gift cards. People can register and obtain them through
our dispensing machines. The money donated can only be used for basic necessities,
like food and beverages at selected stores.
Result: Future lions shortlist 2018.

89 MORE IS NEVER ENOUGH | School: New York Institute of Technology
Instructor/Professor: Youjeong Kim | Student: Radamanthys Chourdakis
Assignment: The brief was to create an emotionally intense commercial with comedic
relief. The instructor urged us to use cliches and breathe new life to them.
Approach: The approach chosen was to create a commercial for Dove chocolate but give
it a twist. We all know eating candy is part of everyone's cheat day but what if the cheating
was a tad more literal? The approach was to use the cliche "caught in the act" moments
from pop culture.
Result: The result is to drive brand awareness for Dove Chocolate and make it more
appealing and authentic to the eyes of the Zillennial consumer.

89 SCAN A BEE | School: Miami Ad School | Instructor/Professor: Hank Richardson
Student: Alana Vitrian | Art Director: Claudia Dompe

90 HOOKED | School: Miami Ad School | Instructor/Professor: Brent Sloan | Student:
Nidal Koteich | Art Directors: Nidal Koteich, Daniel Pujol, Lisette Azulay
Copywriter: Agustina Lavignasse
Assignment: The brief asks to create innovative ideas and raise awareness about the
Opioid crisis in the U.S.
Approach: To raise awareness and reduce the stigma associated with opioid consump-
tion, we made people relate to this problem throughout an everyday practice. When
binge-watching your favorite show, your brain produces dopamine and your body
experiences a drug-like high.
Result: The campaign received acclaim and recognition nationwide and won numerous
advertising awards including a Gold Addy in the American Advertising Awards 2018.

90 IHELP | School: Miami Ad School San Francisco | Instructor/Professor: Manolo Garcia
Students: Hatem El Akad, Donghoon Lee, Paola Delgado Cornejo
Assignment: In today's world, stress, work and responsibilities are on the dramatic
rise. That means less sleep, more nicotine, alcohol and narcotic consumption, and
added stress, which combined together puts people's mental and physical health in
great risk. The problem is also amplified with our dependence on and excessive use of
technological devices. How can we know when our bodies need a break from devices?
Approach: Introducing iHelp, the innovative iPhone and Macbook feature that scans
your eyes and measures your fatigue to tell you not only when, but also how to pro-
ductively take a break.

90 GOOGLE CLOUD HOME STORAGE | School: Miami Ad School | Instructor/Professor:
Marlon Koster-von Franquemont | Student: Axel Livijn Carlman | Chief Creative Director:
Marlon Von Franquemont | Creative Director: Niklas Frings-Rupp Copywriter: Alessandra Gorla
Assignment: Every once in a while, a natural disaster afflicts an area of the world. Despite
much of our online data being backed up, our physical possessions are left vulnerable.
Approach: Cloud Home Storage is a platform that makes it possible to store your
personal belongings on an online cloud. Once a disaster strikes, those affected can list
possessions that have been destroyed, offering a way for others to find replacements.
Result: Creative Conscience Awards: winner, Summit Creative Awards: Gold, New
York Festival: merit.

90 SPOTIFY MUSE | School: Miami Ad School | Instructor/Professor: Unattributed
Student: Anna Cevallos | Copywriters: Oliver Permut, Tuhin Pahri
Assignment: Recently, museums have witnessed a decline in attendance, especially
from millennials. How can we help preserve the preservers of culture and history?
Approach: Incorporate music into the museum experience. Create playlists curated by
popular artists among millennials.
Result: An increase in museum foot-traffic, increase in artists' plays (and therefore
income) on Spotify, increase in Spotify downloads.

91 XACTDOSE1920 | School: School of Visual Arts | Instructor/Professor: Frank Anselmo
Students: Jake Blankenship, Joe Chong | Art Director: Yifei You

91 PERMANENT REMARKS | School: Miami Ad School
Instructor/Professor: Zorayma Guevara | Student: Ana Miraglia
Assignment: Show that Sharpie is the best permanent marker.
Approach: Make politicians' remarks permanent using a Sharpie.
Result: Sharpie uses a social cause to show the qualities of its product.

91 HAPPY SOCKS 5 FUN PACK | School: Miami Ad School
Instructor/Professor: Juan Munoz | Student: Alana Vitrian
Approach: Happy Socks 5 Fun Pack is the new solution for those lonely socks.

91 ALLSTATE ECHOALERT | School: School of Visual Arts
Instructor/Professor: Frank Anselmo | Students: Jake Blankenship, Yifei You

92 LOCATE MATE | School: The Newhouse School, Syracuse University
Instructor/Professor: Mel White | Students: Chi-Ching Ada Lam, Danika Petersen
Assignment: Find something you are passionate about, find a problem, and solve it.
Approach: Locate Mate is an app that ensures you never leave something behind
again, by using RFID Chip Stickers to provide an automated interactive checklist. The
only options on the market use location services to find your lost items, so we decided
to create one that provides a preventive measure, helping you to make sure you don't
lose track of your items.

92 23ANDMONSTER | School: Miami Ad School | Instructor/Professor: Jonathan Castro
Students: Natalia Serur, Christian Harkna, Nico Gandrup, Justin Hoover
Assignment: Use current technology in a way it has never been used before.
Approach: A partnership between 23andMe and Monster.com.
Result: The result we came up with was the use of typography to a beat with an easy
going, straight forward approach to convey the message.

92 AMAZON ALEXA REHAB | School: School of Visual Arts
Instructor/Professor: Frank Anselmo | Students: Ezequiel Consoli, Jack Welles

92 SONNET SUPERCLAW | School: School of Visual Arts
Instructor/Professor: Frank Anselmo | Students: HyunJin Stella Kim, Tamara Yakov

93 BADBLOCKER-NEW-1440X1080 | School: School of Visual Arts
Instructor/Professor: Frank Anselmo | Students: Jake Blankenship, Yifei You

93 SPOTIFY-OD-5.9.18-1920X1080 | School: School of Visual Arts
Instructor/Professor: Frank Anselmo | Students: Jake Blankenship, Yifei You

93 OPIOID THE LAST POST | School: School of Visual Arts
Instructor/Professor: Frank Anselmo | Students: HyunJin Stella Kim, Tamara Yakov

93 EXPENSIVE DOESN'T MEAN FAIR | School: New York Institute of Technology
Instructor/Professor: Youjeong Kim | Student: Radamanthys Chourdakis

Assignment: The assignment was to create an out-of-the-box commercial video of any charity that would completely immerse the viewer in the beginning of the video but would do a 180° storyline change at the climax.
Approach: The approach was to capture the viewer's attention first with a classic "Behind The Brand" video about MaxMara, fully immersive using footage and Italian VoiceOver and then at the critical point reveal that the footage they have been looking at are actually from the brand's sweatshops in Italy.
Result: Make the consumers think before they invest their money in luxury brands.

94 THE MUSEUM OF INCOMPLETE | School: Miami Ad School
Instructors/Professors: Frank Garcia, Giulia Magaldi | Student: Diane Danneels
Assignment: Gun violence statistics only tell half the story. The other half is written in what the victims left behind.
Approach: We wanted to show that when a life is lost to gun violence, there is a lot left behind that will never be completed.

94 THE UNFORGETTABLE SOUVENIR | School: Miami Ad School
Instructor/Professor: Unattributed | Copywriter: Paula Gete-Alonso
Art Director: Claudio Castagnola | Camera: Tadgh Ennis
Assignment: Raise awareness and fight gun violence in the United States.
Approach: State postcards that reveal the hidden truth, weak gun laws, behind America's worst problem. The goal of the postcards is not just to raise awareness about the problem but to give people a chance to change it. By visiting the website on the back you can send these reminders to senators online or via mail to start demanding change.
Result: We took the postcards to the streets in order to spread the word.

94 WHENEVER WE WANT | School: Academy of Art University | Instructor/Professor: Mark Edwards | Art Directors: Max Gawell, Frans Ahlberg | Copywriter: Sam Salehian
Assignment: Women in big cities don't feel safe running when it's dark.
Approach: In these cities, there are thousands of shelter dogs, they are given a home, but the staff doesn't have time to take them out for walks. So Adidas will team up women with dogs, making them feel safe running at night. While giving dogs in shelters something to run for.

94 ILLUMINIKE | School: School of Visual Arts
Instructor/Professor: Frank Anselmo | Students: Sujin Lim, Taekyoung Debbie Park

ADVERTISING FILM/VIDEO SILVER WINNERS:
95 ARIZONA PRICE TAG | School: Miami Ad School
Instructor/Professor: Zorayma Guevara | Students: Ana Miraglia, Marina Ferraz

95 GOOGLE MILLENNIAL APP | School: The Newhouse School, Syracuse University
Instructor/Professor: Mel White | Students: Yunxuan Wu, Elaina Berkowitz

95 LEARNING CURVE WITH AMAZON ALEXA | School: Miami Ad School Wynwood
Instructor/Professor: Bill Wosar | Student: Landon Watnick
Art Directors: Landon Watnick, Ajaj Thompson | Copywriters: Raquel Chisholm, Celia Perry

95 EMOJIC | School: School of Visual Arts | Instructor/Professor: Frank Anselmo
Students: Tamara Yakov, HyunJin Kim, Taekyoung Debbie Park

95 SPREAD THE RED #COCACOLARENEW | School: Miami Ad School
Instructor/Professor: Kimberly Capron Gonzalez | Student: Ashutosh Thakkar
Art Director: Ranjana Naik | Copywriter: Qi Shen

95 BASEL BRAILLE | School: Miami Ad School | Instructor/Professor: Ralph Budd
Students: Elisa Sain, Cris Cordero

95 COLLUTION | School: Miami Ad School Madrid
Instructor/Professor: Chus Rasines | Student: Lucia Mendezona
Art Directors: Mayi Blanch, Alia Littles | Copywriter: Cesar Rodriguez

95 PETFLIX | School: Miami Ad School | Instructor/Professor: Unattributed
Students: Ching Ting, Katy Huang | Graphic Designer: Gabriella Vieira

96 NECKTIFY | School: Miami Ad School Wynwood
Instructor/Professor: Carlos Roncajolo | Student: Bader Salahuddin | Art Director: Qi Shen

96 SWING BY BUDWEISER | School: Miami Ad School | Instructor/Professor: Jerrod New
Student: Matias Cachiquis | Copywriter: Jessica Simmons

96 TAKE7 FOR FANDANGO | School: Miami Ad School Wynwood | Instructor/Professor: Shannon Sanon | Art Director: Landon Watnick | Creative Director: Shannon Sanon
Copywriter: Ranjana Naik | Marketing Manager: Julio Rodriguez

96 PURE BY BELKIN | School: Miami Ad School | Instructor/Professor: Manolo Garcia
Students: Nutnicha Achavakulthep, Deepika Desai

96 OD-VR | School: School of Visual Arts | Instructor/Professor: Frank Anselmo
Students: Cindy Hernandez, Tut Pinto

96 DORY'S FOUNDATION | School: Miami Ad School
Instructor/Professor: Hank Richardson | Student: Alana Vitrian | Art Director: Nidal Koteich
Copywriter: Valentina Spielberger

96 DENNY'S - DAY OFF | School: Miami Ad School
Instructors/Professors: Frank Garcia, Giulia Magaldi | Student: Diane Danneels

96 EQUALHIRE | School: School of Visual Arts
Instructor/Professor: Frank Anselmo | Student: Yifei You

DESIGN PLATINUM WINNERS:
100 CHUCK 70 | School: Pennsylvania State University
Instructor/Professor: Ryan Russell | Students: Nick Wilson, Amelia Ball, Noemi Noullet
Assignment: A full branding campaign for the release of the Converse Chuck70 High Top Sneaker. This is a high end spin off of the traditional Converse High Top, in order to attract a new demographic of consumer that has a greater appreciation for sneaker and street style culture.
Approach: We focused on a specific demographic. We created a tagline, "Details Matter" and new logo rebrand which replicates the classic bottom of the Chuck Shoe.
Result: We created a campaign around the idea that details matter in all situations, displaying a large scene, and then focusing in on the smaller details. We completed this project with the development of social media content, billboard and poster designs, a logo, copy, and merchandise.

101 19: A DESIGN EXPERIENCE | School: Pennsylvania State University
Instructor/Professor: Kristin Sommese | Student: Graphic Design Class of 2019
Assignment: The assignment was to create and brand a design experience for an audience to exhibit our summer internships.
Approach: All nineteen students in our class broke up into teams and collaboratively

worked on branding, promotional material, videos, and experience design to create a show to showcase our summer internships.
Result: A concept based on the number nineteen, a significant number to our class of nineteen students, the class of 2019. This resulted in a successful show with a great turnout.

102 HERMAN MILLER | School: Academy of Art University
Instructor/Professor: Eszter Clark | Student: Pauline Capote
Assignment: Choose an existing company to create a brochure for. Along with the brochure, additional forms of media must accompany it.
Approach: The brand selected was Herman Miller because of their standout style and timeless presence. Although the home, office, and decor company is known for many things, the concept of the brochure was a tribute to the iconic designers that have paved the way for their brand.
Results: Once the brochure was completed, it expanded into a series of additional deliverables. The final package consisted of a brochure, poster series, alternative covers (for the following issues), and shopping bags.

103 DWELL MAGAZINE | School: Brigham Young University
Instructor/Professor: Adrian Pulfer | Student: Todd McAllister
Assignment: Re-design an existing magazine, taking into account the current design and considering how I might change it with traditional magazine cover elements.
Approach: My approach to designing the covers of Dwell Magazine was to elevate the visual identity of the magazine from something relatively mundane and forgettable to a more memorable, intriguing visual direction. I wanted the magazine to stand out for its beautiful simplicity, reflecting the goals of the architecture and design it contains.
Result: I was able to elevate its visual language, bringing it to a higher level of design.

104 NEW YORK TIMES BOOK REVIEW | School: School of Visual Arts
Instructor/Professor: Carin Goldberg | Student: Yunchung Chung
Assignment: Redesign of the NYT Book Review.

105 CANDRAPRABHA School: School of Visual Art
Instructor/Professor: Marvin Mattelson | Student: Anyu Wu

106 ZANELE MUHOLI POSTER | School: Art Center College of Design
Instructor/Professor: Brad Bartlett | Student: Charles Lin
Assignment: Poster campaign for re-brand of performing arts organization, Performa. Founded by RoseLee Goldberg in 2004, Performa is the leading organization dedicated to exploring the critical role of live performance in the history of twentieth-century art and to encouraging new directions in performance for the twenty-first century.

107 DYNAMIC KOREA | School: Hansung University of Design & Art Institute
Instructors/Professors: Dong-Joo Park, Seung-Min Han | Student: Yeji Kim
Assignment: Create a poster to promote Korea. It reflects the spirit of salpuri dance.
Approach: There is sorrowful resentment in Korean emotion. There is a salpuri dance that expresses this. The shape of the black cloth in the poster represents one of the salpuri dances as a Chinese character. Because there is joy in sorrowful resentment, I expressed each stroke of the Chinese character dynamically.

108 EAST ASIA FEMINISM | School: Hansung University of Design & Art Institute
Instructors/Professors: Dong-Joo Park, Seung-Min Han | Student: Jumi Park
Assignment: This poster is about the exhibition of East Asia Feminism. This exhibition is about the reality that East Asia is a patriarchal society.
Approach: I made "Feminism" to be a long letter which looks like geometry shape when we see it from far away. It means that suppressed society and looked like falling down from the sky to the ground. I made a red color for "East Asia" to emphasize the reality. I wanted to say that men and women are the same.
Result: We should try to know and to understand each other's gender. I want to change people's thinking if I can.

109 ROCKET CHAIR | School: School of Visual Arts
Instructor/Professor: Kevin O'Callaghan | Student: Fernando Alvarenga
Assignment: Create a chair that represents what inspires you.
Approach: As designers we can draw inspiration from the past. As a kid, my Saturday mornings were filled with cartoons like the Jetsons and Duck Rodgers. They captured my imagination and so did the rocket ships that were featured. Now as a designer, their colorful aesthetics and craftsmanship inspire me, and inspired this chair. This chair was created for a child, with the hope that it would spark their imagination like it did with me.

110 CONVERSATION TABLE | School: Portfolio Center
Instructor/Professor: Devan Carter | Student: Danner Washburn
Assignment: Representative of person-to-person communication, this table's visually-shifting form and vibrant colors serves to reclaim and reorient meal times toward conversation and, ultimately, a more wholesome experience of community.

DESIGN GOLD WINNERS:
112 SCARS ON MY HEART | School: Temple University
Instructor/Professor: Abby Guido | Student: Shimin Li
Assignment: Create a senior thesis project of our own selection.
Approach: I chose a very important forgotten Chinese history, Nanking massacre, which I have done a lot of research on. I wanted to design a survivor storybook that can educate people. I used many design elements related to Chinese cultures, such as brush writing, paper cutting, and ink painting.
Result: This project ended up with a memory kit for Memorial Hall of the Victims in Nanking, called "scars on my heart." This memory kit includes The Survivor storybook, eight bookmarks, and a rain flower stone. The storybook tells the true story of six Survivors and two important wetness. Each bookmark belongs to one of the survivors in the book. The rain flower stone represents the city of Nanking.

113 MODA | School: School of Visual Arts
Instructor/Professor: Eric Baker | Student: Woohyun Kim

114 PIMA AIR MUSEUM School: Brigham Young University
Instructor/Professor: Adrian Pulfer | Student: McCall Keller
Assignment: Rebrand for Pima Air Museum. Located in the Arizona desert, Pima is one of North America's largest air and space museums. The museum has a collection of some of the most iconic aircrafts ever built. I wanted to create an identity system that allowed visitors to imagine as if they were on explorations of unknown territory.
Approach: After doing extensive research on the history of flight, I was strongly influenced by the unique typographic treatments used in aerospace. At times, type is bold and highly legible from a far distance, while at other times it is used in miniscule blocks of detailed information. This lead me to pair bold type with small details.

Results: Extensive research allowed me to find a system that not only would appeal to well informed aviation enthusiasts, but was also simple enough for children to enjoy.

115 MONO | School: School of Visual Arts
Instructors/Professors: Kenneth Deegan, Brankica Harvey | Student: Rachel Jisun Kim

116 FNJI FURNITURE BRANDING | School: School of Visual Arts
Instructor/Professor: Brian Collins | Student: Yaman Hu
Assignment: This is the assignment from class "Design and Branding." In this course, students were asked to develop a comprehensive brand identity that reinforces the narrative of a chosen business or service. My proposal was rebranding FNJI furniture. FNJI is a cutting-edge cooperation brand that curating minimalist, retro style, furniture products.
Approach: The concepts focus on developing comprehensive solutions that bring the simplicity of forms to a young furniture brand.
Result: The concept and visual presentation achieved the criteria.

117 TRANSFORMING A PERSIAN GEOMETRIC PATTERN INTO A WESTERN VISUAL LANGUAGE | School: Art Center College of Design | Instructors/Professors: Nikolaus Hafermaas, Samantha Jan Fleming, Sean Adams | Student: Fazel Sayeh
Assignment: For my thesis project, I focused on elements of Eastern visual culture. I'm originally from Iran and have been working in the U.S. for five years. I framed my project around this as a personal interest and connected my work with my heritage as an Iranian American designer.
Approach: During my research process I focused on Persian geometric patterns. They are rooted in mathematics, which share similar principles in Western graphic design.
Result: 100 shapes were generated as 100 is a sacred number in Iran. Using the shapes, I explored the possibility of generating typography within the forms. A carpet was digitally woven with hidden messages embedded into the pattern. "We are part of the whole" is inscribed into the carpet, a piece of text quoted from Saadi Shirazi, a 12th-century Persian poet. To extend the use of this visual language I explored environmental applications of the pattern, like how patterns were embedded in architecture.

118 ICFF | School: School of Visual Arts | Instructors/Professors: Kenneth Deegan, Brankica Harvey | Student: Rachel Jisun Kim

119 FORM ARCOSANTI REDESIGN | School: Art Center College of Design
Instructor/Professor: Brad Bartlett | Student: Ricardo Imperial
Assignment: Redesign of a creative retreat and music festival.
Approach: FORM is a creative retreat and music festival held in the desert eco-city of Arcosanti, AZ. Immersed in otherworldly architecture, FORM participants experience three days and nights of live music, talks/panels, workshops, experiential art, and more. A typeface was created for this festival in order to organically integrate communication within the Arcosanti ecosystem.

120 MUSEUM OF ALTERNATIVE FACTS | School: Maryland Institute College of Art
Instructor/Professor: Jason Gottlieb | Student: Jenna Klein
Assignment: The Imaginary Museum assignment called for designers to come up with a speculative museum concept, and then create a brand identity and other supplemental deliverables such as exhibition posters, gift shop items, etc.
Approach: For my Imaginary Museum, I took a new look at alternative facts, elevating them to an institutional status, typically known for presenting absolute truths.
Result: Facts and truth are subjective, right? At the Museum of Alternative Facts, facts are never questioned or disputed, but rather universally believed and accepted. After all, what is the responsibility of institutions to provide the truth to the public and should the public always believe everything they see in museums?

121 KONZERHAUS | School: Brigham Young University
Instructor/Professor: Adrian Pulfer | Student: Dallin Diehl

122 TASTEBUDS | School: Temple University
Instructor/Professor: Abby Guido | Student: Sarah Demers
Assignment: My senior design thesis project is a meal kit which cooks with cannabis, Tastebuds. It consisted of all the necessary food ingredients, recipe book, a stash box containing all the required forms of cannabis, and a website where the user can educate themselves on the cannabis plant, allowing them to determine what kind of experience they want using an online assessment.
Approach: The goal was to elevate marijuana's stereotypical reputation and educate users on the plant. The color choice is restricted but vibrant, capturing the energy surrounding the topic. The pattern work is a lively typographic pattern paired with a subtle geometric pattern inspired by the two main chemical compounds found in cannabis.
Result: The final project consists of food packaging, recipe cards, and a website. First, the user can complete a brief quiz of their desired effects, then Tastebuds picks from their selection of strains for the best strain for the user and their desired experience. Meals are then chosen by the user and divided into sections, entree, sides, and dessert.

122 PARAGUAY | School: Portland Community College
Instructor/Professor: Nathan Savage | Student: Diego Mancilla
Assignment: Develop a cohesive and harmonious brand that inspires visitors to visit a forgotten country while creating a unique country brand, including a packaging design, brand book, process book, and business card design.
Approach: I developed a brand for Paraguay that captured the essence of this unknown land and showcased it with a focus on 3 core values: Adventurous Warriors, Kinetic Spirits and Risk Seekers.
Result: The brand was inspired by Paraguay's flora and fauna while designing a unique combination logo with a curvaceous bold type. Paraguay's essence was further developed to incorporate two visual identity features—Las Olas (the waves) and El Tribu guarani (Guarani Tribe) patterns to demonstrate the brand's unity, courage, heritage, and fluidity.

123 FISHER HOUSE FOUNDATION | School: Portfolio Center
Instructor/Professor: M.C. Coppage | Student: Courtney Jacobs
Assignment: The assignment was to re-brand the non-profit organization, Fisher House Foundation. The organization provides housing for military and veteran families whose loved ones are in the hospital.
Approach: My approach was to design a brand identity for Fisher House that emphasized community, family, and patriotism in an accessible and friendly way. I combined the visual elements of a home and the American flag to create the visual identity for the brand.
Result: A new logo, website, and brand guidelines book. The overall look and feel of the new brand identity uses deconstructed elements of the American flag as its visual identity. The logo represents the American flag folding into the shape of house.

124 DOWNTOWN PAWZ | School: The University of Texas at Arlington
Instructor/Professor: Veronica Vaughan | Student: Jill Schoenstein
Assignment: Rebrand a local business.
Approach: Downtown Pawz is a pet store located in Dallas, Texas. For this rebrand, I wanted the company's aesthetic to originate from the "downtown" part of their name.
Result: Sophisticated drawings of cats and dogs in bow ties were created to personalize the brand, along with colors referencing the Texas flag.

125 ILLY CAFE | School: School of Visual Arts
Instructor/Professor: Dirk Kammerzell | Student: Min Kyung Kim

126 LP OF ELECTRIC LIGHT ORCHESTRA | School: School of Visual Arts
Instructor/Professor: Eileen Hedy Schultz | Student: Jae Wook Baik
Assignment: Redesign the LP of legendary British Brand, Electric Light Orchestra.

127 ECO SWITCH | School: School of Visual Arts
Instructor/Professor: Shawn Hasto | Student: John Patrikas

128 KING KONG MAGAZINE | School: Brigham Young University
Instructor/Professor: Adrian Pulfer | Student: McCall Keller
Assignment: Redesign a publication of my choice. I decided on King Kong Magazine; a biannual publication, dedicated to showing the works of ground-breaking artists.
Approach: Create a system that places focus on the artists. All typographic treatments are meant to complement their work and in no way distract from the subject matter.
Results: Ultimately, this redesign has transformed King Kong into a captivating showcase for the young creative minds who are changing the game.

129 CRAZY SEXY COOL | School: School of Visual Arts
Instructor/Professor: Carin Goldberg | Student: Soohyun Kim

130 SOUND SHAPES SPACE | School: Art Center College of Design
Instructor/Professor: Brad Bartlett | Student: Priscilla Chong
Assignment: Design and Develop an editorial piece on a subject of your choosing.
Approach: Sound Shapes Space is a book that explains the connection between Sound Art and the environment that it lives in. The narrative expands on how sound artists may collaborate, rely on, change, install, or embrace a space with their sounds.

131 MY PICTURE DICTIONARY | School: School of Visual Arts
Instructor/Professor: Carin Goldberg | Student: Yunchung Chung

132 HERE ART CENTER | School: School of Visual Arts
Instructors/Professors: Courtney Gooch, Paula Scher | Student: Seoyoung Lee
Assignment: HERE is a non-profit institution that deals with various kinds of unconventional performing arts. Each genre of performances has different stages and theater settings. The main idea of this logotype is the same dimension but different composition which makes the flexible system.

133 GATOR DREAM'S END | School: School of Visual Arts
Instructor/Professor: Henrik Drescher | Student: Kaitlin O'Connor

134 GREEK GODDESS | School: School of Visual Arts
Instructor/Professor: Marvin Mattelson | Student: Siyi Hemu

135 SELF PORTRAIT | School: School of Visual Arts
Instructors/Professors: Marcos Chin, Yuko Shimizu | Student: Yang Du

136 SHOPPING EFFICIENCY IN SAFEWAY | School: Oregon State University
Instructor/Professor: Jun Bum Shin | Student: Dan Anecito
Assignment: Document the food items currently stocked in your pantry. Create an infographic with the data you gather.
Approach: Shopping is not an enjoyable experience on a Sunday when everybody runs last minute errands. I measured the store then calculated the energy needed to push a cart from one point to another considering food weights and distances. Millions of routes were calculated, but one was the most efficient.
Result: A map of the store guides you through the shortest route.

137 TESLA AUTOPILOT: LEVEL 5 AUTONOMOUS CAR CONTROL APP
School: California Institute of the Arts | Instructor/Professor: Gail Swanlund
Student: Ray Yeunsu Shin
Assignment: I decided to make an app where users can control their level 5 autonomous Tesla like as their personal driver or personal assistant.
Approach: Based on brand research, I came up with five keywords: Middle-aged, Luxurious, Elegant, Progressive and Sophisticated. I focused on making user interfaces operable, and understandable for people with a range of abilities and ages. For the icon system, I used the curved edges of Tesla's logotype as the foundation.
Result: The app allows the user to control the car remotely. The user can control the interior climate of the vehicle, doors, lights and driving mode. Especially in the driving mode control page, the user can set the maximum speed that the car can go.

138 BARBER BOARD CO. | School: Texas State University
Instructor/Professor: Mikaela Buck | Student: Logan Brannen
Assignment: To design a conceptual pictorial logo by combining two objects.
Approach: For this assignment, I combined a barber pole + a skateboard to create a logo for a skate and barber shop. I wanted to integrate the two similar forms in order to create a cohesive mark that reads as both a barber pole and a skateboard.
Result: I was able to create a simplified logo with a familiar color palette and a bold, contemporary typeface to give both a modern and classic feel.

138 BOOK BAT CAFE LOGO | School: Texas State University
Instructor/Professor: Vic Rodriguez | Student: Kaitlyn Tostado
Assignment: Create a logo for a company in Austin, Texas. The intent for the company is to provide a safe and welcoming environment where college students can hang out.
Approach: My first step was to create a wordlist of things associated with Austin and places that college students would spend their time. Next, I made thumbnail sketches of possible combinations. I settled on a logo that combines a book and a bat. This resulted in the creation of a company called Book Bat Cafe. Book Bat Cafe is a 24-hour cafe/lounge where students can safely and comfortably study long into the night.
Result: The final stage of making this logo was selecting colors and choosing a typeface that reflected the company's hip and inviting aura.

138 OCEANIC INSTITUTE | School: Portfolio Center
Instructor/Professor: M.C. Coppage | Student: Sarah Wood
Assignment: Oceanic Institute is elite, integrative, and research-driven. The logo represents the cyclical nature of sustainability and our relationship with the ocean - what

we take out, we must put back in. The spherical shape represents our globe and our people coming together as one to take care of the oceans.

138 TD BANK REDESIGN | School: School of Visual Arts
Instructor/Professor: Eileen Hedy Schultz | Student: Hai Nguyen
Assignment: The assignment was to redesign an existing brand logo.
Approach: I choose to redesign TD Bank.
Result: This design for TD Bank was created so it can emphasize their slogan "America's Most Convenient Bank." From this design, it shows the potential within the company making themselves reliable and modern with their customers.

139 AUSTIN AZTEX FOOTBALL CLUB | School: Texas A&M University Commerce
Instructor/Professor: Josh Ege | Student: Jiyun Park
Assignment: Logo
Approach: Used Aztec patterns on the wings because the name is Aztex, and an eagle head to represent strength, speed, and the USA.

139 RED ROOSTER | School: University of Texas at Arlington
Instructor/Professor: Benjamin Dolezal | Student: Noel Ramos
Assignment: Redesign a logo for an existing restaurant.
Approach: I chose to redesign the restaurant, Red Rooster. I based the fundamentals of the rooster on an egg shape, I then used that same elliptical shape to build the rest of it.
Result: Going for a geometric approach allows the logo to be both eye-catching and flow smoothly. Overall, the new logo received a overwhelmingly positive response.

139 RUNNING OF THE BULLS | School: Portfolio Center
Instructor/Professor: Mike Kelly | Student: Courtney Jacobs
Assignment: Re-design a logo for the Running of the Bulls competition in Spain.
Approach: Showcase the danger and excitement of the event.
Result: The results are a logo that combines an angry bull's face with two people running. The runners are hidden in the horns of the bull.

139 BAUHAUS TOYS | School: Portfolio Center
Instructor/Professor: Mike Kelly | Student: Rowan Griscom
Assignment: This logo is for a toy company that uses the Bauhaus philosophy of play as a means to teach children. The mark is composed of the Bauhaus B as well as the basic form of a square and circles. It employs the philosophy of simple shapes forming a more complex whole and is colored in the primary colors favored by the Bauhaus.

139 PRESSURE SCOPE MARINE TECHNOLOGY | School: Texas State University
Instructor/Professor: Mikaela Buck | Student: Logan Brannen
Assignment: To design a conceptual pictorial logo by combining two objects.
Approach: For this assignment, I combined a whale + a submarine to create a logo for a sustainable marine technology company.
Result: I was able to create a reduced logo where both of the combined elements are visible, but also read as one object. I chose to make the whale the main focus of the mark in order to emphasize and reinforce the companies' agenda of sustainability.

140 BAUHAUS TOYS | School: Portfolio Center
Instructor/Professor: Mike Kelly | Student: Aaron Blake Navarro
Assignment: Create a logo for Bauhaus Toys.
Approach: I used the symbol of a rocking horse as a metaphor for play then simplified and constructed it out of shapes in a playful bauhaus style.

140 ROOTCYCLE | School: Texas State University
Instructor/Professor: Genaro Solis Rivero | Student: Juliana Ratchford
Assignment: This assignment called for creating a brandmark for the company Rootcycle, a toy market that sells repurposed, recycled, and eco-friendly toys.
Approach: Emphasize the kid-friendly aspect of the company while also making the mark appeal to adults. The goal was to create a gender-neutral brandmark that communicates a sense of charm, amusement, and eco-friendliness, but also establishes a mark that can be developed further into the brand experience.
Result: In finalizing the brandmark, I created an emblem with simple features to suggest a clean and honest feeling. The radish represents the health aspect of the company while the wind-up key is part of a child's toy and represents potential for interaction.

140 NOCTUNE | School: Texas State University
Instructor/Professor: Genaro Solis Rivero | Student: Juliana Ratchford
Assignment: This assignment called for creating a brandmark for the company Noctune, a late-night radio station that prides itself on playing the best hits all night long.
Approach: I wanted to utilize the visual of a "night owl" but also communicate the radio station aspect of Noctune as well. The goal was to create a timeless brandmark that not only communicates a sense of modernity and friendliness, but also establishes a mark that can be expanded further into the brand experience.
Result: In finalizing the logo, I wanted a simple form that would easily translate in any scale and have an expandable brand for a general audience.

140 CATTLE BARON'S BALL | School: Portfolio Center
Instructor/Professor: Mike Kelly | Student: Carsyn Ciuba
Assignment: Create a logo for the Cattle Baron's Ball
Approach: I used principles of psychology, specifically the gestalt theory, to showcase a cowboy boot print as the white space in a cow's head.

141 FINFARES | School: Texas State University
Instructor/Professor: Genaro Solis Rivero | Student: Noah Lewis
Assignment: In this project the goal was to make a logo for Finfares, a Cross-Atlantic airliner located in Miami, Florida.
Approach: I curated a word list of items relating to airliners, their location, and the Atlantic. I proceeded to sketch objects or symbols I felt best represented each word. After that I went through the list and looked for objects that shared similar forms.
Result: The end result was a dolphin merged with an airplane. The emblem form helps it become easily recognizable as a brand and elevates it higher than the mark on its own.

141 ROOSTER'S RISE | School: Portfolio Center
Instructor/Professor: Mike Kelly | Student: Jackson Watkins
Assignment: We were tasked with designing a logo for a Portland, Oregon-made Red Ale alcoholic beverage called Rooster's Rise.
Approach: I decided to go with a simpler, more direct approach that valued maximum immediate impact and communication to ensure that consumers understand the product, the company ethos and everything it stands for.
Result: The Roosters Rise logo has four layers of meaning: A craft appropriate tulip

glass is used here to give distinction and credibility to the mark. The tulip glass is used to give the rooster his body. The comb of the rooster is made from a stalk of barley malt (pre malting of course).

141 PRAIRIE HOME BRANDING | School: Brigham Young University
Instructor/Professor: Adrian Pulfer | Student: Ian Sullivan

141 GARDENING DEVILS | School: Portfolio Center
Instructor/Professor: Mike Kelly | Student: Jackson Watkins
Assignment: To design a logo for an urban horticulture business called gardening devils.
Approach: I dug into the history of devilish imagery and its association with nature.
Result: While the Gardening Devils logo only has two layers of meaning, the central layer has a rich history. The central layer of meaning is the face of the green man, a common motif found on old churches and pubs in the UK and Europe, which in turn is derived from a vegetative deity of pre-Christian Europe, the worship of whom was demonized as the work of the devil as Christianity spread to the British Isles. To emphasize the devilish aspects of the mark, two leaves were made to look like horns.

141 MANDARINA & CANELA | School: Portfolio Center
Instructor/Professor: Elizabeth Kelley | Student: Rafael Villasana
Assignment: Mandarina y Canela is a family owned bakery established in Caracas, Venezuela in summer of 2017. It specializes in baking up the sweetest treats, birthday cakes and custom cakes and breads for any occasion. The brand is reminiscent of mid-century Venezuela, a prosperous and exciting time for the country; where their founders, Cecilia and Iraima were raised.
Approach: M&C's identity deploys vintage typography and ornaments that, coupled with a muted color palette, reflect the brand's caring and nostalgic spirit.

142 MAVERICK BEARD CARE CO. | School: Auburn University
Instructor/Professor: Robert Finkel | Student: Madison Elrod
Assignment: Maverick Beard Care Co. was created for a Design I packaging project. All of the deliverables were created specifically for this assignment including target audience, concept, logo, design, and final packaging. Maverick Beard Care Company beard oil and beard balm are the highest quality blends on the market.
Approach: This design embodies the authentic and classic qualities of the company. The branding was heavily influenced by the typography and color schemes of the California Gold Rush but incorporated a modern twist.
Result: This selection of beard oil embodies the vintage and authentic feel of the company and to the select target audience.

143 RARE CROP BREW HOUSE | School: Portfolio Center
Instructor/Professor: Hank Richardson | Student: Danner Washburn
Assignment: Based off the unique Atlanta neighborhood of Cabbagetown, Rare Crop Brew House celebrates the quirky people, architecture, and art found exclusively in this area. Each bottle highlights an individual in the neighborhood whose life adds a piece to this community's eclectic tapestry.

144 BLACK HAMMER BREWERY | School: Academy of Art University
Instructor/Professor: Thomas McNulty | Student: Celina Oh

145 BLK WATER | School: Brigham Young University
Instructor/Professor: Adrian Pulfer | Student: Christian Santiago
Assignment: Reimagine packaging for the product, and I chose BLK Water. Its possibilities as a product line and brand were unexplored.
Approach: I sought to overcome the products' unnatural looking color, by referencing the original intended use of the product while also explaining the color. The periodic table of elements provided the main structural inspiration for the packaging.
Results: The bottles form remains recognizable. The B, L, and K are enlarged and twisted within the new framework. A ribbon of type reads vertically next to the logo.

146 MAVIS SHUTTLECOCK PACKAGING DESIGN | School: Texas A&M University Commerce | Instructor/Professor: Josh Ege | Student: Haebinna Choi
Assignment: This project for packaging design for Mavis Shuttlecock.
Approach: Mavis Shuttlecock has three different types of speed. The most important thing is how people recognize easily which one is fast, medium and slow.
Result: I decided to create shuttlecock in space instead of spacecraft. I designed different position of shuttlecocks to show speed.

147 JEJU BEER | School: Hansung University of Design & Art Institute
Instructor/Professor: Dong-Joo Park | Student: Su In Kim
Assignment: Jeju beer package project.
Approach: We expressed the figure of a lover proposing in beautiful scenery of camellia, citrus, and reed symbolizing Jeju Island. It is a romantic island beer package design with a romantic mood that can be felt only in Jeju beer by combining the sensation that can be felt in Jeju Island trip and the emotions that come when you drink beer.

147 HEX - THE CLASH OF COLORS, BOARD GAME | School: Academy of Art University | Instructor/Professor: Christine George | Student: Pauline Capote

148 JEJUBEER_WAVE | School: Hansung University of Design & Art Institute
Instructor/Professor: Dong-Joo Park | Students: Park Yuna, Kim Subin
Assignment: Jeju beer souvenir package only for Jeju island. Because it sells only in Jeju Island, it can increase the value as a gift.
Approach: I used the concept of 'time' to enjoy beer while looking at Jeju's beautiful appearance. It is a design goal that Jeju Island will be able to take a romantic and enjoyable time through Jeju beer.

149 IN CASE OF EMERGENCY COCKTAIL MIXER PACKAGING | School: Concordia University | Instructor/Professor: John Dufresne | Student: Matthew Sullivan
Assignment: This assignment was to produce a comprehensive portfolio project exemplifying the highest expectations of the graphic design profession.
Approach: In Case of Emergency (I.C.E.) mixers are pre-canned mixes which are used for easily making delicious cocktails whenever someone's in need of a delicious drink. For the packaging, I explored a contemporary approach to vintage inspired aesthetics.
Result: This packaging system exploration resulted in creating and utilizing detailed visual assets such as patterns, typography, icons, and illustrations to create a playful, yet unified packaging system.

150 KIKKOMAN SOY SAUCE | School: Brigham Young University
Instructor/Professor: Adrian Pulfer | Student: Mia Meredith

151 BARNEYS NEW YORK | MENS SKINCARE | School: Art Center College of Design
Instructor/Professor: Gerardo Herrera | Student: Hyek Im

Assignment: To develop and create a men's premium skincare line, with a focus on ocean conservation for Barneys New York.

Approach: Solve the problem of ocean pollution contributed by cosmetic industries while providing a unique male imagery for contemporary male audience. There was a lack of diversity regarding the male imagery being promoted in the premium male cosmetics market. This project sought to contribute to help solve that problem by using plastics recovered in the polluted ocean along with a charity campaign supported by Alexander Wang, who was known for participating in charities in the past.

152 BORDERLAND DISTILLING CO. | School: The Newhouse School, Syracuse University | Instructor/Professor: Unattributed | Student: Erin Reeves
Assignment: Packaging, Branding, Website, Advertising
Approach: Create a new look and feel for a fictitious family-owned distillery. Founded in 1926, this family-owned distillery is dedicated to crafting fine spirits that combine the rich cultures surrounding tea and liquor. Borderland's line of tea infused spirits offer a range of flavors specific to their origins; placing a modern twist on two timeless products.
Result: Timeless design, pattern work, emphasis on typography and illustration

152 GARAMOND: DRINK THE STANDARD | School: Portfolio Center
Instructor/Professor: Alice Chaosurawong | Student: Rowan Griscom
Assignment: Create a line of beers based off a typeface.
Approach: Similar to how Garamond was a standard for typography, Garamond: Drink the Standard becomes a standard for all beer packaging.

153 KANNA—A RECREATIONAL CANNABIS BRAND
School: Art Center College of Design | Instructor/Professor: Dan Hoy | Student: Yi Mao
Assignment: A hypothetical line of products targeted for recreational cannabis markets. It aims to offer California customers a luxurious cannabis brand experience.
Approach: The first challenge in designing this product line, is how to successfully create a premium and aesthetic appearance to audience through visuals under the strict laws of California cannabis packaging.
Result: A series packaging design for the entire product line of Kanna.

153 G BY GLOSSIER | FOR MEN | School: Art Center College of Design
Instructor/Professor: Gerardo Herrera | Student: Yvonne Tseng
Assignment: Develop a brand and packaging extension for a men's personal care line utilizing intelligent packaging and retail.
Approach: What if personal care was more approachable for men? What if there was a way to educate men about the importance of early skincare? G by Glossier is a personal care brand that will encourage men to stay fresh.

154 ZANELE MUHOLI POSTER | School: Art Center College of Design
Instructor/Professor: Brad Bartlett | Student: Charles Lin
Assignment: Poster campaign for re-branding of the performing arts organization, Performa based in NY. Founded by Rose Lee Goldberg in 2004, Performa is a organization dedicated to exploring the critical role of live performance in the history of twentieth-century art and encourages new directions in performance for today.

155 RUBBER DUCK REGATTA POSTER | School: Texas A&M University Commerce
Instructor/Professor: Josh Ege | Student: Jisu Jung
Assignment: The project was designing a poster for the Rubber Duck Regatta.
Approach: My concept is to visually show that rubber duck is almost to the finish line. To win at the race, a duck stretches out his foot. Originally, the rubber duck has no foot. But, I want to show fun element in my poster. So, I put the duck foot in my poster.

156 REBELLE "RÉ·VOLUTION" COLLECTION POSTERS | School: Art Center College of Design | Instructor/Professor: Cheri Gray | Student: Yi Mao
Assignment: "Rebelle" is a project which stemmed from the Experimental Type class at ArtCenter College of Design. "Rebelle" can be understood as exploring and practicing typography through fashion and clothing.
Approach: Digital Photography, scanning, digital collages, graphic design.
Result: A series of digital and printed promotion posters. For further information, please visit yimao.design/Rebelle

157 I'M NOT INVISIBLE | School: Temple University
Instructor/Professor: Bryan Satalino | Student: Rose Schisler
Approach: A series of typographic posters geared towards letting people know that they are heard, seen, and loved. The series is typographic and minimal in order to make a bold statement. The series is designed to be in locations where people feel lost or alone such as help centers and schools.

158 PERCEPTION UNFOLDS INTO SUBTLE IMAGES | School: Royal Melbourne Institute of Technology University | Instructor/Professor: Russell Kerr | Student: Tristan Danino
Assignment: Create an experimental poster using plastic typography as the primary visual element. The focus is on creating a work that embraces experimental practice and visually represents the energy of the chosen aphorism.
Approach: This poster exploits loopholes in the isometric grid to create seemingly impossible shapes to present geometry that seems to bend with only straight lines. In doing so, the typography directly plays with the audience's perception and their sense of reality.
Result: The poster is used to as the primary canvas to examine Elliots Earl's proposed five defining elements of 1990's Experimental Graphic Design and their relevance in 2018.

159 THE NEON DEMON MOVIE POSTERS | School: School of Visual Arts
Instructor/Professor: Eileen Hedy Schultz | Student: Gisell Bastidas Jaramillo
Assignment: The assignment was to make a poster for a movie of our choice.
Approach: When looking at the original posters I decided to keep the color palette.

160 NEW YORK COLORS EXHIBITION | School: School of Visual Arts
Instructor/Professor: Shawn Hasto | Student: Ahyoung Lim

161 PLEXUS - POSTER SERIES | School: Drexel University
Instructor/Professor: Shushi Yoshinaga | Student: Natalie Vaughan
Assignment: Senior thesis, Plexus logo and marketing poster series. Plexus is for all ages, but only comes in adult sizes currently. It is especially geared towards sneakerheads and those who take pride in the items they own.
Approach: I created the brand identity for a conceptual product that consists of top part of sneakers and 3D-printed soles that can be clipped together.
Result: Using the idea of customization and modular connections, I created a poster series, brand, and logo that relate to this product's unique selling points.

162 MANHATTAN | School: School of Visual Arts
Instructor/Professor: Peter Ahlberg | Student: Yunchung Chung

163 TOLERANCE POSTER | School: School of Visual Arts
Instructors/Professors: Ivan Chermayeff, Tom Geismar | Student: Soohyun Kim

164 I HEART HUCKABEES MOVIE POSTER | School: Savannah College of Art & Design
Instructor/Professor: Sohee Kwon | Student: Katherine Weaver
Assignment: This academic exercise's design prompt was to curate ten lines from a selected movie for use in a poster. This submission is an interpretation of the lines from the movie, "I Heart Huckabees," directed by David O. Russell.
Approach: I privileged instability through the lack of compositional hierarchy. In the deconstruction of hierarchy, I played with the Gestalt laws of visual perception organization to create disassociations.
Result: An anti-hierarchical composition that speaks to unity through fragmentation.

165 PROJECT CLOTHING | School: School of Visual Arts
Instructor/Professor: Shawn Hasto | Student: Ahyoung Lim
Assignment: Designing a poster for the clothing line "Project Clothing."

166 MYSTERY FEST | School: Texas Christian University
Instructor/Professor: Lewis Glaser | Student: Ashley Geroge
Assignment: Create a poster advertising a film festival.
Approach: My festival is titled Mystery Fest and is a compilation of the AFI's Top Mystery Movies. To represent the feeling of mystery movies, I photographed a file folder on a wooden desk. This, along with the added details such as blood and a drink, help to give off the feeling of being within a detective's office during an important case.
Result: After shooting my photo, I added on the information digitally through multiple styles of typography. My final project was printed to be 20x30.

167 LA MAMA | School: School of Visual Arts
Instructor/Professor: Peter Ahlberg | Student: Axel Lindmarker
Assignment: The first poster outlines the entire brand. It contains information on how to create new illustrations for posters and other collateral.

168 MOVABLE TYPES | School: School of Visual Arts
Instructor/Professor: Peter Ahlberg | Student: Min Kyung Kim

169 VISION - A VIEW OF MY POTENTIAL | School: Hansung University of Design & Art Institute | Instructors/Professors: Dong-Joo Park, Seung-Min Han | Student: Dahyun Kang
Assignment: Whoever you are, the possibilities are hidden in me. An infinite possibility.
Approach: I tried to formulate the hidden possibilities of each person and express their diversity in their respective arrangements and lines to produce a clear explanation.

170 STEDELIJK MOIRE POSTER | School: School of Visual Arts
Instructor/Professor: Craig Ward | Student: Lindmarker Axel
Assignment: A chair that inspires you

171 A BREAKING FRAME | School: Hansung University of Design & Art Institute
Instructors/Professors: Dong-Joo Park, Seung-Min Han | Student: Ye Rin Jeon
Assignment: This work is a personal exhibition poster expressing a new perspective and value when breaking the frame of limit.
Approach: I expressed the word "frame" as if it were hardened, showing impunity and frustration, and expressing that it was out of bounds by breaking. The 'v' on this poster means 'vision' and 'value', and it is reminiscent of visual design as well.

171 BREATHE MANTRA POSTER | School: Texas Christian University
Instructor/Professor: Bill Galyean | Student: Michele Farren
Assignment: Typographically express a personal quote or mantra in a poster design.
Approach: Breathe—a reminder that brings me back to the basics of being human.
Result: This piece was executed by hand, finalized in Adobe Draw, printed out at 20x30", then hand quilled with 100lb paper from Clampitt Paper Company.

172 GUN VIOLENCE | School: Hansung University of Design & Art Institute
Instructors/Professors: Dong-Joo Park, Seung-Min Han | Student: Hee Jung Lee
Assignment: Using firearms returns to you. Inform people of their perceptions.
Approach: It is in the form of a shadow combining gun and tombstone. The muzzle of a gun is bent and connected with the tombstone of the coffin.

173 CALDER STAMP SERIES | School: The Newhouse School, Syracuse University
Instructor/Professor: Renée Stevens | Student: Yingying Yue
Assignment: Create a series of stamps to honor the artwork of Alexander Calder.
Approach: Instead of representing his work directly, I chose to design new sculptures by mimicking his style. I chose four types of his work which can show his personality.
Result: I create a stamp series honoring Calder's wire sculpture, wall sculpture, hanging mobile and monumental sculpture respectively.

174 PROTO-TYPE | School: University of Texas at Arlington
Instructor/Professor: Andrew Klein | Student: Noel Ramos
Assignment: Developing a typeface over something that interests you personally.
Approach: With my obsession for geometric design, I wanted to create an alphabet based on mechanical objects. I employed this concept by adding a blueprint aesthetic.
Result: Overall, this alphabet received overwhelmingly positive response from the viewers, along with international recognition in competitions.

175 TOPOGRAPHIC TYPOGRAPHY | School: University of Illinois at Chicago
Instructor/Professor: Amir Berbic | Students: T. Alioto, E. Andrade, M. Castro, H. Friedman, A. Galvan, H. Hasanieh, B. Hurlbert, M. Kwiatkowski, E. Mendez, D. Mujagić, C. Ortiz, K. Richmond, N. Schmidt, K. Smith, J. Stabner, J. Taylor, D. Truong, T. Webb, A. Yepez.
Assignment: This class project engages the study of three-dimensional typography through exploration of relief conditions with letterforms.
Approach: Examine how digital fabrication can expand the way graphic designers engage in the physical act of making and looks at new typographic forms that emerge in the process.
Result: The collection of individual models designed and fabricated by students forms a full three-dimensional alphabet set.

176 FAIRY | School: Maryland Institute College of Art
Instructor/Professor: Ellen Lupton | Student: Potch Auacherdkul
Assignment: Display Typeface
Approach: Fairy was inspired by looking back at Tuscan serif typefaces during the wood type era, and then redrawing them.
Result: Fairy Tuscan is a display typeface that is the result of combining a Tuscan serif with medieval calligraphy style.

176 SELF PORTRAIT | School: School of Visual Arts
Instructor/Professor: JungIn Yun | Student: Ryoko Kondo

Assignment: This animation was made to represent myself by designing each letter of my first name: Ryoko. The visual concept is the evolution and transformation of me as a person in terms of my design, thoughts, and life. One piece of object morphs into another completely new object and this process represents the constant change in my life.

DESIGN SILVER WINNERS:

178 ILLUSTRATED BOOK COVER | School: School of Visual Arts
Instructor/Professor: Barbara deWilde | Student: Claire Filipek

178 1984 | School: School of Visual Arts
Instructor/Professor: Pablo Delcan | Student: Davina Hwang

178 ARCANE GEMOLOGY | School: West Chester University
Instructor/Professor: Karen Watkins | Student: Amber O'Brien

179 SPACE TRILOGY | School: Portfolio Center
Instructor/Professor: Hank Richardson | Student: Mckenzie Martin

179 BOUNTY TRILOGY | School: Portfolio Center
Instructor/Professor: Hank Richardson | Student: Katie Tynes

179 NEW YORK TRILOGY | School: Portfolio Center
Instructor/Professor: Hank Richardson | Student: Laura McMullan

179 EXPOSED | School: Pennsylvania State University
Instructor/Professor: Kristin Sommese | Student: Kayla Corazzi

179 SHAKESPEARE SERIES | School: School of Visual Arts
Instructor/Professor: Ivan Chermayeff | Student: Soohyun Kim

179 FEVERDREAM | School: Pennsylvania State University
Instructor/Professor: Kristin Sommese | Student: Eleanor Wing

179 A MONSTER CALLS BOOK COVER | School: School of Visual Arts
Instructor/Professor: Christopher Rypkema | Student: Gisell Bastidas Jaramillo

179 ARS FORTUNAM (THE ART OF LUCK) | School: Savannah College of Art & Design
Instructor/Professor: Rhonda Arntsen | Student: Katherine Weaver

180 COLOR STUDIES EDUCATION CAMPAIGN | School: School of Visual Arts
Instructor/Professor: Unattributed | Student: Hyeonjeong Jang

180 BIPOLAR DISORDER | School: School of Visual Arts
Instructor/Professor: Shawn Hasto | Student: Yuo Ning Chien

180 BAM NEXT WAVE FESTIVAL | School: School of Visual Arts
Instructor/Professor: Peter Ahlberg | Student: Donglin Huang

180 LANG TECH CONFERENCE | School: Art Center College of Design
Instructor/Professor: Simon Johnston | Student: Mansi Soni

181 JUNIOR PLAYERS | School: Texas A&M University Commerce
Instructor/Professor: Josh Ege | Student: Haebinna Choi

181 ICFF | School: School of Visual Arts
Instructors/Professors: Kenneth Deegan, Brankica Harvey | Student: Hanbyul Park

181 COMERICA BANK REBRAND | School: Art Center College of Design
Instructor/Professor: Gerardo Herrera | Student: Christina Kwang

182 BACTERIA MUSEUM | VISUAL IDENTITY | School: School of Visual Arts
Instructors/Professors: Natasha Jen, Joseph Han | Student: Zhang Shengying

182 LAND O' LAKES | School: Portfolio Center
Instructor/Professor: Hank Richardson | Student: Madison Defillipes

182 FARM TO MARKET | School: Texas State University
Instructor/Professor: Bill Meek | Student: Pedro Moreno

183 NYC COMEDY FESTIVAL | School: School of Visual Arts
Instructor/Professor: Eric Baker | Student: Min Jeong Kim

183 K LEAGUE REBRANDING | School: School of Visual Arts
Instructor/Professor: Peter Ahlberg | Student: Dongjun Woo

183 SOS ONLINE RADIO FESTIVAL | School: Art Center College of Design
Instructor/Professor: Brad Bartlett | Student: Lulubi Garcia

183 DONUT PALACE | School: University of Texas at Arlington
Instructor/Professor: Deanna Gibson | Student: Noel Ramos

183 HIRMER PUBLISHERS BRAND IDENTITY | School: School of Visual Arts
Instructors/Professors: Paula Scher, Courtney Gooch | Student: Seoyoung Lee

183 MOOSE CANOE FOOD TRUCK BRANDING | School: Concordia University
Instructor/Professor: John DuFresne | Student: Matthew Sullivan

183 OLD NOG | School: Portfolio Center
Instructor/Professor: Hank Richardson | Student: Casey Lovegrove

184 ELECTRIC ILLUSION MUSIC FESTIVAL | School: University of Texas at Arlington
Instructor/Professor: Loryn O'Donnell | Student: Noel Ramos

184 ALDER PLANETARIUM | School: Brigham Young University
Instructor/Professor: Adrian Pulfer | Student: Tiffany Plier

184 SONGS OF THE WANDERERS | School: Art Center College of Design
Instructor/Professor: Cheri Gray | Student: Shiang-jye Yang

185 UNIVERSITY OF HANSUNG'S IDENTITY EXTENSION AND MD DESIGN
School: Hansung University of Design & Art Institute | Instructor/Professor: Dong-Joo Park, Seung-Min Han | Students: Jang Yeon Woo, Lee Sun Hee, Kang Ju Yeon

185 NEW YORK FILM FESTIVAL BRANDING
School: Brigham Young University Instructor/Professor: Adrian Pulfer
Student: Laura Ann McNeill

185 OHIO AVIATORS | School: Texas A&M University Commerce
Instructor/Professor: Josh Ege | Student: Solbinna Choi

186 FABLE DISCS | School: Texas State University
Instructor/Professor: Genaro Solis Rivero | Student: Emily Castillo

186 BAHAMA BUCK'S | School: Texas A&M University Commerce
Instructor/Professor: David Beck | Student: Solbinna Choi

186 SUNNYSIDE REBRANDING | School: School of Visual Arts
Instructor/Professor: Jon Kudos | Student: Jiwon Lee

186 MENIL COLLECTION IDENTITY | School: Art Center College of Design
Instructor/Professor: Kristen Chon | Student: Gerardo Herrera

186 BEARDED BASTARD | School: Texas State University
Instructor/Professor: Genaro Solis Rivero | Student: Vanessa Kerr

186 LACROIX SPARKLING WATER BRANDING / REPACKAGING
School: Portland Community College | Instructor/Professor: Tracey Ullom
Student: Anthony J Mottola

187 OLIVE & OAK | School: Texas Christian University
Instructor/Professor: Jan Ballard | Student: Michele Farren

187 WHISTLES | School: Brigham Young University
Instructor/Professor: Adrian Pulfer | Student: Emmie Brower

187 ALBUQUERQUE AIR | School: Portfolio Center
Instructor/Professor: Sam Eckersley | Student: McKenzie Martin

187 BUMBLE BEE REDESIGN BRAND IDENTITY | School: School of Visual Arts
Instructor/Professor: Eileen Hedy Schultz | Student: Hai Nguyen

187 FLYTE BRANDING | School: Temple University
Instructor/Professor: Abby Guido | Student: Leigh Menkevich

187 METHODS OF MADNESS | School: Academy of Art University
Instructor/Professor: Hunter Wimmer | Student: Raymond Monsada

188 GILL SANS - TYPEBOOK | School: University of Texas at Arlington
Instructor/Professor: Veronica Vaughan | Student: Noel Ramos

188 JAPAN 2020 | School: George Brown College
Instructor/Professor: Ian Gregory | Student: Yusuke Yamazaki

188 ADRIAN YOUNGE: SOMETHING ABOUT APRIL II | School: Portfolio Center
Instructor/Professor: Pippa Seichrist | Student: Justin Tompkins

189 0 TO 9 CALENDAR | School: School of Visual Arts
Instructor/Professor: Young Sun Compton | Student: Chaei Mo

189 APHEX TWIN—SELECTED AMBIENT WORKS 85–92
School: Art Center College of Design | Instructor/Professor: Cheri Gray
Student: Shiang-jye Yang

190 JACKJACK EDITORIAL | School: Art Center College of Design
Instructor/Professor: Anni Huang | Student: Sam Yen

190 GRETA MAGAZINE | School: Academy of Art University
Instructor/Professor: Phil Hamlett | Student: Sadie Williams

191 CRAZY SEXY COOL: WOOD TYPE REDESIGN
School: School of Visual Arts | Instructor/Professor: Carin Goldberg | Student: Julia Yu

191 PAPER MAGAZINE | School: Brigham Young University
Instructor/Professor: Adrian Pulfer | Student: Ian Sullivan

191 JUXTAPOZ MAGAZINE | School: Brigham Young University
Instructor/Professor: Adrian Pulfer | Student: Laura Ann McNeill

191 OBJEKT MAGAZINE | School: Brigham Young University
Instructor/Professor: Adrian Pulfer | Student: Abby DeWitt

191 CRAZY SEXY COOL VER.1 | School: School of Visual Arts
Instructor/Professor: Carin Goldberg | Student: Yunchung Chung

191 A10 MAGAZINE | School: Brigham Young University
Instructor/Professor: Adrian Pulfer | Student: Erica Bevan

191 SOCIAL MAGAZINE | School: Pennsylvania State University
Instructor/Professor: Kristin Sommese | Student: Emily Adar

191 TAKE TWO MAGAZINE DESIGN | School: George Brown College
Instructor/Professor: Jerri Johnson | Student: Patrick Blanchard

191 ECHO MAGAZINE 2018 | School: Columbia College of Chicago
Instructors/Professors: Guy Villa Jr., Sharon Bloyd-Peshkin | Student: Echo Design Team

192 NY TIMES BOOK REVIEW SERIES | School: School of Visual Arts
Instructor/Professor: Carin Goldberg | Student: Soohyun Kim

192 ETH ZURICH | School: School of Visual Arts
Instructors/Professors: Courtney Gooch, Paula Scher | Student: JiSoo Eom

193 FIAT SWEET SPOT | School: Portfolio Center
Instructor/Professor: Lauren Bernstein | Student: Rowan Griscom

193 NEW WAVE MOVEMENT EXHIBITION DESIGN | School: Savannah College of Art and Design | Instructor/Professor: Melissa Kuperminc | Student: Puxi Yang

194 FIRST CUP OF THE DAY | School: School of Visual Arts
Instructor/Professor: Kevin O'Callaghan | Student: Tae Gyung Kang

194 UKULELE SHOES | School: School of Visual Arts
Instructor/Professor: Kevin O'Callaghan | Student: Tae Gyung Kang

194 DINNER WITH THE SLOBS | School: Temple University
Instructor/Professor: Bryan Satalino | Student: Ying Ying Zhang

195 IN A HALF HOUR | School: School of Visual Arts
Instructors/Professors: Chris Buzelli, Yuko Shimizu | Student: Lydia Kassinos

195 TOOTHACHE | School: School of Visual Arts
Instructor/Professor: Henrik Drescher | Student: Grace Milk

195 HELLO FROM THE ROOFTOP | School: School of Visual Arts
Instructor/Professor: Aya Kakeda | Student: Cindy Kang

195 SISTERS | School: School of Visual Arts
Instructors/Professors: Marcos Chin, Yuko Shimizu | Student: Seung Won Chun

196 SNOW WHITE | School: School of Visual Arts
Instructor/Professor: Marvin Mattelson | Student: Yutong Wu

196 EGYPTIAN GODDESS | School: School of Visual Arts
Instructor/Professor: Marvin Mattelson | Student: Siyi Hemu

196 HUDSON | School: School of Visual Arts
Instructor/Professor: Henrik Drescher | Student: Sasha Brodski

197 BROTHER IN WHITE | School: School of Visual Arts
Instructors/Professors: T.M. Davy, Thomas Woodruff | Student: Brianna Yovino

197 SHALL WE DANCE | School: School of Visual Arts
Instructor/Professor: Steve Brodner | Student: Tianxin Yu

197 SCRAMBLE | School: School of Visual Arts
Instructor/Professor: Marvin Mattelson | Student: Yutong Wu

197 GROW | School: School of Visual Arts
Instructor/Professor: Marvin Mattelson | Student: Agniya Tolstokulakova

197 UNTITLED | School: School of Visual Arts
Instructors/Professors: T.M. Davy, Thomas Woodruff | Student: Yang Tzu Chung

197 NILE RIVER | School: School of Visual Arts
Instructor/Professor: Aya Kakeda | Student: Linda Shi

197 HUNTER MASTODON | School: School of Visual Arts
Instructors/Professors: Chris Buzelli, Yuko Shimizu | Student: Brian Scagnelli

197 SELF PORTRAIT | School: School of Visual Arts
Instructor/Professor: Henrik Drescher | Student: Grace Milk

197 UNTITLED | School: School of Visual Arts
Instructor/Professor: Steve Brodner | Student: Annabelle Doan

198 SPRING | School: School of Visual Arts
Instructors/Professors: Marcos Chin, Yuko Shimizu | Student: Seung Won Chun

198 BINDING OF FENRIR | School: School of Visual Arts
Instructors/Professors: Marcos Chin, Yuko Shimizu | Student: Lydia Kassinos

198 MUNROE | School: School of Visual Arts
Instructors/Professors: T.M. Davy, Thomas Woodruff | Student: Evan Pavley

198 BANNIC | School: School of Visual Arts
Instructors/Professors: Marcos Chin, Yuko Shimizu | Student: Wenjia Wang

198 FLOATING | School: School of Visual Arts
Instructor/Professor: Steve Brodner | Student: Yuan Tian

198 WITCHES FIRE | School: School of Visual Arts
Instructors/Professors: Marcos Chin, Yuko Shimizu | Student: Kyle Smeallie

198 HIPSTER BREADS TAKING OVER NYC | School: School of Visual Arts
Instructors/Professors: Chris Buzelli, Yuko Shimizu | Student: Brian Scagnelli

198 DETECTIVE | School: School of Visual Arts
Instructor/Professor: Henrik Drescher | Student: Sasha Brodski

198 SMALL THINGS | School: School of Visual Arts
Instructor/Professor: Jon Kudos | Student: Danae Gosset

199 HERE | School: Art Center College of Design
Instructor/Professor: Carolina Trigo | Student: Na Yeon Kim

199 SCAD FASH PIERRE CARDIN INVITATION CARD | School: Savannah College of Art & Design | Instructor/Professor: Peter Wong | Student: Hazel Hwang

199 DALLAS HOLOCAUST MUSEUM GRAND OPENING INVITATION CARD
School: Texas A&M University Commerce | Instructor/Professor: Katie Kitchens
Student: Sohyeon Ahn

199 CREATE | School: Temple University
Instructor/Professor: Abby Guido | Student: Luke Harding

199 MAKE-A-WISH NORTH TEXAS INVITATION | School: Texas A&M University Commerce | Instructor/Professor: Katie Kitchens | Student: Brandi Hamilton

200 ONEDER | School: Portfolio Center
Instructor/Professor: Hank Richardson | Student: Katie Tynes

200 PURRM KITTY SALON | School: Temple University
Instructor/Professor: Abby Guido | Student: Michaela Williams

200 ALOHA HAWAIIAN BARBEQUE | School: Texas A&M University Commerce
Instructor/Professor: Josh Ege | Student: Jisu Jung

200 MISO HUNGRY | School: Texas Christian University
Instructor/Professor: Dusty Crocker | Student: Kahla Watkins

200 GARDENING DEVILS | School: Portfolio Center
Instructor/Professor: Mike Kelly | Student: Rowan Griscom

200 AQUATURE LOGO | School: Texas State University
Instructor/Professor: Genaro Solis Rivero | Student: Stephan Tynes

200 MAVERICK WEDDING PLANNING | School: Texas State University
Instructor/Professor: Genaro Solis Rivero | Student: Jazmine Beatty

200 VIPER ELECTRIC | School: Texas State University
Instructor/Professor: Genaro Solis Rivero | Student: Noah Lewis

200 MUSCARCEO | School: Texas State University
Instructor/Professor: Genaro Solis Rivero | Student: Haley Buckner

200 ZENGINE | School: Texas State University
Instructor/Professor: Genaro Solis Rivero | Student: Tracy Hang

200 CHESSEX REDESIGN | School: Metropolitan State University of Denver
Instructor/Professor: Carrie Osgood | Student: Devon Iredale

200 LAKESIDE GRILL | School: Texas State University
Instructor/Professor: Genaro Solis Rivero | Student: Noah Lewis

201 TEXAS BURLESQUE FESTIVAL RE-BRAND | School: Texas State University
Instructor/Professor: Unattributed | Student: Bronte Giardina

201 GLOWING TULIP | School: Texas State University
Instructor/Professor: Genaro Solis Rivero | Student: Mia Rendon

201 THE SOUND FOUNDATION LOGO CONCEPT | School: Texas A&M University Commerce | Instructor/Professor: Josh Ege | Student: Stephanie Williams

201 BLUE MARLIN ELECTRIC | School: Portfolio Center
Instructor/Professor: Mike Kelly | Student: Aaron Blake Navarro

201 HAMMERED BLOODY MARY MIX | School: Texas State University
Instructor/Professor: Genaro Solis Rivero | Student: Lauren Zawodni

201 BABEE NATURAL | School: Texas State University
Instructor/Professor: Genaro Solis Rivero | Student: Jazmine Beatty

201 ATHENS LOGO | School: Portland Community College
Instructor/Professor: Nathan Savage | Student: Dante Stewart

201 STATE OF PLAY LOGO | School: Texas A&M University Commerce
Instructor/Professor: Josh Ege | Student: Sohyeon Ahn

201 JUNGLE ISLAND | School: Texas State University
Instructor/Professor: Zachary Vernon | Student: Jose Moreno

201 KOSMOS COFFEE CO-OP | School: Texas State University
Instructor/Professor: Jeff Davis | Student: Paul Davis

201 GARDENING DEVILS | School: Portfolio Center
Instructor/Professor: Mike Kelly | Student: Aaron Blake Navarro

201 SPOTIFY LOGO REDESIGN | School: Portfolio Center
Instructor/Professor: Mike Kelly | Student: Jackson Watkins

202 OAHU CRUNCH PACKAGE SERIES | School: Texas Christian University
Instructor/Professor: Yvonne Cao | Student: Britta Wichary

202 JEJU BEER 2019 NEW YEAR'S LIMITED EDITION
School: Hansung University of Design & Art Institute
Instructor/Professor: Dong-Joo Park | Student: Minseo Ji

202 SEE'S REBRAND & PACKAGING | School: Art Center College of Design
Instructor/Professor: Ania Borysiewicz | Student: Cid W. Lee

203 MURRIETA'S WELL VINEYARD | School: Academy of Art University
Instructor/Professor: Thomas McNulty | Student: Yvonne Anaya

203 EPOCH | School: Academy of Art University
Instructor/Professor: Thomas McNulty | Students: Silvia Abruzzese, Maria Wong Chang, Jason de Cruz, Lucy Tsai, Tiffany Byrd, Jonathan Biehl

203 ELASTICO | School: Temple University
Instructor/Professor: Bryan Satalino | Student: Alex Bruce

203 DE CECCO - PACKAGING | School: School of Visual Arts
Instructor/Professor: Louise Fili | Student: Isabella Cuda

203 FESTIVAL JEJU BEER | School: Hansung University of Design & Art Institute
Instructor/Professor: Dong-Joo Park | Student: Ji Yun Kim

203 GOLDEN DRAGON | School: George Brown College
Instructor/Professor: Jerri Johnson | Student: Yusuke Yamazaki

204 MRS. EAVES BEER PACKAGING | School: Portfolio Center
Instructor/Professor: Alice Chaosurawong | Student: Sarah Wood

204 BERRYESSA BREWING | School: Academy of Art University
Instructor/Professor: Thomas McNulty | Student: Zhenni Duan

204 SUMMER NIGHT LEMONADE | School: Kutztown University of Pennsylvania
Instructor/Professor: Vicki Meloney | Student: Lily Stamm

204 YOI SUSHI PACKAGING | School: Texas Christian University
Instructor/Professor: Yvonne Cao | Student: Kirstin Mullins

204 CASTELLO DI AMOROSA | School: Academy of Art University
Instructor/Professor: Thomas McNulty | Student: Anya Widyawati

204 NICORETTE GUM PACKAGING | School: Portfolio Center
Instructor/Professor: Hank Richardson | Student: Danner Washburn

205 HAN DYNASTY | School: School of Visual Arts
Instructors/Professors: Natasha Jen, Joseph Han | Student: Ji Soo Eom

205 XL RECORDINGS | School: School of Visual Arts
Instructors/Professors: Courtney Gooch, Paula Scher | Student: Ji Soo Eom

206 GRAMERCY THEATRE | School: School of Visual Arts
Instructors/Professors: Pablo Delcan, Ben Grandgenett | Student: Jay Giraldo

206 KOREAN ALPHABET, HANGEUL | School: Savannah College of Art & Design
Instructor/Professor: Peter Wong | Student: Rosa Sung

206 POSTER DESIGN PROJECT | School: Miami Ad School Wynwood
Instructor/Professor: Carlos Roncajolo | Student: Qi Shen

206 FREAK OUT | School: Royal Melbourne Institute of Technology University
Instructor/Professor: Russell Kerr | Student: Tristan Danino

207 HERE ARTS CENTER POSTER | School: School of Visual Arts
Instructor/Professor: Peter Ahlberg | Student: Manchanda Noora

207 DOLLY PARTON CONCERT POSTER | School: Miami Ad School
Instructor/Professor: Hank Richardson | Student: Alex Somoza

207 BOLT FUTURISTS: 3 TECHNICAL PIONEERS
School: University of Cincinnati DAAP | Instructor/Professor: Reneé Seward
Student: Christine Bosch

207 HARRY POTTER AND THE CURSED CHILD | School: Miami Ad School
Instructor/Professor: Unattributed | Student: Hridaynag Kooretti

207 MOTHER! MOVIE POSTERS | School: School of Visual Arts
Instructor/Professor: Santiago Carrasquilla | Student: Gisell Bastidas Jaramillo

207 GIRLS' RIGHTS ARE HUMAN RIGHTS
School: Texas A&M University Commerce | Instructor/Professor: Rick Gavos
Student: Monica Williams

207 INACTION | School: Royal Melbourne Institute of Technology University
Instructor/Professor: Russell Kerr | Student: Chiara Ananda Croserio

207 HAYDEN PLANETARIUM POSTER | School: School of Visual Arts
Instructor/Professor: Eileen Hedy Schultz | Student: Gisell Bastidas Jaramillo

207 OPIOID OVERDOSE IS A KILLER | School: Portfolio Center
Instructor/Professor: Pippa Seichrist | Student: Shivani Shah

208 TRANS SIBERIAN RAILWAY | School: School of Visual Arts
Instructor/Professor: Paula Scher | Student: Haejung Jun

208 ECHOES OF AN ERA | School: Miami Ad School
Instructor/Professor: Hank Richardson | Student: Esther Lee

208 DE STIJL POSTER | School: School of Visual Arts
Instructor/Professor: Carin Goldberg | Student: Soohyun Kim

208 FLOW | School: Hansung University of Design & Art Institute
Instructors/Professors: Dong-Joo Park, Seung-Min Han | Student: Jeon Min Gyeong

208 MADRID FILM FESTIVAL | School: Miami Ad School Europe
Instructor/Professor: Florian Weitzel | Student: Claudio Castagnola

208 DIWALI: OUT OF THE DARKNESS | School: Woodbury University
Instructor/Professor: Rebekah Albrecht | Student: Genesis Huchim

208 REPETITION IS A FORM OF CHANGE | School: Royal Melbourne Institute of
Technology University | Instructor/Professor: Russell Kerr | Student: Adrian Franzese

208 CONVERSION TO JOY | School: Hansung University of Design & Art Institute
Instructors/Professors: Dong-Joo Park, Seung-Min Han | Student: Su In Kim

208 WORLD OF DREAMS | School: Pennsylvania State University
Instructor/Professor: Kristin Sommese | Student: Emily Adar

209 EMPOWERMENT | School: West Chester University
Instructor/Professor: Karen Watkins | Student: Kelsey Dowling

209 SURVIVORS PATHWAY: LGBT ORGANIZATION POSTER | School: Miami Ad
School | Instructor/Professor: Hank Richardson | Student: Nidal Koteich

209 WHAT'S UP | School: Portfolio Center
Instructor/Professor: Hank Richardson | Student: Laura McMullan

209 CFF IDENTITY DESIGN | School: School of Visual Arts
Instructors/Professors: Kenneth Deegan, Brankica Harvey | Student: Seowoo Han

209 SOCIAL DIVISION, SOCIAL HONESTY
School: Hansung University of Design & Art Institute
Instructors/Professors: Dong-Joo Park, Seung-Min Han | Student: Jang Yeon Woo

209 TOM SACHS EXHIBITION | School: School of Visual Arts
Instructor/Professor: Eileen Hedy Schultz | Student: Nuri Park

209 BOY/GIRL | School: Metropolitan State University of Denver
Instructor/Professor: Shawn Meek | Student: Jack Grupe

210 K LEAGUE POSTER | School: School of Visual Arts
Instructor/Professor: Peter Ahlberg | Student: Dongjun Woo

210 DISORDERED | School: School of Visual Arts
Instructor/Professor: Peter Ahlberg | Student: Min Kyung Kim

210 COPENHAGEN | School: West Chester University
Instructor/Professor: Karen Watkins | Student: Sophie Olson

210 SCIFEST 2018 | School: Art Center College of Design
Instructor/Professor: Brad Bartlett | Student: Alpha Lung

210 MONOGRAM TYPEFACE | School: School of Visual Arts
Instructor/Professor: Douglas Riccardi | Student: Hai Nguyen

210 IMMIGRATION EVENT | School: Academy of Art University
Instructor/Professor: Andrew Loesel | Student: Krishnapriya Dutta Gupta

210 EXTRA FATTY | School: Maryland Institute College of Art
Instructor/Professor: Ellen Lupton | Student: Jenna Klein

210 SELF PROMOTION | School: School of Visual Arts
Instructors/Professors: Jungin Yun, Brian Bowman | Student: Eunah Hwang

211 IRMA BOOM POSTER | School: San Jose State University
Instructor/Professor: Randall Sexton | Student: Marina Menéndez-Pidal

211 STEERHEAD REGATTA | School: Texas A&M University Commerce
Instructor/Professor: Josh Ege | Student: Jiyun Park

211 UPSTREAM COLOR, MOVIE POSTER | School: Drexel University
Instructor/Professor: Shushi Yoshinaga | Student: Jenna Lecours

211 ROSALIND FRANKLIN IDENTITY EXPRESSION POSTER | School: Metropolitan
State University of Denver | Instructor/Professor: Carrie Osgood | Student: Eleeza Palmer

211 THE ULTIMATE BLANK CANVAS | School: Maryland Institute College of Art
Instructor/Professor: Ellen Lupton | Student: Jenna Klein

211 PENNY DRESS | School: School of Visual Arts
Instructor/Professor: Kevin O'Callaghan | Student: Mert Avadya

211 HAIR DRYER SHOES | School: School of Visual Arts
Instructor/Professor: Kevin O'Callaghan | Student: Nakyung Youn

211 OCULUS - UI DESIGN | School: Metropolitan State University of Denver
Instructor/Professor: Shawn Meek | Student: Klovit Kikanga

PHOTOGRAPHY GOLD WINNERS:
213 SMILE A FILM NOIR CAMPAIGN | School: Miami Ad School Wynwood | Instructor/
Professor: Ralph Budd | Students: Yasmine Nur, Annie Bardhwaj, Tierra Armstrong
Assignment: Create a film noir video.
Approach: Involve a brand, product placement and brand story.
Result: A film noir video with an editorial style photoshoot and a film poster.

214 FLOATING | School: Art Institute of Atlanta
Instructor/Professor: Taylor Bareford | Student: Kristopher Burris
Assignment: I shot this image within my specialization: luxury portraits and products.
Approach: I wanted to do something more creative than to simply photograph a model
wearing jewelry, so the addition of water worked well with the concept.
Result: The texture of the water enhanced the jewelry, making it a compelling image!

214 MOTHER NATURE | School: Miami Ad School
Instructor/Professor: Hank Richardson | Student: Amaya De Vleeschauwer
Assignment: Capture the best moments of your school break and present in class.
Approach: Exploring nature and cultures around the world has always given me inspi-
ration and thirst for more. I produced a series capturing "Mother Nature" moments.
Result: Since I wanted my series to consist of Mother Nature, I needed to wait for the
perfect moments to take shots with my camera. Those are the moments that inspire me.

215 BLACKSMITH | School: Art Institute of Atlanta
Instructor/Professor: Lynda Green | Student: Andrew Segovia
Assignment: Portrait on location involving someone at work.

Approach: The blacksmith shop would make for a very grungy and interesting subject.
Result: The dirt and grease presented in the shot helped create contrast in the image.

216 KRAKEN | School: Art Institute of Atlanta
Instructor/Professor: Taylor Bareford | Student: Alexandra Sheaffer
Assignment: Liquor bottle shot.
Approach: I wanted to create a scene that felt like the bottle was at sea while also
referencing the label itself.

PHOTOGRAPHY SILVER WINNERS:
217 PATIENCE | School: Texas Christian University
Instructor/Professor: Dusty Crocker | Student: Mackenzie Malpass

217 REVLON LIPGLOSS | School: Art Institute of Atlanta
Instructor/Professor: Taylor Bareford | Student: Marisa Bedard

217 VERSACE | School: Art Institute of Atlanta
Instructor/Professor: Lynda Green | Student: Tyler King

218 MIAMI AD SCHOOL AD CAMPAIGN | School: Portfolio Center
Instructor/Professor: Pippa Seichrist | Students: Shivani Shah, De'ja Pocahontas Mays

218 UNTITLED | School: Miami Ad School
Instructor/Professor: Ginny Dixon | Student: Ryan Blackmon

218 GLASS APPLES | School: Portfolio Center
Instructor/Professor: Pippa Seichrist | Student: Justin Tompkins

219 SPRAY BOOTH | School: Art Institute of Atlanta
Instructor/Professor: Lynda Green | Student: Tyler King

219 EARTH PROJECT | School: Miami Ad School
Instructor/Professor: Zorayma Guevara | Student: Ana Miraglia

219 VICTORINOX WATCH | School: Art Institute of Atlanta
Instructor/Professor: Lynda Green | Student: Marisa Bedard

VIDEO GOLD WINNERS:
221 GOODFELLAS | School: Pennsylvania State University
Instructor/Professor: Ryan Russell | Student: Daniel Ziegler
Assignment: The assignment was to design a relevant introduction and title sequence
to the movie of our choice. We had to think about the importance of the design of the
title sequence on setting the mood for the particular film or allude to the events, char-
acters, or climax of the movie.
Approach: Create a title sequence from vintage mob and Italian photography paired
with red text to subtly hint at the story arc of Goodfellas.
Result: The result yielded a title sequence that would make people realize that the main
plot of the movie was spoiled only after watching the full movie.

221 HUGO | School: Pennsylvania State University
Instructor/Professor: Ryan Russell | Student: Colleen Wade
Assignment: Design an introduction and title sequence to the movie of your choice.
Approach: A simplistic title sequence for the movie Hugo. I played off the idea of the
clock in old-style stop motion and paid tribute to the Georges Melies style represented.
Result: I created the sequence though the process of scanning in images of old and very
elegant clocks from the past. I cut and manipulated the images to create a stop motion
style sequence inline with the movement of the clock and the ticking noise it creates.

221 INCEPTION TITLE SEQUENCE | School: School of Visual Arts
Instructor/Professor: Ori Kleiner | Student: Julia Yu
Assignment: A title sequence for a chosen movie, including credits and moving images.
Approach: Inception is a film that explores topics of life, death, dreams, and memories.
Result: An abstract and emotive title sequence reboot of the film, Inception.

221 AMELIE | School: Pennsylvania State University
Instructor/Professor: Ryan Russell | Student: Emily Adar
Assignment: Design an introduction and title sequence to the movie of our choice.
Approach: The film that I chose, Amelie, is eclectic and quirky and I wanted to make a
title sequence that matched that energy. I decided to do a stop motion of a few different
stills that each representing a character from the film.
Result: I overlaid instrumental piano that is heard throughout the film and adds to the
nostalgic quality of the title sequence. I also added a white border around the edges to
get the feeling that these still lifes were old polaroids and stills of moments in time.

222 SUSPIRIA | School: Pennsylvania State University
Instructor/Professor: Ryan Russell | Student: Eleanor Wing
Assignment: Design a relevant introduction and title sequence to the movie of our
choice. Think about the importance of the title sequence on setting the mood.
Approach: Colorized vintage medical footage in an abstract way to replicate the
kitschy bright colors of the movie and create a dripping effect.
Result: The result yielded a slightly creepy feel to fit the mood of the movie.

222 PLEXUS WEBSITE (DEMO) | School: Drexel University
Instructor/Professor: Mark Willie | Student: Natalie Vaughan
Assignment: Senior Thesis project: I designed a conceptual sneakers brand identity, as
well as the website to customize your own sneaker.
Approach: The design speaks to the product's modular concept of puzzle piecing.
Result: I animated a video demo version of the Plexus website to show how the sneaker
tops and 3D-printed soles can be clipped together.

222 THE INTERN TITLE SEQUENCE | School: School of Visual Arts
Instructor/Professor: Adam Gault | Student: Will Jin

222 CHILDREN MARRIAGE | School: School of Visual Arts
Instructor/Professor: Hye Sung Park | Student: Park So Hyun

223 CALL ME BY YOUR NAME | School: School of Visual Arts
Instructor/Professor: Ori Kleiner | Student: Daris Dazhi Wang

223 MIDNIGHT IN PARIS | School: School of Visual Arts
Instructor/Professor: Ori Kleiner | Student: Lisa Kim

223 TELL ME ABOUT SOMETHING BRAVE | School: School of Visual Arts
Instructor/Professor: Ori Kleiner | Student: Yewon Lee

223 DIGITAL AFTERLIFE | School: School of Visual Arts
Instructor/Professor: Hye Sung Park | Student: Lynn Hwirin Park

224 THE GIVING TREE | School: School of Visual Arts
Instructor/Professor: JungIn Yun | Student: Minha Kim

224 LEAVE HER ALONE | School: School of Visual Arts
Instructor/Professor: Adam Gault | Student: Connie Van

224 TAXI | School: School of Visual Arts
Instructor/Professor: Ori Kleiner | Student: Hsiaopu Chang

224 PRIVATE VIEW - IAN STRANGE | School: School of Visual Arts
Instructor/Professor: Ori Kleiner | Student: Yijia Xu

225 HANGOVER | School: School of Visual Arts
Instructor/Professor: Ori Kleiner | Student: Yijia Xie

225 WHEN YOU ARE YOUNG | School: School of Visual Arts
Instructor/Professor: Ori Kleiner | Student: Qiuyu Guo

225 TEASERS FOR THE 100TH ANNIVERSARY OF BAUHAUS
School: Academy of Fine Arts and Design | Instructor/Professor: Eduard Čehovin
Student: Rok Malovrh | Music & Sound: Florjan Kavčič | Assistant: Damir Birsa
Assignment: Create promotional teasers for the upcoming 100th Bauhaus anniversary.
Approach: Short teasers present the basic design principles of the movement. People
who are not familiar with it are triggered to want to know more and they search for
additional information.

225 WASH YOUR HANDS | School: School of Visual Arts
Instructor/Professor: JungIn Yun | Student: Luella Mendoza

226 LES DIABOLIQUES | School: School of Visual Arts
Instructor/Professor: Adam Gault | Student: Nina Tsur

226 G, BROOKMAN | School: School of Visual Arts
Instructor/Professor: Hye Sung Park | Student: Seongjin Yoon

226 FISH IN THE POOL | School: School of Visual Arts
Instructor/Professor: Christopher Palazzo | Student: Shiyi Xiang

226 LUCY IN THE SKY | School: School of Visual Arts
Instructor/Professor: JungIn Yun | Student: Zuleika Ishrak

227 TRAIN AS LIFE | School: School of Visual Arts
Instructor/Professor: Ori Kleiner | Student: Keiko Hirakawa

227 SPOTIFY BALLOONS | School: School of Visual Arts
Instructor/Professor: Gerald Soto | Student: Elizabeth Galian
Assignment: Logo animation for Spotify.
Approach: Spotify has very diverse listeners. All music is so different, and picking
imagery to favor a certain kind of music didn't seem appropriate for the brand. I
decided that air is the common factor: without it, there is no sound.
Result: With air as the driving concept, balloons seemed to be an appropriate visual.

227 19-2000, GORILLAZ | School: School of Visual Arts
Instructor/Professor: Ori Kleiner | Student: Hyungjin Park

227 JEJU BEER COMPANY | School: Hansung University of Design & Art Institute
Instructor/Professor: Dong-Joo Park | Student: Heejin Jung
Assignment: This video is a reflection of the spatial characteristics of "Jeju Beer Com-
pany," a Korean craft beer manufacturer. Visitors not only go to the brewery but also
see the process of making Jeju beer, so it becomes a "brand experience."
Result: Through this video, experience "Jeju Beer Company" indirectly and make a
happy trip with "Jeju Beer."

228 TOMATO JUICE | School: School of Visual Arts
Instructor/Professor: Hye Sung Park | Student: So Hyun Lee

228 YOGA BREATHING | School: School of Visual Arts
Instructor/Professor: JungIn Yun | Student: Gina Lee

228 JUST IN CASE WHOPPER | School: Miami Ad School | Instructor/Professor:
Unattributed | Students: Nicolas Perez-Molina, Mauricio Borda, Martin Otero
Art Director: Hridaynag Kooretti | Assignment: Associate Burger King with Fire.
Approach: Being the Home of the Whopper is something Burger King does not take
lightly. In fact, they're so committed to serving delicious whoppers that even when
fire falls in the wrong hands, they're prepared. Introducing the Just in Case Whopper.

228 WIRES_THE BEGINNING. | School: Miami Ad School
Instructor/Professor: Stacey Fenster | Student: Ashutosh Thakkar
Assignment: Promotional Teaser video for launching an electronics brand.

229 SUNDANCE 2020 TRAILER | School: Auburn University
Instructor/Professor: Courtney Windham | Student: Heidi Kieffer
Assignment: Create a print piece and video promotion that are connected using an aug-
mented reality app. The concept is a rebrand for Sundance Film Festival.
Approach: Take simple forms from print and bring them to life as moving objects.
Result: This trailer is successful because it fully communicates the concept and does
so in an interesting way. It is fast paced and promotes the festival in a unique way.

229 ROCKIN' ROBOTS | School: West Chester University
Instructors/Professors: Jeremy Holmes, Karen Watkins | Student: Daniel Rodgers
Assignment: Senior Thesis
Approach: Using motion and sound, I wanted to show how music can be created in a
obscure way and how a story can be told without words. The limited color palette con-
veyed the setting of an alien planet and cold, machine-like feeling to the background.

229 SMILE - A SHORT FILM NOIR BRAND CAMPAIGN FOR GELAREH MIZRAHI
School: Miami Ad School Wynwood | Instructor/Professor: Unattributed
Students: Yasmine Nur, Annie Bardhwaj, Tierra Armstrong
Assignment: Create meaning from a specific sequence of events. Modify the image
(color correct) and make it a black and white video.
Approach: We altered the sequence, involved a brand, product placement, and a story.
Result: A setting in the 1950's with an editorial style photoshoot and a film poster.

229 MEN'S HEALTH MAGAZINE - AMERICAN PIE PROMOTIONAL VIDEO | School:
Miami Ad School | Instructor/Professor: Rajath Ramamurthy | Student: Ashutosh Thakkar
Assignment: Promotional Video for Men's Health Magazine.
Approach: Promo made with American Pie clips. Insight: We often get non-factual
information from sources we believe are true. But Men's Health is always a better read.

FILM/VIDEO SILVER WINNERS:
230 STONES THROW | School: School of Visual Arts
Instructor/Professor: Paula Scher | Student: Hae Jung Jun

230 UPSTREAM COLOR TITLE SEQUENCE | School: Drexel University
Instructor/Professor: Mark Willie | Student: Jenna Lecours

230 VISUAL ESSAY "HISTORY" | School: School of Visual Arts
Instructor/Professor: Adam Gault | Student: Jonghoon Kang

230 BEAN BLOSSOM | School: School of Visual Arts
Instructor/Professor: Hye Sung Park | Student: Jae Yearn Kim

230 NO EXIT | School: School of Visual Arts
Instructor/Professor: JungIn Yun | Student: Jihye Kang

230 LEMONADE | School: School of Visual Arts
Instructor/Professor: JungIn Yun | Student: Ryoko Kondo

230 WHATCHA THINKING | School: School of Visual Arts
Instructor/Professor: Christopher Palazzo | Student: Won Joon Khil

230 BRIEF HISTORY OF MY CONSCIOUSNESS | School: School of Visual Arts
Instructor/Professor: Ori Kleiner | Student: Yumin Kwon

231 10 MINDFUL MINUTES | School: School of Visual Arts
Instructor/Professor: Christopher Palazzo | Student: Darius Pippi

231 HUMAN | School: School of Visual Arts
Instructor/Professor: JungIn Yun | Student: Jihye Kang

231 CAPTURE THE MOMENT | School: School of Visual Arts
Instructor/Professor: Hye Sung Park | Student: Koki Kobori

231 DAY DREAM | School: School of Visual Arts
Instructor/Professor: Hye Sung Park | Student: Koki Kobori

231 BEST FRIENDS | School: School of Visual Arts
Instructor/Professor: JungIn Yun | Student: Ryoko Kondo

231 AMBIVALENCE | School: School of Visual Arts
Instructor/Professor: Gerald Soto | Student: Seulgi Kim

231 SELF PORTRAIT | School: School of Visual Arts
Instructor/Professor: Gerald Soto | Student: Seulgi Kim

231 DEAR KITTEN | School: School of Visual Arts
Instructor/Professor: Ori Kleiner | Student: Tianyu Jin

232 DAYDREAMING | School: School of Visual Arts
Instructor/Professor: Ori Kleiner | Student: Xuening E

232 COOKIE BOY | School: School of Visual Arts
Instructor/Professor: Ori Kleiner | Student: Sarah Ji-Won Kim

232 BELONGING | School: School of Visual Arts
Instructor/Professor: Hye Sung Park | Student: Wooyoung Kim

232 ARE YOU HUMAN | School: School of Visual Arts
Instructor/Professor: Ori Kleiner | Student: Sarah Ji-Won Kim

232 SELF PORTRAIT | School: School of Visual Arts
Instructor/Professor: Ori Kleiner | Student: Jung Eun Han

232 SKIN | School: School of Visual Arts
Instructor/Professor: Ori Kleiner | Student: Hyewon Lee

232 LION MIGHT EAT YOU | School: School of Visual Arts
Instructor/Professor: Ori Kleiner | Student: Se Jin Joo

232 AMC PROMO | School: School of Visual Arts
Instructor/Professor: Christopher Palazzo | Student: Anelisa Rosario

233 SELF PROMO | School: School of Visual Arts
Instructor/Professor: Hye Sung Park | Student: Min Jae Lee

233 MYGRATION | School: The Newhouse School, Syracuse University | Instructor/
Professor: Renée Stevens | Students: A. Wortz, Lucy Naland, Conner Lee, Jessica Sheldon

233 HOW TO COMPARE | School: School of Visual Arts
Instructor/Professor: Gerald Soto | Student: Elizabeth Galian

233 BE LIKE WATER | School: School of Visual Arts
Instructor/Professor: Ori Kleiner | Student: Dorothy Tang

233 APA PROMO | School: School of Visual Arts
Instructor/Professor: Gerald Soto | Student: Christopher Owen George

233 ME, ABOUT ME | School: School of Visual Arts
Instructor/Professor: Hye Sung Park | Student: Jenny Mascia

233 MEOWPAN | School: School of Visual Arts
Instructor/Professor: JungIn Yun | Student: Ryoko Kondo

233 2D/3D | School: Dankook University
Instructor/Professor: Hoon-Dong Chung | Student: Soobin Yeo

234 FOOD SHARING SERVICE, "GOOD FILLING" | School: Art Center College of Design
Instructor/Professor: Brian Boyle | Student: Na Yeon Kim

234 A MAZE IN TYPE | School: Miami Ad School
Instructor/Professor: Kimberly Capron Gonzalez | Student: Naadiya Mills

234 BISHOP | School: Portfolio Center | Instructor/Professor: Pippa Seichrist
Student: Justin Tompkins | Assistant: Derek Tromp

234 C O N T A C T | School: Miami Ad School
Instructor/Professor: Zorayma Guevara | Student: Vanessa Bittante

234 BOLO, BANKING FOR THE ILLITERATE | School: Miami Ad School
Instructor/Professor: Tu Phan | Students: Donghoon Lee, Philip Tabah, Deepika Desai

234 INSECURE TITLE SEQUENCE | School: Miami Ad School
Instructor/Professor: Kimberly Capron Gonzalez | Student: Alexandra Floresmeyer

234 "FOR TIPS ON..." - REAL SIMPLE | School: Miami Ad School Wynwood
Instructor/Professor: Carlos Roncajolo | Student: Bader Salahuddin | Art Director: Qi Shen

234 SHINER BOCK REPOSITIONING | School: Texas Christian University
Instructor/Professor: Bill Galyean | Student: Jessica Dawson

Academy of Art University
www.academyart.edu
79 New Montgomery St.
San Francisco, CA 94105
United States
Tel +1 415-274-2222

Academy of Fine Arts and Design
www.vsvu.sk/en/
Drotárska 44
Bratislava 811 02
Slovakia
Tel +421 2 6829 9500
international@vsvu.sk

Art Center College of Design
www.artcenter.edu
1700 Lida St.
Pasadena, CA 91103
United States
Tel +1 626 396 2200
frontdesk@artcenter.edu

Art Institute of Atlanta
www.artinstitutes.edu/atlanta
6600 Peachtree Dunwoody Rd., NE.
Atlanta, GA 30328
United States
Tel +1 770 394 8300
aiaadm@aii.edu

Auburn University
www.auburn.edu
361 Graves Drive
Auburn, AL 36849
United States
Tel +1 334 844 4000
jackssy@auburn.edu

Brigham Young University
www.byu.edu
270 Clyde Building
Provo, UT 84602
United States
Tel +1 801 422 4636

California Institute of the Arts
www.calarts.edu
24700 McBean Parkway
Valencia, CA 91355
United States
Tel +1 661 255 1050
communications@calarts.edu

Columbia College of Chicago
600 S. Michigan Ave.
Chicago, IL 60605
United States
Tel +1 312 369 1000
admissions@colum.edu

Concordia University
2811 NE. Holman St.
Portland, OR 97211
United States
Tel +1 503 288 9371
ctas@cu-portland.edu

Dankook University
www.dankook.ac.kr
152 Jukjeon-ro, Suji-gu, Yongin-si,
Gyeonggi-do
South Korea
Tel +82 1899 3700
ysb3355@naver.com

Drexel University
www.drexel.edu
3141 Chestnut St.
Philadelphia, PA 19104
United States
Tel +1 215 895 2000
info@drexel.com

George Brown College
www.georgebrown.ca
230 Richmond St. E., Room 116
Toronto, Ontario M5A 1P4
Canada
Tel +1 416 415 2000
ask.george@georgebrown.ca

**Hansung University of Design
& Art Institute**
edubank.hansung.ac.kr
116 Samseongyoro-16
Gil Seongbuk-Gu
Seoul 136-792
South Korea
Tel +82 02 760 5533/5534

Kutztown University of Pennsylvania
www.kutztown.edu
15200 Kutztown Road
Kutztown, PA 19530
United States
Tel +1 610 683 4000
admissions@kutztown.edu

Maryland Institute College of Art
www.mica.edu
1300 W. Mt. Royal Ave.
Baltimore, MD 21217
United States
Tel +1 410 669 9200

**Metropolitan State University
of Denver**
www.msudenver.edu
P.O. Box 173362
Denver, CO 80217-3362
Tel +1 303 556 5740
askmetro@msudenver.edu

Miami Ad School
www.miamiadschool.com
571 NW 28th St.
Miami, FL 33127
United States
Tel +1 305 538 3193
shannon@miamiadschool.com

Miami Ad School Brazil
www.miamiadschool.com/
advertising-school/sao-paulo
R. Me. Cabrini, 495 - Vila Mariana
São Paulo, SP 04020-001
Brazil
Tel +55 11 5081 8338
viviane@miamiadschool.com

Miami Ad School Europe
www.miamiadschool.com/
advertising-school/berlin
Feurigstrasse 54
Berlin 10827
Germany
+49 40 413 46 70
vanessa@miamiadschool.de

Miami Ad School Hamburg
www.miamiadschool.com/
advertising-school/hamburg
Finkenau 35e
Hamburg 22081
Germany
Tel +49 40 413 46 70
vanessa@miamiadschool.de

Miami Ad School Madrid
www.miamiadschool.com/
advertising-school/madrid
Santa Cruz de Marcenado 4
Madrid 28015
Spain
Tel +34 91 754 03 75
hola@miamiadschool.com

Miami Ad School NY
www.miamiadschool.com/
advertising-school/new-york
35-37 36th St.
Queens, NY 11106
United States
Tel +1 917 773 8820
eva@miamiadschool.com

Miami Ad School San Francisco
www.miamiadschool.com/
advertising-school/san-francisco
1414 Van Ness Ave.
San Francisco, CA 94109
United States
Tel +1 415 837 0966
malu@miamiadschool.com

Miami Ad School Wynwood
www.miamiadschool.com/
advertising-school/miami
571 NW. 28th St.
Miami, FL 33127
United States
Tel +1 305 538 3193
shannon@miamiadschool.com

Mississippi State University
www.msstate.edu
B. S. Hood Road
Starkville, MS 39759
United States
Tel +1 662 325 2323
news@caad.msstate.edu

**The Newhouse School,
Syracuse University**
www.syr.edu
900 S. Crouse Ave.
Syracuse, NY 13244
United States
Tel +1 315 443 1870

New York Institute of Technology
www.nyit.edu
1855 Broadway
New York, NY 10023
United States
Tel +1 212 261 1500
asknyit@nyit.edu

Oregon State University
www.oregonstate.edu
1500 SW. Jefferson St.
Corvallis, OR 97331
United States
Tel +1 541 737 1000

Pennsylvania State University
www.psu.edu
Old Main, State College
PA 16801
United States
Tel +1 814 865 4700
admissions@psu.edu

Portfolio Center
www.portfoliocenter.edu
125 Bennett St. NW.
Atlanta, GA 30309
United States
Tel +1 404 351 5055
hello@portfoliocenter.edu

Portland Community College
www.pcc.edu
12000 SW. 49th Ave.
Portland, OR 97219
United States
Tel +1 971 722 6111
sydesign@pcc.edu

**Royal Melbourne Institute
of Technology University**
www.rmit.edu.au
124 La Trobe St.
Melbourne VIC 3000
Australia
Tel +61 3 9925 2000
design@rmit.edu.au

San Jose State University
www.sjsu.edu
One Washington Square
San Jose, CA 95192
United States
Tel +1 408 924 1000

Savannah College of Art & Design
www.scad.edu
342 Bull St.
Savannah, GA 31401
United States
Tel +1 912 525 5100

School of Visual Arts
www.sva.edu
209 E. 23rd St.
New York, NY 10010
United States
Tel +1 212 592 2000

Temple University
www.temple.edu
1801 N. Broad St.
Philadelphia, PA 19122
United States
Tel +1 215 204 7000

Texas A&M University Commerce
www.tamuc.edu
2200 Campbell St.
Commerce, TX 75428
United States
Tel +1 903 886 5102
art@tamuc.edu

Texas Christian University
www.tcu.edu
2800 S. University Drive
Fort Worth, TX 76129
United States
Tel +1 817 257 7000

Texas State University
www.txstate.edu
601 University Drive
San Marcos, TX 78666
United States
Tel +1 512 245 211

University of Cincinnati DAAP
daap.uc.edu
2624 Clifton Ave.
Cincinnati, OH 45221
United States
Tel +1 513 556 4933
daap-admissions@uc.edu

University of Illinois at Chicago
www.uic.edu
1200 W. Harrison St.
Chicago, IL 60607
United States
Tel +1 312 996 7000

The University of Texas at Arlington
www.uta.edu/uta/
701 W. Nedderman Drive
Arlington, TX 76019
United States
Tel +1 817 272 2011

West Chester University
www.wcupa.edu
700 S. High St.
West Chester, PA 19383
United States
Tel +1 610 436 1000

Woodbury University
7500 N. Glenoaks Blvd.
Burbank, CA 91504
United States
Tel +1 818 767 0888
info@woodbury.edu

INDEX

AWARD-WINNING SCHOOLS

AWARD-WINNING INSTRUCTORS

AWARD-WINNING STUDENTS

Schools:
Academy of Art University
Art Center College of Design
Art Institute of Atlanta
Art Institute of North Hollywood
Brigham Young University
California State University,
 Fullerton Company/Agency
Concordia University
George Brown College
Hansung University of Design
 & Art Institute
Kutztown University of Pennsylvania
Metropolitan State University
 of Denver
Miami Ad School
Miami Ad School Europe
Mississippi State University
The Newhouse School,
 Syracuse University
Pennsylvania State University
Portfolio Center
Portland Community College
Savannah College of Art & Design
School of Visual Arts
Temple University
Texas A&M University Commerce
Texas Christian University
Texas State University
The University of Texas at Arlington
West Chester University
Woodbury University

Instructors:
Abby Guido
Adrian Pulfer
Allison Truch
Andrew Loesel
Aya Kakeda
Benjamin Dolezal
Bill Galyean
Bill Meek
Brad Bartlett
Brankica Harvey
Brittany Baum
Brooke Southerland
Bryan Dodd
Bryan Satalino
Carin Goldberg
Carmen Garcia
Cassie Hester
Cate Roman
Chris Buzelli
Courtney Gooch
Daniel Soucy
David Elizalde
Dirk Kammerzell
Dong-Joo Park
Eileen Hedy Schultz
Elizabeth Kelley
Eric Baker
Eric Doctor
Evanthia Milara
Eszter Clark
Florian Weitzel
Frank Anselmo
Frank Garcia
Genaro Solis Rivero
Gerald Soto
Gerardo Herrera
Ginny Dixon
Giulia Magaldi
Hank Richardson
Henrieta Condak
Holly Sterling
Irina Lee

Jeff Davis
Jerri Johnson
Jerrod New
Joel Becker
John DuFresne
John Nettleson
Josh Ege
Justin Colt
Karen Watkins
Kathy Mueller
Katie Kitchens
Kelly Holohan
Kenneth Deegan
Kevin O'Callaghan
Kevin O'Neill
Kimberly Capron Gonzalez
Kristin Sommese
Lauren Bernstein
Lee Whitmarsh
Lewis Glaser
Lisa Psihramis
Lynda Green
Marcos Chin
Marvin Mattelson
Mel White
Michael Osborne
Mikaela Buck
Mike Kelly
Mina Mikhael
Natasha Jen
Nathan Savage
Ori Kleiner
Paula Scher
Peter Ahlberg
Peter Wong
Pippa Seichrist
Professor
Rick Gavos
Ryan Russell
Sam Eckersley
Seung-Min Han
Shawn Hasto
Shawn Meek
Summer Doll-Myers
T.M. Davy
Theo Rudnak
Theron Moore
Thomas McNulty
Thomas Woodruff
Unattributed ACCD, Pasadena
Unattributed MAD
Veronica Vaughan
Yuko Shimizu
Yvonne Cao
Zachary Vernon
Zorayma Guevara

Students:
Aaron Blake Navarro
Abbey Dean
Abby Broekhuizen
Abby Rementer
Abdelrahman Galal
Ahyoung Lim
Aiden Yang
Ainsley Rose Romero
Alex Somoza
Alexa Lyons
Alexandra Floresmeyer
Alexis Stern
Alyssa Dosmann
Amit Greenberg
Amy Schwartz
Ana Miraglia
Andrew Segovia
Andy Mendes

Angela Godoy
Anna Dedi
Ashutosh Thakkar
Axel Ahlberg
Axel Livijn Carlman
Azadeh Mej
Bach Tran
Bader Salahuddin
Ben Bittner
Bianca Bergeron
Bryan Beomseok Oh
Bryn Rohner
Caleb Finn
Caleb Manning
Carey Feng
Carly Longo
Carson Chang
Carsyn Ciuba
Casey Lovegrove
Cate Roman
Chaei Mo
Chang Liu
Chantal Jahchan
Charles Attisano
Charles Lin
Chelsea Rust
Chelsea Ryan
Cherlyn Rebultan
Chi Hao Chang
Ching Tien Lee
Christian Santiago
Christine Lee
Chuxuan (Vern) Liu
Clive Neish
Colin Gallagher
Colleen Wade
Congrong Zhou
Constituent Name
Courtney Jacobs
Dakota Foster
Dan McGovern
Danae Gosset
Daniel Piedra
Daniel Ziegler
Daniela Connor
Danner Washburn
Dante Stewart
Dara Morgenstern
Deepika Desai
Desiree Jackson
Diane Danneels
Edmund Lee
Ein Jung
Elana Cooper
Eleanor Wing
Elizabeth Galian
Emily Adar
Emily Giroux
Emily Marquez
Emily McMurray
Emma Solomons
Erik Campay
Esther Chow
Eunpyo Hong
Eunseok Park
Evan Pavley
Ezequiel Consoli
Fernando Alvarenga
Gabriel Barbosa
Garret Wheeler
Giulianna Hull
Gordo Du rich
Ha Eun Chung
Hae Ryeon Lee
Haley Buckner
Han Meng

Hannah Gaskamp
Hannah Scibetta
Hans Heisler
Huiwen Ong
Hunwoo Choi
Hyeon-A Kim
HyunJin Stella Kim
Ioannis Kalomarkis
Isaiah Guzman
Jack Jungho Hwang
Jack Welles
Jackie Akerley
Jacklyn Munck
Jackson Watkins
Jacqueline Klier
Jae Wook Baik
Jake Blankenship
Jake Carson
Janelle Hammerstrom
Jay Jeon
Jaylynn Davenport
JeeHee Shin
Jennifer Kiser
Jens Marklund
Jessica Dawson
Jessica Luna
Jessica Wonomihardjo
Ji yun Kim
Jiayin Shi
Jihye Han
Jill Cordisco
Jill Schoenstein
Jisoo Hong
Jisu Jung
Jiyeong Kim
Joe Chong
Jose Moreno
Josi Liang Matson
Julia Hartnett
Julian Fama
Juliana Ratchford
Junho Lee, Evan Choi
Justin Tompkins
Justina Hnatowicz
Karl Wanhainen
Kasper Tinus
Kate Webb
Kateri Gemperlein-Schirm
Kathleen Mensing
Katia Mena
Katie Tynes
Kayla Corazzi
Kendra Little
Krishapriya (KP) Dutta Gupta
Landon Taylor
Landon Watnick
Laura Ann McNeill
Laura McMullan
Laura Ortiz
Leigh Menkovich
Liu Chang
lorenzo della giovanna
Luc' a Mendezona
Lucy Benson
Mackenzie Malpass
Madeline Wood
Madison DeFilippis
Marcelo Shalders
Marcus Holloway
Margaux Essey
Maria Trejo
Marina Ferraz
Marissa Klick
Mary Wynn
Matthew Sullivan
McCall Keller

Mckenzie Martin
Meredith Stringfellow
Mert Avadya
Mia Rendon
Michael Curry
Michele Farren
Michele Sabty
Michelle Sadler
Min Kyung Kim
Minjeong Lee
Minyoung Park
Monica Williams
Mya Passmore
Naadiya Mills
Nakyung Youn
Neha Biluve
Niamh Murphy
Noah Lewis
Noel Ramos
Nuri Park
Omar Hernandez
Paula Gete-Alonso
Pedro Moreno
Peyton Foley
Radhika Subramanian
Rafael Villasana
Rhea Shah
Robin van Eijk
Rogier van der Galie
Rosie Bellon
Rowan Griscom
Ryan Blackmon
Sam Cush
Sanja Pavlovic
Sanjana Ranka
Sara Nassar
Sarah Halmon
Sarah Wood
Sarai Wingate
Seona Kim
Shandi Tajima
Shani Azizollahoff
Sheng Dong
Shivani Shah
Shivani Shah
Stacey Fenster
Stephan Tynes
Stephanie Williams
Sung Eun Kim
Sunmi Lee
Tamara Yakov
Taylor Mertz
Tori Evert
Tut Pinto
Tyler Balogh
Wang Shuyue
William Liao
William Palizo
Yasmine Ali
Yi Hsin Chen
Yifei You
Yoonseo Chang
Youlho Jeon
Younghoe Koo
Yunchung Chung
Yuxin Xiong
Yvonne Tseng
Zeke Wattles
Zhilin Liu
Zhixin Fan
Zhuo Zhen He
Ziqi (Ora) Xu
Zoe Halpern
Zuheng Yin

The students clearly designed their works with free expression, seldom taken hold by tradition. The work was simply outstanding.

Masahiro Aoyagi, *Art Director, Toppan Printing Co., Ltd*

The quality of the work submitted to the New Talent Annual was superb. It was refreshing to see many unique solutions that did not result in stylistic cliches.

Jennifer Morla, *Creative Director, Morla Design*

Advertising 2019	Branding 7	Design 2019

Advertising 2019

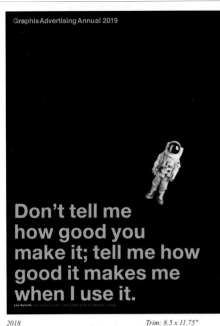

GraphisAdvertisingAnnual 2019

Don't tell me how good you make it; tell me how good it makes me when I use it.

Leo Burnett,

2018 Trim: 8.5 x 11.75"
Hardcover: 240 pages ISBN: 978-1-931241-74-8
200-plus color illustrations US $90

Awards: 16 Platinum, 122 Gold, and 310 Silver Awards, totaling more than 600 Winners, along with 197 Honorable Mentions.
Platinum Winners: 21X Design, Earnshaw's Magazine, Entro, Fred Woodward, hufax arts, IF Studio & Magnus Gjoen, Ken-tsai Lee Design Lab/Taiwan Tech, Michael Pantuso Design, Morla Design, Shadia Design, Steiner Graphics, Stranger & Stranger, Studio 5 Designs Inc., Toppan Printing Co., Ltd., and Traction Factory.
Judges: Ronald Burrage of PepsiCo Design & Innovation, Randy Clark, John Ewles, William J. Gicker, Matthias Hofmann, John Krull, and Carin Stanford.
Content: Designs by the Judges and award-winning student work.

Branding 7

GraphisBranding7

PLATINUM WINNERS:
Ventress Design Works
cosmos
SVIDesign
Commission Studio
Karousel
COLLINS
Ginger Brand
Tiny Hunter
STUDIO INTERNATIONAL

2018 Trim: 8.5 x 11.75"
Hardcover: 240 pages ISBN: 978-1-931241-73-1
200-plus color illustrations US $90

Awards: 10 Platinum, 73 Gold, and 194 Silver Awards, totaling nearly 500 winners, along with 124 Honorable Mentions.
Platinum Winners: Tiny Hunter, COLLINS, cosmos, Ventress Design Works, Karousel, SVIDesign, Ginger Brand, Commission Studio, and STUDIO INTERNATIONAL.
Judges: All entries were judged by a panel of highly accomplished, award-winning Branding Designers: Adam Brodsley of Volume Inc., Cristian "Kit" Paul of Brandient, and Sasha Vidakovic of SVIDesign.
Content: Branding designs from New Talent Annual 2018, award-winning designs by the Judges, and Q&As with this year's Platinum Winners, along with some of their additional work.

Design 2019

GraphisDesignAnnual 2019

PLATINUM WINNERS:
Studio 5 Designs Inc.
Toppan Printing Co., Ltd.
GQ
McCandliss and Campbell
hufax arts Co., Ltd.
Entro
Michael Pantuso Design
Morla Design
21xdesign
IF Studio
Magnus Gjoen
Steiner Graphics
Traction Factory
Ken-Tsai Lee Design Lab /Taiwan Tech
Shadia Design
Stranger & Stranger

2018 Trim: 8.5 x 11.75"
Hardcover: 256 pages ISBN: 978-1-931241-71-7
200-plus color illustrations US $90

Awards: 16 Platinum, 122 Gold, and 310 Silver Awards, totaling nearly 500 winners, along with 197 Honorable Mentions.
Platinum Winners: 21X Design, Earnshaw's Magazine, Entro, Fred Woodward, hufax arts, IF Studio & Magnus Gjoen, Ken-tsai Lee Design Lab/Taiwan Tech, Michael Pantuso Design, Morla Design, Shadia Design, Steiner Graphics, Stranger & Stranger, Studio 5 Designs Inc., Toppan Printing Co., Ltd., and Traction Factory.
Judges: Ronald Burrage of PepsiCo Design & Innovation, Randy Clark, John Ewles of Jones Knowles Ritchie, William J. Gicker of The United States Postal Service, Matthias Hofmann of hofmann.to, John Krull of Shine United, and Carin Standford of Shotopop.
Content: Designs by the Judges and award-winning student work.

Poster 2019	Photography Annual 2018	Type 4

Poster 2019

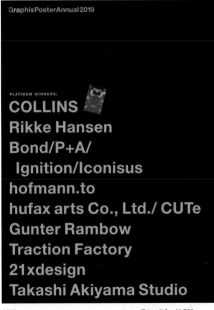

GraphisPosterAnnual 2019

PLATINUM WINNERS:
COLLINS
Rikke Hansen
Bond/P+A/ Ignition/Iconisus
hofmann.to
hufax arts Co., Ltd./ CUTe
Gunter Rambow
Traction Factory
21xdesign
Takashi Akiyama Studio

2018 Trim: 8.5 x 11.75"
Hardcover: 240 pages ISBN: 978-1-931241-69-4
200-plus color illustrations US $90

Awards: This year, Graphis awarded 10 Platinum, 110 Gold, and 162 Silver Awards, along with 241 Honorable Mentions, totaling over 500 winners, all equally presented and archived on Graphis.com.
Platinum Winners: 21X Design, Takashi Akiyama, Peter Bell, Rikke Hansen, Matthias Hofmann, Fa-Hsiang Hu, Gunter Rambow, COLLINS, and FX Networks/Bond/P+A/Ignition/Iconisus.
Judges: All entries were judged by a panel of highly accomplished Poster Designers: Fons Hickmann, Andrew Hoyne, Zach Minnich, Daeki Shim, Hyojun Shim, and Rick Valicenti.
Content: Included are Professor and student posters from New Talent Annual 2018. Also featured are award-winning posters by this year's Judges. A poster museum directory is also presented.

Photography Annual 2018

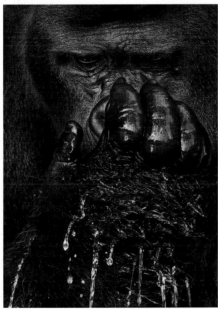

2018 Trim: 8.5 x 11.75"
Hardcover: 256 pages ISBN: 978-1-931241-66-3
200-plus color illustrations US $90

This year's Platinum Award-winning Photographers are **Athena Azevedo**, **Athena Azevedo**, **Ricardo de Vicq de Cumptich**, **Tim Flach**, **Bjorn Iooss**, **Parish Kohanim**, **Gregory Reid**, **Mark Seliger**, **Adam Voorhes**, and **Dan Winters**. Work was judged by a panel of award-winning Photographers, all of whom are Graphis Masters: Craig Cutler, Parish Kohanim, RJ Muna, and Lennette Newell. Also presented is an In Memoriam feature on Graphis Master Photographer Pete Turner, which includes his biography and some of his most extraordinary photographs. As always, a list of international photography museums is also presented. This Annual is a valuable resource for Photographers, Design Firms, Advertising Agencies, Museums, students, and Photography enthusiasts.

Type 4

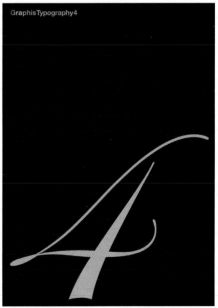

GraphisTypography4

2018 Trim: 8.5 x 11.75"
Hardcover: 256 pages ISBN: 978-1-931241-68-7
200-plus color illustrations US $90

Awards: This year, Graphis awarded 18 Platinum, 150 Gold, 219 Silver, and 116 Merit Awards, totaling over 500 winners.
Platinum Winners: ARSONAL, Chemi Montes, DAEKI & JUN, Hufax Arts, Jones Knowles Ritchie, McCandliss & Campbell, Ron Taft Design, SCAD, Selman Design, Studio 32 North, Traction Factory, Umut Altintas, Atlas, Jamie Clarke Type, Jones Knowles Ritchie, Linotype, SVA, and Söderhavet.
Judges: Entries were judged by highly accomplished Type Designers: Nadine Chahine (LB), Akira Kobayashi (JP), and Dan Rhatigan (US).
Content: A documentation of the history of typeface design from the 5th Century B.C. to 2018, as well as informative articles on Typeface Design Masters Matthew Carter and Ed Benguiat.
